W9-AEQ-256

OXFORD WORLD'S CLASSICS

A VINDICATION OF THE RIGHTS OF MEN

AND

A VINDICATION OF THE RIGHTS OF WOMAN

MARY WOLLSTONECRAFT was born in 1759 and suffered a peripatetic childhood following an increasingly impecunious and drunken father. Fuelled by indignation at the inequality of treatment of herself and the eldest son, she left home to follow the few occupations open to a lady: as companion, schoolteacher, and governess. Her great break came when she was employed as assistant and reviewer for the radical publisher Joseph Johnson in London through whom she met such thinkers as Thomas Paine, Henry Fuseli, William Godwin, and William Blake. Excited by the possibilities of the French Revolution, she entered the propaganda war in England and within a short time wrote both *A Vindication of the Rights of Men* and *A Vindication of the Rights of Woman*, arguing the rights of all people to education and consideration. Over the next years she struggled with the problems of trying to be an independent woman despite a conditioning in dependence. In France she entered an ultimately unhappy relationship with Gilbert Imlay and bore a daughter. During this time she wrote her history of the early French Revolution trying to come to terms with the violence and cruelty she had witnessed. In the last year of her life she married Godwin; she died following childbirth a few months later.

Godwin's *Memoirs* of his wife was frank about Wollstonecraft's illegitimate child and suicide attempts and in the public mind welded her emotional romantic life onto the stern nationalist philosophy of the two *Vindications*.

JANET TODD is Grierson Professor of English Literature at the University of Aberdeen. She is the author of many books, including *Mary Wollstonecraft: A Revolutionary Life* (2000) and *Death and the Maidens: Fanny Wollstonecraft and the Shelley Circle* (2007), and the editor of *The Collected Letters of Mary Wollstonecraft* (2004).

OXFORD WORLD'S CLASSICS

*For over 100 years Oxford World's Classics have brought
readers closer to the world's great literature. Now with over 700
titles—from the 4,000-year-old myths of Mesopotamia to the
twentieth century's greatest novels—the series makes available
lesser-known as well as celebrated writing.*

*The pocket-sized hardbacks of the early years contained
introductions by Virginia Woolf, T. S. Eliot, Graham Greene,
and other literary figures which enriched the experience of reading.
Today the series is recognized for its fine scholarship and
reliability in texts that span world literature, drama and poetry,
religion, philosophy and politics. Each edition includes perceptive
commentary and essential background information to meet the
changing needs of readers.*

OXFORD WORLD'S CLASSICS

MARY WOLLSTONECRAFT

A Vindication of the Rights of Men

A Vindication of the Rights of Woman

An Historical and Moral View of the French Revolution

OXFORD
UNIVERSITY PRESS

OXFORD

UNIVERSITY PRESS

Great Clarendon Street, Oxford OX2 6DP

Oxford University Press is a department of the University of Oxford.
It furthers the University's objective of excellence in research, scholarship,
and education by publishing worldwide in

Oxford New York

Athens Auckland Bangkok Bogotá Buenos Aires Calcutta
Cape Town Chennai Dar es Salaam Delhi Florence Hong Kong Istanbul
Karachi Kuala Lumpur Madrid Melbourne Mexico City Mumbai
Nairobi Paris São Paulo Singapore Taipei Tokyo Toronto Warsaw

with associated companies in Berlin Ibadan

Published in the United States
by Oxford University Press Inc., New York

Editorial material © Janet Todd 1993

Hardback published by Pickering and Chatto Ltd. 1993

First published as a World's Classics paperback 1994
Reissued as an Oxford World's Classics paperback 1999
Reissued 2008

British Library Cataloguing in Publication Data

Data available

Library of Congress Cataloging in Publication Data

Data available

ISBN 978–0–19–955546–8

2

Printed in Great Britain by
Clays Ltd, St Ives plc

CONTENTS

INTRODUCTION

The works published in this volume are all parts of a controversy concerning the French Revolution. All were written between 1790 and 1794, a peculiar period in English culture which, in its richness of theoretical writing and enthusiasm for political discussion, can be compared only with the turbulent mid-seventeenth century. It was a period in which neighbouring France followed seventeenth-century England in trying to act out political and social theories. For its part, the English government, noting the direction of those theories, tried to limit the spread of activity by controlling the dissemination of ideas. The men and women who wrote on socio-political issues in such a context were not the sages of more peaceful periods but engaged polemicists who believed that their ideas might soon be put into practice; they also knew that their publishing might have political and social consequences for their personal lives.

The two works printed here in full, *A Vindication of the Rights of Men* and *A Vindication of the Rights of Woman*, and *An Historical and Moral View . . . of the French Revolution* printed in part, were all reactive and provocative, elements in a series by people who knew or knew of each other; they make points in a debate about a single phenomenon, the French Revolution. When this event had begun in 1789, most liberal-thinking people in England judged it comparable with the English revolution of 1688. If the works here do not breathe this moderate acceptance, it is mainly because, after the publication in 1790 of Burke's vehement and emotional denunciation, *Reflections on the Revolution in France*, political alignments became both more problematical and more positive. In certain fundamental respects it is possible to see all Wollstonecraft's political works in dialogue with Burke's ideas and rhetorical stance.

A Vindication of the Rights of Men

Wollstonecraft was ready to enter the political fray with her first *Vindication* in 1790 because her life had provided a preparation for it. She was born in 1759 just before George III came to the throne and his emphasis on domestic policies must have highlighted the

irregular nature of her unstable home, headed by a dissipated and unthrifty father. As her family fell down the social scale, losing all hopes of remaining gentlemen-farmers, Wollstonecraft seethed less at the social embarrassment than at the injustice of concentrating dwindling resources on the eldest son of a large family in which she was the eldest daughter. Consequently, at 19 she left home to take a position as a paid companion, returning in 1781 to care for her dying mother. After her mother's death she moved in with Fanny Blood, a dear friend from whom she claimed to have derived some of her education. Soon she fashioned a plan for keeping herself, Fanny, and her sisters, by establishing a small school.

Wollstonecraft had little pedagogical preparation for this enterprise although for a short time in Yorkshire she had received lessons from the intellectual father of her first close friend, Jane Arden. Later Jane Arden founded a school with her sisters, and her action probably encouraged Wollstonecraft, with whom she still corresponded. The very fact that Wollstonecraft could set up an establishment with so little preparation suggests the sort of institutions most middle-class girls would enter. In *The Rights of Woman* Wollstonecraft recommended that communities regulate their schools.

The lack of kindly parental authority seems to have haunted Wollstonecraft throughout her life. She railed against all forms of patriarchal power, whether of father over children, king over country, or of public schoolboy over fag, a form of tyranny she saw briefly at Eton. In the place of the father she seems to have idealized a substitute father-figure, an unthreatening, desexualized, and intellectually admirable figure, portrayed in her final fiction *The Wrongs of Woman* in the kindly, generous, and uncontrolling uncle. In her life the role seems to have been played at one time by Richard Price, who nurtured her ideas in Newington Green, where her school was established. The minister of a Dissenting Chapel, a liberal intellectual, and fellow of the Royal Society, honoured in Scotland and the new United States, Price was a staunch advocate of political and economic reforms and he was in contact with many leading philosophers of the time such as Franklin and Condorcet (whose views on women's rights would be close to Wollstonecraft's). Through Price and others living in Newington Green, she came to consider Locke's theories about the basic nature of sensory experience and the power

of environment in education, which went some way to explaining her own character and gave her a language with which to begin to express her long-held sense of discrimination.

Because of her background and influences, it is fitting that Wollstonecraft's first work *Thoughts on the Education of Daughters* should be on education and partially follow Locke in stressing the power of environment; it differs from her later educational works primarily in its allowance for innate qualities and in its strain of compensatory piety. The book was published by the liberal London publisher Joseph Johnson, with whom one of her Newington Green friends had put her in touch.

In the light of such a past, Wollstonecraft hardly seems best fitted for service to the aristocracy. But, following her trip to Portugal, where the now-married Fanny had died in childbirth, she abandoned her ailing school and became a governess to the children of Lord and Lady Kingsborough in Ireland. Predictably it was a short-term employment, during which the most useful events for her intellectual development were the writing of her first and most sentimental novel, *Mary: A Fiction* (in which she allowed her heroine to find solace from life's miseries in an assumption of superior sensibility), and the reading of Rousseau's educational work *Émile*, which, she was pleased to find, chose 'a *common* capacity to educate' and gave 'as a reason, that a genius will educate itself'; she much admired its description of a system of natural education suited to the capacities of the child.[1] Later, however, she would deplore the contents of book v, which confined the admirable system, outlined in the early books, to the boy: the girl Sophie was left to suffer a contingent upbringing fitting her more for marriage and childbearing than for independent adulthood.

Dismissed by Lady Kingsborough, Wollstonecraft settled in London in 1787 to work for Johnson, another of her nurturing avuncular figures. In May 1788 he began his new journal, the *Analytical Review*, for which she was speedily reviewing, frequently on educational and fictional works, sometimes on political and aesthetic. She also translated Salzmann, who, grounding his views on Locke and Rousseau, insisted that education be related to the imme-

[1] *Collected Letters of Mary Wollstonecraft*, ed. Ralph Wardle (Ithaca, NY: Cornell University Press, 1979), 145.

diate world and to the child's experiences, advice clearly followed in
her own book for children, the rather fearsome *Original Stories*.
Later Salzmann would return the compliment by translating *The
Rights of Woman* into German. Through Johnson, Wollstonecraft
met many different people, among them the radical political writer
Thomas Paine and the painter and critic Henry Fuseli.

On 14 July 1789 the Bastille fell. Liberal English people varied
between enthusiasm and moderate welcome. In some circles the
Revolution became fashionable and its heroes were commemorated
on commodities such as snuff boxes and scarves. The Dissenters,
however, saw providence rather than fashion, discerning in it the
latest phase of the unfinished English revolution of 1688. Conse-
quently, on 4 November Price delivered an anniversary sermon for
the Glorious Revolution at the Old Jewry meeting-house urging
England to continue its radical development.

His vision, though couched in Dissenting millenarian language,
was close to that of the new Whigs. He opposed hereditary power,
accepted civil authority as a trust from the people, and imagined a
spreading liberty that would replace kings with the rule of law, and
priests with the rule of reason and conscience. Months later Price
and several Whigs attended a dinner at the Crown and Anchor
Tavern to celebrate the first anniversary of the fall of the Bastille; at
the dinner he toasted the idea of a United States of the World.

Edmund Burke, a Whig of an older school, champion of Ameri-
can Independence as exemplary of traditional English liberties, saw
the Glorious Revolution of 1688 as a moderate and cautious settle-
ment rather than as the start of a revolutionary agenda, and he
was affronted by Price's interpretation, as well as by his apparent
confusing of English with French developments. *Reflections on the
Revolution in France*, appearing on 1 November 1790, aimed to
denounce Price, to attack the French revolutionaries and their prin-
ciples, and to defend the British constitution and the notion of
prescriptive right. He saw a levelling tendency in Price which allied
him to the French and their abstract 'metaphysical' notion of lib-
erty, and he therefore judged his views closer to the spirit of 1649,
the year of Charles I's execution, than to the regulated principles of
1688.

Burke insisted that France's *ancien régime* had been an extreme
version of the system which England had reformed. He was particu-

larly astute in making this system of privileges of rank checked by duties, of the status quo of king and Church, appear peculiarly English and worthy of patriotic devotion. Conversely he made it seem 'French' to believe in radical ideas.

Holding to a Christian pessimistic view of human nature, Burke accepted its fixed condition and thoroughly opposed any notion of perfectibility. He considered that vice and individual selfishness rather than government were the cause of social unhappiness. People were ruled by passion not abstract reason, he argued; manners and civilization distinguished modern society from the barbaric, and a concept of nobility was 'the Corinthian capital of political society'.

Burke made part of his argument through sentimentalized pictures of sexual and familial relationships, especially of the French queen Marie Antoinette as mother and lady, worthy object of chivalric devotion. These pictures were particularly galling to Wollstonecraft, who had seen little to admire either in families or in aristocratic society. In his emotional adherence to a chivalric notion of aristocracy, Burke actually went beyond the views of many old Whigs and even a good number of contemporary Tories. None the less, this nostalgic vision, more literary than historical, was the major appeal of *Reflections* to others of both political parties and it sold about 19,000 copies in its first year, with about another 30,000 over the next five years.

Over fifty replies followed, some by new or moderate Whigs such as James Mackintosh, wanting to ally the Revolution with the ideals of 1688, and some by more radical writers doubting that monarchy and aristocracy could ever be the best of systems, even for a flawed humanity. In their place they advocated a variety of systems from reformist to revolutionary, the most famous of which were included in Paine's *The Rights of Man* (1791) and Godwin's *Political Justice* (1793), but the first reply was Wollstonecraft's *Vindication of the Rights of Men*, written hurriedly and excitedly and printed by the page as she wrote. It appeared anonymously in December 1790 and was republished almost immediately.[2]

[2] See Godwin's *Memoirs of the Author of a Vindication of the Rights of Woman* for an episode during the writing of *The Rights of Men*: the publisher Joseph Johnson cleverly goaded Wollstonecraft, caught in a fit of 'torpor and indolence', into finishing the work by accepting her defection and offering to destroy the pages that he had already printed.

Wollstonecraft had learnt many of her libertarian principles from the Dissenters, and their rhetoric marked her work. Raised as an Anglican and never formally renouncing the affiliation, she probably derived from Price her criticism of any alliance of temporal and spiritual powers such as that displayed in the Established Church. More specifically, she may have derived from Price her serious sense of social progress in almost millenarian terms, the belief that the moment must be taken or progress would be halted. From her later radical associates in London, such as Paine in *Common Sense* (1776), she took arguments concerning natural rights, asserting that, in their light, monarchy became ridiculous and hereditary honours unjust. She rehearsed history to dispose of British smugness in the inexorable progress towards the perfection of 1688. Burke, she charged, had made liberty into the unjust maintenance of property, where she took her stand on the idea of God-given rights of men from birth as rational creatures. He was holding to a feudal world-view quite out of keeping with an advanced commercial society on which, as a woman denied the mystifying education in the classics, she took her modern stand. Rational justice not sentimental pity was wanted.

Beyond the political arguments of Dissenters and radicals, however, Wollstonecraft made at times vicious *ad hominem* attacks on Burke himself. This became justified by Burke's own attacks on Price, who had befriended and nurtured her intellectually and who in *The Rights of Men* became the benevolent uncle figure, much being made of his advanced age, 68 (which was, in fact, close to Burke's own 62 years). Cleverly providing a close reading of Burke's text, for which her time working for the *Analytical Review* must have prepared her, she moved from Burke's arguments about the hereditary principle, the constitution, and the law, to attack the mental structure that supported them, assaulting the patriarchal message in his tropes (which made revolution into parricide) as much as the message in his arguments.

Burke took a stand on the family and aristocracy, idealizing both and emblematizing them in the person of Marie Antoinette. Not only opposing the eulogistic reading of a queen she regarded as vulgar, Wollstonecraft also uncovered the belittling nature of Burke's idealizing. He tended, she implied, to praise precisely what did not deserve praise: the frivolous and the trivial. For Marie

Antoinette, suddenly uncovered—albeit for rhetorical purposes—
as an 'animal not of the highest order', irrational respect was de-
manded.[3] Yet her weakness as a woman had been exposed. The
argument was, then, really about power, and the kind of mystifying
chivalrous respect Burke advocated was really an expression of
power.

Burke's mystification came from his rhetoric. Although it some-
times seems in her work that she was more obsessed with attacking
sentimental writing and habit of mind than with refuting Burke's
overt argument, it is this obfuscating rhetoric that she opposed as
the basis of this argument. The 'effeminacy' of Burke was not just
the expression of a flabby mind but really a statement of power since
it put the reader in the place of the woman as object (as well as
subject) of his sentimental rhetoric. The power of aristocracy, which
Wollstonecraft always associated with effeminacy, was different
from the power of 'woman', since it was in the last analysis substan-
tial power. But, like that granted to woman, it was based on mysti-
fication since it demanded emotional acceptance without cause
and was, although substantial, none the less power without rational-
ity. The effeminacy of Burke's discourse was thus political and
dangerous.

To discredit Burke as a man revealed in his text Wollstonecraft
cleverly reversed the gender roles. Although the thrust of her argu-
ment was against *Reflections*, it is clear that she took exception also to
Burke's earlier and influential book on aesthetics, *A Philosophical
Enquiry into the Origin of our Ideas of the Sublime and Beautiful*
(1757), with its aesthetic genderizing in which beauty became asso-
ciated with women and sublimity with men. Her response was to
ally herself with the sublimity Burke was, by implication, associat-
ing with himself.

She displayed herself as the provoked and impartial rationalist
exasperated by the maudlin sentimentality and confusion of an emo-
tional and flawed man. She was a rationalist and plain dealer; he was
a muddled idealist hiding behind notions of natural feeling and
common sense, dealing in the mystification of courtliness and art.
She had firm principles, he was an opportunist; she was androgy-

[3] Edmund Burke, *Reflections on the Revolution in France*, ed. J. G. A. Pocock
(Indianapolis: Hackett Publishing Company, 1987), 67.

nous in her self-presentation but manly in her force and reason, unintimidated by a 'horse laugh' with which men tended to greet female intellectual endeavour, and not moved by tears, which she refused to see as natural and feminine but rather as part of a manipulating rhetoric. While she was unaffected and serious, Burke became a vain, trivial, and effeminate man whose anxious wit could be compared to that of a celebrated beauty. It was in keeping that he should display the bad taste in his attacks on the venerable and right-thinking Price and on the mad King George. In these attacks he also displayed the contradictions in his stance: his mystifying demand for respect for the weak or impotent complicated his demand on the one hand for respect for the aged constitution of England and on the other for contempt for Price, described as a fool, and for the King, described as a madman.

The Rights of Men was so hurriedly written it would be surprising if it were not rambling and ill organized. But, although it seemed to be following minor over major points, it was thereby, arguably, mounting a subtle attack on a habit of mind in Burke that was at bottom aesthetic and amoral rather than rational and moral. It could also be argued that the apparent disorganization was part of the message; certainly the charge might be levelled also at Wollstonecraft's most famous book, *A Vindication of the Rights of Woman*, as indeed at Paine's initial reply to Burke, the first part of *The Rights of Man*. Clearly the style was a common one for polemicists desiring to make their work appear gut reaction and to present themselves as moved by honest indignation and forced into print by absolute conviction and exasperation.

Among the refutations after Wollstonecraft, one of the most notable was James Mackintosh's *Vindiciae Gallicae* coming out in early 1791; in it he insisted that Burke had trampled on the ideals of Whiggism and aligned himself instead with Tory superstition and chivalry. In opposition to Paine, Mackintosh invoked the ideals of 1688, which he saw as needing a little improvement, regarding France as correctly endeavouring, like England, to move itself from a feudal to a commercial society. In *Observations on the Reflections of . . . Burke* (1790), however, Catherine Macaulay took a very different view, regarding the French Revolution not as a repetition of English development but as something new and unique, a 'sudden

spread of an enlightened spirit', and, like Price, she saw benevolent providence in it.[4]

Most important of the replies was, of course, Paine's *The Rights of Man*, part I of which was published in February 1791; the more systematic second part followed in the next year. Ringingly asserting the rights of the living over the dead, it argued firmly for republican government based on reason and the contract *between the people* to form a government, not between the people and a ruler, as Locke had assumed. It also argued for an acceptance of natural human rights from divine authority (not historical rights) on which civil rights were based and it reprinted the French *Declaration of the Rights of Man and of the Citizen*. Like Wollstonecraft, Paine attacked inadequate parliamentary representation, primogeniture, aristocracy, and state religion, and he denied reverence for 1688 and its 'Bill of Wrongs' created by a non-elected Commons. Like Wollstonecraft, Paine did not wish to destroy the property system completely; both wished only that large estates be divided.

A Vindication of the Rights of Woman

Given all this political endeavour, all this seeking and justifying of rights, it is quite remarkable how little constructive comment there was on women and their political status. Although during the American conflict in 1775 Paine had published 'An Occasional Letter on the Female Sex', when he included the French *Declaration of the Rights of Man* in his own *Rights of Man* he did not think to annotate the document to show the systematic exclusion of women from its principles, as the feminist Olympe de Gouges would do in France. It is Wollstonecraft's distinction that, without being the first to put forward feminist views or, indeed, the only one to do so at the time, she brought the issue of women's rights for a short moment in the 1790s into the general debate about civil rights.

An earlier debate, mainly about women's exclusion from education, had been joined a century before in the final decades of the seventeenth century. Most notably Poulain de la Barre in France

[4] Catherine Macaulay, *Observations on the Reflections of the Right Hon. Edmund Burke on the Revolution in France in a Letter to the Right Hon. the Earl of Stanhope* (London, 1790), 95.

had asserted the intellectual equality of the sexes, going even further in insisting that the natural powers remained less contaminated in women owing to their exclusion from the violent process of establishing civil society; consequently they should play an active part in the future development of that society.

The 1690s saw the publication of Locke's *Two Treatises of Government* (1690), in which chapter IV of the second book opened with the words: 'The *Natural History* of Man is to be free from any Superior Power on Earth, and not to be under the Will or Legislative Authority of Man, but to have only the Law of Nature for his Rule.'[5] In her *Serious Proposal to the Ladies . . .* (1694 and 1697) Mary Astell took her stand on far less libertarian principles than Locke, but yet quickly surpassed him in feminist concern when she argued for education and a breaking down of the 'enclosure' excluding women from human knowledge. Although much discussion of women followed during the next decades, with many just and subtle remarks being made by women such as Lady Mary Wortley Montagu, under the increasing emphasis on the sensitivity and childlikeness of women—qualities traditionally, if never before so assertively and positively, seen as 'feminine'—there was relatively little argument for civil and educational rights for women during the main part of the eighteenth century.[6]

In 1790, just before she embarked on *The Rights of Woman*, Wollstonecraft read a book for which she declared her admiration in a review in the *Analytical Review*: Catherine Macaulay's *Letters on Education*.[7] A religious work, in tone closer to Astell than Wollstonecraft, it argued forcibly that women needed rational education before they could be judged moral beings; if they were regarded primarily as sexual, they could not be fully human. Feminine frivolity and triviality could only be remedied by the cultivation of female intellect. In her overt feminist arguments, Wollstonecraft did

[5] John Locke, *Two Treatises of Government*, ed. Peter Laslett (Cambridge: Cambridge University Press, 1988).

[6] Some exceptions are the pamphlets of 'Sophia', *Woman not Inferior to Man* (1739) and *Woman's Superior Excellence over Men* (1740). Lady Mary Wortley Montagu's comments about women are found mainly in her letters; see *Complete Letters*, ed. Robert Halsband (Oxford, 1965–7).

[7] *The Works of Mary Wollstonecraft*, ed. Janet Todd and Marilyn Butler (London: Pickering and Chatto, 1989), vii. 309–22.

not go further than Macaulay, and indeed she sometimes does not go as far, for instance when she concedes, both in her book and in her review, that intellectual equality was still to be proven.

As in the twentieth century, so in the eighteenth there was more concern for racial than sexual injustice; both French and British liberal and radical theorists and philosophers, much concerned with racial matters, hardly took up the issue of women's status and rights. Many indeed associated femaleness with reaction, darkness, and superstition and tended to couch their enterprise of enlightenment in gendered terms of 'mastering' a feminized nature, ordering a feminine chaos, or penetrating feminine darkness. In a way Wollstonecraft responded to this language by taking up the misogyny and admitting its justification: women would indeed dim enlightenment if they were allowed to rest ignorant, thereby stopping the progress of knowledge and virtue in general.

In France, Condorcet was an exception among the indifferent *philosophes*. He had written of women's rights in *Letters of a Bourgeois of Newhaven* in 1787; in July 1790 he published 'On the Admission of Women to the Rights of Citizenship' to draw attention to the violation of the principle of equality of rights in the exclusion of half the population from citizenship. In the following year he published 'The Nature and Purpose of Public Instruction', in which he declared that differences among groups of people were due to education. Although he made Wollstonecraft's point that male superiority seemed clear in the present situation, but remained to be properly investigated, he was on the whole more concerned with political than social rights; consequently, since the highest achievement was not necessary for political rights and genius not essential for citizenship, he had in many ways an easier time in his argument and could occasionally invoke the gallantry Wollstonecraft so deplored, as well as the gendered concept of character she despised.

In 1793, now in hiding, Condorcet wrote his *Sketch for a Historical Picture of the Progress of the Human Mind*; powerless and away from practicalities, he became more definite about women's status and closer to Wollstonecraft:

Among the causes of the progress of the human mind that are of the utmost importance to the general happiness, we must number the complete annihilation of the prejudices that have brought about an inequality of rights between the sexes, an inequality fatal even to the party in whose favour it

works. It is vain for us to look for a justification of this principle in any differences of physical organization, intellect, or moral sensibility between men and women. This inequality has its origin solely in an abuse of strength, and all the late sophistical attempts that have been made to excuse it are vain.[8]

By concentrating on social rather than political debasement, Wollstonecraft suggested a more intractable problem than Condorcet addressed in his earlier works and was forced to castigate not only male intransigence but also women's collusion in their own oppression. She did not, however, discuss or take issue with Condorcet's view and appears not to have read him before writing *The Rights of Woman*, although Price had known him in the past and Paine knew him in Paris; with her penchant for telling biological comparisons, it seems unlikely that she would have omitted his analogy of gout and pregnancy: 'Why should individuals exposed to pregnancies and other passing indispositions be unable to exercise rights which no one has dreamed of withholding from persons who have the gout all winter or catch cold quickly?'[9] Conversely, the later Condorcet does not mention Wollstonecraft, whose books were being printed in the gaps of his own, choosing instead to give his admiration to Catherine Macaulay, who appears in his work as a historian, fitted to express her views in Parliament, rather than as a writer on women's rights and education.

In *The Rights of Woman* even more than *The Rights of Men* Wollstonecraft was caught up in the revolutionary excitement of progressive thought in England, clearly writing in the context of an actual revolution that indicated a possibility of real political change. In *The Rights of Men* she had addressed a reactionary Burke; in *The Rights of Woman* she primarily took issue with a philosopher whose views were intimately bound up with the French Revolution: Jean-Jacques Rousseau, whose *Émile* had had a profound effect on her educational thinking and whose heady novel *La Nouvelle Héloïse* she found both fascinating and dangerous. As she wrote later in a letter of 1794 she had 'always been half in love with [Rousseau]' and some of the aggression in her remarks in *The Rights of Woman* no doubt

[8] *Condorcet: Selected Writings*, ed. Keith Michael (Indianapolis: Bobbs-Merrill Co., 1976), 274.

[9] Ibid. 98.

stemmed from her admiration of him on subjects other than women's intellectual abilities.[10]

As with the earlier work she wrote quickly, spending about six weeks on the book, which is personal, journalistic, and repetitive. Having completed it she wrote to a friend, 'I am dissatisfied with myself for not having done justice to the subject.'[11] But the book made her famous and she became for many Horace Walpole's 'hyena in petticoats', for others Mary Hays's champion of the female sex.

A Vindication of the Rights of Woman is extraordinary for the disjunction between its title and contents. It is not a female equivalent of her own *Rights of Men*, nor a political treatise in the manner of Paine's *Rights of Man*, with which its ringing title allied it. In fact it is more of a courtesy book than a political tract, concerning manners more than civil rights. And it is this which seems most revolutionary: an insistence that private and public are joined and, long before the 1960s, that personal and political are one.

More than Catherine Macaulay, who as a Whig historian saw a progress in history, Wollstonecraft believed in individual progress, a sense that with some changes everyone could improve. Women, she argued, were human before they were feminine and the soul was unsexed: for everyone this life should be a preparation for the next, not for marriage. Society could not progress if half its members were kept backward. At present women had the vices of any oppressed group, such as slaves, but inequality of power in society and home corrupted both parties. Sure of the importance of environment, she gave nothing to heredity.

Repeatedly she asserted the common beliefs of the early 1790s, that with a few 'simple principles'—the perfectibility of human nature, the equality of individuals, and the natural right of each to determine his or her own destiny—the ignorance of society and the oppressive nature of government would be obliterated. In doing so, she linked feminism to the general struggle for political and social reform, arguing that the abstract rights of woman were inextricably linked with the abstract rights of men and that the tyranny of man, husband, king, primogeniture, and hereditary privilege must all cease, in the name of reason, a reason that was woman's as well as man's.

[10] *Collected Letters*, 263. [11] Ibid. 205.

The main thrust of her argument was on education. In 1791 the French National Assembly approved the constitution and demanded a national system of free education. One of the architects of the policy was Talleyrand. *The Rights of Woman* is a plea to Talleyrand to give equality of opportunity to women. With her contempt for classical education in isolation, for what she slightingly called the 'dead languages', for imitation and rote learning, she did not, however, aim simply to extend the education of upper-class boys to women but to form a new curriculum for both sexes. She had the Dissenting belief in science and the discipline of factual knowledge although she declared that her regime for the able 'would not exclude polite literature'.

The education she promoted was a mixture of information and rational skills. Still influenced by Rousseau's *Émile*, despite her strictures on its pictures of female development, she insisted that boys and girls should be educated together from the sensory to the abstract, accepting a division based on abilities and rank only at a later stage. She continued the emphasis of Locke and Rousseau on physical health and insisted on exercise and play; in addition she suggested that all should study biology so that they would understand the body and become better parents. Later, when mockery of Wollstonecraft became fashionable, this suggestion would be greatly ridiculed as a direction that girls should 'name their backsides as it were their faces'.[12]

In religion the contrast with *Thoughts* is extreme; even from *The Rights of Men*, where evil seemed still part of God's plan, there is a change. The God who inhabits *The Rights of Woman* is not the mysterious comforter of *Thoughts* or the unknowable deity of *The Rights of Men* but a severe rationalist, bound by the reason he has given his creatures and providing an afterlife as reward for its proper use. Women should prepare for heaven by activity and rational exertion in the world, activity most likely to occur in the life not of the indolent aristocrat or the overburdened working woman but of the middle-class woman, who appeared to Wollstonecraft to be 'in the most rational state'. Women should aim at being good rational mothers and good citizens and so fulfil their duties to themselves and God. In *The French Revolution* she would take the process

[12] 'The Vision of Liberty', *Anti-Jacobin Review and Magazine*, 9 (1801).

further and allow Christianity to fade even more: God would no longer be even the severe rationalist but simply the inward pattern of reason.

As God had been compensatory in *Thoughts*, so in *Mary: A Fiction* sensibility had compensated for the practical miseries of the heroine's existence. The Wollstonecraft of the rational *Rights of Woman* would have none of this compensation and it is clear that, although Burke was not the overt enemy, she was still arguing her case against his aesthetic and political views. In her rigorous opposition to self-indulgent sensibility she appears part of a reaction at the end of the eighteenth century which includes such politically diverse writers as Coleridge, Godwin, Austen, and Hannah More. The majority of her male contemporaries, however, based their attack on the sentimental emphasis on sensibility in men, which had supposedly weakened them and rendered them unmanly, while such writers accepted its continuing association with women: Coleridge saw sensibility as female and urged men to curb its effeminating tendency, while German theorists accused sentimental literature of 'effeminate tenderness' and demanded rational virile art.

At the same time many female writers feared that sensibility had been taken too far for women as well. Conservatives such as Hannah More and Jane West, who accepted the division of roles and the assumptions of different capacities which the idea of sensibility implied, yet disliked the amoral self-indulgence inherent in it. From the outset in the early eighteenth century there had been repeated warnings that the sentimental woman might prefer to live in the fantasy of books rather than face the bracing realities of marital life and that she might trust to her sensations, including her sexual ones, before the dictates of acquired morality. In a review of 1789 Wollstonecraft followed these writers in claiming that sentimental novels could shake girls' principles and make love appear irresistible. Here and in the *Rights of Woman* the enlightened Wollstonecraft sounds indistinguishable from the conservative Hannah More who refused to read her.

Occasionally *The Rights of Woman* functions as a straight rebuke of Wollstonecraft's early fictional heroine, Mary of *Mary: A Fiction*, a heroine of superior and suffering sensibility. The innately benevolent Mary, if she had halted her progress towards easeful death to

read her creator's later book, would have learnt that 'it is a farce to call any being virtuous whose virtues do not result from the exercise of its own reason'. She would have found her superior sensibility labelled as 'constitutional melancholy' and 'romantic unnatural delicacy of feeling'. The displays of sentiment so riveting to the hero and to Mary herself in the novel would now be seen raising an emotion 'similar to what we feel when children are playing or animals sporting'. In place of the romantic love of the feminized hero and the heroine or fervid female friendship, Wollstonecraft now put forward calm respectful marriage in which 'a master or mistress of a family ought not to continue to love each other with passion' and in which a man should not lavish caresses on 'the overgrown child, his wife'. The misery of Mary, married at the end of her novel to a man for whom she feels sexual horror, is briskly rebuked: a woman 'might as well pine married as single, for she would not be a jot more unhappy with a bad husband than longing for a good one'.

In her treatment of sensibility Wollstonecraft had erased the sentimental construction of woman (endowed with superior sensitivity and delicacy but marked by lesser reasoning capacity) so important through life and literature during the past century. With it went the question of female sexuality or passion and the struggle to express it. For, however inadequately, the idea of greater female sensibility had allowed a hint of woman's right to sexual feelings—certainly the opponents of the cult of sensibility thought so when they imagined sentimental ladies falling prey to seducers and their own fantasies. In his *Progress of the Human Mind* Condorcet accepted sex as an inclination; he believed that it need not be repressed and could be reconciled with public duty in a more equal society. But, because of the social and psychological harm caused by the emphasis on female sexuality, Wollstonecraft was rigorously antagonistic to the claims of sex as grand mover of human action. Consequently, the asexual rational woman of *The Rights of Woman* has little on the emotional and physical side to do but suckle her baby and make sure she does not overfondle it. As in the sentimental construction, motherhood remains the important role for women, but, stripped of its support in the notion of superior female gentleness and tenderness, its absolute responsibilities become a rather problematic infringement of the freedom and autonomy assumed for men and women.

In *The Rights of Woman* a brisk sense of self is preferred to seductiveness and there is little room for sexual activity in the energetic life. Sexuality depends on a depravity of appetite that brings the sexes together, a distasteful activity that weakens the frame and coarsens the spirit. It should be used for procreation only. As Wollstonecraft was attacked in the eighteenth century for her apparent encouragement of sexual openness, so in the late twentieth century she would be mocked for her robust views on sexuality as desire leading to harmful dependence. There does, however, seem to be considerable advantage in her proposed supportive friendships over promiscuous sexual relationships in an era with rudimentary birth control.

Yet, if she sternly opposed sexual desire, the text of *The Rights of Woman*, as of many of her other books, does reveal a fascination with passive sexuality and exaggerated femininity. And here Burke, an alleged homosexual, seems to function as something of a seductive figure for the homophobic Wollstonecraft, as perhaps he had done when she succumbed to 'torpor' during the writing of *The Rights of Men*. Despite her assertion of the superiority of a plain style and her distrust of Burkean rhetoric, and despite her awareness of the power of words, as well as their ability to confuse reality and substitute for it 'a jargon of words in the room of things', as she expressed it in the introduction to *The Rights of Woman*, she managed, through her choice of words, images, and constructions, to reveal a good deal that was not comprehended in her antagonism. This is especially so in her frequent deployment of the language of the body and of effeminacy, which she fails to acknowledge; it is used overtly to underline her message while covertly revealing the necessity for it.

The notion of the rights of men and the rights of women supports activity and vigour; yet Wollstonecraft constantly alludes to sexual passivity, indolence, and effortless power, so deeply implicated in her concept of aristocracy. She praises adult masculine rationality, while giving examples of infantile self-absorption and the desire to be desired. Repeatedly she refers to luxury, relaxation, and voluptuousness, and the references and imagery sometimes threaten to stay in the reader's mind beyond the stern urgings towards abstract reason, liberty, and rights. Some of the imagery is indeed extraordinary: the body of the woman is a dish for every male glutton to eat of; passion is sickly, gross, and voluptuous; lust is the desperate

effort of lascivious weakness; hell is the desiring spirit continually hovering with abortive eagerness round the defiled dead body. If, as *The Rights of Woman* argues, sexual passion is imprisoning obsession, then the reader might well see part of the book as imprisoned.

As with her treatment of sexuality, Wollstonecraft also had a significant if less intractable problem with her concept of unchanging rights and her notion of individualistic human nature. Resolutely she refused to historicize the situation of women or see the idea of rights in general as the product of a historical moment and of a gendered society. Again one might see the negative influence of Burke, who insisted on a historical view and on value given by history. The idea of rights was the expression of reason, accepted as the universal transcendental panacea. Likewise the classes she knew, of aristocracy and middle and lower orders, tend to be accepted as absolute and she rarely saw gender crossing through all of them yet carrying peculiar difficulties for members of each. She could sympathize with the lower middle class but not with the aristocracy, which she found irredeemable, or with the lowest class, which she still regarded as contaminating. So too she sympathized with the fallen woman as victim, for whom she demanded proper support from her betrayer, but she did not sympathize with the prostitute as economic agent or allow her to suggest the economic basis of all marriage or sexuality—despite her use of Defoe's phrase for some marriages: 'legal prostitution'.

Although she clearly distrusted large-scale capitalism, Wollstonecraft was impressed by the small-scale merchant, and she linked female emancipation to the values of the mercantile middle class so thoroughly that it had to share its contradictions. The earlier rationalist feminist Mary Astell, seemingly perverse in her antagonism to the concept of rights, had partly opposed it because she saw its basis in commercial values, which she then regarded as allying relationships to interest and power. In contrast, in *The Rights of Woman* Wollstonecraft praised the strenuous commercial man who had no aristocratic privilege but who rose by his own exertions. The rational woman who had renounced the unearned privileges of gender, gallantry and self-indulgence, should be in this position. At this stage of her thinking, eager to destroy the seduction of sensibility, Wollstonecraft did not look beyond the commercial rational con-

struction, and she avoided the traditional utopian method of fantasizing an original state of interest-free relationships, a state associated by early women writers, such as Aphra Behn, with the pre-patriarchal order, before law, religion, commerce, and shame constricted and corrupted men and women.

However sure she remained in her political writings, in her life she had ample opportunity to doubt her rationalist and commercial beliefs, though not her diagnosis of the failings of women. After an attempt to form a rational ménage with Fuseli, whose wife lacked her own lofty principles, Wollstonecraft left for France 'a Spinster on the wing'; she would return an unmarried mother, having borne a child to the American trader Gilbert Imlay, whose wanderings both before and after the birth of their child she imputed in part to his obsession with commerce.

An Historical and Moral View of the Origin and Progress of the French Revolution, and the Effect it Has Produced in Europe

In *The Rights of Man* Paine claimed that no great violence had yet marred the Revolution. By the time Wollstonecraft came to write her history, however, massacres had soured opinion in England and radicalism was neither fashionable nor safe. In France it was uncomfortable to be English; so, despite a dislike of the institution of marriage, Imlay registered Wollstonecraft as his wife, allowing her temporarily to claim American citizenship.

When she had first arrived in France she had poured out her disillusion with revolutionary practice in a letter back to Johnson. In it she showed that her sympathy for an embattled king as an individual human being was outweighing her abstract anti-monarchical principles—as it had done in her treatment of the insane George III in *The Rights of Men*. Her pessimism had grown even stronger by the time she wrote a 'Letter on the Present Character of the French Nation', sent to Johnson but not published by him at the time: here she renounced her rationalist faith in human progress altogether, as well as the revolutionary belief, so strong in Price, of sudden political change producing social amelioration. (Price, who died in 1791, had been spared the necessity of fitting the bloody events into his utopian theory.) Aristocracy, Wollstonecraft suspected, had simply been replaced by plutocracy and it appeared that the spur of selfish-

ness or misery was necessary for any effort; the grand mobile of human action was no longer reason but vice and evil.

In the following year, however, she began to write *The French Revolution*, a projected series on the history of the Revolution, in which she revealed that she had modified her opinion. No doubt she wrote to exploit the British interest in French events since she needed money, but also probably to bolster her own flagging ideals. Perhaps, before writing, she reread her own *Vindications* and learnt that she had fallen prey to her emotions and that her early judgements derived from the kind of reaction for which she had castigated Burke. When she wrote *The French Revolution* she had largely regained her faith in people in general and she sternly took to task—in much the same manner as she had earlier taken Burke—those who followed the 'erroneous inferences of sensibility'. None the less the book is marked by her painful progress.

As with *A Vindication of the Rights of Men*, so with this work she produced one book among many. Of the various outpourings of English comment on the extraordinary happenings so close to home, very few were judicious or aimed at impartiality, and almost all demanded assent to a political philosophy of some sort. One comparison for Wollstonecraft might be made with the lengthy works of Helen Maria Williams, whom she came to know in France. Williams suffered more directly than Wollstonecraft, being herself imprisoned and watching close friends go to the guillotine; she too tried to exonerate the ideals of the Revolution from the carnage that followed the first inspiring and heady days. She herself had witnessed these days and she praised them with the kind of sentimental language Wollstonecraft so intensely opposed. Although never as involved in revolutionary events as Williams, during the planning and writing of *The French Revolution*, Wollstonecraft did see something of the bloody purges of Robespierre and inevitably her interpretation of the early months, all that are covered in her volume, is coloured by later events.

She began the work in 1793 in a village close to Paris whither she had fled to avoid the imprisonment of the British and where she conceived her child with Imlay. She managed to finish the work in Paris and Le Havre, where her child was born. Unusually in her writings, she avoided personal reference and the miserable story of

her private life during the period can be read in her letters to Imlay, published after her death.

As *The Rights of Woman* promised a sequel never written, so *The French Revolution* is the only one of a projected series, covering the early months of the Revolution which Wollstonecraft had not observed. Much consists of transcriptions of speeches given in the National Assembly and outside by delegates and revolutionaries such as Mirabeau and Lafayette. Many of these were taken from the *New Annual Register* written in England by writers with staunch libertarian principles, though most would later parallel Wollstonecraft in recoiling from Jacobin violence.

The view that can be derived from *The French Revolution* is a more evolutionary one than that found in the *Vindications*. Sometimes there seems to be almost a Burkean fear of political chaos or control by the vulgar and stupid—and a reading of this book after *The Rights of Men* inevitably suggests how much Burke and Wollstonecraft shared. Some of her treatments of French events, such as the march to Versailles, sound remarkably similar to those in the much maligned *Reflections*.

Yet on the whole the similarity is not in political analysis, and Wollstonecraft continued to rewrite key episodes and repaint Burke's symbolic portraits. The similarity is, rather, in a way of seeing, although the two writers came to different conclusions from their insight. Marie Antoinette, for example, is analysed by Wollstonecraft much as Burke had analysed her: as a woman dependent on mystification and the gaze of others. Wollstonecraft sees her misunderstanding her role and trying to throw aside the 'cumbersome brocade of ceremony' on which her influence depended. Both she and Burke agree it was the 'frippery' that was wanting for the reverence. Only Burke reverenced the reverence and felt the seduction.

Although after *The Rights of Men* there is not much mention of Burke in her works, it is possible to see her carrying on the argument of 1790, still insisting on revising the view of the hierarchical family, still making the connection of this family with the system of aristocracy, and still distrusting sentimental emotionality as the language of the powerful about and to the powerless. It is perhaps because she is more open about the seduction of this rhetoric that the final

assertion of the Revolution as genuine progress feels like an asser-
tion against the odds and almost against the tenor of her book.

In *The French Revolution* she continues her overt attack on sensi-
bility by blaming much of the cruelty of the apparently liberated
French on a despotic past and on a self-indulgent emotionality that
prevents them from living up to the lofty republican ideals of liberty
and justice. Her discussion of the prehistory of the Revolution uses
history not in the cautionary way of Burke but to make the point that
the past has conditioned the present and that revolutionary Terror
has grown from monarchy.

If her earlier arguments had been unsettled by actual Revolution,
so her problems with the commercial Imlay seem to have disturbed
the commercial part of her argument. Clearly by now she feared the
effects of advancing capitalism in general, attacking, for example,
the notion of the division of labour. In his *Wealth of Nations* (1776)
Adam Smith had remarked that, the less specialized the mechanical
occupations, the greater the danger that people will become lazy and
slothful; Condorcet, fearing rather the stupidity of repetition, had
suggested a remedy in instruction. Wollstonecraft, however, wanted
to erase the development altogether, and return to an earlier state of
things when each man was his own master and efficiency of manu-
facture was not the main end. In this fear of the effects of the
industrial system she sounds more like her old mentor Price, who
retained the traditional early fear of commerce as promoter of
luxury and selfishness, and less like the Whig liberals who recon-
ciled trade and republicanism, or indeed Paine, who respected
increasing commerce as a promoter of liberty.

In imagery *The French Revolution* continued development from
The Rights of Woman. There is, however, more political justification
for her employment of the biological imagery of death, disease, and
sexual corruption, since she is blaming the 'effeminacy' and indo-
lence of the French for their failure of revolution. There is much
reference to luxury, indolence, and indulgence, as well as to the
corruption of power associated with the decadent French court. The
ancien régime was corrupt and luxurious, defiling as well as exploit-
ing its people; unfortunately it appeared that some revolutionaries
shared the national character and had become copies of their pre-
decessors. Hence the apparent failure of a revolution founded on
correct principles.

Wollstonecraft was a born journalist and polemical writer, not waiting to perfect a system but eager to display the effects of experience on her excited thinking, even when she revealed contradictions, not only between but also within works. Little interested in parable and narrative, she was at her weakest when telling a story, as in her two novels, or when rehearsing events, as in her account of the early part of the Revolution; conversely she was at her strongest when freely associating and disclosing her personal investment in her comments.

Despite her worry over the 'jargon of words' in *The Rights of Woman*, she claimed an absolute sense of truth, allied to a belief that words could arrive at reality, if not manipulated and twisted by bad men, just as men and women could arrive at reason if not corrupted or perverted by society. While clearly disliking the 'effeminate' expression and approving the 'manly' construction, she was gendering within the gendered constructions of the time; she did not wish to be a man but to write a 'manly' prose which she construed as rational prose able to achieve truth, the expression of an androgynous mind erroneously termed 'masculine'.

Through all her works ran the thread of disgust at the genderizing of all people according to sex, combated by her intensive use of gendered language for acquired characteristics regardless of sex— her effeminate courts and womanlike soldiers—and by her hatred of the familial metaphors that enforced the fixed gendered view in writers such as Burke. These metaphors extended their baneful influence to politics, religion, and morality. In *The Rights of Woman* there is consequently little mention of good fathers but much attention to the mother and child; in *The French Revolution* 'family love' comes from selfishness while liberty itself seems to become a mother, a sort of divine single parent.

Although there is a considerable amount of interest in *The Rights of Men* and *The French Revolution*, both in the works themselves and in their positions within Wollstonecraft's developing philosophy, her main fame now rests on the central *Vindication of the Rights of Woman* and its remarkable statement of enlightenment feminism. It is easy to be critical of this feminism and perhaps judge that the progress of feminism between 1792 and 1992 has rendered much of her hope and analysis obsolete. Co-education, which she desired, has been achieved; so has the vote. Most of what she suggested for systematic education now seems acceptable, some verges on the

illiberal, although her expectation that education will result in a rational character still seems a radical belief.

Other parts of her social analysis remain to be addressed. She noticed, for example, the importance of gender in attitudes to ageing: for women physical change brought with the contempt of a culture which assumed that older privileged men deserved young women, and that female perfection was a matter of physical not mental worth. The emphasis she noted on female immaturity and the blank beauty of the childwoman does not seem entirely anachronistic.

It has always been easier to make a case about women from the biological standpoint, noting innate feminine maternal instinct, for example, or feminine intuition and superior sensitivity, emphasizing difference rather than sameness. William Godwin, who came to love Wollstonecraft after her various unhappy loves, called his biography of her after her most famous work, *Memoirs of the Author of a Vindication of Rights of Woman*, but, for all his own severe rationalism, a little modified by his liaison with Mary Wollstonecraft, he showed himself uncomfortable with his wife in vindicating mood; in his biography he claimed he found parts of the *Rights of Woman* 'rigid, and somewhat amazonian' and he was won to love by the melancholy and sensitive *Letters from Sweden*.

If her feminism still presents difficulties, its basis presents even more: her rational, outdated, un-Freudian concept of human nature, so necessary for the kind of social progress she anticipated. All her major polemical works are rationalist, although they are surrounded by others—*Mary: A Fiction, Letters from Sweden*, and *The Wrongs of Woman*—which overtly question the possibility of pure rationalism and display the seduction of the sensibility she so ringingly opposed in her polemics. Because she felt the appeal of sentiment and pity in her life and writing, she did not therefore let them skew the rationalist ideal on which she had set her mind—if perhaps not entirely her heart. It might now be judged an absurd ideal but surely not an easy or undignified one.

NOTE ON THE TEXTS

The texts reprinted here, of *A Vindication of the Rights of Men, in a Letter to the Right Honourable Edmund Burke* and of *A Vindication of the Rights of Woman with Strictures on Political and Moral Subjects*, are from the second editions of 1790 and 1792. *An Historical and Moral View of the Origin and Progress of the French Revolution; and the Effect it Has Produced in Europe* had only one edition, in 1794. A selection is reproduced here.

Notes by the editor are signified by asterisks in the text; they are to be found at the end of the volume. Notes by Wollstonecraft are indicated by numbers and are printed below the text to which they refer.

SELECT BIBLIOGRAPHY

1. Original Works of Mary Wollstonecraft

Thoughts on the Education of Daughters: With Reflections on Female Conduct, in the more Important Duties of Life. London: Joseph Johnson, 1787. Facsimile by Garland Publishing Inc., 1974.

Mary: A Fiction. London: Joseph Johnson, 1788. Facsimile by Garland Publishing Inc., 1974. Reprinted by Oxford University Press, 1976, by Schocken Books, Inc., 1977, and by Pickering and Chatto, 1991, and Penguin Books, 1992.

Original Stories from Real Life: With Conversations Calculated to Regulate the Affections and Form the Mind to Truth and Goodness. London: Joseph Johnson, 1788.

The Female Reader; or, Miscellaneous Pieces, in Prose and Verse; Selected from the Best Writers, and Disposed under Proper Heads; for the Improvement of Young Women. London: Joseph Johnson, 1789. Facsimile by Scholars' Facsimiles & Reprints, 1979.

A Vindication of the Rights of Men, in a Letter to the Right Honourable Edmund Burke. London: Joseph Johnson, 1790. Facsimile by Scholars' Facsimiles & Reprints, 1960.

A Vindication of the Rights of Woman with Strictures on Political and Moral Subjects. London: Joseph Johnson, 1792. Reprinted by W. W. Norton & Co., 1967 and 1975, and by Penguin Books, 1975.

An Historical and Moral View of the Origin and Progress of the French Revolution; and the Effect it Has Produced in Europe. London: Joseph Johnson, 1794. Facsimile by Scholars' Facsimiles & Reprints, 1975.

Letters Written during a Short Residence in Sweden, Norway, and Denmark. London: Joseph Johnson, 1796. Reprinted by University of Nebraska Press, 1976, and by Penguin Books, 1989.

Posthumous Works of the Author of a Vindication of the Rights of Woman. London: Joseph Johnson, 1798. Facsimile by Garland Publishing Inc., 1974, and by Augustus M. Kelley, 1972.

The Wrongs of Woman; or, Maria (part of *Posthumous Works*). Reprinted by Oxford University Press, 1976, and as *Maria or the Wrongs of Woman* by W. W. Norton & Co., 1975, and by Pickering and Chatto, 1991, and Penguin Books, 1992.

The Complete Works of Mary Wollstonecraft, Pickering and Chatto, 1989.

2. Major Collections of Letters

The Love Letters of Mary Wollstonecraft to Gilbert Imlay, with a Prefatory Memoir. London: Hutchinson & Co., 1908.

Supplement to *Memoirs of Mary Wollstonecraft*. London: Constable & Co. Ltd., 1927.

Four New Letters of Mary Wollstonecraft and Helen Maria Williams. Berkeley, Calif.: University of California Press, 1937.

Shelley and His Circle: 1773–1822. Ed. Kenneth Neill Cameron, Cambridge, Mass.: Harvard University Press, 1961.

Godwin and Mary: Letters of William Godwin and Mary Wollstonecraft. Lawrence, Kan.: University of Kansas Press, 1966.

Collected Letters of Mary Wollstonecraft. Ithaca, NY: Cornell University Press, 1979.

3. Recent Biographies

Flexner, Eleanor, *Mary Wollstonecraft: A Biography*. New York: Coward, McCann & Geoghegan, 1972.

George, Margaret, *One Woman's 'Situation'; A Study of Mary Wollstonecraft*. Urbana, Ill.: University of Illinois Press, 1970.

Nixon, Edna, *Mary Wollstonecraft: Her Life and Times*. London: J. M. Dent & Sons, 1971.

Sunstein, Emily W., *A Different Face: The Life of Mary Wollstonecraft*. New York: Harper & Row, 1975.

Tomalin, Claire, *The Life and Death of Mary Wollstonecraft*. London: Weidenfeld & Nicolson, 1974.

Wardle, Ralph M., *Mary Wollstonecraft: A Critical Biography*. 1951; Lincoln, Nebr.: University of Nebraska Press, 1966.

4. Some Recent Comments on Wollstonecraft's Life and Works

Boulton, James T., *The Language of Politics in the Age of Wilkes and Burke*. London: Routledge & Kegan Paul, 1963.

Butler, Marilyn, *Jane Austen and the War of Ideas*. Oxford: Oxford University Press, 1988.

Ferguson, Frances, 'Wollstonecraft Our Contemporary', and Reiss, Timothy J., 'Revolution in Bounds: Wollstonecraft, Women, and Reason', in Linda Kauffman (ed.), *Gender and Theory: Dialogues on Feminist Criticism*. New York: Basil Blackwell, 1989.

Gatens, Maria, '"The Oppressed State of My Sex": Wollstonecraft on Reason, Feeling and Equality', in Mary Lyndon Shanley and Carole

Pateman (eds.), *Feminist Interpretations and Political Theory*. Cambridge: Cambridge University Press, 1991.

Janes, Regina, 'Mary, Mary, Quite Contrary, or, Mary Astell and Mary Wollstonecraft Compared', in Ronald C. Rosbottom (ed.), *Studies in Eighteenth-Century Culture*. Madison, Wis.: University of Wisconsin Press, 1976.

Kaplan, Cora, *Sea Changes: Essays on Culture and Feminism*. London: Verso, 1986.

Nicholes, Eleanor L., 'Mary Wollstonecraft', in Kenneth Neill Cameron (ed.), *Romantic Rebels: Essays on Shelley and his Circle*. Cambridge, Mass.: Harvard University Press, 1973.

Paul, Charles Kegan, *William Godwin: His Friends and Contemporaries*. London: H. S. King & Co., 1876.

Poovey, Mary, *The Proper Lady and the Woman Writer: Ideology as Style in the Works of Mary Wollstonecraft and Jane Austen*. Chicago: University of Chicago Press, 1984.

Rendall, Jane, *The Origin of Modern Feminism: Women in Britain, France and the United States 1780–1860*. London: Macmillan, 1985.

Sapiro, Virginia, *A Vindication of Political Virtue: The Political Theory of Mary Wollstonecraft*. Chicago: University of Chicago Press, 1992.

Todd, Janet, *The Sign of Angellica: Women, Writing and Fiction, 1660–1800*. London: Virago, 1989.

Tomaselli, Sylvana, 'Remembering Mary Wollstonecraft on the Bicentenary of the Publication of *A Vindication of the Rights of Woman*', *British Journal for Eighteenth-Century Studies*, 15/2 (Autumn 1992), 125–30.

Wardle, Ralph M., 'Mary Wollstonecraft, Analytical Reviewer', *PMLA* 62 (Dec. 1947), 1000–9.

A CHRONOLOGY OF
MARY WOLLSTONECRAFT

1759 Mary Wollstonecraft born 27 April in London. Her father Edward
 John Wollstonecraft (b. 1736) and mother Elizabeth Dickson
 (c.1740) were married in 1756. Their oldest child Edward (Ned) was
 born in 1757. Other children: Henry Woodstock (1761); Elizabeth
 (Eliza) (1763); Everina (Averina) (1765); James (1768); and Charles
 (1770).

1775 Meets Fanny Blood.

1778 Leaves home to become a paid companion to Mrs Dawson in
 Bath.

1781 Returns home to nurse her mother.

1782 Mother dies (19 April). Goes to live with Fanny Blood and family.
 Eliza married Meredith Bishop.

1783 Eliza's daughter born (probably 10 August).

1784 Asked to tend her sister Eliza during postpartum breakdown
 (January); removes Eliza from Bishop's house. With Fanny Blood
 and Eliza establishes school at Islington, then at Newington Green.
 Joined by Everina. Meets Dr Richard Price and Dissenters.

1785 Consumptive Fanny Blood marries Hugh Skeys in Lisbon in
 February. Wollstonecraft travels there for birth of Fanny's child in
 November. Fanny dies in childbirth.

1786 Returns to London. The school fails and the sisters disperse.
 Writes *Thoughts on the Education of Daughters*, published by Joseph
 Johnson. Hired as governess to Kingsborough children in Ireland.
 Brief visit to Eton College.

1787 Completes *Mary: A Fiction* in Ireland; dismissed by Lady
 Kingsborough in Bristol. Returns to London. Hired by Joseph
 Johnson as translator and reader (and later as reviewer and editorial
 assistant) for his forthcoming *Analytical Review*. Writes *The Cave of
 Fancy* and *Original Stories from Real Life* and completes *The Female
 Reader*, all published by Johnson.

1788–1790 From self-taught French, German, Dutch, translates Necker's
 Of the Importance of Religious Opinions, Salzmann's *Element of
 Morality for the Use of Children*, and Madame de Cambon's *Young
 Grandison*.

1790 In answer to Edmund Burke, writes *A Vindication of the Rights of
 Men*, published under her own name in the second edition. For a
 short period takes in 7-year-old Ann (relative of Hugh Skeys) as

foster daughter. Begins writing *A Vindication of the Rights of Woman* in September. Briefly meets William Godwin in November.

1792 *A Vindication of the Rights of Woman* is published. Intends to go to Paris with Johnson and Henry and Sophia Fuseli; emotional crisis with Henry Fuseli; leaves for Paris alone in December.

1793 Meets Gilbert Imlay. Conceives her first child in August. Imlay registers her at US embassy as his wife for protection against anti-British legislation. *The Emigrants* is published (probably written by Imlay, although a case has been made for Wollstonecraft's authorship).

1794 Daughter Fanny is born (14 May) in Le Havre. Finishes *An Historical and Moral View of the Origin and Progress of the French Revolution and the Effect it Has Produced in Europe*, which Johnson publishes in London.

1795 Returns to London with Fanny in April. Imlay indifferent. First suicide attempt in May. Travels with Fanny and nurse to Scandinavia in June. Returns in September. Second suicide attempt in October.

1796 *Letters Written during a Short Residence in Sweden, Norway, and Denmark* published by Johnson.

1797 Marries Godwin (29 March). Continues work on *The Wrongs of Woman; or, Maria*. Plans a book called *Letters on the Management of Children*. Second daughter, Mary, is born (30 August). Dies following childbirth (10 September).

A Vindication of
the Rights of Men

ADVERTISEMENT

Mr Burke's Reflections on the French Revolution* first engaged my attention as the transient topic of the day; and reading it more for amusement than information, my indignation was roused by the sophistical arguments, that every moment crossed me, in the questionable shape of natural feelings and common sense.

Many pages of the following letter were the effusions of the moment; but, swelling imperceptibly to a considerable size, the idea was suggested of publishing a short vindication of *the Rights of Men*.

Not having leisure* or patience to follow this desultory writer through all the devious tracks in which his fancy has started fresh game, I have confined my strictures, in a great measure, to the grand principles at which he has levelled many ingenious arguments in a very specious garb.

A LETTER TO
THE RIGHT HONOURABLE
EDMUND BURKE

Sir,

It is not necessary, with courtly insincerity, to apologise to you for thus intruding on your precious time, not to profess that I think it an honour to discuss an important subject with a man whose literary abilities have raised him to notice in the state.* I have not yet learned to twist my periods, nor, in the equivocal idiom of politeness, to disguise my sentiments, and imply what I should be afraid to utter: if, therefore, in the course of this epistle, I chance to express contempt, and even indignation, with some emphasis, I beseech you to believe that it is not a flight of fancy; for truth, in morals, has ever appeared to me the essence of the sublime; and, in taste, simplicity the only criterion of the beautiful. But I war not with an individual when I contend for the *rights of men** and the liberty of reason. You see I do not condescend to cull my words to avoid the invidious phrase, nor shall I be prevented from giving a manly definition of it, by the flimsy ridicule which a lively fancy has interwoven with the present acceptation of the term. Reverencing the rights of humanity, I shall dare to assert them; not intimidated by the horse laugh that you have raised, or waiting till time has wiped away the compassionate tears which you have elaborately laboured to excite.

From the many just sentiments interspersed through the letter before me, and from the whole tendency of it, I should believe you to be a good, though a vain man, if some circumstances in your conduct did not render the inflexibility of your integrity doubtful; and for this vanity a knowledge of human nature enables me to discover such extenuating circumstances, in the very texture of your mind, that I am ready to call it amiable, and separate the public from the private character.

I know that a lively imagination renders a man particularly calculated to shine in conversation and in those desultory productions where method is disregarded; and the instantaneous applause which his eloquence* extorts is at once a reward and a spur. Once a wit and always a wit, is an aphorism that has received the sanction of experi-

ence; yet I am apt to conclude that the man who with scrupulous anxiety endeavours to support that shining character, can never nourish by reflection any profound, or, if you please, metaphysical passion. Ambition becomes only the tool of vanity, and his reason, the weathercock of unrestrained feelings, is only employed to varnish over the faults which it ought to have corrected.

Sacred, however, would the infirmities and errors of a good man be, in my eyes, if they were only displayed in a private circle; if the venial fault only rendered the wit anxious, like a celebrated beauty, to raise admiration on every occasion, and excite emotion, instead of the calm reciprocation of mutual esteem and unimpassioned respect. Such vanity enlivens social intercourse, and forces the little great man to be always on his guard to secure his throne; and an ingenious man, who is ever on the watch for conquest, will, in his eagerness to exhibit his whole store of knowledge, furnish an attentive observer with some useful information, calcined by fancy and formed by taste.

And though some dry reasoner might whisper that the arguments were superficial, and should even add, that the feelings which are thus ostentatiously displayed are often the cold declamation of the head, and not the effusions of the heart—what will these shrewd remarks avail, when the witty arguments and ornamental feelings are on a level with the comprehension of the fashionable world, and a book is found very amusing? Even the Ladies, Sir, may repeat your sprightly sallies, and retail in theatrical attitudes many of your sentimental exclamations. Sensibility is the *manie* of the day, and compassion the virtue which is to cover a multitude of vices, whilst justice is left to mourn in sullen silence, and balance truth in vain.

In life, an honest man with a confined understanding is frequently the slave of his habits and the dupe of his feelings, whilst the man with a clearer head and colder heart makes the passions of others bend to his interest; but truly sublime is the character that acts from principle, and governs the inferior springs of activity without slackening their vigour; whose feelings give vital heat to his resolves, but never hurry him into feverish eccentricities.

However, as you have informed us that respect chills love, it is natural to conclude, that all your pretty flights arise from your pampered sensibility; and that, vain of this fancied pre-eminence of organs, you foster every emotion till the fumes, mounting to your

brain, dispel the sober suggestions of reason. It is not in this view surprising, that when you should argue you become impassioned, and that reflection inflames your imagination, instead of enlightening your understanding.

Quitting now the flowers of rhetoric, let us, Sir, reason together; and, believe me, I should not have meddled with these troubled waters, in order to point out your inconsistencies, if your wit had not burnished up some rusty, baneful opinions, and swelled the shallow current of ridicule till it resembled the flow of reason, and presumed to be the test of truth.

I shall not attempt to follow you through 'horse-way and foot-path;'* but, attacking the foundation of your opinions, I shall leave the superstructure to find a centre of gravity on which it may lean till some strong blast puffs it into the air; or your teeming fancy, which the ripening judgment of sixty years* has not tamed, produces another Chinese erection,* to stare, at every turn, the plain country people in the face, who bluntly call such an airy edifice—a folly.

The birthright of man, to give you, Sir, a short definition of this disputed right, is such a degree of liberty, civil and religious, as is compatible with the liberty of every other individual with whom he is united in a social compact, and the continued existence of that compact.*

Liberty, in this simple, unsophisticated sense, I acknowledge, is a fair idea that has never yet received a form in the various governments that have been established on our beauteous globe; the demon of property has ever been at hand to encroach on the sacred rights of men, and to fence round with awful pomp laws that war with justice. But that it results from the eternal foundation of right—from immutable truth—who will presume to deny, that pretends to rationality—if reason has led them to build their morality[1] and religion on an everlasting foundation—the attributes of God?

I glow with indignation when I attempt, methodically, to unravel your slavish paradoxes, in which I can find no fixed first principle to refute; I shall not, therefore, condescend to shew where you affirm in one page what you deny in another; and how frequently you draw

[1] As religion is included in my idea of morality, I should not have mentioned the term without specifying all the simple ideas which that comprehensive word generalizes; but as the charge of atheism has been very freely banded about in the letter I am considering, I wish to guard against misrepresentation.

conclusions without any previous premises:—it would be something like cowardice to fight with a man who had never exercised the weapons with which his opponent chose to combat, and irksome to refute sentence after sentence in which the latent spirit of tyranny appeared.

I perceive, from the whole tenor of your Reflections, that you have a mortal antipathy to reason; but, if there is any thing like argument, or first principles, in your wild declamation, behold the result:—that we are to reverence the rust of antiquity, and term the unnatural customs, which ignorance and mistaken self-interest have consolidated, the sage fruit of experience: nay, that, if we do discover some errors, our *feelings* should lead us to excuse, with blind love, or unprincipled filial affection, the venerable vestiges of ancient days. These are gothic notions of beauty—the ivy is beautiful, but, when it insidiously destroys the trunk from which it receives support, who would not grub it up?

Further, that we ought cautiously to remain for ever in frozen inactivity, because a thaw, whilst it nourishes the soil, spreads a temporary inundation; and the fear of risking any personal present convenience should prevent a struggle for the most estimable advantages. This is sound reasoning, I grant, in the mouth of the rich and short-sighted.

Yes, Sir, the strong gained riches, the few have sacrificed the many to their vices; and, to be able to pamper their appetites, and supinely exist without exercising mind or body, they have ceased to be men.—Lost to the relish of true pleasure, such beings would, indeed, deserve compassion, if injustice was not softened by the tyrant's plea—necessity; if prescription was not raised as an immortal boundary against innovation. Their minds, in fact, instead of being cultivated, have been so warped by education, that it may require some ages to bring them back to nature, and enable them to see their true interest, with that degree of conviction which is necessary to influence their conduct.

The civilization which has taken place in Europe has been very partial, and, like every custom that an arbitrary point of honour has established, refines the manners at the expence of morals, by making sentiments and opinions current in conversation that have no root in the heart, or weight in the cooler resolves of the mind.—And what has stopped its progress?—hereditary property—hereditary hon-

ours. <u>The man has been changed into an artificial monster by the station in which he was born,</u> and the consequent homage that benumbed his faculties like the torpedo's touch;—or a being, with a capacity of reasoning, would not have failed to discover, as his faculties unfolded, that true happiness arose from the friendship and intimacy which can only be enjoyed by equals; and that charity is not a condescending distribution of alms, but an intercourse of good offices and mutual benefits, founded on respect for justice and humanity.

Governed by these principles, the poor wretch, whose *inelegant* distress extorted from a mixed feeling of disgust and animal sympathy present relief, would have been considered as a man, whose misery demanded a part of his birthright, supposing him to be industrious; but should his vices have reduced him to poverty, he could only have addressed his fellow-men as weak beings, subject to like passions, who ought to forgive, because they expect to be forgiven, for suffering the impulse of the moment to silence the suggestions of conscience, or reason, which you will; for, in my view of things, they are synonymous terms.

Will Mr Burke be at the trouble to inform us, how far we are to go back to discover the rights of men, since the light of reason is such a fallacious guide that none but fools trust to its cold investigation?

In the infancy of society, confining our view to our own country, customs were established by the lawless power of an ambitious individual; or a weak prince was obliged to comply with every demand of the licentious barbarous insurgents, who disputed his authority with irrefragable arguments at the point of their swords; or the more specious requests of the Parliament, who only allowed him conditional supplies.

Are these the venerable pillars of our constitution? And is Magna Charta to rest for its chief support on a former grant,* which reverts to another, till chaos becomes the base of the mighty structure—or we cannot tell what?—for coherence, without some pervading principle of order, is a solecism.

Speaking of Edward the IIId. Hume observes, that 'he was a prince of great capacity, not governed by favourites, not led astray by any unruly passion, sensible that nothing could be more essential to his interests than to keep on good terms with his people: yet, on

the whole, it appears that the government, at best, was only a barbarous monarchy, not regulated by any fixed maxims, or bounded by any certain or undisputed rights,* which in practice were regularly observed. The King conducted himself by one set of principles; the Barons by another; the Commons by a third; the Clergy by a fourth. All these systems of government were opposite and incompatible: each of them prevailed in its turn, as incidents were favourable to it: a great prince rendered the monarchical power predominant: the weakness of a king gave reins to the aristocracy: a superstitious age saw the clergy triumphant: the people, for whom chiefly government was instituted, and who chiefly deserve consideration, were the weakest of the whole.'*

And just before that most auspicious aera, the fourteenth century, during the reign of Richard II. whose total incapacity to manage the reins of power, and keep in subjection his haughty Barons, rendered him a mere cypher; the House of Commons, to whom he was obliged frequently to apply, not only for subsidies but assistance to quell the insurrections that the contempt in which he was held naturally produced, gradually rose into power; for whenever they granted supplies to the King, they demanded in return, though it bore the name of petition, a confirmation, or the renewal of former charters, which had been infringed, and even utterly disregarded by the King and his seditious Barons, who principally held their independence of the crown by force of arms, and the encouragement which they gave to robbers and villains, who infested the country, and lived by rapine and violence.

To what dreadful extremities were the poorer sort reduced, their property, the fruit of their industry, being entirely at the disposal of their lords, who were so many petty tyrants!

In return for the supplies and assistance which the king received from the commons, they demanded privileges, which Edward, in his distress for money to prosecute the numerous wars in which he was engaged during the greater part of his reign, was constrained to grant them; so that by degrees they rose to power, and became a check on both king and nobles. Thus was the foundation of our liberty established, chiefly through the pressing necessities of the king, who was more intent on being supplied for the moment, in order to carry on his wars and ambitious projects, than aware of the blow he gave to kingly power, by thus making a body of men feel

their importance, who afterwards might strenuously oppose tyranny and oppression, and effectually guard the subject's property from seizure and confiscation. Richard's weakness completed what Edward's ambition began.

At this period, it is true, Wickliffe opened a vista for reason by attacking some of the most pernicious tenets of the church of Rome;* still the prospect was sufficiently misty to authorize the question—Where was the dignity of thinking of the fourteenth century?

A Roman Catholic, it is true, enlightened by the reformation, might, with singular propriety, celebrate the epoch that preceded it, to turn our thoughts from former atrocious enormities; but a Protestant must acknowledge that this faint dawn of liberty only made the subsiding darkness more visible; and that the boasted virtues of that century all bear the stamp of stupid pride and headstrong barbarism. Civility was then called condescension, and ostentatious almsgiving humanity; and men were content to borrow their virtues, or, to speak with more propriety, their consequence, from posterity, rather than undertake the arduous task of acquiring it for themselves.

The imperfection of all modern governments must, without waiting to repeat the trite remark, that all human institutions are unavoidably imperfect, in a great measure have arisen from this simple circumstance, that the constitution, if such an heterogeneous mass deserve that name, was settled in the dark days of ignorance, when the minds of men were shackled by the grossest prejudices and most immoral superstition. And do you, Sir, a sagacious philosopher, recommend night as the fittest time to analyze a ray of light?

Are we to seek for the rights of men in the ages when a few marks were the only penalty imposed for the life of a man, and death for death when the property of the rich was touched? when—I blush to discover the depravity of our nature—when a deer was killed! Are these the laws that it is natural to love, and sacrilegious to invade?—Were the rights of men understood when the law authorized or tolerated murder?—or is power and right the same in your creed?

But in fact all your declamation leads so directly to this conclusion, that I beseech you to ask your own heart, when you call yourself a friend of liberty, whether it would not be more consistent to style yourself the champion of property, the adorer of the golden

image which power has set up?—And, when you are examining your heart, if it would not be too much like mathematical drudgery, to which a fine imagination very reluctantly stoops, enquire further, how it is consistent with the vulgar notions of honesty, and the foundation of morality—truth; for a man to boast of his virtue and independence, when he cannot forget that he is at the moment enjoying the wages of falsehood;[1] and that, in a skulking, unmanly way, he has secured himself a pension* of fifteen hundred pounds per annum on the Irish establishment? Do honest men, Sir, for I am not rising to the refined principle of honour, even receive the reward of their public services, or secret assistance, in the name of *another*?

But to return from a digression which you will more perfectly understand than any of my readers—on what principle you, Sir, can justify the reformation, which tore up by the roots an old establishment, I cannot guess—but, I beg your pardon, perhaps you do not wish to justify it—and have some mental reservation to excuse you, to yourself, for not openly avowing your reverence. Or, to go further back;—had you been a Jew—you would have joined in the cry, crucify him!—crucify him! The promulgator of a new doctrine, and the violator of old laws and customs, that not melting, like ours, into darkness and ignorance, rested on Divine authority, must have been a dangerous innovator, in your eyes, particularly if you had not been informed that the Carpenter's Son was of the stock and lineage of David. But there is no end to the arguments which might be deduced to combat such palpable absurdities, by shewing the manifest inconsistencies which are necessarily involved in a direful train of false opinions.

It is necessary emphatically to repeat, that there are rights which men inherit at their birth, as rational creatures, who were raised above the brute creation by their improvable faculties; and that, in receiving these, not from their forefathers but, from God, prescription can never undermine natural rights.

A father may dissipate his property without his child having any right to complain;—but should he attempt to sell him for a slave, or fetter him with laws contrary to reason; nature, in enabling him to discern good from evil, teaches him to break the ignoble chain, and

[1] See Mr Burke's Bills* for oeconomical reform.

not to believe that bread becomes flesh, and wine blood, because his parents swallowed the Eucharist with this blind persuasion.

There is no end to this implicit submission to authority—some where it must stop, or we return to barbarism; and the capacity of improvement, which gives us a natural sceptre on earth, is a cheat, an ignis-fatuus, that leads us from inviting meadows into bogs and dung-hills. And if it be allowed that many of the precautions, with which any alteration was made, in our government, were prudent, it rather proves its weakness than substantiates an opinion of the soundness of the stamina, or the excellence of the constitution.

But on what principle Mr Burke could defend American independence,* I cannot conceive; for the whole tenor of his plausible arguments settles slavery on an everlasting foundation. Allowing his servile reverence for antiquity, and prudent attention to self-interest, to have the force which he insists on, the slave trade ought never to be abolished; and, because our ignorant forefathers, not understanding the native dignity of man, sanctioned a traffic that outrages every suggestion of reason and religion, we are to submit to the inhuman custom, and term an atrocious insult to humanity the love of our country, and a proper submission to the laws by which our property is secured.—Security of property! Behold, in a few words, the definition of English liberty. And to this selfish principle every nobler one is sacrificed.—The Briton takes place of the man, and the image of God is lost in the citizen! But it is not that enthusiastic flame which in Greece and Rome consumed every sordid passion: no, self is the focus; and the disparting rays rise not above our foggy atmosphere. But softly—it is only the property of the rich that is secure; the man who lives by the sweat of his brow has no asylum from oppression; the strong man may enter—when was the castle of the poor sacred? and the base informer steal him from the family that depend on his industry for subsistence.

Fully sensible as you must be of the baneful consequences that inevitably follow this notorious infringement on the dearest rights of men, and that it is an infernal blot on the very face of our immaculate constitution, I cannot avoid expressing my surprise that when you recommended our form of government as a model, you did not caution the French against the arbitrary custom of pressing men for the sea service.* You should have hinted to them, that property in England is much more secure than liberty, and not have concealed

that the liberty of an honest mechanic—his all—is often sacrificed to secure the property of the rich. For it is a farce to pretend that a man fights *for his country, his hearth, or his altars*, when he has neither liberty nor property.—His property is in his nervous* arms—and they are compelled to pull a strange rope at the surly command of a tyrannic boy, who probably obtained his rank on account of his family connections, or the prostituted vote of his father, whose interest in a borough, or voice as a senator, was acceptable to the minister.

Our penal laws punish with death the thief who steals a few pounds;* but to take by violence, or trepan, a man, is no such heinous offence.—For who shall dare to complain of the venerable vestige of the law that rendered the life of a deer more sacred than that of a man? But it was the poor man with only his native dignity who was thus oppressed—and only metaphysical sophists and cold mathematicians can discern this insubstantial form; it is a work of abstraction—and a *gentleman* of lively imagination must borrow some drapery from fancy before he can love or pity a *man*. Misery, to reach your heart, I perceive, must have its cap and bells; your tears are reserved, very *naturally* considering your character, for the declamation of the theatre, or for the downfall of queens, whose rank alters the nature of folly, and throws a graceful veil over vices that degrade humanity; whilst the distress of many industrious mothers, whose *helpmates* have been torn from them, and the hungry cry of helpless babes, were vulgar sorrows that could not move your commiseration, though they might extort an alms. 'The tears that are shed for fictitious sorrow are admirably adapted', says Rousseau, 'to make us proud of all the virtues which we do not possess.'*

The baneful effects of the despotic practice of pressing we shall, in all probability, soon feel; for a number of men, who have been taken from their daily employments, will shortly be let loose on society, now that there is no longer any apprehension of a war.

The vulgar, and by this epithet I mean not only to describe a class of people, who, working to support the body, have not had time to cultivate their minds; but likewise those who, born in the lap of affluence, have never had their invention sharpened by a necessity are, nine out of ten, the creatures of habit and impulse.

If I were not afraid to derange your nervous system by the bare mention of a metaphysical enquiry, I should observe, Sir, that self-preservation is, literally speaking, the first law of nature; and that the care necessary to support and guard the body is the first step to unfold the mind, and inspire a manly spirit of independence. The mewing babe in swaddling-clothes, who is treated like a superior being, may perchance become a gentleman; but nature must have given him uncommon faculties if, when pleasure hangs on every bough, he has sufficient fortitude either to exercise his mind or body in order to acquire personal merit. The passions are necessary auxiliaries of reason: a present impulse pushes us forward, and when we discover that the game did not deserve the chace, we find that we have gone over much ground, and not only gained many new ideas, but a habit of thinking. The exercise of our faculties is the great end, though not the goal we had in view when we started with such eagerness.

It would be straying still further into metaphysics to add, that this is one of the strongest arguments for the natural immortality of the soul.—Every thing looks like a means, nothing like an end, or point of rest, when we can say, now let us sit down and enjoy the present moment; our faculties and wishes are proportioned to the present scene; we may return without repining to our sister clod. And, if no conscious dignity whisper that we are capable of relishing more refined pleasures, the thirst of truth appears to be allayed; and thought, the faint type of an immaterial energy, no longer bounding it knows not where, is confined to the tenement that affords it sufficient variety.—The rich man may then thank his God that he is not like other men—but when is retribution to be made to the miserable, who cry day and night for help, and there is no one at hand to help them? And not only misery but immorality proceeds from this stretch of arbitrary authority. The vulgar have not the power of emptying their mind of the only ideas they imbibed whilst their hands were employed; they cannot quickly turn from one kind of life to another. Pressing them entirely unhinges their minds; they acquire new habits, and cannot return to their old occupations with their former readiness; consequently they fall into idleness, drunkenness, and the whole train of vices which you stigmatize as gross.

A government that acts in this manner cannot be called a good parent, nor inspire natural (habitual is the proper word) affection, in the breasts of children who are thus disregarded.

The game laws are almost as oppressive to the peasantry as press-warrants* to the mechanic. In this land of liberty what is to secure the property of the poor farmer when his noble landlord chooses to plant a decoy field* near his little property? Game devour the fruit of his labour; but fines and imprisonment await him if he dare to kill any—or lift up his hand to interrupt the pleasure of his lord. How many families have been plunged, in the *sporting* countries, into misery and vice for some paltry transgression of these coercive laws, by the natural consequence of that anger which a man feels when he sees the reward of his industry laid waste by unfeeling luxury?—when his children's bread is given to dogs!

You have shewn, Sir, by your silence on these subjects, that your respect for rank has swallowed up the common feelings of humanity; you seem to consider the poor as only the live stock of an estate, the feather of hereditary nobility. When you had so little respect for the silent majority of misery, I am not surprised at your manner of treating an individual whose brow a mitre will never grace, and whose popularity may have wounded your vanity—for vanity is ever sore. Even in France, Sir, before the revolution, literary celebrity procured a man the treatment of a gentleman; but you are going back for your credentials of politeness to more distant times.— Gothic affability is the mode you think proper to adopt, the conde-scension of a Baron, not the civility of a liberal man. Politeness is, indeed, the only substitute for humanity; or what distinguishes the civilised man from the unlettered savage? and he who is not gov-erned by reason should square his behaviour by an arbitrary stand-ard; but by what rule your attack on Dr Price* was regulated we have yet to learn.

I agree with you, Sir, that the pulpit is not the place for political discussions* though it might be more excusable to enter on such a subject, when the day was set apart merely to commemorate a political revolution and no stated duty was encroached upon. I will, however, wave this point, and allow that Dr Price's zeal may have carried him further than sound reason can justify. I do also most cordially coincide with you, that till we can see the remote consequences of things, present calamities must appear in the ugly

form of evil, and excite our commiseration. The good that time slowly educes from them may be hid from mortal eye, or dimly seen; whilst sympathy compels man to feel for man, and almost restrains the hand that would amputate a limb to save the whole body. But, after making this concession, allow me to expostulate with you, and calmly hold up the glass which will shew you your partial feelings.

In reprobating Dr Price's opinions you might have spared the man; and if you had had but half as much reverence for the grey hairs of virtue as for the accidental distinctions of rank, you would not have treated with such indecent familiarity and supercilious contempt, a member of the community whose talents and modest virtues place him high in the scale of moral excellence.* I am not accustomed to look up with vulgar awe, even when mental superiority exalts a man above his fellows; but still the sight of a man whose habits are fixed by piety and reason, and whose virtues are consolidated into goodness, commands my homage—and I should touch his errors with a tender hand when I made a parade of my sensibility. Granting, for a moment, that Dr Price's political opinions are Utopian reveries, and that the world is not yet sufficiently civilized to adopt such a sublime system of morality; they could, however, only be the reveries of a benevolent mind. Tottering on the verge of the grave, that worthy man in his whole life never dreamt of struggling for power or riches; and, if a glimpse of the glad dawn of liberty rekindled the fire of youth in his veins, you, who could not stand the fascinating glance of a *great* Lady's eyes,* when neither virtue nor sense beamed in them, might have pardoned his unseemly transport,—if such it must be deemed.

I could almost fancy that I now see this respectable old man, in his pulpit, with hands clasped, and eyes devoutly fixed, praying with all the simple energy of unaffected piety; or, when more erect, inculcating the dignity of virtue, and enforcing the doctrines his life adorns; benevolence animated each feature, and persuasion attuned his accents; the preacher grew eloquent, who only laboured to be clear; and the respect that he extorted, seemed only the respect due to personified virtue and matured wisdom.*—Is this the man you brand with so many opprobrious epithets? he whose private life will stand the test of the strictest enquiry—away with such unmanly sarcasms, and puerile conceits.—But, before I close this part of my

animadversions, I must convict you of wilful misrepresentation and wanton abuse.

Dr Price, when he reasons on the necessity of men attending some place of public worship, concisely obviates an objection that has been made in the form of an apology,* by advising those, who do not approve of our Liturgy, and cannot find any mode of worship out of the church, in which they can conscientiously join, to establish one for themselves.* This plain advice you have tortured into a very different meaning, and represented the preacher as actuated by a dissenting phrensy, recommending dissensions, 'not to diffuse truth, but to spread contradictions.'[1]* A simple question will silence this impertinent declamation.—What is truth? A few fundamental truths meet the first enquiry of reason, and appear as clear to an unwarped mind, as that air and bread are necessary to enable the body to fulfil its vital functions; but the opinions which men discuss with so much heat must be simplified and brought back to first principles; or who can discriminate the vagaries of the imagination, or scrupulosity of weakness, from the verdict of reason? Let all these points be demonstrated, and not determined by arbitrary authority and dark traditions, lest a dangerous supineness should take place; for probably, in ceasing to enquire, our reason would remain dormant, and delivered up, without a curb, to every impulse of passion, we might soon lose sight of the clear light which the exercise of our understanding no longer kept alive. To argue from experience, it should seem as if the human mind, averse to thought, could only be opened by necessity; for, when it can take opinions on trust, it gladly lets the spirit lie quiet in its gross tenement. Perhaps the most improving exercise of the mind, confining the argument to the enlargement of the understanding, is the restless enquiries that hover on the boundary, or stretch over the dark abyss of uncertainty. These lively conjectures are the breezes that preserve the still lake from stagnating. We should be aware of confining all moral excellence to one channel, however capacious; or, if we are so narrow-minded, we should not forget how much we owe to chance that our inheritance was not Mahometism; and that the iron hand of destiny, in the shape of deeply rooted authority, has not sus-

[1] Page 15.

pended the sword of destruction over our heads. But to return to the misrepresentation.

Blackstone,[1] to whom Mr Burke pays great deference,* seems to agree with Dr Price, that the succession of the King of Great Britain depends on the choice of the people, or that they have a power to cut it off; but this power, as you have fully proved, has been cautiously exerted, and might with more propriety be termed a *right* than a power. Be it so!—yet when you elaborately cited precedents to shew that our forefathers paid great respect to hereditary claims, you might have gone back to your favourite epoch, and shewn their respect for a church that fulminating laws have since loaded with opprobrium. The preponderance of inconsistencies, when weighed with precedents, should lessen the most bigotted veneration for antiquity, and force men of the eighteenth century to acknowledge, that our *canonized forefathers* were unable, or afraid, to revert to reason, without resting on the crutch of authority; and should not be brought as a proof that their children are never to be allowed to walk alone.

When we doubt the infallible wisdom of our ancestors, it is only advancing on the same ground to doubt the sincerity of the law, and the propriety of that servile appellation—OUR SOVEREIGN LORD THE KING.* Who were the dictators of this adulatory language of the law? Were they not courtly parasites and worldly priests? Besides, whoever at divine service, whose feelings were not deadened by habit, or their understandings quiescent, ever repeated without hor-

[1] 'The doctrine of *hereditary* right does by no means imply an *indefeasible* right to the throne. No man will, I think, assert this, that has considered our laws, constitution, and history, without prejudice, and with any degree of attention. It is unquestionably in the breast of the supreme legislative authority of this kingdom, the King and both Houses of Parliament, to defeat this hereditary right; and, by particular entails, limitations, and provisions, to exclude the immediate heir, and vest the inheritance in any one else. This is strictly consonant to our laws and constitution; as may be gathered from the expression so frequently used in our statute books, of "the King's Majesty, his heirs, and successors." In which we may observe that, as the word "heirs" necessarily implies an inheritance, or hereditary right, generally subsisting in "the royal person;" so the word successors, distinctly taken, must imply that this inheritance may sometimes be broken through; or, that there may be a successor, without being the heir of the king.'*

I shall not, however, rest in something like a subterfuge, and quote, as partially as you have done, from Aristotle.* Blackstone has so cautiously fenced round his opinion with provisos, that it is obvious he thought the letter of the law leaned towards your side of the question—but a blind respect for the law is not a part of my creed.

ror the same epithets applied to a man and his Creator? If this is confused jargon—say what are the dictates of sober reason, or the criterion to distinguish nonsense?

You further sarcastically animadvert on the consistency of the democratists, by wresting the obvious meaning of a common phrase, *the dregs of the people*;* or your contempt for poverty may have led you into an error. Be that as it may, an unprejudiced man would have directly perceived the single sense of the word, and an old Member of Parliament could scarcely have missed it. He who had so often felt the pulse of the electors needed not have gone beyond his own experience to discover that the dregs alluded to were the vicious, and not the lower class of the community.

Again, Sir, I must doubt your sincerity or your discernment.— You have been behind the curtain; and, though it might be difficult to bring back your sophisticated heart to nature and make you feel like a man, yet the awestruck confusion in which you were plunged must have gone off when the vulgar emotion of wonder, excited by finding yourself a Senator, had subsided. Then you must have seen the clogged wheels of corruption continually oiled by the sweat of the laborious poor, squeezed out of them by unceasing taxation. You must have discovered that the majority in the House of Commons was often purchased by the crown, and that the people were op- pressed by the influence of their own money, extorted by the venal voice of a packed representation.

You must have known that a man of merit cannot rise in the church, the army, or navy, unless he has some interest in a borough; and that even a paltry exciseman's place can only be secured by electioneering interest.* I will go further, and assert that few Bish- ops, though there have been learned and good Bishops, have gained the mitre without submitting to a servility of dependence that de- grades the man.—All these circumstances you must have known, yet you talk of virtue and liberty, as the vulgar talk of the letter of the law; and the polite of propriety. It is true that these ceremonial observances produce decorum; the sepulchres are white-washed, and do not offend the squeamish eyes of high rank; but virtue is out of the question when you only worship a shadow, and worship it to secure your property.

Man has been termed, with strict propriety, a microcosm, a little world in himself.—He is so;—yet must, however, be reckoned an

ephemera, or, to adopt your figure of rhetoric, a summer's fly.* The perpetuation of property in our families is one of the privileges you most warmly contend for; yet it would not be very difficult to prove that the mind must have a very limited range that thus confines its benevolence to such a narrow circle, which, with great propriety, may be included in the sordid calculations of blind self-love.

A brutal attachment to children has appeared most conspicuous in parents who have treated them like slaves, and demanded due homage for all the property they transferred to them, during their lives. It has led them to force their children to break the most sacred ties; to do violence to a natural impulse, and run into legal prostitution* to increase wealth or shun poverty; and, still worse, the dread of parental malediction has made many weak characters violate truth in the face of Heaven; and, to avoid a father's angry curse, the most sacred promises have been broken. It appears to be a natural suggestion of reason, that a man should be freed from implicit obedience to parents and private punishments, when he is of an age to be subject to the jurisdiction of the laws of his country; and that the barbarous cruelty of allowing parents to imprison their children, to prevent their contaminating their noble blood by following the dictates of nature when they chose to marry, or for any misdemeanor that does not come under the cognizance of public justice, is one of the most arbitrary violations of liberty.*

Who can recount all the unnatural crimes which the *laudable*, *interesting* desire of perpetuating a name has produced? The younger children have been sacrificed to the eldest son; sent into exile, or confined in convents, that they might not encroach on what was called, with shameful falsehood, the *family* estate. Will Mr Burke call this parental affection reasonable or virtuous?—No; it is the spurious offspring of over-weening, mistaken pride—and not that first source of civilization, natural parental affection, that makes no difference between child and child, but what reason justifies by pointing out superior merit.

Another pernicious consequence which unavoidably arises from this artificial affection is, the insuperable bar which it puts in the way of early marriages. It would be difficult to determine whether the minds or bodies of our youth are most injured by this impediment. Our young men become selfish coxcombs, and gallantry with modest women, and intrigues with those of another description,

weaken both mind and body, before either has arrived at maturity. The character of a master of a family, a husband, and a father, forms the citizen imperceptibly, by producing a sober manliness of thought, and orderly behaviour; but, from the lax morals and depraved affections of the libertine, what results?—a finical man of taste, who is only anxious to secure his own private gratifications, and to maintain his rank in society.

The same system has an equally pernicious effect on female morals.—Girls are sacrificed to family convenience, or else marry to settle themselves in a superior rank, and coquet, without restraint, with the fine gentleman whom I have already described. And to such lengths has this vanity, this desire of shining, carried them, that it is not now necessary to guard girls against imprudent love matches; for if some widows did not now and then *fall* in love, Love and Hymen* would seldom meet, unless at a village church.

I do not intend to be sarcastically paradoxical when I say, that women of fashion take husbands that they may have it in their power to coquet, the grand business of genteel life, with a number of admirers, and thus flutter the spring of life away, without laying up any store for the winter of age, or being of any use to society. Affection in the marriage state can only be founded on respect—and are these weak beings respectable? Children are neglected for lovers, and we express surprise that adulteries are so common! A woman never forgets to adorn herself to make an impression on the senses of the other sex, and to extort the homage which it is gallant to pay, and yet we wonder that they have such confined understandings.

Have ye not heard that we cannot serve two masters? an immoderate desire to please contracts the faculties, and immerges, to borrow the idea of a great philosopher, the soul in matter, till it becomes unable to mount on the wing of contemplation.*

It would be an arduous task to trace all the vice and misery that arise in society from the middle class of people apeing the manners of the great. All are aiming to procure respect on account of their property; and most places are considered as sinecures that enable men to start into notice. The grand concern of three parts out of four is to contrive to live above their equals, and to appear to be richer than they are. How much domestic comfort and private satisfaction is sacrificed to this irrational ambition! It is a destructive mildew that blights the fairest virtues; benevolence, friendship, gen-

erosity, and all those endearing charities which bind human hearts together, and the pursuits which raise the mind to higher contemplations, all that were not cankered in the bud by the false notions that 'grew with its growth and strengthened with its strength,'* are crushed by the iron hand of property!

Property, I do not scruple to aver it, should be fluctuating, which would be the case, if it were more equally divided amongst all the children of a family; else it is an everlasting rampart, in consequence of a barbarous feudal institution, that enables the elder son to over-power talents and depress virtue.*

Besides, an unmanly servility, most inimical to true dignity of character is, by this means, fostered in society. Men of some abilities play on the follies of the rich, and mounting to fortune as they degrade themselves, they stand in the way of men of superior talents, who cannot advance in such crooked paths, or wade through the filth which *parasites* never boggle at. Pursuing their way straight forward, their spirit is either bent or broken by the rich man's contumelies, or the difficulties they have to encounter.

The only security of property that nature authorizes and reason sanctions is, the right a man has to enjoy the acquisitions which his talents and industry have acquired; and to bequeath them to whom he chooses. Happy would it be for the world if there were no other road to wealth or honour; if pride, in the shape of parental affection, did not absorb the man, and prevent friendship from having the same weight as relationship. Luxury and effeminacy would not then introduce so much idiotism into the noble families which form one of the pillars of our state: the ground would not lie fallow, nor would undirected activity of mind spread the contagion of restless idleness, and its concomitant, vice, through the whole mass of society.

Instead of gaming they might nourish a virtuous ambition, and love might take place of the gallantry which you, with knightly fealty, venerate. Women would probably then act like mothers, and the fine lady, become a rational woman, might think it necessary to superintend her family and suckle her children, in order to fulfil her part of the social compact. But vain is the hope, whilst great masses of property are hedged round by hereditary honours; for number-less vices, forced in the hot-bed of wealth, assume a sightly form to dazzle the senses and cloud the understanding. The respect paid to rank and fortune damps every generous purpose of the soul, and

stifles the natural affections on which human contentment ought to be built. Who will venturously ascend the steeps of virtue, or explore the great deep for knowledge, when *the one thing needful*, attained by less arduous exertions, if not inherited, procures the attention man naturally pants after, and vice 'loses half its evil by losing all its grossness.'[1]*—What a sentiment to come from a moral pen!

A surgeon would tell you that by skinning over a wound you spread disease through the whole frame; and, surely, they indirectly aim at destroying all purity of morals, who poison the very source of virtue, by smearing a sentimental varnish over vice, to hide its natural deformity. Stealing, whoring, and drunkenness, are gross vices, I presume, though they may not obliterate every moral sentiment, and have a vulgar brand that makes them appear with all their native deformity; but overreaching, adultery, and coquetry, are venial offences, though they reduce virtue to an empty name, and make wisdom consist in saving appearances.

'On this scheme of things[2] a king *is* but a man; a queen *is* but a woman; a woman *is* but an animal, and an animal not of the highest order.'—All true, Sir; if she is not more attentive to the duties of humanity than queens and fashionable ladies in general are. I will still further accede to the opinion you have so justly conceived of the spirit which begins to animate this age.—'All homage paid to the sex in general, as such, and without distinct views, is to be regarded as *romance** and folly.' Undoubtedly; because such homage vitiates them, prevents their endeavouring to obtain solid personal merit; and, in short, makes those beings vain inconsiderate dolls, who ought to be prudent mothers and useful members of society. 'Regicide and sacrilege are but fictions of superstition corrupting jurisprudence, by destroying its simplicity. The murder of a king, or a queen, or a bishop, are only common homicide.'*—Again I agree with you; but you perceive, Sir, that by leaving out the word *father*, I think the whole extent of the comparison invidious.

You further proceed grossly to misrepresent Dr Price's meaning;* and, with an affectation of holy fervour, express your indignation at his profaning a beautiful rapturous ejaculation, when alluding to the King of France's submission to the National

[1] Page 113. [2] As you ironically observe, p. 114.

Assembly;[1] he rejoiced to hail a glorious revolution, which promised an universal diffusion of liberty and happiness.

Observe, Sir, that I called your piety affectation.—A rant to enable you to point your venomous dart, and round your period. I speak with warmth, because, of all hypocrites, my soul most indignantly spurns a religious one;—and I very cautiously bring forward such a heavy charge, to strip you of your cloak of sanctity. Your speech at the time the bill for a regency was agitated now lies before me.—*Then* you could in direct terms, to promote ambitious or interested views, exclaim without any pious qualms—'Ought they to make a mockery of him, putting a crown of thorns on his head, a reed in his hand, and dressing him in a raiment of purple, cry, Hail! King of the British!'* Where was your sensibility when you could utter this cruel mockery, equally insulting to God and man? Go hence, thou slave of impulse, look into the private recesses of thy heart, and take not a mote from thy brother's eye, till thou hast removed the beam* from thine own.

Of your partial feelings I shall take another view, and shew that following nature, which is, you say, 'wisdom without reflection, and *above it*'—has led you into great inconsistences, to use the softest phrase. When, on a late melancholy occasion,* a very important question was agitated, with what indecent warmth did *you* treat a woman, for I shall not lay any stress on her title, whose conduct in life has deserved praise, though not, perhaps, the servile elogiums which have been lavished on the queen. But sympathy, and you tell us that you have a heart of flesh, was made to give way to party spirit and the feelings of a man, not to allude to your romantic gallantry, to the views of the statesman. When you descanted on the horrors of the 6th of October, and gave a glowing, and, in some instances, a most exaggerated description of that infernal night, without having troubled yourself to clean your palette, you might have returned home and indulged us with a sketch of the misery you personally aggravated.*

With what eloquence might you not have insinuated, that the sight of unexpected misery and strange reverse of fortune makes the mind recoil on itself; and, pondering, traced the uncertainty of all

[1] In July, when he first submitted to his people; and not the mobbing triumphal catastrophe in October, which you chose, to give full scope to your declamatory powers.

human hope, the frail foundation of sublunary grandeur! What a climax lay before you. A father torn from his children,—a husband from an affectionate wife,—a man from himself! And not torn by the resistless stroke of death, for time would then have lent its aid to mitigate remediless sorrow; but that living death, which only kept hope alive in the corroding form of suspense, was a calamity that called for all your pity.

The sight of august ruins, of a depopulated country—what are they to a disordered soul! when all the faculties are mixed in wild confusion. It is then indeed we tremble for humanity—and, if some wild fancy chance to cross the brain, we fearfully start, and pressing our hand against our brow, ask if we are yet men?—if our reason is undisturbed?—if judgment hold the helm? Marius might sit with dignity on the ruins of Carthage,* and the wretch in the Bastille, who longed in vain to see the human face divine, might yet view the operations of his own mind, and vary the leaden prospect by new combinations of thought: poverty, shame, and even slavery, may be endured by the virtuous man—he has still a world to range in—but the loss of reason appears a monstrous flaw in the moral world, that eludes all investigation, and humbles without enlightening.

In this state was the King, when you, with unfeeling disrespect, and indecent haste, wished to strip him of all his hereditary honours.*—You were so eager to taste the sweets of power, that you could not wait till time had determined, whether a dreadful delirium would settle into a confirmed madness; but, prying into the secrets of Omnipotence, you thundered out that God had *hurled him from his throne*,* and that it was the most insulting mockery to recollect that he had been a king, or to treat him with any particular respect on account of his former dignity.—And who was the monster whom Heaven had thus awfully deposed, and smitten with such an angry blow? Surely as harmless a character as Lewis XVIth; and the queen of Great Britain, though her heart may not be enlarged by generosity, who will presume to compare her character with that of the queen of France?

Where then was the infallibility of that extolled instinct which rises above reason? was it warped by vanity, or *hurled* from its throne by self-interest? To your own heart answer these questions in the sober hours of reflection—and, after reviewing this gust of passion, learn to respect the sovereignty of reason.

I have, Sir, been reading, with a scrutinizing, comparative eye, several of your insensible and profane speeches during the King's illness. I disdain to take advantage of a man's weak side, or draw consequences from an unguarded transport—A lion preys not on carcasses! But on this occasion you acted systematically. It was not the passion of the moment, over which humanity draws a veil: no; what but the odious maxims of Machiavelian policy could have led you to have searched in the very dregs of misery for forcible arguments to support your party? Had not vanity or interest steeled your heart, you would have been shocked at the cold insensibility which could carry a man to those dreadful mansions, where human weakness appears in its most awful form to *calculate* the chances against the King's recovery. Impressed as *you are* with respect for royalty, I am astonished that you did not tremble at every step, lest Heaven should avenge on your guilty head the insult offered to its vice-regent. But the conscience that is under the direction of transient ebullitions of feeling, is not very tender or consistent, when the current runs another way.

Had you been in a philosophizing mood, had your heart or your reason been at home, you might have been convinced, by ocular demonstration, that madness is only the absence of reason.—The ruling angel leaving its seat, wild anarchy ensues. You would have seen that the uncontrouled imagination often pursues the most regular course in its most daring flight; and that the eccentricities are boldly relieved when judgment no longer officiously arranges the sentiments, by bringing them to the test of principles. You would have seen every thing out of nature in that strange chaos of levity and ferocity, and of all sorts of follies jumbled together. You would have seen in that monstrous tragicomic scene the most opposite passions necessarily succeed, and sometimes mix with each other in the mind; alternate contempt and indignation; alternate laughter and tears; alternate scorn and horror.[1]—This is a true picture of that chaotic state of mind, called madness; when reason gone, we know not where, the wild elements of passion clash, and all is horror and confusion. You might have heard the best turned conceits, flash following flash, and doubted whether the rhapsody was not eloquent, if it had not been delivered in an equivocal lan-

[1] This quotation is not marked with inverted commas, because it is not exact.* p. 11.

guage, neither verse nor prose, if the sparkling periods had not stood alone, wanting force because they wanted concatenation.

It is a proverbial observation, that a very thin partition divides wit and madness.* Poetry therefore naturally addresses the fancy, and the language of passion is with great felicity borrowed from the heightened picture which the imagination draws of sensible objects concentred by impassioned reflection. And, during this 'fine phrensy,'* reason has no right to rein-in the imagination, unless to prevent the introduction of supernumerary images; if the passion is real, the head will not be ransacked for stale tropes and cold rodomontade.* I now speak of the genuine enthusiasm of genius, which, perhaps, seldom appears, but in the infancy of civilization; for as this light becomes more luminous reason clips the wing of fancy—the youth becomes a man.

Whether the glory of Europe is set, I shall not now enquire; but probably the spirit of romance and chivalry is in the wane; and reason will gain by its extinction.

From observing several cold romantic characters I have been led to confine the term romantic to one definition—false, or rather artificial, feelings. Works of genius are read with a prepossession in their favour, and sentiments imitated, because they were fashionable and pretty, and not because they were forcibly felt.

In modern poetry the understanding and memory often fabricate the pretended effusions of the heart, and romance destroys all simplicity; which, in works of taste, is but a synonymous word for truth. This romantic spirit has extended to our prose, and scattered artificial flowers over the most barren heath; or a mixture of verse and prose producing the strangest incongruities. The turgid bombast of some of your periods fully proves these assertions; for when the heart speaks we are seldom shocked by hyperbole, or dry raptures.

I speak in this decided tone, because from turning over the pages of your late publication, with more attention than I did when I first read it cursorily over; and comparing the sentiments it contains with your conduct on many important occasions, I am led very often to doubt your sincerity, and to suppose that you have said many things merely for the sake of saying them well; or to throw some pointed obloquy on characters and opinions that jostled with your vanity.

It is an arduous task to follow the doublings of cunning, or the subterfuges of inconsistency; for in controversy, as in battle, the

brave man wishes to face his enemy, and fight on the same ground. Knowing, however, the influence of a ruling passion,* and how often it assumes the form of reason when there is much sensibility in the heart, I respect an opponent, though he tenaciously maintains opinions in which I cannot coincide; but, if I once discover that many of those opinions are empty rhetorical flourishes, my respect is soon changed into that pity which borders on contempt; and the mock dignity and haughty stalk, only reminds me of the ass in the lion's skin.

A sentiment of this kind glanced across my mind when I read the following exclamation. 'Whilst the royal captives, who followed in the train, were slowly moved along, amidst the horrid yells, and shrilling screams, and frantic dances, and infamous contumelies, and all the unutterable abominations of the furies of hell, in the abused shape of the vilest of women.'[1] Probably you mean women who gained a livelihood by selling vegetables or fish, who never had had any advantages of education; or their vices might have lost part of their abominable deformity, by losing part of their grossness. The queen of France—the great and small vulgar, claim our pity; they have almost insuperable obstacles to surmount in their progress towards true dignity of character; still I have such a plain downright understanding that I do not like to make a distinction without a difference. But it is not very extraordinary that *you* should, for throughout your letter you frequently advert to a sentimental jargon, which has long been current in conversation, and even in books of morals, though it never received the *regal* stamp of reason. A kind of mysterious instinct is *supposed* to reside in the soul, that instantaneously discerns truth, without the tedious labour of ratiocination. This instinct, for I know not what other name to give it, has been termed *common sense*, and more frequently *sensibility*; and, by a kind of *indefeasible* right, it has been *supposed* for rights of this kind are not easily proved, to reign paramount over the other faculties of the mind, and to be an authority from which there is no appeal.

This subtle magnetic fluid, that runs round the whole circle of society, is not subject to any known rule, or, to use an obnoxious phrase, in spite of the sneers of mock humility, or the timid fears of some well-meaning Christians, who shrink from any freedom of

[1] Page 106.

thought, lest they should rouse the old serpent, to the *eternal fitness of things*.* It dips, we know not why, granting it to be an infallible instinct, and, though supposed always to point to truth, its pole-star, the point is always shifting, and seldom stands due north.

It is to this instinct, without doubt, that you allude, when you talk of the 'moral constitution of the heart.' To it, I allow, for I consider it as a congregate of sensations and passions, *Poets* must apply, 'who have to deal with an audience not yet graduated in the school of the rights of men.'* They must, it is clear, often cloud the understanding, whilst they move the heart by a kind of mechanical spring; but that 'in the theatre the first intuitive glance'* of feeling should discriminate the form of truth, and see her fair proportion, I must beg leave to doubt. Sacred be the feelings of the heart! concentred in a glowing flame, they become the sun of life; and, without his invigorating impregnation, reason would probably lie in helpless inactivity, and never bring forth her only legitimate offspring— virtue. But to prove that virtue is really an acquisition of the individual, and not the blind impulse of unerring instinct, the bastard vice has often been begotten by the same father.

In what respect are we superior to the brute creation, if intellect is not allowed to be the guide of passion? Brutes hope and fear, love and hate; but, without a capacity to improve, a power of turning these passions to good or evil, they neither acquire virtue nor wisdom.—Why? Because the Creator has not given them reason.[1]

But the cultivation of reason is an arduous task, and men of lively fancy, finding it easier to follow the impulse of passion, endeavour to persuade themselves and others that it is most *natural*. And happy is it for those, who indolently let that heaven-lighted spark rest like the ancient lamps in sepulchres, that some virtuous habits, with which the reason of others shackled them, supplies its place.—Affection for parents, reverence for superiors or antiquity, notions of honour, or that worldly self-interest that shrewdly shews them that honesty is the best policy: all proceed from the reason for which they serve as substitutes;—but it is reason at second-hand.

Children are born ignorant, consequently innocent;* the passions, are neither good nor evil dispositions, till they receive a

[1] I do not now mean to discuss the intricate subject of their mortality; reason may, perhaps, be given to them in the next stage of existence, if they are to mount in the scale of life, like men, by the medium of death.

direction, and either bound over the feeble barrier raised by a faint glimmering of unexercised reason, called conscience, or strengthen her wavering dictates till sound principles are deeply rooted, and able to cope with the headstrong passions that often assume her awful form. What moral purpose can be answered by extolling good dispositions, as they are called, when these good dispositions are described as instincts: for instinct moves in a direct line to its ultimate end, and asks not for guide or support. But if virtue is to be acquired by experience, or taught by example, reason, perfected by reflection, must be the director of the whole host of passions, which produce a fructifying heat, but no light, that you would exalt into her place.—She must hold the rudder, or, let the wind blow which way it list, the vessel will never advance smoothly to its destined port; for the time lost in tacking about would dreadfully impede its progress.

In the name of the people of England, you say, 'that we know *we* have made no discoveries; and we think that no discoveries are to be made in morality; nor many in the great principles of government, nor in the ideas of liberty, which were understood long before we were born, altogether as well as they will be after the grave has heaped its mould upon our presumption, and the silent tomb shall have imposed its law on our pert loquacity. In England we have not yet been completely emboweled of our natural entrails; we still feel within us, and we cherish and cultivate those inbred sentiments which are faithful guardians, the active monitors of our duty, the true supporters of all liberal and manly morals.'[1] —What do you mean by inbred sentiments? From whence do they come? How were they bred? Are they the brood of folly, which swarm like the insects on the banks of the Nile, when mud and putrefaction have enriched the languid soil? Were these *inbred* sentiments faithful guardians of our duty when the church was an asylum for murderers, and men worshipped bread as a God? when slavery was authorized by law to fasten her fangs on human flesh, and the iron eat into the very soul? If these sentiments are not acquired, if our passive dispositions do not expand into virtuous affections and passions, why are not the Tartars in the first rude horde endued with sentiments white and *elegant* as the driven snow? Why is passion or heroism the child of

[1] Page 128.

reflection, the consequence of dwelling with intent contemplation on one object? The appetites are the only perfect inbred powers that I can discern; and they like instincts have a certain aim, they can be satisfied—but improveable reason has not yet discovered the perfection it may arrive at—God forbid!

First, however, it is necessary to make what we know practical. Who can deny, that has marked the slow progress of civilization, that men may become more virtuous and happy without any new discovery in morals? Who will venture to assert that virtue would not be promoted by the more extensive cultivation of reason? If nothing more is to be done, let us eat and drink, for to-morrow we die—and die for ever! Who will pretend to say, that there is as much happiness diffused on this globe as it is capable of affording? as many social virtues as reason would foster, if she could gain the strength she is able to acquire even in this imperfect state; if the voice of nature was allowed to speak audibly from the bottom of the heart, and the *native* unalienable rights of men were recognized in their full force; if factitious merit did not take place of genuine acquired virtue, and enable men to build their enjoyment on the misery of their fellow creatures; if men were more under the dominion of reason than opinion, and did not cherish their prejudices 'because they were prejudices?'[1]* I am not, Sir, aware of your sneers, hailing a millennium, though a state of greater purity of morals may not be a mere poetic fiction; nor did my fancy ever create a heaven on earth, since reason threw off her swaddling clothes. I perceive, but too forcibly, that happiness, literally speaking, dwells not here;—and that we wander to and fro in a vale of darkness as well as tears. I perceive that my passions pursue objects that the imagination enlarges, till they become only a sublime idea that shrinks from the enquiry of sense, and mocks the experimental philosophers who would confine this spiritual phlogiston* in their material crucibles. I know that the human understanding is deluded with vain shadows, and that when we eagerly pursue any study, we only reach the boundary set to human enquires.—Thus far shalt thou go, and no further, says some stern difficulty; and the *cause* we were pursuing melts into utter darkness. But these are only the trials of contemplative minds, the foundation of virtue remains firm.— The power of exercising our understanding raises us above the

[1] Page 129.

brutes; and this exercise produces that 'primary morality,' which you term 'untaught feelings.'*

If virtue be an instinct, I renounce all hope of immortality; and with it all the sublime reveries and dignified sentiments that have smoothed the rugged path of life: it is all a cheat, a lying vision; I have disquieted myself in vain; for in my eye all feelings are false and spurious, that do not rest on justice as their foundation, and are not concentred by universal love.

I reverence the rights of men.—Sacred rights! for which I acquire a more profound respect, the more I look into my own mind; and, professing these heterodox opinions, I still preserve my bowels; my heart is human, beats quick with human sympathies—and I FEAR God!

I bend with awful reverence when I enquire on what my fear is built.—I fear that sublime power, whose motive for creating me must have been wise and good; and I submit to the moral laws which my reason deduces from this view of my dependence on him.—It is not his power that I fear—it is not to an arbitrary will, but to unerring *reason* I submit.—Submit—yes; I disregard the charge of arrogance, to the law that regulates his just resolves; and the happiness I pant after must be the same in kind, and produced by the same exertions as his—though unfeigned humility overwhelms every idea that would presume to compare the goodness which the most exalted created being could acquire, with the grand source of life and bliss.

This fear of God makes me reverence myself.—Yes, Sir, the regard I have for honest fame, and the friendship of the virtuous, falls far short of the respect which I have for myself. And this, enlightened self-love, if an epithet the meaning of which has been grossly perverted will convey my idea, forces me to see; and, if I may venture to borrow a prostituted term, to *feel*, that happiness is reflected, and that, in communicating good, my soul receives its noble aliment.—I do not trouble myself, therefore, to enquire whether this is the fear the *people* of England feel:—and, if it be *natural* to include all the modifications which you have annexed—it is not.[1]

[1] *Vide* Reflections, p. 128. 'We fear God; we look up with *awe* to kings; with *affection* to parliaments; with *duty* to magistrates; with *reverence* to priests; and with *respect* to nobility.'*

Besides, I cannot help suspecting that, if you had the *enlightened* respect for yourself, which you affect to despise, you would not have said that the constitution of our church and state, formed, like most other modern ones, by degrees, as Europe was emerging out of barbarism, was formed 'under the auspices, and was confirmed by the sanctions, of religion and piety.'* You have turned over the historic page; have been hackneyed in the ways of men, and must know that private cabals and public feuds, private virtues and vices, religion and superstition, have all concurred to foment the mass and swell it to its present form; nay more, that it in part owes its sightly appearance to bold rebellion and insidious innovation. Factions, Sir, have been the leaven, and private interest has produced public good.

These general reflections are not thrown out to insinuate that virtue was a creature of yesterday: No; she had her share in the grand drama. I guard against misrepresentation; but the man who cannot modify general assertions, has scarcely learned the first rudiments of reasoning. I know that there is a great portion of virtue in the Romish church, yet I should not choose to neglect clothing myself with a garment of my own righteousness, depending on a kind donative of works of supererogation. I know that there are many clergymen, of all denominations, wise and virtuous; yet I have not that respect for the whole body, which, you say, characterizes our nation, 'emanating from a certain plainness and directness of understanding.'*—Now we are stumbling on *inbred* feelings and secret lights again—or, I beg your pardon, it may be the furbished up face which you choose to give to the argument.

It is a well-known fact, that when *we*, the people of England, have a son whom we scarcely know what to do with—*we* make a clergyman of him.* When a living is in the gift of a family, a son is brought up to the church; but not always with hopes full of immortality. 'Such sublime principles are *not constantly* infused into persons of exalted birth;' they sometimes think of 'the paltry pelf of the moment'[1]*—and the vulgar care of preaching the gospel, or practising self-denial, is left to the poor curates, who, arguing on your ground, cannot have, from the scanty stipend they receive, 'very high and worthy notions of their function and destination.'* This consecration *for ever*; a word, that from lips of flesh is big with a mighty

[1] Page 137.

nothing, has not purged the *sacred temple* from all the impurities of fraud, violence, injustice, and tyranny. Human passions still lurk in her *sanctum sanctorum*; and, without the profane exertions of reason, vain would be her ceremonial ablutions; morality would still stand aloof from this national religion, this ideal consecration of a state; and men would rather choose to give the goods of their body, when on their death beds, to clear the narrow way to heaven, than restrain the mad career of passions during life.

Such a curious paragraph occurs in this part of your letter, that I am tempted to transcribe it,[1] and must beg you to elucidate it, if I misconceive your meaning.

The only way in which the people interfere in government, religious or civil, is in electing representatives. And, Sir, let me ask you, with manly plainness—are these *holy* nominations? Where is the booth of religion? Does she mix her awful mandates, or lift her persuasive voice, in those scenes of drunken riot and beastly gluttony? Does she preside over those nocturnal abominations which so evidently tend to deprave the manners of the lower class of people? The pestilence stops not here—the rich and poor have one common nature, and many of the great families, which, on this side adoration, you venerate, date their misery, I speak of stubborn matters of fact, from the thoughtless extravagance of an electioneering frolic.*— Yet, after the effervescence of spirits, raised by opposition, and all the little and tyrannic arts of canvassing are over—quiet souls! they only intend to march rank and file to say YES—or NO.

Experience, I believe, will shew that sordid interest, or licentious thoughtlessness, is the spring of action at most elections.—Again, I beg you not to lose sight of my modification of general rules. So far are the people from being habitually convinced of the sanctity of the

[1] 'When the people have emptied themselves of all the lust of selfish will, which without religion it is utterly impossible they ever should; when they are conscious that they exercise, and exercise perhaps in an higher link of the order of delegation, the power, which to be legitimate must be according to that eternal immutable law, in which will and reason are the same, they will be more careful how they place power in base and incapable hands. In their nomination to office, they will not appoint to the exercise of authority as to a pitiful job, but as to an holy function; not according to their sordid selfish interest, nor to their wanton caprice, nor to their arbitrary will; but they will confer that power (which any man may well tremble to give or to receive) on those only, in whom they may discern that predominant proportion of active virtue and wisdom, taken together and fitted to the charge, such, as in the great and inevitable mixed mass of human imperfections and infirmities, is to be found.'

charge they are conferring, that the venality of their votes must admonish them that they have no right to expect disinterested conduct. But to return to the church, and the habitual conviction of the people of England.

So far are the people from being 'habitually convinced that no evil can be acceptable, either in the act or the permission, to him whose essence is good;'[1]* that the sermons which they hear are to them almost as unintelligible as if they were preached in a foreign tongue. The language and sentiments rising above their capacities, very orthodox Christians are driven to fanatical meetings for amusement, if not for edification. The clergy, I speak of the body, not forgetting the respect and affection which I have for individuals, perform the duty of their profession as a kind of fee-simple,* to entitle them to the emoluments accruing from it; and their ignorant flock think that merely going to church is meritorious.

So defective, in fact, are our laws, respecting religious establishments, that I have heard many rational pious clergymen complain, that they had no method of receiving their stipend that did not clog their endeavours to be useful; whilst the lives of many less conscientious rectors are passed in litigious disputes with the people they engaged to instruct; or in distant cities, in all the ease of luxurious idleness.

But you return to your old firm ground.—*Art thou there, True-penny?** Must we swear to secure property, and make assurance doubly sure, to give your perturbed spirit rest? Peace, peace to the manes of thy patriotic phrensy, which contributed to deprive some of thy fellow-citizens of their property in America: another spirit now walks abroad to secure the property of the church.*—The tithes are safe!—We will not say for ever—because the time may come, when the traveller may ask where proud London stood? when its *temples*, its laws, and its trade, may be buried in one common ruin, and only serve as a by-word to point a moral, or furnish senators, who wage a wordy war, on the other side of the Atlantic, with tropes to swell their thundering bursts of eloquence.

Who shall dare to accuse you of inconsistency any more, when you have so staunchly supported the despotic principles which agree so perfectly with the unerring interest of a large body of your fellow-

[1] Page 140.

citizens; not the largest—for when you venerate parliaments—I presume it is not the majority, as you have had the presumption to dissent, and loudly explain your reasons.—But it was not my intention, when I began this letter, to descend to the minutiae of your conduct, or to weigh your infirmities in a balance; it is only some of your pernicious opinions that I wish to hunt out of their lurking holes; and to shew you to yourself, stripped of the gorgeous drapery in which you have enwrapped your tyrannic principles.

That the people of England respect the national establishment I do not deny; I recollect the melancholy proof which they gave, in this very century, of their *enlightened* zeal and reasonable affection. I likewise know that, according to the dictates of a *prudent* law, in a commercial state, truth is reckoned a libel; yet I acknowledge, having never made my humanity give place to Gothic gallantry, that I should have been better pleased to have heard that Lord George Gordon* was confined on account of the calamities which he brought on his country, than for a *libel* on the queen of France.

But one argument which you adduce to strengthen your assertion, appears to carry the preponderancy towards the other side.

You observe that 'our education is so formed as to confirm and fix this impression, (respect for the religious establishment); and that our education is in a manner wholly in the hands of ecclesiastics, and in all stages from infancy to manhood.'[1] Far from agreeing with you, Sir, that these regulations render the clergy a more useful and respectable body, experience convinces me that the very contrary is the fact. In schools and colleges they may, in some degree, support their dignity within the monastic walls; but, in paying due respect to the parents of the young nobility under their tutorage, they do not forget, obsequiously, to respect their noble patrons. The little respect paid, in great houses, to tutors and chaplains proves, Sir, the fallacy of your reasoning. If would be almost invidious to remark, that they sometimes are only modern substitutes for the jesters of Gothic memory, and serve as whetstones for the blunt wit of the noble peer who patronizes them; and what respect a boy can imbibe for a *butt*, at which the shaft of ridicule is daily glanced, I leave those to determine who can distinguish depravity of morals under the specious mask of refined manners.

[1] Page 148.

Besides, the custom of sending clergymen to travel with their noble pupils, as humble companions, instead of exalting, tends inevitably to degrade the clerical character: it is notorious that they meanly submit to the most servile dependence, and gloss over the most capricious follies, to use a soft phrase, of the boys to whom they look up for preferment. An airy mitre dances before them, and they wrap their sheep's clothing more closely about them, and make their spirits bend till it is prudent to claim the rights of men and the honest freedom of speech of an Englishman. How, indeed, could they venture to reprove for his vices their patron: the clergy only give the true feudal emphasis to this word. It has been observed,* by men who have not superficially investigated the human heart, that when a man makes his spirit bend to any power but reason, his character is soon degraded, and his mind shackled by the very prejudi[c]es to which he submits with reluctance. The observations of experience have been carried still further; and the servility to superiors, and tyranny to inferiors, said to characterize our clergy, have rationally been supposed to arise naturally from their associating with the nobility. Among unequals there can be no society;—giving a manly meaning to the term; from such intimacies friendship can never grow; if the basis of friendship is mutual respect, and not a commercial treaty. Taken thus out of their sphere, and enjoying their tithes at a distance from their flocks, is it not natural for them to become courtly parasites, and intriguing dependents on great patrons, or the treasury? Observing all this—for these things have not been transacted in the dark—our young men of fashion, by a common, though erroneous, association of ideas, have conceived a contempt for religion, as they sucked in with their milk a contempt for the clergy.

The people of England, Sir, in the thirteenth and fourteenth centuries, I will not go any further back to insult the ashes of departed popery, did not settle the establishment, and endow it with princely revenues, to make it proudly rear its head, as a part of the constitutional body, to guard the liberties of the community; but, like some of the laborious commentators on Shakespeare, you have affixed a meaning to laws that chance, or, to speak more philosophically, the interested views of men, settled, not dreaming of your ingenious elucidations.

What, but the rapacity of the only men who exercised their reason, the priests, secured such vast property to the church, when

a man gave his perishable substance to save himself from the dark torments of purgatory; and found it more convenient to indulge his depraved appetites, and pay an exorbitant price for absolution, than listen to the suggestions of reason, and work out his own salvation: in a word, was not the separation of religion from morality the work of the priests, and partly achieved in those *honourable* days which you so piously deplore?

That civilization, that the cultivation of the understanding, and refinement of the affections, naturally make a man religious, I am proud to acknowledge.—What else can fill the aching void in the heart, that human pleasures, human friendships can never fill? What else can render us resigned to live, though condemned to ignorance?—What but a profound reverence for the model of all perfection, and the mysterious tie which arises from a love of goodness? What can make us reverence ourselves, but a reverence for that Being, of whom we are a faint image? That mighty Spirit moves on the waters—confusion hears his voice, and the troubled heart ceases to beat with anguish, for trust in Him bade it be still. Conscious dignity may make us rise superior to calumny, and sternly brave the winds of adverse fortune,—raised in our own esteem by the very storms of which we are the sport—but when friends are unkind, and the heart has not the prop on which it fondly leaned, where can a tender suffering being fly but to the Searcher of hearts? and, when death has desolated the present scene, and torn from us the friend of our youth—when we walk along the accustomed path, and, almost fancying nature dead, ask, Where art thou who gave life to these well-known scenes? when memory heightens former pleasures to contrast our present prospects— there is but one source of comfort within our reach;—and in this sublime solitude the world appears to contain only the Creator and the creature, of whose happiness he is the source.—These are human feelings; but I know not of any common nature or common relation amongst men but what results from reason. The common affections and passions equally bind brutes together; and it is only the continuity of those relations that entitles us to the denomination of rational creatures; and this continuity arises from reflection—from the operations of that reason which you contemn with flippant disrespect.

If then it appears, arguing from analogy, that reflection must be the natural foundation of *rational* affections, and of that experience

which enables one man to rise above another, a phenomenon that has never been seen in the brute creation, it may not be stretching the argument further than it will go to suppose, that those men who are obliged to exercise their reason have the most reason, and are the persons pointed out by Nature to direct the society of which they make a part, on any extraordinary emergency.

Time only will shew whether the general censure, which you afterwards qualify, if not contradict, and the unmerited contempt that you have ostentatiously displayed of the National Assembly,* by founded on reason, the offspring of conviction, or the spawn of envy. Time may shew, that this obscure throng knew more of the human heart and of legislation than the profligates of rank, emasculated by hereditary effeminacy.

It is not, perhaps, of very great consequence who were the founders of a state; savages, thieves, curates, or practitioners in the law. It is true, you might sarcastically remark, that the Romans had always a *smack* of the old leaven, and that the private robbers, supposing the tradition to be true, only became public depredators. You might have added, that their civilization must have been very partial, and had more influence on the manners than morals of the people; or the amusements of the amphitheatre would not have remained an everlasting blot not only on their humanity, but on their refinement, if a vicious elegance of behaviour and luxurious mode of life is not a prostitution of the term. However, the thundering censures which you have cast with a ponderous arm, and the more playful bushfiring of ridicule, are not arguments that will ever depreciate the National Assembly, for applying to their understanding rather than to their imagination, when they met to settle the newly acquired liberty of the state on a solid foundation.

If you had given the same advice to a young history painter of abilities, I should have admired your judgment, and re-echoed your sentiments.[1] Study, you might have said, the noble models of antiquity, till your imagination is inflamed; and, rising above the vulgar

[1] Page 51. 'If the last generations of your country appeared without much lustre in your eyes, you might have passed them by, and derived your claims from a more early race of ancestors. Under a pious predilection to those ancestors, your imaginations would have realized in them a standard of virtue and wisdom, beyond the vulgar practice of the hour: and you would have risen with the example to whose imitation you aspired. Respecting your forefathers, you would have been taught to respect yourselves.'

practice of the hour, you may imitate without copying those great originals. A glowing picture, of some interesting moment, would probably have been produced by these natural means; particularly if one little circumstance is not overlooked, that the painter had noble models to revert to, calculated to excite admiration and stimulate exertion.

But, in settling a constitution that involved the happiness of millions, that stretch beyond the computation of science, it was, perhaps, necessary for the Assembly to have a higher model in view than the *imagined* virtues of their forefathers; and wise to deduce their respect for themselves from the only legitimate source, respect for justice. Why was it a duty to repair an ancient castle, built in barbarous ages, of Gothic materials? Why were the legislators obliged to rake amongst heterogeneous ruins; to rebuild old walls, whose foundations could scarcely be explored, when a simple struc-ture might be raised on the foundation of experience, the only valuable inheritance our forefathers could bequeath? Yet of this bequest we can make little use till we have gained a stock of our own; and even then, their inherited experience would rather serve as lighthouses, to warn us against dangerous rocks or sand-banks, than as fingerposts that stand at every turning to point out the right road.

Nor was it absolutely necessary that they should be diffident of themselves when they were dissatisfied with, or could not discern the *almost obliterated* constitution of their ancestors.[1] They should first have been convinced that our constitution was not only the best modern, but the best possible one; and that our social compact was the surest foundation of all the *possible* liberty a mass of men could enjoy, that the human understanding could form. They should have been certain that our representation answered all the purposes of representation; and that an established inequality of rank and prop-erty secured the liberty of the whole community, instead of render-ing it a sounding epithet of subjection, when applied to the nation at large. They should have had the same respect for our House of Commons that you, vauntingly, intrude on us, though your conduct

[1] Page 53. 'If diffident of yourselves, and not clearly discerning the almost obliterated constitution of your ancestors, you had looked to your neighbours in this land, who had kept alive the ancient principles and models of the old common law of Europe meliorated and adapted to its present state—by following wise examples you would have given new ex-amples of wisdom to the world.'

throughout life has spoken a very different language; before they made a point of not deviating from the model which first engaged their attention.

That the British House of Commons is filled with every thing illustrious in rank, in descent, in hereditary, and acquired opulence, may be true,—but that it contains every thing respectable in talents, in military, civil, naval, and political distinction, is very problematical. Arguing from natural causes, the very contrary would appear to the speculatist to be the fact; and let experience say whether these speculations are built on sure ground.

It is true you lay great stress on the effects produced by the bare idea of a liberal descent;[1] but from the conduct of men of rank, men of discernment would rather be led to conclude, that this idea obliterated instead of inspiring native dignity, and substituted a factitious pride that disemboweled the man. The liberty of the rich has its ensigns armorial to puff the individual out with insubstantial honours; but where are blazoned the struggles of virtuous poverty? Who, indeed, would dare to blazon what would blur the pompous monumental inscription you boast of, and make us view with horror, as monsters in human shape, the superb gallery of portraits proudly set in battle array?

But to examine the subject more closely. Is it among the list of possibilities that a man of rank and fortune *can* have received a good education? How can he discover that he is a man, when all his wants are instantly supplied, and invention is never sharpened by necessity? Will he labour, for every thing valuable must be the fruit of laborious exertions, to attain knowledge and virtue, in order to merit the affection of his equals, when the flattering attention of sycophants is a more luscious cordial?

Health can only be secured by temperance; but is it easy to persuade a man to live on plain food even to recover his health, who has been accustomed to fare sumptuously every day? Can a man relish the simple food of friendship, who has been habitually pampered by flattery? And when the blood boils, and the senses meet

[1] Page 49. 'Always acting as if in the presence of canonized forefathers, the spirit of freedom, leading in itself to misrule and excess, is tempered with an awful gravity. This idea of a liberal descent inspires us with a sense of habitual native dignity, which prevents that upstart insolence almost inevitably adhering to and disgracing those who are the first acquirers of any distinction!'

allurements on every side, will knowledge be pursued on account of its abstract beauty? No; it is well known that talents are only to be unfolded by industry, and that we must have made some advances, led by an inferior motive, before we discover that they are their own reward.

But *full blown* talents *may*, according to your system, be hereditary, and as independent of ripening judgment, as the inbred feelings that, rising above reason, naturally guard Englishmen from error. Noble franchises! what a grovelling mind must that man have, who can pardon his step-dame Nature for not having made him at least a lord?

And who will, after your description of senatorial virtues,* dare to say that our House of Commons has often resembled a bear-garden; and appeared rather like a committee of *ways and means* than a dignified legislative body, though the concentrated wisdom and virtue of the whole nation blazed in one superb constellation? That it contains a dead weight of benumbing opulence I readily allow, and of ignoble ambition; nor is there any thing surpassing belief in a supposition that the raw recruits, when properly drilled by the minister, would gladly march to the Upper House to unite hereditary honours to fortune. But talents, knowledge, and virtue, must be a part of the man, and cannot be put, as robes of state often are, on a servant or a block, to render a pageant more magnificent.

Our House of Commons, it is true, has been celebrated as a school of eloquence, a hot-bed for wit, even when party intrigues narrow the understanding and contract the heart; yet, from the few proficients it has accomplished, this inferior praise is not of great magnitude: nor of great consequence, Mr Locke would have added, who was ever of opinion that eloquence was oftener employed to make 'the worse appear the better part,' than to support the dictates of cool judgment.* However, the greater number who have gained a seat by their fortune and hereditary rank, are content with their pre-eminence, and struggle not for more hazardous honours. But you are an exception; you have raised yourself by the exertion of abilities, and thrown the automatons of rank into the back ground. Your exertions have been a generous contest for secondary honours, or a grateful tribute of respect due to the noble ashes that lent a hand to raise you into notice, by introducing you into the house of which you have ever been an ornament, if not a support. But, unfortu-

nately, you have lately lost a great part of your popularity: members were tired of listening to declamation, or had not sufficient taste to be amused when you ingeniously wandered from the question, and said certainly many good things, if they were not to the present purpose. You were the Cicero* of one side of the house for years; and then to sink into oblivion, to see your blooming honours fade before you, was enough to rouse all that was human in you—and make you produce the impassioned *Reflections* which have been a glorious revivification of your fame.—Richard is himself again!* He is still a great man, though he has deserted his post, and buried in elogiums, on church establishments,* the enthusiasm that forced him to throw the weight of his talents on the side of liberty and natural rights, when the *will*[1] of the nation oppressed the Americans.

There appears to be such a mixture of real sensibility and fondly cherished romance in your composition, that the present crisis carries you out of yourself; and since you could not be one of the grand movers, the next *best* thing that dazzled your imagination was to be a conspicuous opposer. Full of yourself, you make as much noise to convince the world that you despise the revolution, as Rousseau did to persuade his contemporaries to let him live in obscurity.*

Reading your Reflections warily over, it has continually and forcibly struck me, that had you been a Frenchman, you would have been, in spite of your respect for rank and antiquity, a violent revolutionist; and deceived, as you now probably are, by the passions that cloud your reason, have termed your romantic enthusiasm an enlightened love of your country, a benevolent respect for the rights of men. Your imagination would have taken fire, and have found arguments, full as ingenious as those you now offer, to prove that the constitution, of which so few pillars remained, that constitution which time had almost obliterated, was not a model sufficiently noble to deserve close adherence. And, for the English constitution, you might not have had such a profound veneration as you have lately acquired; nay, it is not impossible that you might have entertained the same opinion of the English Parliament, that you professed to have during the American war.

[1] Page 6. 'Being a citizen of a particular state, and bound up in a considerable degree, by its *public will*',* etc.

Another observation which, by frequently occurring, has almost grown into a conviction, is simply this, that had the English in general reprobated the French revolution, you would have stood forth alone, and been the avowed Goliath of liberty. But, not liking to see so many brothers near the throne of fame, you have turned the current of your passions, and consequently of your reasoning, another way. Had Dr Price's sermon not lighted some sparks very like envy in your bosom, I shrewdly suspect that he would have been treated with more candour; nor is it charitable to suppose that any thing but personal pique and hurt vanity could have dictated such bitter sarcasms* and reiterated expressions of contempt as occur in your Reflections.

But without fixed principles even goodness of heart is no security from inconsistency, and mild affectionate sensibility only renders a man more ingeniously cruel, when the pangs of hurt vanity are mistaken for virtuous indignation, and the gall of bitterness for the milk of Christian charity.

Where is the dignity, the infallibility of sensibility, in the fair ladies, whom, if the voice of rumour is to be credited, the captive negroes curse in all the agony of bodily pain, for the unheard of tortures they invent? It is probable that some of them, after the sight of a flagellation, compose their ruffled spirits and exercise their tender feelings by the perusal of the last imported novel.—How true these tears are to nature, I leave you to determine. But these ladies may have read your Enquiry concerning the origin of our ideas of the Sublime and Beautiful,* and, convinced by your arguments, may have laboured to be pretty, by counterfeiting weakness.

You may have convinced them that *littleness* and *weakness* are the very essence of beauty; and that the Supreme Being, in giving women beauty in the most supereminent degree, seemed to command them, by the powerful voice of Nature, not to cultivate the moral virtues that might chance to excite respect, and interfere with the pleasing sensations they were created to inspire. Thus confining truth, fortitude, and humanity, within the rigid pale of manly morals, they might justly argue, that to be loved, women's high end and great distinction! they should 'learn to lisp, to totter in their walk, and nick-name God's creatures.'* Never, they might repeat after you, was any man, much less a woman, rendered amiable by the force of those exalted qualities, fortitude, justice, wisdom, and

truth; and thus forewarned of the sacrifice they must make to those austere, unnatural virtues, they would be authorized to turn all their attention to their persons, systematically neglecting morals to secure beauty.—Some rational old woman indeed might chance to stumble at this doctrine, and hint, that in avoiding atheism you had not steered clear of the mussulman's creed;* but you could readily exculpate yourself by turning the charge on Nature, who made our idea of beauty independent of reason. Nor would it be necessary for you to recollect, that if virtue has any other foundation than worldly utility, you have clearly proved that one half of the human species, at least, have not souls; and that Nature, by making women *little, smooth, delicate, fair* creatures, never designed that they should exercise their reason to acquire the virtues that produce opposite, if not contradictory, feelings. The affection they excite, to be uniform and perfect, should not be tinctured with the respect which moral virtues inspire, lest pain should be blended with pleasure, and admiration disturb the soft intimacy of love. This laxity of morals in the female world is certainly more captivating to a libertine imagination than the cold arguments of reason, that give no sex to virtue. If beautiful weakness be interwoven in a woman's frame, if the chief business of her life be (as you insinuate) to inspire love, and Nature has made an eternal distinction between the qualities that dignify a rational being and this animal perfection, her duty and happiness in this life must clash with any preparation for a more exalted state. So that Plato and Milton* were grossly mistaken in asserting that human love led to heavenly, and was only an exaltation of the same affection; for the love of the Deity, which is mixed with the most profound reverence, must be love of perfection, and not compassion for weakness.

To say the truth, I not only tremble for the souls of women, but for the good natured man, whom every one loves. The *amiable* weakness of his mind is a strong argument against its immateriality, and seems to prove that beauty relaxes the *solids* of the soul as well as the body.

It follows then immediately, from your own reasoning, that respect and love are antagonist principles; and that, if we really wish to render men more virtuous, we must endeavour to banish all enervating modifications of beauty from civil society. We must, to carry your argument a little further, return to the Spartan regulations,*

and settle the virtues of men on the stern foundation of mortification and self-denial; for any attempt to civilize the heart, to make it humane by implanting reasonable principles, is a mere philosophic dream. If refinement inevitably lessens respect for virtue, by rendering beauty, the grand tempter, more seductive; if these relaxing feelings are incompatible with the nervous exertions of morality, the sun of Europe is not set; it begins to dawn, when cold metaphysicians try to make the head give laws to the heart.

But should experience prove that there is a beauty in virtue, a charm in order, which necessarily implies exertion, a depraved sensual taste may give way to a more manly one—and *melting* feelings to rational satisfactions. Both may be equally natural to man; the test is their moral difference, and that point reason alone can decide.

Such a glorious change can only be produced by liberty. Inequality of rank must ever impede the growth of virtue, by vitiating the mind that submits or domineers; that is ever employed to procure nourishment for the body, or amusement for the mind. And if this grand example be set by an assembly of unlettered clowns, if they can produce a crisis that may involve the fate of Europe, and 'more than Europe,'[1] you must allow us to respect unsophisticated reason, and reverence the active exertions that were not relaxed by a fastidious respect for the beauty of rank, or a dread of the deformity produced by any *void* in the social structure.

After your contemptuous manner of speaking of the National Assembly, after descanting on the coarse vulgarity of their proceedings, which, according to your own definition of virtue,* is a proof of its genuineness; was it not a little inconsistent, not to say absurd, to assert, that a dozen people of quality* were not a sufficient counterpoise to the vulgar mob with whom they condescended to associate? Have we half a dozen leaders of eminence in our House of Commons, or even in the fashionable world? yet the sheep obsequiously pursue their steps with all the undeviating sagacity of instinct.

In order that liberty should have a firm foundation, an acquaintance with the world would naturally lead cool men to conclude that it must be laid, knowing the weakness of the human heart, and the

[1] Page 11. 'It looks to me as if I were in a great crisis, not of the affairs of France alone but of all Europe, perhaps of more than Europe. All circumstances taken together, the French revolution is the most astonishing that has hitherto happened in the world.'

'deceitfulness of riches,'* either by *poor* men, or philosophers, if a sufficient number of men, disinterested from principle, or truly wise, could be found. Was it natural to expect that sensual prejudices should give way to reason, or present feelings to enlarged views?—No; I am afraid that human nature is still in such a weak state, that the abolition of titles, the corner-stone of despotism, could only have been the work of men who had no titles to sacrifice. The National Assembly, it is true, contains some honourable exceptions;* but the majority had not such powerful feelings to struggle with, when reason led them to respect the naked dignity of virtue.

Weak minds are always timid. And what can equal the weakness of mind produced by servile flattery, and the vapid pleasures that neither hope nor fear seasoned? Had the constitution of France been new modelled, or more cautiously repaired, by the lovers of elegance and beauty, it is natural to suppose that the imagination would have erected a fragile temporary building; or the power of one tyrant, divided amongst a hundred, might have rendered the struggle for liberty only a choice of masters. And the glorious *chance* that is now given to human nature of attaining more virtue and happiness than has hitherto blessed our globe, might have been sacrificed to a meteor of the imagination, a bubble of passion. The ecclesiastics, indeed, would probably have remained in quiet possession of their sinecures; and your gall might not have been mixed with your ink on account of the daring sacrilege* that brought them more on a level. The nobles would have had bowels for their younger sons, if not for the misery of their fellow-creatures. An august mass of property would have been transmitted to posterity to guard the temple of superstition, and prevent reason from entering with her officious light. And the pomp of religion would have continued to impress the senses, if she were unable to subjugate the passions.

Is hereditary weakness necessary to render religion lovely? and will her form have lost the smooth delicacy that inspires love, when stripped of its Gothic drapery? Must every grand model be placed on the pedestal of property? and is there no beauteous proportion in virtue, when not clothed in a sensual garb?

Of these questions there would be no end, though they lead to the same conclusion;—that your politics and morals, when simplified, would undermine religion and virtue to set up a spurious, sen-

sual beauty, that has long debauched your imagination, under the specious form of natural feelings.

And what is this mighty revolution in property? The present incumbents only are injured, or the hierarchy of the clergy, an ideal part of the constitution, which you have personified, to render your affection more tender. How has posterity been injured by a distribution of the property snatched, perhaps, from innocent hands, but accumulated by the most abominable violation of every sentiment of justice and piety? Was the monument of former ignorance and iniquity to be held sacred, to enable the present possessors of enormous benefices to *dissolve* in indolent pleasures? Was not their convenience, for they have not been turned adrift on the world, to give place to a just partition of the land belonging to the state? And did not the respect due to the natural equality of man require this triumph over Monkish rapacity? Were those monsters to be reverenced on account of their antiquity, and their unjust claims perpetuated to their ideal children, the clergy, merely to preserve the sacred majesty of Property inviolate, and to enable the Church to retain her pristine splendor? Can posterity be injured by individuals losing the chance of obtaining great wealth, without meriting it, by its being diverted from a narrow channel, and disembogued into the sea that affords clouds to water all the land? Besides, the clergy not brought up with the expectation of great revenues will not feel the loss; and if bishops should happen to be chosen on account of their personal merit, religion may be benefited by the vulgar nomination.

The sophistry of asserting that Nature leads us to reverence our civil institutions from the same principle that we venerate aged individuals, is a palpable fallacy 'that is so like truth, it will serve the turn as well.' And when you add, 'that we have chosen our nature rather than our speculations, our breasts rather than our inventions,'[1] the pretty jargon seems equally unintelligible.

But it was the downfall of the visible power and dignity of the church that roused your ire; you could have excused a little squeez-

[1] Page 50. 'We procure reverence to our civil institutions on the principle upon which nature teaches us to revere individual men; on account of their age; and on account of those from whom they are descended. All your sophisters cannot produce any thing better adapted to preserve a rational and manly freedom than the course that we have pursued; who have chosen our nature rather than our speculations, our breasts rather than our inventions, for the great conservatories and magazines of our rights and privileges.'

ing of the individuals to supply present exigencies; the actual pos-
sessors of the property might have been oppressed with something
like impunity, if the church had not been spoiled of its gaudy
trappings. You love the church, your country, and its laws, you
repeatedly tell us, because they deserve to be loved; but from you
this is not a panegyric: weakness and indulgence are the only incite-
ments to love and confidence that you can discern, and it cannot be
denied that the tender mother you venerate deserves, on this score,
all your affection.

It would be as vain a task to attempt to obviate all your passionate
objections, as to unravel all your plausible arguments, often illus-
trated by known truths, and rendered forcible by pointed invectives.
I only attack the foundation. On the natural principles of justice I
build my plea for disseminating the property artfully said to be
appropriated to religious purposes, but, in reality, to support idle
tyrants, amongst the society whose ancestors were cheated or forced
into illegal grants. Can there be an opinion more subversive of
morality, than that time sanctifies crimes, and silences the blood
that calls out for retribution, if not for vengeance? If the revenue
annexed to the Gallic church was greater than the most bigoted
protestant would now allow to be its reasonable share, would it not
have been trampling on the rights of men to perpetuate such an
arbitrary appropriation of the common flock, because time had ren-
dered the fraudulent seizure venerable? Besides, if Reason had sug-
gested, as surely she must, if the imagination had not been allowed
to dwell on the fascinating pomp of ceremonial grandeur, that the
clergy would be rendered both more virtuous and useful by being
put more on a par with each other, and the mass of the people it was
their duty to instruct;—where was there room for hesitation? The
charge of presumption, thrown by you on the most reasonable inno-
vations, may, without any violence to truth, be retorted on every
reformation that has meliorated our condition, and even on the
improvable faculty that gives us a claim to the pre-eminence of
intelligent beings.

Plausibility, I know, can only be unmasked by shewing the ab-
surdities it glosses over, and the simple truths it involves with
specious errors. Eloquence has often confounded triumphant
villany; but it is probable that it has more frequently rendered the
boundary that separates virtue and vice doubtful.—Poisons may be
only medicines in judicious hands; but they should not be adminis-

tered by the ignorant, because they have sometimes seen great cures performed by their powerful aid.

The many sensible remarks and pointed observations which you have mixed with opinions that strike at our dearest interests, fortify those opinions, and give them a degree of strength that render them formidable to the wise, and convincing to the superficial. It is impossible to read half a dozen pages of your book without admiring your ingenuity, or indignantly spurning your sophisms. Words are heaped on words, till the understanding is confused by endeavouring to disentangle the sense, and the memory by tracing contradictions. After observing a host of these contradictions, it can scarcely be a breach of charity to think that you have often sacrificed your sincerity to enforce your favourite arguments, and called in your judgment to adjust the arrangement of words that could not convey its dictates.

A fallacy of this kind, I think, could not have escaped you when you were treating the subject that called forth your bitterest animadversions,* the confiscation of the ecclesiastical revenue. Who of the vindicators of the rights of men ever ventured to assert, that the clergy of the present day should be punished on account of the intolerable pride and inhuman cruelty of many of their predecessors?[1] No; such a thought never entered the mind of those who warred with inveterate prejudices. A desperate disease required a powerful remedy. Injustice had no right to rest on prescription; nor has the character of the present clergy any weight in the argument.

You find it very difficult to separate policy from justice: in the political world they have frequently been separated with shameful dexterity. To mention a recent instance. According to the limited views of timid, or interested politicians, an abolition of the infernal slave trade would not only be unsound policy, but a flagrant infringement of the laws (which are allowed to have been infamous) that induced the planters to purchase their estates. But is it not consonant with justice, with the common principles of humanity, not to mention Christianity, to abolish this abominable mischief?[2]

[1] *Vide* Page 210.*

[2] 'When men are encouraged to go into a certain mode of life by the existing laws, and protected in that mode as in a lawful occupation—when they have accommodated *all their ideas, and all their habits to it*,'* etc.—'I am sure it is unjust in legislature, by an arbitrary act, to offer a sudden violence to their minds and their feelings; forcibly to degrade them from their state and condition, and to stigmatize with shame and infamy that character and those customs which before had been made the measure of their happiness.' Page 230.

There is not one argument, one invective, levelled by you at the confiscators of the church revenue, which could not, with the strictest propriety, be applied by the planters and negro-drivers to our Parliament, if it gloriously dared to shew the world that British senators were men: if the natural feelings of humanity silenced the cold cautions of timidity, till this stigma on our nature was wiped off, and all men were allowed to enjoy their birth-right—liberty, till by their crimes they had authorized society to deprive them of the blessing they had abused.

The same arguments might be used in India, if any attempt were made to bring back things to nature, to prove that a man ought never to quit the cast that confined him to the profession of his lineal forefathers. The Bramins would doubtless find many ingenious reasons to justify this debasing, though venerable prejudice; and would not, it is to be supposed, forget to observe that time, by interweaving the oppressive law with many useful customs, had rendered it for the present very convenient, and consequently legal. Almost every vice that has degraded our nature might be justified by shewing that it had been productive of *some* benefit to society: for it would be as difficult to point out positive evil as unallayed good, in this imperfect state. What indeed would become of morals, if they had no other test than prescription? The manners of men may change without end; but, wherever reason receives the least cultivation—wherever men rise above brutes, morality must rest on the same base. And the more man discovers of the nature of his mind and body, the more clearly he is convinced, that to act according to the dictates of reason is to conform to the law of God.

The test of honour may be arbitrary and fallacious, and, retiring into subterfuge, elude close enquiry; but true morality shuns not the day, nor shrinks from the ordeal of investigation. Most of the happy revolutions that have taken place in the world have happened when weak princes held the reins they could not manage; but are they, on that account, to be canonized as saints or demi-gods, and pushed forward to notice on the throne of ignorance? Pleasure wants a zest, if experience cannot compare it with pain; but who courts pain to heighten his pleasures? A transient view of society will further illustrate arguments which appear so obvious that I am almost ashamed to produce illustrations. How many children have been taught oeconomy, and many other virtues, by the extravagant

thoughtlessness of their parents; yet a good education is allowed to be an inestimable blessing. The tenderest mothers are often the most unhappy wives; but can the good that accrues from the private distress that produces a sober dignity of mind justify the inflictor? Right or wrong may be estimated according to the point of sight, and other adventitious circumstances; but, to discover its real nature, the enquiry must go deeper than the surface, and beyond the local consequences that confound good and evil together. The rich and weak, a numerous train, will certainly applaud your system, and loudly celebrate your pious reverence for authority and establishments—they find it pleasanter to enjoy than to think; to justify oppression than correct abuses.—*The rights of men* are grating sounds that set their teeth on edge; the impertinent enquiry of philosophic meddling innovation. If the poor are in distress, they will make some *benevolent* exertions to assist them; they will confer obligations, but not do justice. Benevolence is a very amiable specious quality; yet the aversion which men feel to accept a right as a favour, should rather be extolled as a vestige of native dignity, than stigmatized as the odious offspring of ingratitude. The poor consider the rich as their lawful prey; but we ought not too severely to animadvert on their ingratitude. When they receive an alms they are commonly grateful at the moment; but old habits quickly return, and cunning has ever been a substitute for force.

That both physical and moral evil were not only foreseen, but entered into the scheme of Providence, when this world was contemplated in the Divine mind, who can doubt, without robbing Omnipotence of a most exalted attribute? But the business of the life of a good man should be, to separate light from darkness; to diffuse happiness, whilst he submits to unavoidable misery. And a conviction that there is much unavoidable wretchedness, appointed by the grand Disposer of all events, should not slacken his exertions: the extent of what is possible can only be discerned by God. The justice of God may be vindicated by a belief in a future state; but, only by believing that evil is educing good for the individual, and not for an imaginary whole. The happiness of the whole must arise from the happiness of the constituent parts, or the essence of justice is sacrificed to a supposed grand arrangement. And that may be good for the whole of a creature's existence, that disturbs the comfort of a small portion. The evil which an individual suffers for the good of

the community is partial, it must be allowed, if the account is settled by death.—But the partial evil which it suffers, during one stage of existence, to render another stage more perfect, is strictly just. The Father of all only can regulate the education of his children. To suppose that, during the whole or part of its existence, the happiness of any individual is sacrificed to promote the welfare of ten, or ten thousand, other beings—is impious. But to suppose that the happiness, or animal enjoyment, of one portion of existence is sacrificed to improve and ennoble the being itself, and render it capable of more perfect happiness, is not to reflect on either the goodness or wisdom of God.

It may be confidently asserted that no man chooses evil, because it is evil; he only mistakes it for happiness, the good he seeks. And the desire of rectifying these mistakes, is the noble ambition of an enlightened understanding, the impulse of feelings that Philosophy invigorates. To endeavour to make unhappy men resigned to their fate, is the tender endeavour of short-sighted benevolence, of transient yearnings of humanity; but to labour to increase human happiness by extirpating error, is a masculine godlike affection. This remark may be carried still further. Men who possess uncommon sensibility, whose quick emotions shew how closely the eye and heart are connected, soon forget the most forcible sensations. Not tarrying long enough in the brain to be subject to reflection, the next sensations, of course, obliterate them. Memory, however, treasures up these proofs of native goodness; and the being who is not spurred on to any virtuous act, still thinks itself of consequence, and boasts of its feelings. Why? Because the sight of distress, or an affecting narrative, made its blood flow with more velocity, and the heart, literally speaking, beat with sympathetic emotion. We ought to beware of confounding mechanical instinctive sensations with emotions that reason deepens, and justly terms the feelings of *humanity*. This word discriminates the active exertions of virtue from the vague declamation of sensibility.

The declaration of the National Assembly, when they recognized the rights of men, was calculated to touch the humane heart—the downfall of the clergy, to agitate the pupil of impulse. On the watch to find fault, faults met your prying eye; a different prepossession might have produced a different conviction.

When we read a book that supports our favourite opinions, how eagerly do we suck in the doctrines, and suffer our minds placidly to reflect the images that illustrate the tenets we have previously embraced. We indolently acquiesce in the conclusion, and our spirit animates and corrects the various subjects. But when, on the contrary, we peruse a skilful writer, with whom we do not coincide in opinion, how attentive is the mind to detect fallacy. And this suspicious coolness often prevents our being carried away by a stream of natural eloquence, which the prejudiced mind terms declamation—a pomp of words! We never allow ourselves to be warmed; and, after contending with the writer, are more confirmed in our opinion; as much, perhaps, from a spirit of contradiction as from reason. A lively imagination is ever in danger of being betrayed into error by favourite opinions, which it almost personifies, the more effectually to intoxicate the understanding. Always tending to extremes, truth is left behind in the heat of the chace, and things are viewed as positively good, or bad, though they wear an equivocal face.

Some celebrated writers* have supposed that wit and judgment were incompatible; opposite qualities, that, in a kind of elementary strife, destroyed each other: and many men of wit have endeavoured to prove that they were mistaken. Much may be adduced by wits and metaphysicians on both sides of the question. But, from experience, I am apt to believe that they do weaken each other, and that great quickness of comprehension, and facile association of ideas, naturally preclude profundity of research. Wit is often a lucky hit; the result of a momentary inspiration. We know not whence it comes, and it blows where it lists. The operations of judgment, on the contrary, are cool and circumspect; and coolness and deliberation are great enemies to enthusiasm. If wit is of so fine a spirit, that it almost evaporates when translated into another language, why may not the temperature have an influence over it? This remark may be thought derogatory to the inferior qualities of the mind: but it is not a hasty one; and I mention it as a prelude to a conclusion I have frequently drawn, that the cultivation of reason damps fancy. The blessings of Heaven lie on each side; we must choose, if we wish to attain any degree of superiority, and not lose our lives in laborious idleness. If we mean to build our knowledge or happiness on a rational basis, we must learn to distinguish the *possible*, and not fight

against the stream. And if we are careful to guard ourselves from imaginary sorrows and vain fears, we must also resign many enchanting illusions: for shallow must be the discernment which fails to discover that raptures and ecstasies arise from error.—Whether it will always be so, is not now to be discussed; suffice it to observe, that Truth is seldom arrayed by the Graces; and if she charms, it is only by inspiring a sober satisfaction, which takes its rise from a calm contemplation of proportion and simplicity. But, though it is allowed that one man has by nature more fancy than another, in each individual there is a spring-tide when fancy should govern and amalgamate materials for the understanding; and a graver period, when those materials should be employed by the judgment. For example, I am inclined to have a better opinion of the heart of an *old* man, who speaks of Sterne* as his favourite author, than of his understanding. There are times and seasons for all things: and moralists appear to me to err, when they would confound the gaiety of youth with the seriousness of age; for the virtues of age look not only more imposing, but more natural, when they appear rather rigid. He who has not exercised his judgment to curb his imagination during the meridian of life, becomes, in its decline, too often the prey of childish feelings. Age demands respect; youth love: if this order is disturbed, the emotions are not pure; and when love for a man in his grand climacteric takes place of respect, it, generally speaking, borders on contempt. Judgment is sublime, wit beautiful;* and, according to your own theory,* they cannot exist together without impairing each other's power. The predominancy of the latter, in your endless Reflections, should lead hasty readers to suspect that it may, in a great degree, exclude the former.

But, among all your plausible arguments, and witty illustrations, your contempt for the poor always appears conspicuous, and rouses my indignation. The following paragraph in particular struck me, as breathing the most tyrannic spirit, and displaying the most factitious feelings. 'Good order is the foundation of all good things. To be enabled to acquire, the people, without being servile, must be tractable and obedient. The magistrate must have his reverence, the laws their authority. The body of the people must not find the principles of natural subordination by art rooted out of their minds. They *must* respect that property of which they *cannot* partake. *They*

*must labour to obtain what by labour can be obtained; and when they
find, as they commonly do, the success disproportioned to the endeavour,
they must be taught their consolation in the final proportions of eternal
justice.** Of this consolation, whoever deprives them, deadens their
industry, and strikes at the root of all acquisition as of all conserva-
tion. He that does this, is the cruel oppressor, the merciless enemy,
of the poor and wretched; at the same time that, by his wicked
speculations, he exposes the fruits of successful industry, and the
accumulations of fortune', (ah! there's the rub)* 'to the plunder of
the negligent, the disappointed, and the unprosperous.'[1]

This is contemptible hard-hearted sophistry, in the specious form
of humility, and submission to the will of Heaven.——It is, Sir,
possible to render the poor happier in this world, without depriving
them of the consolation which you gratuitously grant them in the
next. They have a right to more comfort than they at present enjoy;
and more comfort might be afforded them, without encroaching
on the pleasures of the rich: not now waiting to enquire whether
the rich have any right to exclusive pleasures. What do I say?——
encroaching! No; if an intercourse were established between them, it
would impart the only true pleasure that can be snatched in this land
of shadows, this hard school of moral discipline.

I know, indeed, that there is often something disgusting in the
distresses of poverty, at which the imagination revolts, and starts
back to exercise itself in the more attractive Arcadia* of fiction. The
rich man builds a house, art and taste give it the highest finish. His
gardens are planted, and the trees grow to recreate the fancy of the
planter, though the temperature of the climate may rather force him
to avoid the dangerous damps they exhale, than seek the umbra-
geous retreat. Every thing on the estate is cherished but man;——yet,
to contribute to the happiness of man, is the most sublime of all
enjoyments. But if, instead of sweeping pleasure-grounds, obelisks,
temples, and elegant cottages, as *objects* for the eye, the heart was
allowed to beat true to nature, decent farms would be scattered over
the estate, and plenty smile around. Instead of the poor being sub-
ject to the griping hand of an avaricious steward, they would be
watched over with fatherly solicitude, by the man whose duty and
pleasure it was to guard their happiness, and shield from rapacity

[1] Page 351.

the beings who, by the sweat of their brow, exalted him above his fellows.

I could almost imagine I see a man thus gathering blessings as he mounted the hill of life; or consolation, in those days when the spirits lag, and the tired heart finds no pleasure in them. It is not by squandering alms that the poor can be relieved, or improved—it is the fostering sun of kindness, the wisdom that finds them employments calculated to give them habits of virtue, that meliorates their condition. Love is only the fruit of love; condescension and authority may produce the obedience you applaud; but he has lost his heart of flesh who can see a fellow-creature humbled before him, and trembling at the frown of a being, whose heart is supplied by the same vital current, and whose pride ought to be checked by a consciousness of having the same infirmities.

What salutary dews might not be shed to refresh this thirsty land, if men were more *enlightened*! Smiles and premiums might encourage cleanliness, industry, and emulation.—A garden more inviting than Eden would then meet the eye, and springs of joy murmur on every side. The clergyman would superintend his own flock, the shepherd would then love the sheep he daily tended; the school might rear its decent head, and the buzzing tribe, let loose to play, impart a portion of their vivacious spirits to the heart that longed to open their minds, and lead them to taste the pleasures of men. Domestic comfort, the civilizing relations of husband, brother, and father, would soften labour, and render life contented.

Returning once from a despotic country* to a part of England well cultivated, but not very picturesque—with what delight did I not observe the poor man's garden!—The homely palings and twining woodbine, with all the rustic contrivances of simple, unlettered taste, was a sight which relieved the eye that had wandered indignant from the stately palace to the pestiferous hovel, and turned from the awful contrast into itself to mourn the fate of man, and curse the arts of civilization!

Why cannot large estates be divided into small farms? these dwellings would indeed grace our land. Why are huge forests still allowed to stretch out with idle pomp and all the indolence of Eastern grandeur? Why does the brown waste meet the traveller's view, when men want work? But commons cannot be enclosed* without *acts of parliament* to increase the property of the rich! Why

might not the industrious peasant be allowed to steal a farm from the heath? This sight I have seen;—the cow that supported the children grazed near the hut, and the cheerful poultry were fed by the chubby babes, who breathed a bracing air, far from the diseases and the vices of cities. Domination blasts all these prospects; virtue can only flourish amongst equals, and the man who submits to a fellow-creature, because it promotes his worldly interest, and he who relieves only because it is his duty to lay up a treasure in heaven,* are much on a par, for both are radically degraded by the habits of their life.

In this great city, that proudly rears its head, and boasts of its population and commerce, how much misery lurks in pestilential corners, whilst idle mendicants assail, on every side, the man who hates to encourage impostors, or repress, with angry frown, the plaints of the poor! How many mechanics, by a flux of trade or fashion, lose their employment; whom misfortunes, not to be warded off, lead to the idleness that vitiates their character and renders them afterwards averse to honest labour! Where is the eye that marks these evils, more gigantic than any of the infringements of property, which you piously deprecate? Are these remediless evils? And is the humane heart satisfied with turning the poor over to *another* world, to receive the blessings this could afford? If society was regulated on a more enlarged plan; if man was contented to be the friend of man, and did not seek to bury the sympathies of humanity in the servile appellation of master; if, turning his eyes from ideal regions of taste and elegance, he laboured to give the earth he inhabited all the beauty it is capable of receiving, and was ever on the watch to shed abroad all the happiness which human nature can enjoy;—he who, respecting the rights of men, wishes to convince or persuade society that this is true happiness and dignity, is not the cruel *oppressor* of the poor, nor a short-sighted philosopher—HE fears God and loves his fellow-creatures.—Behold the whole duty of man!—the citizen who acts differently is a sophisticated being.

Surveying civilized life, and seeing, with undazzled eye, the polished vices of the rich, their insincerity, want of natural affections, with all the specious train that luxury introduces, I have turned impatiently to the poor, to look for man undebauched by riches or power—but, alas! what did I see? a being scarcely above the brutes,

over which he tyrannized; a broken spirit, worn-out body, and all those gross vices which the example of the rich, rudely copied, could produce. Envy built a wall of separation, that made the poor hate, whilst they bent to their superiors; who, on their part, stepped aside to avoid the loathsome sight of human misery.

What were the outrages of a day[1] to these continual miseries? Let those sorrows hide their diminished head before the tremendous mountain of woe that thus defaces our globe! Man preys on man; and you mourn for the idle tapestry that decorated a gothic pile, and the dronish bell that summoned the fat priest to prayer. You mourn for the empty pageant of a name, when slavery flaps her wing, and the sick heart retires to die in lonely wilds, far from the abodes of men. Did the pangs you felt for insulted nobility, the anguish that rent your heart when the gorgeous robes were torn off the idol human weakness had set up, deserve to be compared with the long-drawn sigh of melancholy reflection, when misery and vice are thus seen to haunt our steps, and swim on the top of every cheering prospect? Why is our fancy to be appalled by terrific perspectives of a hell beyond the grave?*—Hell stalks abroad;—the lash resounds on the slave's naked sides; and the sick wretch, who can no longer earn the sour bread of unremitting labour, steals to a ditch to bid the world a long good night—or, neglected in some ostentatious hospital, breathes his last amidst the laugh of mercenary attendants.

Such misery demands more than tears—I pause to recollect myself; and smother the contempt I feel rising for your rhetorical flourishes and infantine sensibility.

— — — — — — — — — — — —

— — — — — — — — — — — —

Taking a retrospective view of my hasty answer, and casting a cursory glance over your *Reflections*, I perceive that I have not alluded to several reprehensible passages, in your elaborate work; which I marked for censure when I first perused it with a steady eye. And now I find it almost impossible candidly to refute your sophisms, without quoting your own words, and putting the numerous contradictions I observed in opposition to each other. This would be an effectual refutation; but, after such a tedious drudgery, I fear I

[1] The 6th of October.

should only be read by the patient eye that scarcely wanted my assistance to detect the flagrant errors. It would be a tedious process to shew, that often the most just and forcible illustrations are warped to colour over opinions *you* must *sometimes* have secretly despised; or, at least, have discovered, that what you asserted without limitation, required the greatest. Some subjects of exaggeration may have been superficially viewed: depth of judgment is, perhaps, incompatible with the predominant features of your mind. Your reason may have often been the dupe of your imagination; but say, did you not sometimes angrily bid her be still, when she whispered that you were departing from strict truth? Or, when assuming the awful form of conscience, and only smiling at the vagaries of vanity, did she not austerely bid you recollect your own errors, before you lifted the avenging stone? Did she not sometimes wave her hand, when you poured forth a torrent of shining sentences, and beseech you to concatenate them—plainly telling you that the impassioned eloquence of the heart was calculated rather to affect than dazzle the reader, whom it hurried along to conviction? Did she not anticipate the remark of the wise, who drink not at a shallow sparkling stream, and tell you that they would discover when, with the dignity of sincerity, you supported an opinion that only appeared to you with one face; or, when superannuated vanity made you torture your invention?—But I forbear.

I have before animadverted on our method of electing representatives, convinced that it debauches both the morals of the people and the candidates, without rendering the member really responsible, or attached to his constituents; but, amongst your other contradictions, you blame the National Assembly for expecting any exertions from the servile principle of responsibility, and afterwards insult them* for not rendering themselves responsible. Whether the one the French have adopted will answer the purpose better, and be more than a shadow of representation, time only can shew. In theory it appears more promising.*

Your real or artificial affection for the English constitution seems to me to resemble the brutal affection of some weak characters. They think it a duty to love their relations with a blind, indolent tenderness, that *will not* see the faults it might assist to correct, if their affection had been built on rational grounds. They love they know not why, and they will love to the end of the chapter.

Is it absolute blasphemy to doubt of the omnipotence of the law, or to suppose that religion might be more pure if there were fewer baits for hypocrites in the church? But our manners, you tell us, are drawn from the French, though you had before celebrated our native plainness.[1] If they were, it is time we broke loose from dependance—Time that Englishmen drew water from their own springs; for, if manners are not a painted substitute for morals, we have only to cultivate our reason, and we shall not feel the want of an arbitrary model. Nature will suffice; but I forget myself:—Nature and Reason, according to your system, are all to give place to authority; and the gods, as Shakespeare makes a frantic wretch exclaim,* seem to kill us for their sport, as men do flies.

Before I conclude my cursory remarks, it is but just to acknowledge that I coincide with you in your opinion respecting the *sincerity* of many modern philosophers.* Your consistency in avowing a veneration for rank and riches deserves praise; but I must own that I have often indignantly observed that some of the *enlightened* philosophers, who talk most vehemently of the native rights of men, borrow many noble sentiments to adorn their conversation, which have no influence on their conduct. They bow down to rank, and are careful to secure property; for virtue, without this adventitious drapery, is seldom very respectable in their eyes—nor are they very quick-sighted to discern real dignity of character when no sounding name exalts the man above his elbows.—But neither open enmity nor hollow homage destroys the intrinsic value of those principles which rest on an eternal foundation, and revert for a standard to the immutable attributes of God.

[1] Page 118. 'It is not clear, whether in England we learned those grand and decorous principles, and manners, of which considerable traces yet remain, from you, or whether you took them from us. But to you, I think, we trace them best. You seem to me to be—*gentis incunabula nostrae*. France has always more or less influenced manners in England; and when your fountain is choaked up and polluted, the stream will not run long, or not run clear with us, or perhaps with any nation. This gives all Europe, in my opinion, but too close and connected a concern in what is done in France.'

A Vindication of
the Rights of Woman

TO M. TALLEYRAND-PÉRIGORD*
LATE BISHOP OF AUTUN

Sir,

Having read with great pleasure a pamphlet* which you have lately published. I dedicate this volume to you; to induce you to reconsider the subject, and maturely weigh what I have advanced respecting the rights of woman and national education: and I call with the firm tone of humanity;* for my arguments, Sir, are dictated by a disinterested spirit—I plead for my sex—not for myself. Independence I have long considered as the grand blessing of life, the basis of every virtue—and independence I will ever secure by contracting my wants, though I were to live on a barren heath.

It is then an affection for the whole human race that makes my pen dart rapidly along to support what I believe to be the cause of virtue: and the same motive leads me earnestly to wish to see woman placed in a station in which she would advance, instead of retarding, the progress of those glorious principles that give a substance to morality. My opinion, indeed, respecting the rights and duties of woman, seems to flow so naturally from these simple principles, that I think it scarcely possible, but that some of the enlarged minds who formed your admirable constitution,* will coincide with me.

In France there is undoubtedly a more general diffusion of knowledge than in any part of the European world, and I attribute it, in a great measure, to the social intercourse which has long subsisted between the sexes. It is true, I utter my sentiments with freedom, that in France the very essence of sensuality has been extracted to regale the voluptuary, and a kind of sentimental lust has prevailed, which, together with the system of duplicity that the whole tenour of their political and civil government taught, have given a sinister sort of sagacity to the French character, properly termed finesse; from which naturally flow a polish of manners that injures the substance, by hunting sincerity out of society.—And, modesty, the fairest garb of virtue! has been more grossly insulted in France than even in England, till their women have treated as *prudish* that attention to decency, which brutes instinctively observe.

Manners and morals are so nearly allied that they have often been confounded; but, though the former should only be the natural reflection of the latter, yet, when various causes have produced factitious and corrupt manners, which are very early caught, morality becomes an empty name. The personal reserve, and sacred respect for cleanliness and delicacy in domestic life, which French women almost despise, are the graceful pillars of modesty; but, far from despising them, if the pure flame of patriotism have reached their bosoms, they should labour to improve the morals of their fellow-citizens, by teaching men, not only to respect modesty in women, but to acquire it themselves, as the only way to merit their esteem.

Contending for the rights of woman, my main argument is built on this simple principle, that if she be not prepared by education to become the companion of man, she will stop the progress of knowledge and virtue; for truth must be common to all, or it will be inefficacious with respect to its influence on general practice. And how can woman be expected to co-operate unless she know why she ought to be virtuous? unless freedom strengthen her reason till she comprehend her duty, and see in what manner it is connected with her real good? If children are to be educated to understand the true principle of patriotism, their mother must be a patriot; and the love of mankind, from which an orderly train of virtues spring, can only be produced by considering the moral and civil interest of mankind; but the education and situation of woman, at present, shuts her out from such investigations.

In this work I have produced many arguments, which to me were conclusive, to prove that the prevailing notion respecting a sexual character was subversive of morality, and I have contended, that to render the human body and mind more perfect, chastity must more universally prevail, and that chastity will never be respected in the male world till the person of a woman is not, as it were, idolized, when little virtue or sense embellish it with the grand traces of mental beauty, or the interesting simplicity of affection.

Consider, Sir, dispassionately, these observations—for a glimpse of this truth seemed to open before you when you observed, 'that to see one half of the human race excluded by the other from all participation of government, was a political phaenomenon that, according to abstract principles, it was impossible to explain.'* If so,

on what does your constitution rest? If the abstract rights of man will bear discussion and explanation, those of woman, by a parity of reasoning, will not shrink from the same test: though a different opinion prevails in this country, built on the very arguments which you use to justify the oppression of woman—prescription.

Consider, I address you as a legislator, whether, when men contend for their freedom, and to be allowed to judge for themselves respecting their own happiness, it be not inconsistent and unjust to subjugate women, even though you firmly believe that you are acting in the manner best calculated to promote their happiness? Who made man the exclusive judge, if woman partake with him the gift of reason?

In this style, argue tyrants of every denomination, from the weak king to the weak father of a family; they are all eager to crush reason; yet always assert that they usurp its throne only to be useful. Do you not act a similar part, when you *force* all women, by denying them civil and political rights, to remain immured in their families groping in the dark? for surely, Sir, you will not assert, that a duty can be binding which is not founded on reason? If indeed this be their destination, arguments may be drawn from reason: and thus augustly supported, the more understanding women acquire, the more they will be attached to their duty—comprehending it—for unless they comprehend it, unless their morals be fixed on the same immutable principle as those of man, no authority can make them discharge it in a virtuous manner. They may be convenient slaves, but slavery will have its constant effect, degrading the master and the abject dependent.

But, if women are to be excluded, without having a voice, from a participation of the natural rights of mankind, prove first, to ward off the charge of injustice and inconsistency, that they want reason—else this flaw in your NEW CONSTITUTION* will ever shew that man must, in some shape, act like a tyrant, and tyranny, in whatever part of society it rears its brazen front, will ever undermine morality.

I have repeatedly asserted, and produced what appeared to me irrefragable arguments drawn from matters of fact, to prove my assertion, that women cannot, by force, be confined to domestic concerns; for they will, however ignorant, intermeddle with more weighty affairs, neglecting private duties only to disturb, by cun-

ning tricks, the orderly plans of reason which rise above their comprehension.

Besides, whilst they are only made to acquire personal accomplishments, men will seek for pleasure in variety, and faithless husbands will make faithless wives; such ignorant beings, indeed, will be very excusable when, not taught to respect public good, nor allowed any civil rights, they attempt to do themselves justice by retaliation.

The box of mischief thus opened in society, what is to preserve private virtue, the only security of public freedom and universal happiness?

Let there be then no coercion *established* in society, and the common law of gravity prevailing, the sexes will fall into their proper places. And, now that more equitable laws are forming your citizens, marriage may become more sacred: your young men may choose wives from motives of affection, and your maidens allow love to root out vanity.

The father of a family will not then weaken his constitution and debase his sentiments, by visiting the harlot, nor forget, in obeying the call of appetite, the purpose for which it was implanted. And, the mother will not neglect her children to practise the arts of coquetry, when sense and modesty secure her the friendship of her husband.

But, till men become attentive to the duty of a father, it is vain to expect women to spend that time in their nursery which they, 'wise in their generation,'* choose to spend at their glass; for this exertion of cunning is only an instinct of nature to enable them to obtain indirectly a little of that power of which they are unjustly denied a share: for, if women are not permitted to enjoy legitimate rights, they will render both men and themselves vicious, to obtain illicit privileges.

I wish, Sir, to set some investigations of this kind afloat in France; and should they lead to a confirmation of my principles, when your constitution is revised the Rights of Woman may be respected, if it be fully proved that reason calls for this respect, and loudly demands JUSTICE for one half of the human race.

 I am, Sir,
 Your's respectfully,

 M.W.

ADVERTISEMENT

When I began to write this work, I divided it into three parts, supposing that one volume would contain a full discussion of the arguments which seemed to me to rise naturally from a few simple principles; but fresh illustrations ocurring as I advanced, I now present only the first part to the public.

Many subjects, however, which I have cursorily alluded to, call for particular investigation, especially the laws relative to women, and the consideration of their peculiar duties. These will furnish ample matter for a second volume,* which in due time will be published, to elucidate some of the sentiments, and complete many of the sketches begun in the first.

INTRODUCTION

After considering the historic page, and viewing the living world with anxious solicitude, the most melancholy emotions of sorrowful indignation have depressed my spirits, and I have sighed when obliged to confess, that either nature has made a great difference between man and man, or that the civilization which has hitherto taken place in the world has been very partial. I have turned over various books written on the subject of education, and patiently observed the conduct of parents and the management of schools; but what has been the result?—a profound conviction that the neglected education of my fellow-creatures is the grand source of the misery I deplore; and that women, in particular, are rendered weak and wretched by a variety of concurring causes, originating from one hasty conclusion. The conduct and manners of women, in fact, evidently prove that their minds are not in a healthy state; for, like the flowers which are planted in too rich a soil, strength and useful-ness are sacrificed to beauty; and the flaunting leaves, after having pleased a fastidious eye, fade, disregarded on the stalk, long before the season when they ought to have arrived at maturity.—One cause of this barren blooming I attribute to a false system of education, gathered from the books written on this subject by men who, con-sidering females rather as women than human creatures, have been more anxious to make them alluring mistresses than affectionate wives and rational mothers; and the understanding of the sex has been so bubbled by this specious homage, that the civilized women of the present century, with a few exceptions, are only anxious to inspire love, when they ought to cherish a nobler ambition, and by their abilities and virtues exact respect.

In a treatise, therefore, on female rights and manners, the works which have been particularly written for their improvement must not be overlooked; especially when it is asserted, in direct terms, that the minds of women are enfeebled by false refinement; that the books of instruction, written by men of genius, have had the same tendency as more frivolous productions; and that, in the true style of Mahometanism,* they are treated as a kind of subordinate beings,* and not as a part of the human species, when improveable reason is

allowed to be the dignified distinction which raises men above the brute creation, and puts a natural sceptre in a feeble hand.

Yet, because I am a woman, I would not lead my readers to suppose that I mean violently to agitate the contested question respecting the equality or inferiority of the sex; but as the subject lies in my way, and I cannot pass it over without subjecting the main tendency of my reasoning to misconstruction, I shall stop a moment to deliver, in a few words, my opinion.—In the government of the physical world it is observable that the female in point of strength is, in general, inferior to the male. This is the law of nature; and it does not appear to be suspended or abrogated in favour of woman. A degree of physical superiority* cannot, therefore, be denied—and it is a noble prerogative! But not content with this natural pre-eminence, men endeavour to sink us still lower, merely to render us alluring objects for a moment; and women, intoxicated by the adoration which men, under the influence of their senses, pay them, do not seek to obtain a durable interest in their hearts, or to become the friends of the fellow creatures who find amusement in their society.

I am aware of an obvious inference:—from every quarter have I heard exclamations against masculine women; but where are they to be found? If by this appellation men mean to inveigh against their ardour in hunting, shooting, and gaming, I shall most cordially join in the cry; but if it be against the imitation of manly virtues, or, more properly speaking, the attainment of those talents and virtues, the exercise of which ennobles the human character, and which raise females in the scale of animal being, when they are comprehensively termed mankind;—all those who view them with a philosophic eye must, I should think, wish with me, that they may every day grow more and more masculine.

This discussion naturally divides the subject. I shall first consider women in the grand light of human creatures, who, in common with men, are placed on this earth to unfold their faculties; and afterwards I shall more particularly point out their peculiar designation.

I wish also to steer clear of an error which many respectable writers have fallen into; for the instruction which has hitherto been addressed to women, has rather been applicable to *ladies*, if the little indirect advice, that is scattered through Sandford and Merton,* be excepted; but, addressing my sex in a firmer tone, I pay particular attention to those in the middle class, because they appear to be in

the most natural state. Perhaps the seeds of false refinement, immorality, and vanity, have ever been shed by the great. Weak, artificial beings, raised above the common wants and affections of their race, in a premature unnatural manner, undermine the very foundation of virtue, and spread corruption through the whole mass of society! As a class of mankind they have the strongest claim to pity; the education of the rich tends to render them vain and helpless, and the unfolding mind is not strengthened by the practice of those duties which dignify the human character.—They only live to amuse themselves, and by the same law which in nature invariably produces certain effects, they soon only afford barren amusement.

But as I purpose taking a separate view of the different ranks of society, and of the moral character of women, in each, this hint is, for the present, sufficient; and I have only alluded to the subject, because it appears to me to be the very essence of an introduction to give a cursory account of the contents of the work it introduces.

My own sex, I hope, will excuse me, if I treat them like rational creatures, instead of flattering their *fascinating* graces, and viewing them as if they were in a state of perpetual childhood, unable to stand alone. I earnestly wish to point out in what true dignity and human happiness consists—I wish to persuade women to endeavour to acquire strength, both of mind and body, and to convince them that the soft phrases, susceptibility of heart, delicacy of sentiment, and refinement of taste, are almost synonymous with epithets of weakness, and that those beings who are only the objects of pity and that kind of love, which has been termed its sister, will soon become objects of contempt.

Dismissing then those pretty feminine phrases, which the men condescendingly use to soften our slavish dependence, and despising that weak elegancy of mind, exquisite sensibility, and sweet docility of manners, supposed to be the sexual characteristics of the weaker vessel, I wish to shew that elegance is inferior to virtue, that the first object of laudable ambition is to obtain a character as a human being, regardless of the distinction of sex; and that secondary views should be brought to this simple touchstone.

This is a rough sketch of my plan; and should I express my conviction with the energetic emotions that I feel whenever I think of the subject, the dictates of experience and reflection will be felt by some of my readers. Animated by this important object, I shall

disdain to cull my phrases or polish my style;—I aim at being useful, and sincerity will render me unaffected; for, wishing rather to persuade by the force of my arguments, than dazzle by the elegance of my language, I shall not waste my time in rounding periods, or in fabricating the turgid bombast of artificial feelings, which, coming from the head, never reach the heart.—I shall be employed about things, not words!—and, anxious to render my sex more respectable members of society, I shall try to avoid that flowery diction which has slided from essays into novels, and from novels into familiar letters and conversation.

These pretty superlatives,* dropping glibly from the tongue, vitiate the taste, and create a kind of sickly delicacy that turns away from simple unadorned truth; and a deluge of false sentiments and overstretched feelings, stifling the natural emotions of the heart, render the domestic pleasures insipid, that ought to sweeten the exercise of those severe duties, which educate a rational and immortal being for a nobler field of action.

The education of women has, of late, been more attended to than formerly; yet they are still reckoned a frivolous sex, and ridiculed or pitied by the writers who endeavour by satire or instruction to improve them. It is acknowledged that they spend many of the first years of their lives in acquiring a smattering of accomplishments; meanwhile strength of body and mind are sacrificed to libertine notions of beauty, to the desire of establishing themselves,—the only way women can rise in the world,—by marriage. And this desire making mere animals of them, when they marry they act as such children may be expected to act:—they dress; they paint, and nickname God's creatures.—Surely these weak beings are only fit for a seraglio!* Can they be expected to govern a family with judgment, or take care of the poor babes whom they bring into the world?

If then it can be fairly deduced from the present conduct of the sex, from the prevalent fondness for pleasure which takes place of ambition and those nobler passions that open and enlarge the soul; that the instruction which women have hitherto received has only tended, with the constitution of civil society, to render them insignificant objects of desire—mere propagators of fools!—if it can be proved that in aiming to accomplish them, without cultivating their understandings, they are taken out of their sphere of duties, and

made ridiculous and useless when the short-lived bloom of beauty is over,[1] I presume that *rational* men will excuse me for endeavouring to persuade them to become more masculine and respectable.

Indeed the word masculine is only a bugbear: there is little reason to fear that women will acquire too much courage or fortitude; for their apparent inferiority with respect to bodily strength, must render them, in some degree, dependent on men in the various relations of life; but why should it be increased by prejudices that give a sex to virtue, and confound simple truths with sensual reveries?

Women are, in fact, so much degraded by mistaken notions of female excellence, that I do not mean to add a paradox when I assert, that this artificial weakness produces a propensity to tyrannize, and gives birth to cunning, the natural opponent of strength, which leads them to play off those contemptible infantine airs that undermine esteem even whilst they excite desire. Let men become more chaste and modest, and if women do not grow wiser in the same ratio, it will be clear that they have weaker understandings.* It seems scarcely necessary to say, that I now speak of the sex in general. Many individuals have more sense than their male relatives; and, as nothing preponderates where there is a constant struggle for an equilibrium, without it has naturally more gravity, some women govern their husbands without degrading themselves, because intellect will always govern.

[1] A lively writer, I cannot recollect his name, asks what business women turned of forty have to do in the world?

CHAPTER I

THE RIGHTS AND INVOLVED DUTIES OF
MANKIND CONSIDERED

In the present state of society it appears necessary to go back to first principles in search of the most simple truths, and to dispute with some prevailing prejudice every inch of ground. To clear my way, I must be allowed to ask some plain questions, and the answers will probably appear as unequivocal as the axioms on which reasoning is built; though, when entangled with various motives of action, they are formally contradicted, either by the words or conduct of men.

In what does man's pre-eminence over the brute creation consist? The answer is as clear as that a half is less than the whole; in Reason.

What acquirement exalts one being above another? Virtue; we spontaneously reply. *living in accord w̄ the moral law*

For what purpose were the passions implanted? That man by struggling with them might attain a degree of knowledge denied to the brutes; whispers Experience.

Consequently the perfection of our nature and capability of happiness, must be estimated by the degree of reason, virtue, and knowledge, that distinguish the individual, and direct the laws which bind society: and that from the exercise of reason, knowledge and virtue naturally flow, is equally undeniable, if mankind be viewed collectively.

The rights and duties of man thus simplified, it seems almost impertinent to attempt to illustrate truths that appear so incontrovertible; yet such deeply rooted prejudices have clouded reason, and such spurious qualities have assumed the name of virtues, that it is necessary to pursue the course of reason as it has been perplexed and involved in error, by various adventitious circumstances, comparing the simple axiom with casual deviations. Men, in general, seem to employ their reason to justify prejudices, which they have imbibed, they can scarcely trace how, rather than to root them out. The mind must be strong that resolutely forms its own principles; for a kind of intellectual cowardice prevails which makes many men shrink from

the task, or only do it by halves. Yet the imperfect conclusions thus drawn, are frequently very plausible, because they are built on partial experience, on just, though narrow, views.

Going back to first principles, vice skulks, with all its native deformity, from close investigation; but a set of shallow reasoners are always exclaiming that these arguments prove too much, and that a measure rotten at the core may be expedient. Thus expediency is continually contrasted with simple principles, till truth is lost in a mist of words; virtue, in forms, and knowledge rendered a sounding nothing, by the specious prejudices that assume its name.

That the society is formed in the wisest manner, whose constitution is founded on the nature of man, strikes, in the abstract, every thinking being so forcibly, that it looks like presumption to endeavour to bring forward proofs; though proof must be brought, or the strong hold of prescription will never be forced by reason; yet to urge prescription as an argument to justify the depriving men (or women) of their natural rights, is one of the absurd sophisms which daily insult common sense.

The civilization of the bulk of the people of Europe is very partial; nay, it may be made a question, whether they have acquired any virtues in exchange for innocence, equivalent to the misery produced by the vices that have been plastered over unsightly ignorance, and the freedom which has been bartered for splendid slavery. The desire of dazzling by riches, the most certain preeminence that man can obtain, the pleasure of commanding flattering sycophants, and many other complicated low calculations of doting self-love, have all contributed to overwhelm the mass of mankind, and make liberty a convenient handle for mock patriotism. For whilst rank and titles are held of the utmost importance, before which Genius 'must hide its diminished head,'* it is, with a few exceptions, very unfortunate for a nation when a man of abilities, without rank or property, pushes himself forward to notice.—Alas! what unheard of misery have thousands suffered to purchase a cardinal's hat for an intriguing obscure adventurer, who longed to be ranked with princes, or lord it over them by seizing the triple crown!*

Such, indeed, has been the wretchedness that has flowed from hereditary honours, riches, and monarchy, that men of lively sensi-

bility have almost uttered blasphemy in order to justify the dispensations of providence. Man has been held out as independent of his power who made him, or as a lawless planet darting from its orbit to steal the celestial fire of reason; and the vengeance of heaven, lurking in the subtile flame, like Pandora's pent up mischiefs,* sufficiently punished his temerity, by introducing evil into the world.

Impressed by this view of the misery and disorder which pervaded society, and fatigued with jostling against artificial fools, Rousseau became enamoured of solitude,* and, being at the same time an optimist, he labours with uncommon eloquence to prove that man was naturally a solitary animal. Misled by his respect for the goodness of God, who certainly—for what man of sense and feeling can doubt it!—gave life only to communicate happiness, he considers evil as positive, and the work of man; not aware that he was exalting one attribute at the expence of another, equally necessary to divine perfection.

Reared on a false hypothesis his arguments in favour of a state of nature are plausible, but unsound. I say unsound; for to assert that a state of nature is preferable to civilization, in all its possible perfection, is, in other words, to arraign supreme wisdom; and the paradoxical exclamation, that God has made all things right, and that error has been introduced by the creature,* whom he formed, knowing what he formed, is as unphilosophical as impious.

When that wise Being who created us and placed us here, saw the fair idea, he willed, by allowing it to be so, that the passions should unfold our reason, because he could see that present evil would produce future good. Could the helpless creature whom he called from nothing break loose from his providence, and boldly learn to know good by practising evil, without his permission? No.—How could that energetic advocate for immortality argue so inconsistently? Had mankind remained for ever in the brutal state of nature, which even his magic pen cannot paint as a state in which a single virtue took root, it would have been clear, though not to the sensitive unreflecting wanderer, that man was born to run the circle of life and death, and adorn God's garden for some purpose which could not easily be reconciled with his attributes.

But if, to crown the whole, there were to be rational creatures produced, allowed to rise in excellence by the exercise of powers implanted for that purpose; if benignity itself thought fit to call into

existence a creature above the brutes,[1] who could think and improve himself, why should that inestimable gift, for a gift it was, if man was so created as to have a capacity to rise above the state in which sensation produced brutal ease, be called, in direct terms, a curse? A curse it might be reckoned, if the whole of our existence were bounded by our continuance in this world; for why should the gracious fountain of life give us passions, and the power of reflecting, only to imbitter our days and inspire us with mistaken notions of dignity? Why should he lead us from love of ourselves to the sublime emotions which the discovery of his wisdom and goodness excites, if these feelings were not set in motion to improve our nature, of which they make a part,[2] and render us capable of enjoying a more godlike portion of happiness? Firmly persuaded that no evil exists in the world that God did not design to take place, I build my belief on the perfection of God.

Rousseau exerts himself to prove that all *was* right originally: a crowd of authors that all *is* now right: and I, that all will *be* right.

But, true to his first position, next to a state of nature, Rousseau celebrates barbarism, and apostrophizing the shade of Fabricius, he forgets that, in conquering the world, the Romans never dreamed of establishing their own liberty on a firm basis, or of extending the reign of virtue. Eager to support his system, he stigmatizes, as vicious, every effort of genius; and, uttering the apotheosis of savage virtues, he exalts those to demi-gods, who were scarcely human— the brutal Spartans,* who, in defiance of justice and gratitude, sacrificed, in cold blood, the slaves who had shewn themselves heroes to rescue their oppressors.

Disgusted with artificial manners and virtues, the citizen of Geneva,* instead of properly sifting the subject, threw away the wheat

[1] Contrary to the opinion of anatomists, who argue by analogy from the formation of the teeth, stomach, and intestines, Rousseau will not allow a man to be a carnivorous animal. And, carried away from nature by a love of system, he disputes* whether man be a gregarious animal, though the long and helpless state of infancy seems to point him out as particularly impelled to pair, the first step towards herding.

[2] What would you say to a mechanic whom you had desired to make a watch to point out the hour of the day, if, to shew his ingenuity, he added wheels to make it a repeater, etc. that perplexed the simple mechanism; should he urge, to excuse himself—had you not touched a certain spring, you would have known nothing of the matter, and that he should have amused himself by making *an experiment* without doing you any harm: would you not retort fairly upon him, by insisting that if he had not added those needless wheels and springs, the accident could not have happened?

with the chaff, without waiting to inquire whether the evils which his ardent soul turned from indignantly, were the consequence of civilization or the vestiges of barbarism. He saw vice trampling on virtue, and the semblance of goodness taking place of the reality; he saw talents bent by power to sinister purposes, and never thought of tracing the gigantic mischief up to arbitrary power, up to the hereditary distinctions that clash with the mental superiority that naturally raises a man above his fellows. He did not perceive that regal power, in a few generations, introduces idiotism into the noble stem, and holds out baits to render thousands idle and vicious.

Nothing can set the regal character in a more contemptible point of view, than the various crimes that have elevated men to the supreme dignity.—Vile intrigues, unnatural crimes, and every vice that degrades our nature, have been the steps to this distinguished eminence; yet millions of men have supinely allowed the nerveless limbs of the posterity of such rapacious prowlers to rest quietly on their ensanguined thrones.[1]

What but a pestilential vapour can hover over society when its chief director is only instructed in the invention of crimes, or the stupid routine of childish ceremonies? Will men never be wise?—will they never cease to expect corn from tares, and figs from thistles?*

It is impossible for any man, when the most favourable circumstances concur, to acquire sufficient knowledge and strength of mind to discharge the duties of a king, entrusted with uncontrouled power; how then must they be violated when his very elevation is an insuperable bar to the attainment of either wisdom or virtue; when all the feelings of a man are stifled by flattery, and reflection shut out by pleasure! Surely it is madness to make the fate of thousands depend on the caprice of a weak fellow creature, whose very station sinks him *necessarily* below the meanest of his subjects! But one power should not be thrown down to exalt another—for all power inebriates weak man; and its abuse proves that the more equality there is established among men, the more virtue and happiness will reign in society. But this and any similar maxim deduced from simple reason, raises an outcry—the church or the state is in danger,

[1] Could there be a greater insult offered to the rights of man than the beds of justice in France, when an infant was made the organ of the detestable Dubois!*

if faith in the wisdom of antiquity is not implicit; and they who, roused by the sight of human calamity, dare to attack human authority, are reviled as despisers of God, and enemies of man. These are bitter calumnies, yet they reached one of the best of men,[1] whose ashes still preach peace, and whose memory demands a respectful pause, when subjects are discussed that lay so near his heart.——

After attacking the sacred majesty of Kings, I shall scarcely excite surprise by adding my firm persuasion that every profession, in which great subordination of rank constitutes its power, is highly injurious to morality.

A standing army, for instance, is incompatible with freedom; because subordination and rigour are the very sinews of military discipline; and despotism is necessary to give vigour to enterprizes that one will directs. A spirit inspired by romantic notions of honour, a kind of morality founded on the fashion of the age, can only be felt by a few officers, whilst the main body must be moved by command, like the waves of the sea; for the strong wind of authority pushes the crowd of subalterns forward, they scarcely know or care why, with headlong fury.

Besides, nothing can be so prejudicial to the morals of the inhabitants of country towns as the occasional residence of a set of idle superficial young men, whose only occupation is gallantry, and whose polished manners render vice more dangerous, by concealing its deformity under gay ornamental drapery. An air of fashion, which is but a badge of slavery, and proves that the soul has not a strong individual character, awes simple country people into an imitation of the vices, when they cannot catch the slippery graces, of politeness. Every corps is a chain of despots, who, submitting and tyrannizing without exercising their reason, become dead weights of vice and folly on the community. A man of rank or fortune, sure of rising by interest, has nothing to do but to pursue some extravagant freak; whilst the needy *gentleman*, who is to rise, as the phrase turns, by his merit, becomes a servile parasite or vile pander.

Sailors, the naval gentlemen, come under the same description, only their vices assume a different and grosser cast. They are more positively indolent, when not discharging the ceremonials of their station; whilst the insignificant fluttering of soldiers may be termed

[1] Dr Price.*

active idleness. More confined to the society of men, the former acquire a fondness for humour and mischievous tricks; whilst the latter, mixing frequently with well-bred women, catch a sentimental cant.—But mind is equally out of the question, whether they indulge the horse-laugh, or polite simper.

May I be allowed to extend the comparison to a profession where more mind is certainly to be found; for the clergy have superior opportunities of improvement, though subordination almost equally cramps their faculties? The blind submission imposed at college to forms of belief serves as a novitiate to the curate, who must obsequiously respect the opinion of his rector or patron, if he mean to rise in his profession. Perhaps there cannot be a more forcible contrast than between the servile dependent gait of a poor curate and the courtly mien of a bishop. And the respect and contempt they inspire render the discharge of their separate functions equally useless.

It is of great importance to observe that the character of every man is, in some degree, formed by his profession. A man of sense may only have a cast of countenance that wears off as you trace his individuality, whilst the weak, common man has scarcely ever any character, but what belongs to the body; at least, all his opinions have been so steeped in the vat consecrated by authority, that the faint spirit which the grape of his own vine yields cannot be distinguished.

Society, therefore, as it becomes more enlightened, should be very careful not to establish bodies of men who must necessarily be made foolish or vicious by the very constitution of their profession.

In the infancy of society, when men were just emerging out of barbarism, chiefs and priests, touching the most powerful springs of savage conduct, hope and fear, must have had unbounded sway. An aristocracy, of course, is naturally the first form of government. But, clashing interests soon losing their equipoise, a monarchy and hierarchy break out of the confusion of ambitious struggles, and the foundation of both is secured by feudal tenures. This appears to be the origin of monarchical and priestly power, and the dawn of civilization. But such combustible materials cannot long be pent up; and, getting vent in foreign wars and intestine insurrections, the people acquire some power in the tumult, which obliges their rulers to gloss over their oppression with a shew of right. Thus, as wars,

agriculture, commerce, and literature, expand the mind, despots are compelled, to make covert corruption hold fast the power which was formerly snatched by open force.[1] And this baneful lurking gangrene is most quickly spread by luxury and superstition, the sure dregs of ambition. The indolent puppet of a court first becomes a luxurious monster, or fastidious sensualist, and then makes the contagion which his unnatural state spread, the instrument of tyranny.

It is the pestiferous purple which renders the progress of civilization a curse, and warps the understanding, till men of sensibility doubt whether the expansion of intellect produces a greater portion of happiness or misery. But the nature of the poison points out the antidote; and had Rousseau mounted one step higher* in his investigation, or could his eye have pierced through the foggy atmosphere, which he almost disdained to breathe, his active mind would have darted forward to contemplate the perfection of man in the establishment of true civilization, instead of taking his ferocious flight back to the night of sensual ignorance.

[1] Men of abilities scatter seeds that grow up and have a great influence on the forming opinion; and when once the public opinion preponderates, through the exertion of reason, the overthrow of arbitrary power is not very distant.

To account for, and excuse the tyranny of man, many ingenious arguments have been brought forward to prove, that the two sexes, in the acquirement of virtue, ought to aim at attaining a very different character: or, to speak explicitly, women are not allowed to have sufficient strength of mind to acquire what really deserves the name of virtue. Yet it should seem, allowing them to have souls, that there is but one way appointed by Providence to lead *mankind* to either virtue or happiness.

If then women are not a swarm of ephemeron triflers, why should they be kept in ignorance under the specious name of innocence? Men complain, and with reason, of the follies and caprices of our sex, when they do not keenly satirize our headstrong passions and groveling vices.—Behold, I should answer, the natural effect of ignorance! The mind will ever be unstable that has only prejudices to rest on, and the current will run with destructive fury when there are no barriers to break its force. Women are told from their infancy, and taught by the example of their mothers, that a little knowledge of human weakness, justly termed cunning, softness or temper, *outward* obedience, and a scrupulous attention to a puerile kind of propriety, will obtain for them the protection of man; and should they be beautiful, every thing else is needless, for, at least, twenty years of their lives.

Thus Milton describes our first frail mother; though when he tells us that women are formed for softness and sweet attractive grace, I cannot comprehend his meaning, unless, in the true Mahometan strain,* he meant to deprive us of souls, and insinuate that we were beings only designed by sweet attractive grace, and docile blind obedience, to gratify the senses of man when he can no longer soar on the wing of contemplation.*

How grossly do they insult us who thus advise us only to render ourselves gentle, domestic brutes! For instance, the winning softness so warmly, and frequently, recommended, that governs by

obeying. What childish expression, and how insignificant is the being—can it be an immortal one? who will condescend to govern by such sinister methods! 'Certainly,' says Lord Bacon, 'man is of kin to the beasts by his body; and if he be not of kin to God by his spirit, he is a base and ignoble creature!'* Men, indeed, appear to me to act in a very unphilosophical manner when they try to secure the good conduct of women by attempting to keep them always in a state of childhood. Rousseau was more consistent when he wished to stop the progress of reason in both sexes, for if men eat of the tree of knowledge, women will come in for a taste; but, from the imperfect cultivation which their understandings now receive, they only attain a knowledge of evil.

Children, I grant, should be innocent; but when the epithet is applied to men, or women, it is but a civil term for weakness. For if it be allowed that women were destined by Providence to acquire human virtues, and by the exercise of their understandings, that stability of character which is the firmest ground to rest our future hopes upon, they must be permitted to turn to the fountain of light, and not forced to shape their course by the twinkling of a mere satellite. Milton, I grant, was of a very different opinion; for he only bends to the indefeasible right of beauty, though it would be difficult to render two passages which I now mean to contrast, consistent. But into similar inconsistencies are great men often led by their senses.

> 'To whom thus Eve with *perfect beauty* adorn'd.
> My Author and Disposer, what thou bidst
> *Unargued* I obey; so God ordains;
> God is *thy law, thou mine:* to know no more
> Is Woman's *happiest* knowledge and her *praise.*'*

These are exactly the arguments that I have used to children; but I have added, your reason is now gaining strength, and, till it arrives at some degree of maturity, you must look up to me for advice— then you ought to *think*, and only rely on God.

Yet in the following lines Milton seems to coincide with me; when he makes Adam thus expostulate with his Maker.

> 'Hast thou not made me here thy substitute,
> And these inferior far beneath me set?

> Among *unequals* what society
> Can sort, what harmony or true delight?
> Which must be mutual, in proportion due
> Giv'n and receiv'd; but in *disparity*
> The one intense, the other still remiss
> Cannot well suit with either, but soon prove
> Tedious alike: of *fellowship* I speak
> Such as I seek, fit to participate
> All rational delight—'*

In treating, therefore, of the manners of women, let us, disregarding sensual arguments, trace what we should endeavour to make them in order to co-operate, if the expression be not too bold, with the supreme Being.

By individual education, I mean, for the sense of the word is not precisely defined, such an attention to a child as will slowly sharpen the senses, form the temper, regulate the passions as they begin to ferment, and set the understanding to work before the body arrives at maturity; so that the man may only have to proceed, not to begin, the important task of learning to think and reason.

To prevent any misconstruction, I must add, that I do not believe that a private education can work the wonders which some sanguine writers have attributed to it. Men and women must be educated, in a great degree, by the opinions and manners of the society they live in. In every age there has been a stream of popular opinion that has carried all before it, and given a family character, as it were, to the century. It may then fairly be inferred, that, till society be differently constituted, much cannot be expected from education. It is, however, sufficient for my present purpose to assert, that, whatever effect circumstances have on the abilities, every being may become virtuous by the exercise of its own reason; for if but one being was created with vicious inclinations, that is positively bad, what can save us from atheism? or if we worship a God, is not that God a devil?

Consequently, the most perfect education, in my opinion, is such an exercise of the understanding as is best calculated to strengthen the body and form the heart. Or, in other words, to enable the individual to attain such habits of virtue as will render it independent. In fact, it is a farce to call any being virtuous whose virtues do not result from the exercise of its own reason. This was Rousseau's

opinion* respecting men: I extend it to women, and confidently assert that they have been drawn out of their sphere by false refinement, and not by an endeavour to acquire masculine qualities. Still the regal homage which they receive is so intoxicating, that till the manners of the times are changed, and formed on more reasonable principles, it may be impossible to convince them that the illegitimate power, which they obtain, by degrading themselves, is a curse, and that they must return to nature and equality, if they wish to secure the placid satisfaction that unsophisticated affections impart. But for this epoch we must wait—wait, perhaps, till kings and nobles, enlightened by reason, and, preferring the real dignity of man to childish state, throw off their gaudy hereditary trappings: and if then women do not resign the arbitrary power of beauty— they will prove that they have *less* mind than man.

I may be accused of arrogance; still I must declare what I firmly believe, that all the writers who have written on the subject of female education and manners from Rousseau to Dr Gregory,* have contributed to render women more artificial, weak characters, than they would otherwise have been; and, consequently, more useless members of society. I might have expressed this conviction in a lower key; but I am afraid it would have been the whine of affectation, and not the faithful expression of my feelings, of the clear result, which experience and reflection have led me to draw. When I come to that division of the subject, I shall advert to the passages that I more particularly disapprove of, in the works of the authors I have just alluded to; but it is first necessary to observe, that my objection extends to the whole purport of those books, which tend, in my opinion, to degrade one half of the human species, and render women pleasing at the expence of every solid virtue.

Though, to reason on Rousseau's ground,* if man did attain a degree of perfection of mind when his body arrived at maturity, it might be proper, in order to make a man and his wife *one*, that she should rely entirely on his understanding; and the graceful ivy, clasping the oak that supported it, would form a whole in which strength and beauty would be equally conspicuous. But, alas! husbands, as well as their helpmates, are often only overgrown children; nay, thanks to early debauchery, scarcely men in their outward form—and if the blind lead the blind, one need not come from heaven to tell us the consequence.

Many are the causes that, in the present corrupt state of society, contribute to enslave women by cramping their understandings and sharpening their senses. One, perhaps, that silently does more mischief than all the rest, is their disregard of order.

To do every thing in an orderly manner, is a most important precept, which women, who, generally speaking, receive only a disorderly kind of education, seldom attend to with that degree of exactness that men, who from their infancy are broken into method, observe. This negligent kind of guesswork, for what other epithet can be used to point out the random exertions of a sort of instinctive common sense, never brought to the test of reason? prevents their generalizing matters of fact—so they do to-day, what they did yesterday, merely because they did it yesterday.

This contempt of the understanding in early life has more baneful consequences than is commonly supposed; for the little knowledge which women of strong minds attain, is, from various circumstances, of a more desultory kind than the knowledge of men, and it is acquired more by sheer observations on real life, than from comparing what has been individually observed with the results of experience generalized by speculation. Led by their dependent situation and domestic employments more into society, what they learn is rather by snatches; and as learning is with them, in general, only a secondary thing, they do not pursue any one branch with that persevering ardour necessary to give vigour to the faculties, and clearness to the judgment. In the present state of society, a little learning is required to support the character of a gentleman; and boys are obliged to submit to a few years of discipline. But in the education of women, the cultivation of the understanding is always subordinate to the acquirement of some corporeal accomplishment; even while enervated by confinement and false notions of modesty, the body is prevented from attaining that grace and beauty which relaxed half-formed limbs never exhibit. Besides, in youth their faculties are not brought forward by emulation; and having no serious scientific study, if they have natural sagacity it is turned too soon on life and manners. They dwell on effects, and modifications, without tracing them back to causes; and complicated rules to adjust behaviour are a weak substitute for simple principles.

As a proof that education gives this appearance of weakness to females, we may instance the example of military men, who are, like

them, sent into the world before their minds have been stored with knowledge or fortified by principles. The consequences are similar; soldiers acquire a little superficial knowledge, snatched from the muddy current of conversation, and, from continually mixing with society, they gain, what is termed a knowledge of the world; and this acquaintance with manners and customs has frequently been confounded with a knowledge of the human heart. But can the crude fruit of casual observation, never brought to the test of judgment, formed by comparing speculation and experience, deserve such a distinction? Soldiers, as well as women, practise the minor virtues with punctilious politeness. Where is then the sexual difference, when the education has been the same? All the difference that I can discern, arises from the superior advantage of liberty, which enables the former to see more of life.

It is wandering from my present subject, perhaps, to make a political remark; but, as it was produced naturally be the train of my reflections, I shall not pass it silently over.

Standing armies can never consist of resolute, robust men; they may be well disciplined machines, but they will seldom contain men under the influence of strong passions, or with very vigorous faculties. And as for any depth of understanding, I will venture to affirm, that it is as rarely to be found in the army as amongst women; and the cause, I maintain, is the same. It may be further observed, that officers are also particularly attentive to their persons, fond of dancing, crowded rooms, adventures, and ridicule.[1] Like the *fair* sex, the business of their lives is gallantry.—They were taught to please, and they only live to please. Yet they do not lose their rank in the distinction of sexes, for they are still reckoned superior to women, though in what their superiority consists, beyond what I have just mentioned, it is difficult to discover.

The great misfortune is this, that they both acquire manners before morals, and a knowledge of life before they have, from reflection, any acquaintance with the grand ideal outline of human nature. The consequence is natural; satisfied with common nature, they become a prey to prejudices, and taking all their opinions on credit,

[1] Why should women be censured with petulant acrimony, because they seem to have a passion for a scarlet coat?* Has not education placed them more on a level with soldiers than any other class of men?

they blindly submit to authority. So that if they have any sense, it is a kind of instinctive glance, that catches proportions, and decides with respect to manners; but fails when arguments are to be pursued below the surface, or opinions analyzed.

May not the same remark be applied to women? Nay, the argument may be carried still further, for they are both thrown out of a useful station by the unnatural distinctions established in civilized life. Riches and hereditary honours have made cyphers of women to give consequence to the numerical figure; and idleness has produced a mixture of gallantry and despotism into society, which leads the very men who are the slaves of their mistresses to tyrannize over their sisters, wives, and daughters. This is only keeping them in rank and file, it is true. Strengthen the female mind by enlarging it, and there will be an end to blind obedience; but, as blind obedience is ever sought for by power, tyrants and sensualists are in the right when they endeavour to keep women in the dark, because the former only want slaves, and the latter a play-thing. The sensualist, indeed, has been the most dangerous of tyrants, and women have been duped by their lovers, as princes by their ministers, whilst dreaming that they reigned over them.

I now principally allude to Rousseau, for his character of Sophia* is, undoubtedly, a captivating one, though it appears to me grossly unnatural; however it is not the superstructure, but the foundation of her character, the principles on which her education was built, that I mean to attack; nay, warmly as I admire the genius of that able writer, whose opinions I shall often have occasion to cite, indignation always takes place of admiration, and the rigid frown of insulted virtue effaces the smile of complacency, which his eloquent periods are wont to raise, when I read his voluptuous reveries. Is this the man, who, in his ardour for virtue, would banish all the soft arts of peace, and almost carry us back to Spartan discipline? Is this the man who delights to paint the useful struggles of passion, the triumphs of good dispositions, and the heroic flights which carry the glowing soul out of itself?—How are these mighty sentiments lowered when he describes the pretty foot and enticing airs of his little favourite! But, for the present, I wave the subject, and, instead of severely reprehending the transient effusions of overweening sensibility, I shall only observe, that whoever has cast a benevolent eye on society, must often have been gratified by the sight of humble

mutual love, not dignified by sentiment, or strengthened by a union in intellectual pursuits. The domestic trifles of the day have afforded matters for cheerful converse, and innocent caresses have softened toils which did not require great exercise of mind or stretch of thought: yet, has not the sight of this moderate felicity excited more tenderness than respect? An emotion similar to what we feel when children are playing, or animals sporting,[1] whilst the contemplation of the noble struggles of suffering merit has raised admiration, and carried our thoughts to that world where sensation will give place to reason.

Women are, therefore, to be considered either as moral beings, or so weak that they must be entirely subjected to the superior faculties of men.

Let us examine this question. Rousseau declares that a woman should never, for a moment, feel herself independent, that she should be governed by fear to exercise her *natural* cunning, and made a coquetish slave in order to render her a more alluring object of desire, a *sweeter* companion to man, whenever he chooses to relax himself. He carries the arguments, which he pretends to draw from the indications of nature, still further,* and insinuates that truth and fortitude, the corner stones of all human virtue, should be cultivated with certain restrictions, because, with respect to the female character, obedience is the grand lesson which ought to be impressed with unrelenting rigour.

What nonsense! when will a great man arise with sufficient strength of mind to puff away the fumes which pride and sensuality have thus spread over the subject! If women are by nature inferior to men, their virtues must be the same in quality, if not in degree, or virtue is a relative idea; consequently, their conduct should be founded on the same principles, and have the same aim.

Connected with man as daughters, wives, and mothers, their moral character may be estimated by their manner of fulfilling those simple duties; but the end, the grand end of their exertions should

[1] Similar feelings has Milton's pleasing picture* of paradisiacal happiness ever raised in my mind; yet, instead of envying the lovely pair, I have, with conscious dignity, or Satanic pride, turned to hell for sublimer objects. In the same style, when viewing some noble monument of human art, I have traced the emanation of the Deity in the order I admired, till, descending from that giddy height, I have caught myself contemplating the grandest of all human sights;—for fancy quickly placed, in some solitary recess, an outcast of fortune, rising superior to passion and discontent.

be to unfold their own faculties and acquire the dignity of conscious virtue. They may try to render their road pleasant; but ought never to forget, in common with man, that life yields not the felicity which can satisfy an immortal soul. I do not mean to insinuate, that either sex should be so lost in abstract reflections or distant views, as to forget the affections and duties that lie before them, and are, in truth, the means appointed to produce the fruit of life; on the contrary, I would warmly recommend them, even while I assert, that they afford most satisfaction when they are considered in their true, sober* light.

Probably the prevailing opinion, that woman was created for man, may have taken its rise from Moses's poetical story;* yet, as very few, it is presumed, who have bestowed any serious thought on the subject, ever supposed that Eve was, literally speaking, one of Adam's ribs, the deduction must be allowed to fall to the ground; or, only be so far admitted as it proves that man, from the remotest antiquity, found it convenient to exert his strength to subjugate his companion, and his invention to shew that she ought to have her neck bent under the yoke, because the whole creation was only created for his convenience or pleasure.*

Let it not be concluded that I wish to invert the order of things; I have already granted, that, from the constitution of their bodies, men seem to be designed by Providence to attain a greater degree of virtue. I speak collectively of the whole sex; but I see not the shadow of a reason to conclude that their virtues should differ in respect to their nature. In fact, how can they, if virtue has only one eternal standard? I must therefore, if I reason consequentially, as strenuously maintain that they have the same simple direction, as that there is a God.

It follows then that cunning should not be opposed to wisdom, little cares to great exertions, or insipid softness, varnished over with the name of gentleness, to that fortitude which grand views alone can inspire.

I shall be told that woman would then lose many of her peculiar graces, and the opinion of a well known poet might be quoted to refute my unqualified assertion. For Pope has said, in the name of the whole male sex,

> 'Yet ne'er so sure our passion to create,
> As when she touch'd the brink of all we hate.'*

In what light this sally places men and women, I shall leave to the judicious to determine; meanwhile I shall content myself with observing, that I cannot discover why, unless they are mortal, females should always be degraded by being made subservient to love or lust.

To speak disrespectfully of love is, I know, high treason against sentiment and fine feelings; but I wish to speak the simple language of truth, and rather to address the head than the heart. To endeavour to reason love out of the world, would be to out Quixote Cervantes,* and equally offend against common sense; but an endeavour to restrain this tumultuous passion, and to prove that it should not be allowed to dethrone superior powers, or to usurp the sceptre which the understanding should ever coolly wield, appears less wild.

Youth is the season for love in both sexes; but in those days of thoughtless enjoyment provision should be made for the more important years of life, when reflection takes place of sensation. But Rousseau, and most of the male writers who have followed his steps, have warmly inculcated that the whole tendency of female education ought to be directed to one point:—to render them pleasing.*

Let me reason with the supporters of this opinion who have any knowledge of human nature, do they imagine that marriage can eradicate the habitude of life? The woman who has only been taught to please will soon find that her charms are oblique sunbeams, and that they cannot have much effect on her husband's heart when they are seen every day, when the summer is passed and gone. Will she then have sufficient native energy to look into herself for comfort, and cultivate her dormant faculties? or, is it not more rational to expect that she will try to please other men; and, in the emotions raised by the expectation of new conquests, endeavour to forget the mortification her love or pride has received? When the husband ceases to be a lover—and the time will inevitably come, her desire of pleasing will then grow languid, or become a spring of bitterness; and love, perhaps, the most evanescent of all passions, gives place to jealousy or vanity.

I now speak of women who are restrained by principle or prejudice; such women, though they would shrink from an intrigue with real abhorrence, yet, nevertheless, wish to be convinced by the homage of gallantry that they are cruelly neglected by their husbands; or, days and weeks are spent in dreaming of the happiness enjoyed by congenial souls till their health is undermined and their

spirits broken by discontent. How then can the great art of pleasing be such a necessary study? it is only useful to a mistress; the chaste wife, and serious mother, should only consider her power to please as the polish of her virtues, and the affection of her husband as one of the comforts that render her task less difficult and her life happier.—But, whether she be loved or neglected, her first wish should be to make herself respectable, and not to rely for all her happiness on a being subject to like infirmities with herself.

The worthy Dr Gregory* fell into a similar error. I respect his heart; but entirely disapprove of his celebrated Legacy to his Daughters.

He advises them to cultivate a fondness for dress, because a fondness for dress, he asserts, is natural to them. I am unable to comprehend what either he or Rousseau mean, when they frequently use this indefinite term. If they told us that in a pre-existent state the soul was fond of dress, and brought this inclination with it into a new body, I should listen to them with a half smile, as I often do when I hear a rant about innate elegance.—But if he only meant to say that the exercise of the faculties will produce this fondness—I deny it. It is not natural; but arises, like false ambition in men, from a love of power.

Dr Gregory goes much further;* he actually recommends dissimulation, and advises an innocent girl to give the lie to her feelings, and not dance with spirit, when gaiety of heart would make her feet eloquent without making her gestures immodest. In the name of truth and common sense, why should not one woman acknowledge that she can take more exercise than another? or, in other words, that she has a sound constitution; and why, to damp innocent vivacity, is she darkly to be told that men will draw conclusions which she little thinks of?—Let the libertine draw what inference he pleases; but, I hope, that no sensible mother will restrain the natural frankness of youth by instilling such indecent cautions. Out of the abundance of the heart the mouth speaketh;* and a wiser than Solomon hath said,* that the heart should be made clean, and not trivial ceremonies observed, which it is not very difficult to fulfil with scrupulous exactness when vice reigns in the heart.

Women ought to endeavour to purify their heart; but can they do so when their uncultivated understandings make them entirely dependent on their senses for employment and amusement, when no

noble pursuit sets them above the little vanities of the day, or enables them to curb the wild emotions that agitate a reed over which every passing breeze has power? To gain the affections of a virtuous man is affectation necessary? Nature has given woman a weaker frame than man; but, to ensure her husband's affections, must a wife, who by the exercise of her mind and body whilst she was discharging the duties of a daughter, wife, and mother, has allowed her constitution to retain its natural strength, and her nerves a healthy tone, is she, I say, to condescend to use art and feign a sickly delicacy in order to secure her husband's affection? Weakness may excite tenderness, and gratify the arrogant pride of man; but the lordly caresses of a protector will not gratify a noble mind that pants for, and deserves to be respected. Fondness is a poor substitute for friendship!

In a seraglio, I grant, that all these arts are necessary; the epicure must have his palate tickled, or he will sink into apathy; but have women so little ambition as to be satisfied with such a condition? Can they supinely dream life away in the lap of pleasure, or the languor of weariness, rather than assert their claim to pursue reasonable pleasures and render themselves conspicuous by practising the virtues which dignify mankind? Surely she has not an immortal soul who can loiter life away merely employed to adorn her person, that she may amuse the languid hours, and soften the cares of a fellow-creature who is willing to be enlivened by her smiles and tricks, when the serious business of life is over.

Besides, the woman who strengthens her body and exercises her mind will, by managing her family and practising various virtues, become the friend, and not the humble dependent of her husband; and if she, by possessing such substantial qualities, merit his regard, she will not find it necessary to conceal her affection, nor to pretend to an unnatural coldness of constitution to excite her husband's passions. In fact, if we revert to history, we shall find that the women who have distinguished themselves have neither been the most beautiful nor the most gentle of their sex.

Nature, or, to speak with strict propriety, God, has made all things right; but man has sought him out many inventions to mar the work. I now allude to that part of Dr Gregory's treatise, where he advises a wife never to let her husband know the extent of her sensibility or affection.* Voluptuous precaution, and as ineffectual as absurd.—Love, from its very nature, must be transitory. To seek

for a secret that would render it constant, would be as wild a search as for the philosopher's stone,* or the grand panacea: and the discovery would be equally useless, or rather pernicious, to mankind. The most holy band of society is friendship. It has been well said, by a shrewd satirist, 'that rare as true love is, true friendship is still rarer.'*

This is an obvious truth, and the cause not lying deep, will not elude a slight glance of inquiry.

Love, the common passion, in which chance and sensation take place of choice and reason, is, in some degree, felt by the mass of mankind; for it is not necessary to speak, at present, of the emotions that rise above or sink below love. This passion, naturally increased by suspense and difficulties, draws the mind out of its accustomed state, and exalts the affections; but the security of marriage, allowing the fever of love to subside, a healthy temperature is thought insipid, only by those who have not sufficient intellect to substitute the calm tenderness of friendship, the confidence of respect, instead of blind admiration, and the sensual emotions of fondness.

This is, must be, the course of nature—friendship or indifference inevitably succeeds love.—And this constitution seems perfectly to harmonize with the system of government which prevails in the moral world. Passions are spurs to action, and open the mind; but they sink into mere appetites, become a personal and momentary gratification, when the object is gained, and the satisfied mind rests in enjoyment. The man who had some virtue whilst he was struggling for a crown, often becomes a voluptuous tyrant when it graces his brow; and, when the lover is not lost in the husband, the dotard, a prey to childish caprices, and fond jealousies, neglects the serious duties of life, and the caresses which should excite confidence in his children are lavished on the overgrown child, his wife.

In order to fulfil the duties of life, and to be able to pursue with vigour the various employments which form the moral character, a master and mistress of a family ought not to continue to love each other with passion. I mean to say, that they ought not to indulge those emotions which disturb the order of society, and engross the thoughts that should be otherwise employed. The mind that has never been engrossed by one object wants vigour—if it can long be so, it is weak.

A mistaken education, a narrow, uncultivated mind, and many sexual prejudices, tend to make women more constant than men; but, for the present, I shall not touch on this branch of the subject. I will go still further, and advance, without dreaming of a paradox, that an unhappy marriage is often very advantageous to a family, and that the neglected wife is, in general, the best mother. And this would almost always be the consequence if the female mind were more enlarged; for, it seems to be the common dispensation of Providence, that what we gain in present enjoyment should be deducted from the treasure of life, experience; and that when we are gathering the flowers of the day and revelling in pleasure, the solid fruit of toil and wisdom should not be caught at the same time. The way lies before us, we must turn to the right or left; and he who will pass life away in bounding from one pleasure to another, must not complain if he acquire neither wisdom nor respectability of character.

Supposing, for a moment, that the soul is not immortal, and that man was only created for the present scene,—I think we should have reason to complain that love, infantine fondness, ever grew insipid and palled upon the sense. Let us eat, drink, and love, for to-morrow we die, would be, in fact, the language of reason, the morality of life; and who but a fool would part with a reality for a fleeting shadow? But, if awed by observing the improbable powers of the mind, we disdain to confine our wishes or thoughts to such a comparatively mean field of action; that only appears grand and important, as it is connected with a boundless prospect and sublime hopes, what necessity is there for falsehood in conduct, and why must the sacred majesty of truth be violated to detain a deceitful good that saps the very foundation of virtue? Why must the female mind be tainted by coquetish arts to gratify the sensualist, and prevent love from subsiding into friendship, or compassionate tenderness, when there are not qualities on which friendship can be built? Let the honest heart shew itself, and *reason* teach passion to submit to necessity; or, let the dignified pursuit of virtue and knowledge raise the mind above those emotions which rather imbitter than sweeten the cup of life, when they are not restrained within due bounds.

I do not mean to allude to the romantic passion, which is the concomitant of genius.—Who can clip its wing? But that grand

passion not proportioned to the puny enjoyments of life, is only true to the sentiment, and feeds on itself. The passions which have been celebrated for their durability have always been unfortunate. They have acquired strength by absence and constitutional melancholy.— The fancy has hovered round a form of beauty dimly seen—but familiarity might have turned admiration into disgust; or, at least, into indifference, and allowed the imagination leisure to start fresh game. With perfect propriety, according to this view of things, does Rousseau make the mistress of his soul, Eloisa, love St Preux,* when life was fading before her; but this is no proof of the immortality of the passion.

Of the same complexion is Dr Gregory's advice respecting delicacy of sentiment,* which he advises a woman not to acquire, if she have determined to marry. This determination, however, perfectly consistent with his former advice, he calls *indelicate*, and earnestly persuades his daughters to conceal it, though it may govern their conduct:—as if it were indelicate to have the common appetites of human nature.

Noble morality! and consistent with the cautious prudence of a little soul that cannot extend its views beyond the present minute division of existence. If all the faculties of woman's mind are only to be cultivated as they respect her dependence on man; if, when a husband be obtained, she have arrived at her goal, and meanly proud rests satisfied with such a paltry crown, let her grovel contentedly, scarcely raised by her employments above the animal kingdom; but, if, struggling for the prize of her high calling, she looks beyond the present scene, let her cultivate her understanding without stopping to consider what character the husband may have whom she is destined to marry. Let her only determine, without being too anxious about present happiness, to acquire the qualities that ennoble a rational being, and a rough inelegant husband may shock her taste without destroying her peace of mind. She will not model her soul to suit the frailties of her companion, but to bear with them: his character may be a trial, but not an impediment to virtue.

If Dr Gregory confined his remark to romantic expectations of constant love and congenial feelings, he should have recollected that experience will banish what advice can never make us cease to wish for, when the imagination is kept alive at the expence of reason.

I own it frequently happens that women who have fostered a romantic unnatural delicacy of feeling, waste their[1] lives in *imagining* how happy they should have been with a husband who could love them with a fervid increasing affection every day, and all day. But they might as well pine married as single—and would not be a jot more unhappy with a bad husband than longing for a good one. That a proper education; or, to speak with more precision, a well stored mind, would enable a woman to support a single life with dignity, I grant; but that she should avoid cultivating her taste, lest her husband should occasionally shock it, is quitting a substance for a shadow. To say the truth, I do not know of what use is an improved taste, if the individual be not rendered more independent of the casualties of life; if new sources of enjoyment, only dependent on the solitary operations of the mind, are not opened. People of taste, married or single, without distinction, will ever be disgusted by various things that touch not less observing minds. On this conclusion the argument must not be allowed to hinge; but in the whole sum of enjoyment is taste to be denominated a blessing?

The question is, whether it procures most pain or pleasure? The answer will decide the propriety of Dr Gregory's advice, and shew how absurd and tyrannic it is thus to lay down a system of slavery; or to attempt to educate moral beings by any other rules than those deduced from pure reason, which apply to the whole species.

Gentleness of manners, forbearance and long-suffering, are such amiable Godlike qualities, that in sublime poetic strains the Deity has been invested with them; and, perhaps, no representation of his goodness so strongly fastens on the human affections as those that represent him abundant in mercy and willing to pardon. Gentleness, considered in this point of view, bears on its front all the characteristics of grandeur, combined with the winning graces of condescension; but what a different aspect it assumes when it is the submissive demeanour of dependence, the support of weakness that loves, because it wants protection; and is forbearing, because it must silently endure injuries; smiling under the lash at which it dare not snarl. Abject as this picture appears, it is the portrait of an accomplished woman, according to the received opinion of female excellence, separated by specious reasoners from human excellence. Or,

[1] For example, the herd of Novelists.

they[1] kindly restore the rib, and make one moral being of a man and woman; not forgetting to give her all the 'submissive charms.'*

How woman are to exist in that state where there is to be neither marrying nor giving in marriage,* we are not told. For though moralists have agreed that the tenor of life seems to prove that *man* is prepared by various circumstances for a future state, they constantly concur in advising *woman* only to provide for the present. Gentleness, docility, and a spaniel-like affection are, on this ground, consistently recommended as the cardinal virtues of the sex; and, disregarding the arbitrary economy of nature, one writer has declared that it is masculine for a woman to be melancholy. She was created to be the toy of man, his rattle, and it must jingle in his ears whenever, dismissing reason, he chooses to be amused.

To recommend gentleness, indeed, on a broad basis is strictly philosophical. A frail being should labour to be gentle. But when forbearance confounds right and wrong, it ceases to be a virtue; and, however convenient it may be found in a companion—that companion will ever be considered as an inferior, and only inspire a vapid tenderness, which easily degenerates into contempt. Still, if advice could really make a being gentle, whose natural disposition admitted not of such a fine polish, something towards the advancement of order would be attained; but if, as might quickly be demonstrated, only affectation be produced by this indiscriminate counsel, which throws a stumbling-block in the way of gradual improvement, and true melioration of temper, the sex is not much benefited by sacrificing solid virtues to the attainment of superficial graces, though for a few years they may procure the individuals regal sway.

As a philosopher, I read with indignation the plausible epithets which men use to soften their insults; and, as a moralist, I ask what is meant by such heterogeneous associations, as fair defects, amiable weaknesses,* etc.? If there be but one criterion of morals, but one archetype for man, women appear to be suspended by destiny, according to the vulgar tale of Mahomet's coffin;* they have neither the unerring instinct of brutes, nor are allowed to fix the eye of reason on a perfect model. They were made to be loved, and must not aim at respect, lest they should be hunted out of society as masculine.

[1] Vide Rousseau, and Swedenborg.*

But to view the subject in another point of view. Do passive indolent women make the best wives? Confining our discussion to the present moment of existence, let us see how such weak creatures perform their part? Do the women who, by the attainment of a few superficial accomplishments, have strengthened the prevailing prejudice, merely contribute to the happiness of their husbands? Do they display their charms merely to amuse them? And have women, who have early imbibed notions of passive obedience, sufficient character to manage a family or educate children? So far from it, that, after surveying the history of woman, I cannot help, agreeing with the severest satirist, considering the sex as the weakest as well as the most oppressed half of the species. What does history disclose but marks of inferiority, and how few women have emancipated themselves from the galling yoke of sovereign man?—So few, that the exceptions remind me of an ingenious conjecture respecting Newton:* that he was probably a being of a superior order, accidently caged in a human body. Following the same train of thinking, I have been led to imagine that the few extraordinary women who have rushed in eccentrical directions out of the orbit prescribed to their sex, were *male* spirits, confined by mistake in female frames. But if it be not philosophical to think of sex when the soul is mentioned, the inferiority must depend on the organs; or the heavenly fire, which is to ferment the clay, is not given in equal portions.

But avoiding, as I have hitherto done, any direct comparison of the two sexes collectively, or frankly acknowledging the inferiority of woman, according to the present appearance of things, I shall only insist that men have increased that inferiority till women are almost sunk below the standard of rational creatures. Let their faculties have room to unfold, and their virtues to gain strength, and then determine where the whole sex must stand in the intellectual scale, Yet let it be remembered, that for a small number of distinguished women I do not ask a place.

It is difficult for us purblind mortals to say to what height human discoveries and improvements may arrive when the gloom of despotism subsides, which makes us stumble at every step; but, when morality shall be settled on a more solid basis, then, without being gifted with a prophetic spirit, I will venture to predict that woman will be either the friend or slave of man. We shall not, as at present,

doubt whether she is a moral agent, or the link which unites man with brutes. But, should it then appear, that like the brutes they were principally created for the use of man, he will let them patiently bite the bridle, and not mock them with empty praise; or, should their rationality be proved, he will not impede their improvement merely to gratify his sensual appetites. He will not, with all the graces of rhetoric, advise them to submit implicitly their understanding to the guidance of man. He will not, when he treats of the education of women, assert that they ought never to have the free use of reason, nor would he recommend cunning and dissimulation to beings who are acquiring, in like manner as himself, the virtues of humanity.

Surely there can be but one rule of right, if morality has an eternal foundation, and whoever sacrifices virtue, strictly so called, to present convenience, or whose *duty* it is to act in such a manner, lives only for the passing day, and cannot be an accountable creature.

The poet then should have dropped his sneer when he says,

> 'If weak women go astray,
> The stars are more in fault than they.'*

For that they are bound by the adamantine chain of destiny is most certain, if it be proved that they are never to exercise their own reason, never to be independent, never to rise above opinion, or to feel the dignity of a rational will that only bows to God, and often forgets that the universe contains any being but itself and the model of perfection to which its ardent gaze is turned, to adore attributes that, softened into virtues, may be imitated in kind, though the degree overwhelms the enraptured mind.

If, I say, for I would not impress by declamation when Reason offers her sober light, if they be really capable of acting like rational creatures, let them not be treated like slaves; or, like the brutes who are dependent on the reason of man, when they associate with him; but cultivate their minds, give them the salutary, sublime curb of principle, and let them attain conscious dignity by feeling themselves only dependent on God. Teach them, in common with man, to submit to necessity, instead of giving, to render them more pleasing, a sex to morals.

Further, should experience prove that they cannot attain the same degree of strength of mind, perseverance, and fortitude, let their virtues be the same in kind, though they may vainly struggle for the same degree; and the superiority of man will be equally clear, if not clearer; and truth, as it is a simple principle, which admits of no modification, would be common to both. Nay, the order of society as it is at present regulated would not be inverted, for woman would then only have the rank that reason assigned her, and arts could not be practised to bring the balance even, much less to turn it.

These may be termed Utopian dreams.—Thanks to that Being who impressed them on my soul, and gave me sufficient strength of mind to dare to exert my own reason, till, becoming dependent only on him for the support of my virtue, I view, with indignation, the mistaken notions that enslave my sex.

I love man as my fellow; but his scepter, real, or usurped, extends not to me, unless the reason of an individual demands my homage; and even then the submission is to reason, and not to man. In fact, the conduct of an accountable being must be regulated by the operations of its own reason; or on what foundation rests the throne of God?

It appears to me necessary to dwell on these obvious truths, because females have been insulated, as it were; and, while they have been stripped of the virtues that should clothe humanity, they have been decked with artificial graces that enable them to exercise a short-lived tyranny. Love, in their bosoms, taking place of every nobler passion, their sole ambition is to be fair, to raise emotion instead of inspiring respect; and this ignoble desire, like the servility in absolute monarchies, destroys all strength of character. Liberty is the mother of virtue, and if women be, by their very constitution, slaves, and not allowed to breathe the sharp invigorating air of freedom, they must ever languish like exotics, and be reckoned beautiful flaws in nature.

As to the argument respecting the subjection in which the sex has ever been held, it retorts on man. The many have always been enthralled by the few; and monsters, who scarcely have shewn any discernment of human excellence, have tyrannized over thousands of their fellow-creatures. Why have men of superior endowments

_bmitted to such degradation? For, is it not universally acknowl-
edged that kings, viewed collectively, have ever been inferior, in
abilities and virtue, to the same number of men taken from the
common mass of mankind—yet, have they not, and are they not still
treated with a degree of reverence that is an insult to reason? China
is not the only country where a living man has been made a God.*
Men have submitted to superior strength to enjoy with impunity the
pleasure of the moment—*women* have only done the same, and
therefore till it is proved that the courtier, who servilely resigns the
birthright of a man, is not a moral agent, it cannot be demonstrated
that woman is essentially inferior to man because she has always
been subjugated.

Brutal force has hitherto governed the world, and that the science
of politics is in its infancy, is evident from philosophers scrupling to
give the knowledge most useful to man that determinate distinction.

I shall not pursue this argument any further than to establish an
obvious inference, that as sound politics diffuse liberty, mankind,
including woman, will become more wise and virtuous.

CHAPTER III

THE SAME SUBJECT CONTINUED

Bodily strength from being the distinction of heroes is now sunk into such unmerited contempt that men, as well as women, seem to think it unnecessary: the latter, as it takes from their feminine graces, and from that lovely weakness the source of their undue power; and the former, because it appears inimical to the character of a gentleman.

That they have both by departing from one extreme run into another, may easily be proved; but first it may be proper to observe, that a vulgar error has obtained a degree of credit, which has given force to a false conclusion, in which an effect has been mistaken for a cause.

People of genius have, very frequently, impaired their constitutions by study or careless inattention to their health, and the violence of their passions bearing a proportion to the vigour of their intellects, the sword's destroying the scabbard has become almost proverbial,* and superficial observers have inferred from thence, that men of genius have commonly weak, or, to use a more fashionable phrase, delicate constitutions. Yet the contrary, I believe, will appear to be the fact; for, on diligent inquiry, I find that strength of mind has, in most cases, been accompanied by superior strength of body,—natural soundness of constitution,—not that robust tone of nerves and vigour of muscles, which arise from bodily labour, when the mind is quiescent, or only directs the hands.

Dr Priestley has remarked,* in the preface to his biographical chart, that the majority of great men have lived beyond forty-five. And, considering the thoughtless manner in which they have lavished their strength, when investigating a favourite science they have wasted the lamp of life, forgetful of the midnight hour; or, when, lost in poetic dreams, fancy has peopled the scene, and the soul has been disturbed, till it shook the constitution, by the passions that meditation had raised; whose objects, the baseless fabric of a vision,* faded before the exhausted eye, they must have had iron

frames. Shakspeare never grasped the airy dagger with a nerveless hand,* nor did Milton tremble when he led Satan far from the confines of his dreary prison.*—These were not the ravings of imbecility, the sickly effusions of distempered brains; but the exuberance of fancy, that 'in a fine phrenzy'* wandering, was not continually reminded of its material shackles.

I am aware that this argument would carry me further than it may be supposed I wish to go; but I follow truth, and, still adhering to my first position, I will allow that bodily strength seems to give man a natural superiority over woman; and this is the only solid basis on which the superiority of the sex can be built. But I still insist, that not only the virtue, but the *knowledge* of the two sexes should be the same in nature, if not in degree, and that women, considered not only as moral, but rational creatures, ought to endeavour to acquire human virtues (or perfections) by the *same* means as men, instead of being educated like a fanciful kind of *half* being—one of Rousseau's wild chimeras.[1]

[1] 'Researches into abstract and speculative truths, the principles and axioms of sciences, in short, every thing which tends to generalize our ideas, is not the proper province of women; their studies should be relative to points of practice; it belongs to them to apply those principles which men have discovered; and it is their part to make observations, which direct men to the establishment of general principles. All the ideas of women, which have not the immediate tendency to points of duty, should be directed to the study of men, and to the attainment of those agreeable accomplishments which have taste for their object; for as to works of genius, they are beyond their capacity; neither have they sufficient precision or power of attention to succeed in sciences which require accuracy: and as to physical knowledge, it belongs to those only who are most active, most inquisitive; who comprehend the greatest variety of objects: in short, it belongs to those who have the strongest powers, and who exercise them most, to judge of the relations between sensible beings and the laws of nature. A woman who is naturally weak, and does not carry her ideas to any great extent, knows how to judge and make a proper estimate of those movements which she sets to work, in order to aid her weakness; and these movements are the passions of men. The mechanism she employs is much more powerful than ours; for all her levers move the human heart. She must have the skill to incline us to do every thing which her sex will not enable her to do herself, and which is necessary or agreeable to her; therefore she ought to study the mind of man thoroughly, not the mind of man in general, abstractedly, but the dispositions of those men to whom she is subject, either by the laws of her country or by the force of opinion. She should learn to penetrate into their real sentiments from their conversation, their actions, their looks, and gestures. She should also have the art, by her own conversation, actions, looks, and gestures, to communicate those sentiments which are agreeable to them, without seeming to intend it. Men will argue more philosophically about the human heart; but women will read the heart of man better than they. It belongs to women, if I may be allowed the expression, to form an experimental morality, and to reduce the study of man to a system. Women have most wit, men have most genius; women observe, men reason: from the concurrence of both we derive the clearest light and the most perfect knowledge, which

But, if strength of body be, with some shew of reason, the boast of men, why are women so infatuated as to be proud of a defect? Rousseau has furnished them with a plausible excuse, which could only have occurred to a man, whose imagination had been allowed to run wild, and refine on the impressions made by exquisite senses;— that they might, forsooth, have a pretext for yielding to a natural appetite without violating a romantic species of modesty, which gratifies the pride and libertinism of man.

Women, deluded by these sentiments, sometimes boast of their weakness, cunningly obtaining power by playing on the *weakness* of men; and they may well glory in their illicit sway, for, like Turkish bashaws,* they have more real power than their masters: but virtue is sacrificed to temporary gratifications, and the respectability of life to the triumph of an hour.

Women, as well as despots, have now, perhaps, more power than they would have if the world, divided and subdivided into kingdoms and families, were governed by laws deduced from the exercise of reason; but in obtaining it, to carry on the comparison, their character is degraded, and licentiousness spread through the whole aggregate of society. The many become pedestal to the few. I, therefore, will venture to assert, that till women are more rationally educated, the progress of human virtue and improvement in knowledge must receive continual checks. And if it be granted that woman was not created merely to gratify the appetite of man, or to be the upper servant, who provides his meals and takes care of his linen, it must follow, that the first care of those mothers or fathers, who really attend to the education of females, should be, if not to strengthen the body, at least, not to destroy the constitution by mistaken notions of beauty and female excellence; nor should girls ever be allowed to imbibe the pernicious notion that a defect can, by any chemical process of reasoning, become an excellence. In this respect, I am happy to find, that the author of one of the most instructive books, that our country has produced for children, coin-

the human mind is, of itself, capable of attaining. In one word, from hence we acquire the most intimate acquaintance, both with ourselves and others, of which our nature is capable; and it is thus that art has a constant tendency to perfect those endowments which nature has bestowed.—The world is the book of women.' *Rousseau's Emilius.** I hope my readers still remember the comparison, which I have brought forward, between women and officers.

cides with me in opinion; I shall quote his pertinent remarks to give
the force of his respectable authority to reason.[1]

But should it be proved that woman is naturally weaker than man,
whence does it follow that it is natural for her to labour to become
still weaker than nature intended her to be? Arguments of this cast
are an insult to common sense, and savour of passion. The *divine
right* of husbands, like the divine right of kings, may, it is to be
hoped, in this enlightened age, be contested without danger, and,
though conviction may not silence many boisterous disputants, yet,
when any prevailing prejudice is attacked, the wise will consider,
and leave the narrow-minded to rail with thoughtless vehemence at
innovation.

The mother, who wishes to give true dignity of character to her
daughter, must, regardless of the sneers of ignorance, proceed on a
plan diametrically opposite to that which Rousseau has recom-
mended with all the deluding charms of eloquence and philosophi-
cal sophistry: for his eloquence renders absurdities plausible, and
his dogmatic conclusions puzzle, without convincing, those who
have not ability to refute them.

[1] A respectable old man gives the following sensible account of the method he pursued
when educating his daughter. 'I endeavoured to give both to her mind and body a degree of
vigour, which is seldom found in the female sex. As soon as she was sufficiently advanced in
strength to be capable of the lighter labours of husbandry and gardening, I employed her as
my constant companion. Selene, for that was her name, soon acquired a dexterity in all these
rustic employments, which I considered with equal pleasure and admiration. If women are
in general feeble both in body and mind, it arises less from nature than from education. We
encourage a vicious indolence and inactivity, which we falsely call delicacy; instead of
hardening their minds by the severer principles of reason and philosophy, we breed them to
useless arts, which terminate in vanity and sensuality. In most of the countries which I had
visited, they are taught nothing of an higher nature than a few modulations of the voice, or
useless postures of the body; their time is consumed in sloth or trifles, and trifles become the
only pursuits capable of interesting them. We seem to forget, that it is upon the qualities of
the female sex that our own domestic comforts and the education of our children must
depend. And what are the comforts or the education which a race of beings, corrupted from
their infancy, and unacquainted with all the duties of life, are fitted to bestow? To touch a
musical instrument with useless skills, to exhibit their natural or affected graces to the eyes
of indolent and debauched young men, to dissipate their husband's patrimony in riotous and
unnecessary expences, these are the only arts cultivated by women in most of the polished
nations I had seen. And the consequences are uniformly such as may be expected to proceed
from such polluted sources, private misery and public servitude.
 'But Selene's education was regulated by different views, and conducted upon severer
principles; if that can be called severity which opens the mind to a sense of moral and
religious duties, and most effectually arms it against the inevitable evils of life.'
 *Mr Day's Sandford and Merton,** Vol. III

Throughout the whole animal kingdom every young creature requires almost continual exercise, and the infancy of children, comformable to this intimation, should be passed in harmless gambols, that exercise the feet and hands, without requiring very minute direction from the head, or the constant attention of a nurse. In fact, the care necessary for self-preservation is the first natural exercise of the understanding, as little inventions to amuse the present moment unfold the imagination. But these wise designs of nature are counteracted by mistaken fondness or blind zeal. The child is not left a moment to its own direction, particularly a girl, and thus rendered dependent—dependence is called natural.

To preserve personal beauty, woman's glory! the limbs and faculties are cramped with worse than Chinese bands,* and the sedentary life which they are condemned to live, whilst boys frolic in the open air, weakens the muscles and relaxes the nerves.—As for Rousseau's remarks,* which have since been echoed by several writers, that they have naturally, that is from their birth, independent of education, a fondness for dolls, dressing, and talking—they are so puerile as not to merit a serious refutation. That a girl, condemned to sit for hours together listening to the idle chat of weak nurses, or to attend at her mother's toilet, will endeavour to join the conversation, is, indeed, very natural; and that she will imitate her mother or aunts, and amuse herself by adorning her lifeless doll, as they do in dressing her, poor innocent babe! is undoubtedly a most natural consequence. For men of the greatest abilities have seldom had sufficient strength to rise above the surrounding atmosphere; and, if the page of genius have always been blurred by the prejudices of the age, some allowance should be made for a sex, who, like kings, always see things through a false medium.

Pursuing these reflections, the fondness for dress, conspicuous in women, may be easily accounted for, without supposing it the result of a desire to please the sex on which they are dependent. The absurdity, in short, of supposing that a girl is naturally a coquette, and that a desire connected with the impulse of nature to propagate the species, should appear even before an improper education has, by heating the imagination, called it forth prematurely, is so unphilosophical, that such a sagacious observer as Rousseau would not have adopted it, if he had not been accustomed to make reason give way to his desire of singularity, and truth to a favourite paradox.*

Yet thus to give a sex to mind was not very consistent with the principles of a man who argued so warmly, and so well, for the immortality of the soul.*—But what a weak barrier is truth when it stands in the way of an hypothesis! Rousseau respected—almost adored virtue—and yet he allowed himself to love with sensual fondness. His imagination constantly prepared inflammable fewel for his inflammable senses; but, in order to reconcile his respect for self-denial, fortitude, and those heroic virtues, which a mind like his could not coolly admire, he labours to invert the law of nature, and broaches a doctrine pregnant with mischief and derogatory to the character of supreme wisdom.

His ridiculous stories, which tend to prove that girls are *naturally* attentive to their persons, without laying any stress on daily example, are below contempt.—And that a little miss should have such a correct taste as to neglect the pleasing amusement of making O's, merely because she perceived that it was an ungraceful attitude, should be selected with the anecdotes of the learned pig.[1]*

I have, probably, had an opportunity of observing more girls in their infancy than J. J. Rousseau—I can recollect my own feelings, and I have looked steadily around me; yet, so far from coinciding with him in opinion respecting the first dawn of the female character, I will venture to affirm, that a girl, whose spirits have not been damped by inactivity, or innocence tainted by false shame, will always be a romp, and the doll will never excite attention unless confinement allows her no alternative. Girls and boys, in short, would play harmlessly together, if the distinction of sex was not inculcated long before nature makes any difference.—I will go further, and affirm, as an indisputable fact, that most of the women, in the circle of my observation, who have acted like rational creatures, or shewn any vigour of intellect, have accidentally been allowed to

[1] 'I once knew a young person who learned to write before she learned to read, and began to write with her needle before she could use a pen. At first, indeed, she took it into her head to make no other letter than the O: this letter she was constantly making of all sizes, and always the wrong way. Unluckily, one day, as she was intent on this employment, she happened to see herself in the looking-glass; when, taking a dislike to the constrained attitude in which she sat while writing, she threw away her pen, like another Pallas, and determined against making the O any more. Her brother was also equally averse to writing: it was the confinement, however, and not the constrained attitude, that most disgusted him.' *Rousseau's Emilius.**

run wild—as some of the elegant formers of the fair sex would insinuate.

The baneful consequences which flow from inattention to health during infancy, and youth, extend further than is supposed—dependence of body naturally produces dependence of mind; and how can she be a good wife or mother, the greater part of whose time is employed to guard against or endure sickness? Nor can it be expected that a woman will resolutely endeavour to strengthen her constitution and abstain from enervating indulgencies, if artificial notions of beauty, and false descriptions of sensibility, have been early entangled with her motives of action. Most men are sometimes obliged to bear with bodily inconveniencies, and to endure, occasionally, the inclemency of the elements; but genteel women are, literally speaking, slaves to their bodies, and glory in their subjection.

I once knew a weak woman of fashion, who was more than commonly proud of her delicacy and sensibility. She thought a distinguishing taste and puny appetite the height of all human perfection, and acted accordingly.—I have seen this weak sophisticated being neglect all the duties of life, yet recline with self-complacency on a sofa, and boast of her want of appetite as a proof of delicacy that extended to, or, perhaps, arose from, her exquisite sensibility: for it is difficult to render intelligible such ridiculous jargon.—Yet, at the moment, I have seen her insult a worthy old gentlewoman, whom unexpected misfortunes had made dependent on her ostentatious bounty, and who, in better days, had claims on her gratitude. Is it possible that a human creature could have become such a weak and depraved being, if, like the Sybarites,* dissolved in luxury, every thing like virtue had not been worn away, or never impressed by precept, a poor substitute, it is true, for cultivation of mind, though it serves as a fence against vice?

Such a woman is not a more irrational monster than some of the Roman emperors, who were depraved by lawless power. Yet, since kings have been more under the restraint of law, and the curb, however weak, of honour, the records of history are not filled with such unnatural instances of folly and cruelty, nor does the despotism that kills virtue and genius in the bud, hover over Europe with that destructive blast* which desolates Turkey, and renders the men, as well as the soil, unfruitful.

Women are every where in this deplorable state; for, in order to preserve their innocence, as ignorance is courteously termed, truth is hidden from them, and they are made to assume an artificial character before their faculties have acquired any strength. Taught from their infancy that beauty is woman's sceptre, the mind shapes itself to the body, and, roaming round its gilt cage, only seeks to adorn its prison. Men have various employments and pursuits which engage their attention, and give a character to the opening mind; but women, confined to one, and having their thoughts constantly directed to the most insignificant part of themselves, seldom extend their views beyond the triumph of the hour. But were their understanding once emancipated from the slavery to which the pride and sensuality of man and their short-sighted desire, like that of dominion in tyrants, of present sway, has subjected them, we should probably read of their weaknesses with surprise. I must be allowed to pursue the argument a little farther.

Perhaps, if the existence of an evil being were allowed, who, in the allegorical language of scripture, went about seeking whom he should devour,* he could not more effectually degrade the human character than by giving a man absolute power.

This argument branches into various ramifications.—Birth, riches, and every extrinsic advantage that exalt a man above his fellows, without any mental exertion, sink him in reality below them. In proportion to his weakness, he is played upon by designing men, till the bloated monster has lost all traces of humanity. And that tribes of men, like flocks of sheep, should quietly follow such a leader, is a solecism that only a desire of present enjoyment and narrowness of understanding can solve. Educated in slavish dependence, and enervated by luxury and sloth, where shall we find men who will stand forth to assert the rights of man;—or claim the privilege of moral beings, who should have but one road to excellence? Slavery to monarchs and ministers, which the world will be long in freeing itself from, and whose deadly grasp stops the progress of the human mind, is not yet abolished.

Let not men then in the pride of power, use the same arguments that tyrannic kings and venal ministers have used, and fallaciously assert that woman ought to be subjected because she has always been so.—But, when man, governed by reasonable laws, enjoys his natural freedom, let him despise woman, if she do not share it with him;

and, till that glorious period arrives, in descanting on the folly of the sex, let him not overlook his own.

Women, it is true, obtaining power by unjust means, by practising or fostering vice, evidently lose the rank which reason would assign them, and they become either abject slaves or capricious tyrants. They lose all simplicity, all dignity of mind, in acquiring power, and act as men are observed to act when they have been exalted by the same means.

It is time to effect a revolution in female manners—time to restore to them their lost dignity—and make them, as a part of the human species, labour by reforming themselves to reform the world. It is time to separate unchangeable morals from local manners.—If men be demi-gods—why let us serve them! And if the dignity of the female soul be as disputable as that of animals—if their reason does not afford sufficient light to direct their conduct whilst unerring instinct is denied—they are surely of all creatures the most miserable! and, bent beneath the iron hand of destiny, must submit to be a *fair defect* in creation. But to justify the ways of Providence* respecting them, by pointing out some irrefragable reason for thus making such a large portion of mankind accountable and not accountable, would puzzle the subtilest casuist.

The only solid foundation for morality appears to be the character of the supreme Being; the harmony of which arises from a balance of attributes;—and, to speak with reverence, one attribute seems to imply the *necessity* of another. He must be just, because he is wise, he must be good, because he is omnipotent. For to exalt one attribute at the expence of another equally noble and necessary, bears the stamp of the warped reason of man—the homage of passion. Man, accustomed to bow down to power in his savage state, can seldom divest himself of this barbarous prejudice, even when civilization determines how much superior mental is to bodily strength; and his reason is clouded by these crude opinions, even when he thinks of the Deity.—His omnipotence is made to swallow up, or preside over his other attributes, and those mortals are supposed to limit his power irreverently, who think that it must be regulated by his wisdom.

I disclaim that specious humility which, after investigating nature, stops at the author.—The High and Lofty One, who inhabiteth eternity, doubtless possesses many attributes of which we

can form no conception; but reason tells me that they cannot clash with those I adore—and I am compelled to listen to her voice.

It seems natural for man to search for excellence, and either to trace it in the object that he worships, or blindly to invest it with perfection, as a garment. But what good effect can the latter mode of worship have on the moral conduct of a rational being? He bends to power; he adores a dark cloud, which may open a bright prospect to him, or burst in angry, lawless fury, on his devoted head—he knows not why. And, supposing that the Deity acts from the vague impulse of an undirected will, man must also follow his own, or act according to rules, deduced from principles which he disclaims as irreverent. Into this dilemma have both enthusiasts and cooler thinkers fallen, when they laboured to free men from the wholesome restraints which a just conception of the character of God imposes.

It is not impious thus to scan the attributes of the Almighty: in fact, who can avoid it that exercises his faculties? For to love God as the fountain of wisdom, goodness, and power, appears to be the only worship useful to a being who wishes to acquire either virtue or knowledge. A blind unsettled affection may, like human passions, occupy the mind and warm the heart, whilst, to do justice, love mercy, and walk humbly with our God, is forgotten. I shall pursue this subjects still further, when I consider religion in a light opposite to that recommended by Dr Gregory, who treats it as a matter of sentiment or taste.*

To return from this apparent digression. It were to be wished that women would cherish an affection for their husbands, founded on the same principle that devotion ought to rest upon. No other firm base is there under heaven—for let them beware of the fallacious light of sentiment; too often used as a softer phrase for sensuality. It follows then, I think, that from their infancy women should either be shut up like eastern princes, or educated in such a manner as to be able to think and act for themselves.

Why do men halt between two opinions, and expect impossibilities? Why do they expect virtue from a slave, from a being whom the constitution of civil society has rendered weak, if not vicious?

Still I know that it will require a considerable length of time to eradicate the firmly rooted prejudices which sensualists have planted; it will also require some time to convince women that they

act contrary to their real interest on an enlarged scale, when they cherish or affect weakness under the name of delicacy, and to convince the world that the poisoned source of female vices and follies, if it be necessary, in compliance with custom, to use synonymous terms in a lax sense, has been the sensual homage paid to beauty:— to beauty of features; for it has been shrewdly observed by a German writer, that a pretty woman, as an object of desire, is generally allowed to be so by men of all descriptions; whilst a fine woman, who inspires more sublime emotions by displaying intellectual beauty, may be overlooked or observed with indifference, by those men who find their happiness in the gratification of their appetites. I foresee an obvious retort—whilst man remains such an imperfect being as he appears hitherto to have been, he will, more or less, be the slave of his appetites; and those women obtaining most power who gratify a predominant one, the sex is degraded by a physical, if not by a moral necessity.

This objection has, I grant, some force; but while such a sublime precept exists, as, 'be pure as your heavenly Father is pure',* it would seem that the virtues of man are not limited by the Being who alone could limit them; and that he may press forward without considering whether he steps out of his sphere by indulging such a noble ambition. To the wild billows it has been said, 'thus far shalt thou go, and no further; and here shall thy proud waves be stayed.'* Vainly then do they beat and foam, restrained by the power that confines the struggling planets in their orbits, matter yields to the great governing Spirit.—But an immortal soul, not restrained by mechanical laws and struggling to free itself from the shackles of matter, contributes to, instead of disturbing, the order of creation, when, co-operating with the Father of spirits, it tries to govern itself by the invariable rule that, in a degree, before which our imagination faints, regulates the universe.

Besides, if women be educated for dependence; that is, to act according to the will of another fallible being, and submit, right or wrong, to power, where are we to stop? Are they to be considered as vicegerents allowed to reign over a small domain, and answerable for their conduct to a higher tribunal, liable to error?

It will not be difficult to prove that such delegates will act like men subjected by fear, and make their children and servants endure their tyrannical oppression. As they submit without reason, they

will, having no fixed rules to square their conduct by, be kind, or cruel, just as the whim of the moment directs; and we ought not to wonder if sometimes, galled by their heavy yoke, they take a malignant pleasure in resting it on weaker shoulders.

But, supposing a woman, trained up to obedience, be married to a sensible man, who directs her judgment without making her feel the servility of her subjection, to act with as much propriety by this reflected light as can be expected when reason is taken at second hand, yet she cannot ensure the life of her protector; he may die and leave her with a large family.

A double duty devolves on her; to educate them in the character of both father and mother; to form their principles and secure their property. But, alas! she has never thought, much less acted for herself. She has only learned to please[1] men, to depend gracefully on them; yet, encumbered with children, how is she to obtain another protector—a husband to supply the place of reason? A rational man, for we are not treading on romantic ground, though he may think her a pleasing docile creature, will not choose to marry a *family* for love, when the world contains many more pretty creatures. What is then to become of her? She either falls an easy prey to some mean fortune-hunter, who defrauds her children of their parental inheritance, and renders her miserable; or becomes the victim of discontent

[1] 'In the union of the sexes, both pursue one common object, but none in the same manner. From their diversity in this particular, arises the first determinate difference between the moral relations of each. The one should be active and strong, the other passive and weak: it is necessary the one should have both the power and the will, and that the other should make little resistance.

'This principle being established, it follows that woman is expressly formed to please the man: if the obligation be reciprocal also, and the man ought to please in his turn, it is not so immediately necessary: his great merit is in his power, and he pleases merely because he is strong. This, I must confess, is not one of the refined maxims of love; it is, however, one of the laws of nature, prior to love itself.

'If woman be formed to please and be subjected to man, it is her place, doubtless, to render herself agreeable to him, instead of challenging his passion. The violence of his desires depends on her charms; it is by means of these she should urge him to the exertion of those powers which nature hath given him. The most successful method of exciting them, is, to render such exertion necessary by resistance; as, in that case, self-love is added to desire, and the one triumphs in the victory which the other obliged to acquire. Hence arise the various modes of attack and defence between the sexes; the boldness of one sex and the timidity of the other; and, in a word, that bashfulness and modesty with which nature hath armed the weak, in order to subdue the strong.'

*Rousseau's Emilius.**
I shall make no other comment on this ingenious passage, than just to observe, that it is the philosophy of lasciviousness.

and blind indulgence. Unable to educate her sons, or impress them with respect; for it is not a play on words to assert, that people are never respected, though filling an important station, who are not respectable; she pines under the anguish of unavailing impotent regret. The serpent's tooth* enters into her very soul, and the vices of licentious youth bring her with sorrow, if not with poverty also, to the grave.

This is not an overcharged picture; on the contrary, it is a very possible case, and something similar must have fallen under every attentive eye.

I have, however, taken it for granted, that she was well-disposed, though experience shews, that the blind may as easily be led into a ditch as along the beaten road. But supposing, no very improbable conjecture, that a being only taught to please must still find her happiness in pleasing;—what an example of folly, not to say vice, will she be to her innocent daughters! The mother will be lost in the coquette, and, instead of making friends of her daughters, view them with eyes askance, for they are rivals—rivals more cruel than any other, because they invite a comparison, and drive her from the throne of beauty, who has never thought of a seat on the bench of reason.

It does not require a lively pencil, or the discriminating outline of a caricature, to sketch the domestic miseries and petty vices which such a mistress of a family diffuses. Still she only acts as a woman ought to act, brought up according to Rousseau's system. She can never be reproached for being masculine, or turning out of her sphere; nay, she may observe another of his grand rules, and, cautiously preserving her reputation free from spot, be reckoned a good kind of woman. Yet in what respect can she be termed good? She abstains, it is true, without any great struggle, from committing gross crimes; but how does she fulfil her duties? Duties!—in truth she has enough to think of to adorn her body and nurse a weak constitution.

With respect to religion, she never presumed to judge for herself; but conformed, as a dependent creature should, to the ceremonies of the church which she was brought up in, piously believing that wiser heads than her own have settled that business:—and not to doubt is her point of perfection. She therefore pays her tythe of mint and cummin*—and thanks her God that she is not as other women

are.* These are the blessed effects of a good education! These the virtues of man's help-mate![1]

I must relieve myself by drawing a different picture.

Let fancy now present a woman with a tolerable understanding, for I do not wish to leave the line of mediocrity, whose constitution, strengthened by exercise, has allowed her body to acquire its full vigour; her mind, at the same time, gradually expanding itself to comprehend the moral duties of life, and in what human virtue and dignity consist.

Formed thus by the discharge of the relative duties of her station, she marries from affection, without losing sight of prudence, and looking beyond matrimonial felicity, she secures her husband's respect before it is necessary to exert mean arts to please him and feed a dying flame, which nature doomed to expire when the object became familiar, when friendship and forbearance take place of a more ardent affection.—This is the natural death of love, and domestic peace is not destroyed by struggles to prevent its extinction. I also suppose the husband to be virtuous; or she is still more in want of independent principles.

Fate, however, breaks this tie.—She is left a widow, perhaps, without a sufficient provision; but she is not desolate! The pang of nature is felt; but after time has softened sorrow into melancholy resignation, her heart turns to her children with redoubled fondness, and anxious to provide for them, affection gives a sacred heroic cast to her maternal duties. She thinks that not only the eye sees her virtuous efforts from whom all her comfort now must flow, and whose approbation is life; but her imagination, a little abstracted and exalted by grief, dwells on the fond hope that the eyes which her trembling hand closed, may still see how she subdues every wayward passion to fulfil the double duty of being the father as well as the mother of her children. Raised to heroism by misfortunes, she represses the first faint dawning of a natural inclination, before it

[1] 'O how lovely,' exclaims Rousseau, speaking of Sophia, 'is her ignorance! Happy is he who is destined to instruct her! She will never pretend to be the tutor of her husband, but will be content to be his pupil. Far from attempting to subject him to her taste, she will accommodate herself to his. She will be more estimable to him, than if she was learned: he will have a pleasure in instructing her.' *Rousseau's Emilius.**

I shall content myself with simply asking, how friendship can subsist, when love expires, between the master and his pupil?

ripens into love, and in the bloom of life forgets her sex—forgets the pleasure of an awakening passion, which might again have been inspired and returned. She no longer thinks of pleasing, and conscious dignity prevents her from priding herself on account of the praise which her conduct demands. Her children have her love, and her brightest hopes are beyond the grave, where her imagination often strays.

I think I see her surrounded by her children, reaping the reward of her care. The intelligent eye meets hers, whilst health and innocence smile on their chubby cheeks, and as they grow up the cares of life are lessened by their grateful attention. She lives to see the virtues which she endeavoured to plant on principles, fixed into habits, to see her children attain a strength of character sufficient to enable them to endure adversity without forgetting their mother's example.

The task of life thus fulfilled, she calmly waits for the sleep of death, and rising from the grave, may say—Behold, thou gavest me a talent—and here are five talents.*

I wish to sum up what I have said in a few words, for I here throw down my gauntlet, and deny the existence of sexual virtues, not excepting modesty. For man and woman, truth, if I understand the meaning of the word, must be the same; yet the fanciful female character, so prettily drawn by poets and novelists, demanding the sacrifice of truth and sincerity, virtue becomes a relative idea, having no other foundation than utility, and of that utility men pretend arbitrarily to judge, shaping it to their own convenience.

Women, I allow, may have different duties to fulfil; but they are *human* duties, and the principles that should regulate the discharge of them, I sturdily maintain, must be the same.

To become respectable, the exercise of their understanding is necessary, there is no other foundation for independence of character; I mean explicitly to say that they must only bow to the authority of reason, instead of being the *modest* slaves of opinion.

In the superior ranks of life how seldom do we meet with a man of superior abilities, or even common acquirements? The reason appears to me clear, the state they are born in was an unnatural one. The human character has ever been formed by the employments the individual, or class, pursues; and if the faculties are not sharpened by necessity, they must remain obtuse. The argument may fairly be

extended to women; for, seldom occupied by serious business, the pursuit of pleasure gives that insignificancy to their character which renders the society of the *great* so insipid. The same want of firmness, produced by a similar cause, forces them both to fly from themselves to noisy pleasures, and artificial passions, till vanity takes place of every social affection, and the characteristics of humanity can scarcely be discerned. Such are the blessings of civil governments, as they are at present organized, that wealth and female softness equally tend to debase mankind, and are produced by the same cause; but allowing women to be rational creatures, they should be incited to acquire virtues which they may call their own, for how can a rational being be ennobled by any thing that is not obtained by its *own* exertions?

CHAPTER IV

OBSERVATIONS ON THE STATE OF DEGRADATION
TO WHICH WOMAN IS REDUCED
BY VARIOUS CAUSES

That woman is naturally weak, or degraded by a concurrence of circumstances, is, I think, clear. But this position I shall simply contrast with a conclusion, which I have frequently heard fall from sensible men in favour of an aristocracy: that the mass of mankind cannot be any thing, or the obsequious slaves, who patiently allow themselves to be driven forward, would feel their own consequence, and spurn their chains. Men, they further observe, submit every where to oppression, when they have only to lift up their heads to throw off the yoke; yet, instead of asserting their birthright, they quietly lick the dust, and say, let us eat and drink, for to-morrow we die.* Women, I argue from analogy, are degraded by the same propensity to enjoy the present moment; and, at last, despise the freedom which they have not sufficient virtue to struggle to attain. But I must be more explicit.

With respect to the culture of the heart, it is unanimously allowed that sex is out of the question; but the line of subordination in the mental powers is never to be passed over.[1] Only 'absolute in loveliness,'* the portion of rationality granted to woman, is, indeed, very scanty; for, denying her genius and judgment, it is scarcely possible to divine what remains to characterize intellect.

The stamen of immortality, if I may be allowed the phrase, is the perfectibility of human reason; for, were men created perfect, or did a flood of knowledge break in upon him, when he arrived at maturity, that precluded error, I should doubt whether his existence

[1] Into what inconsistencies do men fall when they argue without the compass of principles. Women, weak women, are compared with angels; yet, a superiour order of beings should be supposed to possess more intellect than man; or, in what does their superiority consist? In the same strain, to drop the sneer, they are allowed to possess more goodness of heart, piety, and benevolence.—I doubt the fact, though it be courteously brought forward, unless ignorance be allowed to be the mother of devotion; for I am firmly persuaded that, on an average, the proportion between virtue and knowledge, is more upon a par than is commonly granted.

would be continued after the dissolution of the body. But, in the present state of things, every difficulty in morals that escapes from human discussion, and equally baffles the investigation of profound thinking, and the lightning glance of genius, is an argument on which I build my belief of the immortality of the soul. Reason is, consequentially, the simple power of improvement; or, more properly speaking, of discerning truth. Every individual is in this respect a world in itself. More or less may be conspicuous in one being than another; but the nature of reason must be the same in all, if it be an emanation of divinity, the tie that connects the creature with the Creator; for, can that soul be stamped with the heavenly image, that is not perfected by the exercise of its own reason?[1] Yet outwardly ornamented with elaborate care, and so adorned to delight man, 'that with honour he may love,'[2] the soul of woman is not allowed to have this distinction, and man, ever placed between her and reason, she is always represented as only created to see through a gross medium, and to take things on trust. But dismissing these fanciful theories, and considering woman as a whole, let it be what it will, instead of a part of man, the inquiry is whether she have reason or not. If she have, which, for a moment, I will take for granted, she was not created merely to be the solace of man, and the sexual should not destroy the human character.

Into this error men have, probably, been led by viewing education in a false light; not considering it as the first step to form a being advancing gradually towards perfection;[3] but only as a preparation for life. On this sensual error, for I must call it so, has the false system of female manners been reared, which robs the whole sex of its dignity, and classes the brown and fair with the smiling flowers that only adorn the land. This has ever been the language of men, and the fear of departing from a supposed sexual character, has made even women of superior sense adopt the same sentiments.[4]

[1] 'The brutes,' says Lord Monboddo, 'remain in the state in which nature has placed them, except in so far as their natural instinct is improved by the culture *we* bestow upon them.'*

[2] Vide Milton.*

[3] This word is not strictly just, but I cannot find a better.

[4] 'Pleasure's the portion of th' *inferior* kind;
 But glory, virtue, Heaven for *man* design'd.'*

After writing these lines, how could Mrs Barbauld write the following ignoble comparison?

Thus understanding, strictly speaking, has been denied to woman; and instinct, sublimated into wit and cunning, for the purposes of life, has been substituted in its stead.

The power of generalizing ideas, of drawing comprehensive conclusions from individual observations, is the only acquirement, for an immortal being, that really deserves the name of knowledge. Merely to observe, without endeavouring to account for any thing, may (in a very incomplete manner) serve as the common sense of life; but where is the store laid up that is to clothe the soul when it leaves the body?

This power has not only been denied to women; but writers have insisted that it is inconsistent, with a few exceptions, with their sexual character. Let men prove this, and I shall grant that woman only exists for man. I must, however, previously remark, that the power of generalizing ideas,* to any great extent, is not very common amongst men or women. But this exercise is the true cultivation of the understanding; and every thing conspires to render the cultivation of the understanding more difficult in the female than the male world.

I am naturally led by this assertion to the main subject of the present chapter, and shall now attempt to point out some of the

> 'To a Lady, with some painted flowers.
> Flowers to the fair: to you these flowers I bring,
> And strive to greet you with an earlier spring.
> *Flowers* SWEET, *and gay, and* DELICATE LIKE YOU;
> *Emblems of innocence, and beauty too.*
> With flowers the Graces bind their yellow hair,
> And flowery wreaths consenting lovers wear.
> *Flowers, the sole luxury which nature knew,*
> In Eden's pure and guiltless garden grew.
> *To loftier forms are rougher tasks assign'd;*
> *The sheltering oak, resists the stormy wind,*
> *The tougher yew repels invading foes,*
> *And the tall pine for future navies grows;*
> *But this soft family, to cares unknown,*
> *Were born for pleasure and delight* ALONE.
> Gay without toil, and lovely without art,
> *They spring to* CHEER *the sense, and* GLAD *the heart.*
> Nor blush, my fair, to own you copy these;
> *Your* BEST, *your* SWEETEST *empire* is—TO PLEASE.'*

So the men tell us; but virtue, says reason, must be acquired by *rough* toils, and useful struggles with worldly *cares*.

causes that degrade the sex, and prevent women from generalizing their observations.

I shall not go back to the remote annals of antiquity to trace the history of woman; it is sufficient to allow that she has always been either a slave, or a despot, and to remark, that each of these situations equally retards the progress of reason. The grand source of female folly and vice has ever appeared to me to arise from narrowness of mind; and the very constitution of civil governments has put almost insuperable obstacles in the way to prevent the cultivation of the female understanding:—yet virtue can be built on no other foundation! The same obstacles are thrown in the way of the rich, and the same consequences ensue.

Necessity has been proverbially termed the mother of invention—the aphorism may be extended to virtue. It is an acquirement, and an acquirement to which pleasure must be sacrificed—and who sacrifices pleasure when it is within the grasp, whose mind has not been opened and strengthened by adversity, or the pursuit of knowledge goaded on by necessity?—Happy is it when people have the cares of life to struggle with; for these struggles prevent their becoming a prey to enervating vices, merely from idleness! But, if from their birth men and women be placed in a torrid zone, with the meridian sun of pleasure darting directly upon them, how can they sufficiently brace their minds to discharge the duties of life, or even to relish the affections that carry them out of themselves?

Pleasure is the business of woman's life, according to the present modification of society, and while it continues to be so, little can be expected from such weak beings. Inheriting, in a lineal descent from the first fair defect in nature, the sovereignty of beauty, they have, to maintain their power, resigned the natural rights, which the exercise of reason might have procured them, and chosen rather to be short-lived queens than labour to obtain the sober pleasures that arise from equality. Exalted by their inferiority (this sounds like a contradiction), they constantly demand homage as women, though experience should teach them that the men who pride themselves upon paying this arbitrary insolent respect to the sex, with the most scrupulous exactness, are most inclined to tyrannize over, and despise, the very weakness they cherish. Often do they repeat Mr Hume's sentiments; when, comparing the French and Athenian character, he alludes to women. 'But what is more singular in this

whimsical nation, say I to the Athenians, is, that a frolick of yours during the Saturnalia,* when the slaves are served by their masters, is seriously continued by them through the whole year, and through the whole course of their lives; accompanied too with some circumstances, which still further augment the absurdity and ridicule. Your sport only elevates for a few days those whom fortune has thrown down, and whom she too, in sport, may really elevate for ever above you. But this nation gravely exalts those, whom nature has subjected to them, and whose inferiority and infirmities are absolutely incurable. The women, though without virtue, are their masters and sovereigns.'*

Ah! why do women, I write with affectionate solicitude, condescend to receive a degree of attention and respect from strangers, different from that reciprocation of civility which the dictates of humanity and the politeness of civilization authorise between man and man? And, why do they not discover, when 'in the noon of beauty's power,'* that they are treated like queens only to be deluded by hollow respect, till they are led to resign, or not assume, their natural prerogatives? Confined then in cages like the feathered race, they have nothing to do but to plume themselves, and stalk with mock majesty from perch to perch. It is true they are provided with food and raiment, for which they neither toil nor spin;* but health, liberty, and virtue, are given in exchange. But, where, amongst mankind, has been found sufficient strength of mind to enable a being to resign these adventitious prerogatives; one who, rising with the calm dignity of reason above opinion, dared to be proud of the privileges inherent in man? And it is vain to expect it whilst hereditary power chokes the affections and nips reason in the bud.

The passions of men have thus placed women on thrones, and, till mankind become more reasonable, it is to be feared that women will avail themselves of the power which they attain with the least exertion, and which is the most indisputable. They will smile,—yes, they will smile, though told that—

> 'In beauty's empire is no mean,
> And woman, either slave or queen,
> Is quickly scorn'd when not ador'd.'*

But the adoration comes first, and the scorn is not anticipated.

Lewis the XIVth,* in particular, spread factitious manners, and caught, in a specious way, the whole nation in his toils; for, establishing an artful chain of despotism, he made it the interest of the people at large, individually to respect his station and support his power. And women, whom he flattered by a puerile attention to the whole sex, obtained in his reign that prince-like distinction so fatal to reason and virtue.

A king is always a king—and a woman always a woman:[1] his authority and her sex, ever stand between them and rational converse. With a lover, I grant, she should be so, and her sensibility will naturally lead her to endeavour to excite emotion, not to gratify her vanity, but her heart. This I do not allow to be coquetry, it is the artless impulse of nature, I only exclaim against the sexual desire of conquest when the heart is out of the question.

This desire is not confined to women; 'I have endeavoured,' says Lord Chesterfield, 'to gain the hearts of twenty women, whose persons I would not have given a fig for.'* The libertine, who, in a gust of passion, takes advantage of unsuspecting tenderness, is a saint when compared with this cold-hearted rascal; for I like to use significant words. Yet only taught to please, women are always on the watch to please, and with true heroic ardour endeavour to gain hearts merely to resign or spurn them, when the victory is decided, and conspicuous.

I must descend to the minutiae of the subject.

I lament that women are systematically degraded by receiving the trivial attentions, which men think it manly to pay to the sex, when, in fact, they are insultingly supporting their own superiority. It is not condescension to bow to an inferior. So ludicrous, in fact, do these ceremonies appear to me, that I scarcely am able to govern my muscles, when I see a man start with eager, and serious solicitude, to lift a handkerchief, or shut a door, when the *lady* could have done it herself, had she only moved a pace or two.

A wild wish has just flown from my heart to my head, and I will not stifle it though it may excite a horse-laugh.—I do earnestly wish to see the distinction of sex confounded in society, unless where love animates the behaviour. For this distinction is, I am firmly per-

[1] And a wit, always a wit, might be added; for the vain fooleries of wits and beauties to obtain attention, and make conquests, are much upon a par.

suaded, the foundation of the weakness of character ascribed to woman; is the cause why the understanding is neglected, whilst accomplishments are acquired with sedulous care: and the same cause accounts for their preferring the graceful before the heroic virtues.

Mankind, including every description, wish to be loved and respected by *something*; and the common herd will always take the nearest road to the completion of their wishes. The respect paid to wealth and beauty is the most certain, and unequivocal; and, of course, will always attract the vulgar eye of common minds. Abilities and virtues are absolutely necessary to raise men from the middle rank of life into notice; and the natural consequence is notorious, the middle rank contains most virtue and abilities. Men have thus, in one station, at least an opportunity of exerting themselves with dignity, and of rising by the exertions which really improve a rational creature; but the whole female sex are, till their character is formed, in the same condition as the rich: for they are born, I now speak of a state of civilization, with certain sexual privileges, and whilst they are gratuitously granted them, few will ever think of works of supererogation, to obtain the esteem of a small number of superiour people.

When do we hear of women who, starting out of obscurity, boldly claim respect on account of their great abilities or daring virtues? Where are they to be found?—'To be observed, to be attended to, to be taken notice of with sympathy, complacency, and approbation, are all the advantages which they seek.'*—True! my male readers will probably exclaim; but let them, before they draw any conclusion, recollect that this was not written originally as descriptive of women, but of the rich. In Dr Smith's Theory of Moral Sentiments, I have found a general character of people of rank and fortune, that, in my opinion, might with the greatest propriety be applied to the female sex. I refer the sagacious reader to the whole comparison; but must be allowed to quote a passage to enforce an argument that I mean to insist on, as the one most conclusive against a sexual character. For if, excepting warriors, no great men, of any denomination, have ever appeared amongst the nobility, may it not be fairly inferred that their local situation swallowed up the man, and produced a character similar to that of women, who are *localized*, if I may be allowed the word, by the rank they are placed in, by *courtesy*?

Women, commonly called Ladies, are not to be contradicted in company, are not allowed to exert any manual strength; and from them the negative virtues only are expected, when any virtues are expected, patience, docility, good-humour, and flexibility; virtues incompatible with any vigorous exertion of intellect. Besides, by living more with each other, and being seldom absolutely alone, they are more under the influence of sentiments than passions. Solitude and reflection are necessary to give to wishes the force of passions, and to enable the imagination to enlarge the object, and make it the most desirable. The same may be said of the rich; they do not sufficiently deal in general ideas, collected by impassioned thinking, or calm investigation, to acquire that strength of character on which great resolves are built. But hear what an acute observer says of the great.

'Do the great seem insensible of the easy price at which they may acquire the publick admiration; or do they seem to imagine that to them, as to other men, it must be the purchase either of sweat or of blood? By what important accomplishments is the young nobleman instructed to support the dignity of his rank, and to render himself worthy of that superiority over his fellow-citizens, to which the virtue of his ancestors had raised them? Is it by knowledge, by industry, by patience, by self-denial, or by virtue of any kind? As all his words, as all his motions are attended to, he learns an habitual regard to every circumstance of ordinary behaviour, and studies to perform all those small duties with the most exact propriety. As he is conscious how much he is observed, and how much mankind are disposed to favour all his inclinations, he acts, upon the most indifferent occasions, with that freedom and elevation which the thought of this naturally inspires. His air, his manner, his deportment, all mark that elegant and graceful sense of his own superiority, which those who are born to inferior station can hardly ever arrive at. These are the arts by which he proposes to make mankind more easily submit to his authority, and to govern their inclinations according to his own pleasure: and in this he is seldom disappointed. These arts, supported by rank and pre-eminence, are, upon ordinary occasions, sufficient to govern the world. Lewis XIV during the greater part of his reign, was regarded, not only in France, but over all Europe, as the most perfect model of a great prince. But what were the talents and virtues by which he acquired this great reputa-

tion? Was it by the scrupulous and inflexible justice of all his under-
takings, by the immense dangers and difficulties with which they
were attended, or by the unwearied and unrelenting application
with which he pursued them? Was it by his extensive knowledge, by
his exquisite judgment, or by his heroic valour? It was by none of
these qualities. But he was, first of all, the most powerful prince in
Europe, and consequently held the highest rank among kings; and
then, says his historian, "he surpassed all his courtiers in the grace-
fulness of his shape, and the majestic beauty of his features. The
sound of his voice, noble and affecting, gained those hearts which
his presence intimidated. He had a step and a deportment which
could suit only him and his rank, and which would have been
ridiculous in any other person. The embarrassment which he occa-
sioned to those who spoke to him, flattered that secret satisfaction
with which he felt his own superiority."* These frivolous accom-
plishments, supported by his rank, and, no doubt too, by a degree of
other talents and virtues, which seems, however, not to have been
much above mediocrity, established this prince in the esteem of his
own age, and have drawn, even from posterity, a good deal of respect
for his memory. Compared with these, in his own times, and in his
own presence, no other virtue, it seems, appeared to have any merit.
Knowledge, industry, valour, and beneficence, trembled, were
abashed, and lost all dignity before them.'*

Woman also thus 'in herself complete,'* by possessing all these
frivolous accomplishments, so changes the nature of things

> ——'That what she wills to do or say
> Seems wisest, virtuousest, discreetest, best;
> All higher knowledge in *her presence* falls
> Degraded. Wisdom in discourse with her
> Loses discountenanc'd, and, like Folly, shows;
> Authority and Reason on her wait,'—*

And all this is built on her loveliness!

In the middle rank of life, to continue the comparison, men, in their
youth, are prepared for professions, and marriage is not considered
as the grand feature in their lives, whilst women, on the contrary,
have no other scheme to sharpen their faculties. It is not business,
extensive plans, or any of the excursive flights of ambition, that

engross their attention; no, their thoughts are now employed in rearing such noble structures. To rise in the world, and have the liberty of running from pleasure to pleasure, they must marry advantageously, and to this object their time is sacrificed, and their persons often legally prostituted.* A man when he enters any profession has his eye steadily fixed on some future advantage (and the mind gains great strength by having all its efforts directed to one point), and, full of his business, pleasure is considered as mere relaxation; whilst women seek for pleasure as the main purpose of existence. In fact, from the education, which they receive from society, the love of pleasure may be said to govern them all; but does this prove that there is a sex in souls? It would be just as rational to declare that the courtiers in France, when a destructive system of despotism had formed their character, were not men, because liberty, virtue, and humanity, were sacrificed to pleasure and vanity.— Fatal passions, which have ever domineered over the *whole* race!

The same love of pleasure, fostered by the whole tendency of their education, gives a trifling turn to the conduct of women in most circumstances: for instance, they are ever anxious about secondary things; and on the watch for adventures, instead of being occupied by duties.

A man, when he undertakes a journey, has, in general, the end in view; a woman thinks more of the incidental occurrences, the strange things that may possibly occur on the road; the impression that she may make on her fellow-travellers; and, above all, she is anxiously intent on the care of the finery that she carries with her, which is more than ever a part of herself, when going to figure on a new scene; when, to use an apt French turn of expression, she is going to produce a sensation.—Can dignity of mind exist with such trivial cares?

In short, women, in general, as well as the rich of both sexes, have acquired all the follies and vices of civilization, and missed the useful fruit. It is not necessary for me always to premise, that I speak of the condition of the whole sex, leaving exceptions out of the question. Their senses are inflamed, and their understandings neglected, consequently they become the prey of their senses, delicately termed sensibility, and are blown about by every momentary gust of feeling. Civilized women are, therefore, so weakened by false refinement, that, respecting morals, their condition is much below

what it would be were they left in a state nearer to nature. Ever restless and anxious, their over exercised sensibility not only renders them uncomfortable themselves, but troublesome, to use a soft phrase, to others. All their thoughts turn on things calculated to excite emotion; and feeling, when they should reason, their conduct is unstable, and their opinions are wavering—not the wavering produced by deliberation or progressive views, but by contradictory emotions. By fits and starts they are warm in many pursuits; yet this warmth, never concentrated into perseverance, soon exhausts itself; exhaled by its own heat, or meeting with some other fleeting passion, to which reason has never given any specific gravity, neutrality ensues. Miserable indeed, must be that being whose cultivation of mind has only tended to inflame its passions! A distinction should be made between inflaming and strengthening them. The passions thus pampered, whilst the judgment is left unformed, what can be expected to ensue?—Undoubtedly, a mixture of madness and folly!

This observation should not be confined to the *fair* sex; however, at present, I only mean to apply it to them.

Novels, music, poetry, and gallantry, all tend to make women the creatures of sensation, and their character is thus formed in the mould of folly during the time they are acquiring accomplishments, the only improvement they are excited, by their station in society, to acquire. This overstretched sensibility naturally relaxes the other powers of the mind, and prevents intellect from attaining that sovereignty which it ought to attain to render a rational creature useful to others, and content with its own station: for the exercise of the understanding, as life advances, is the only method pointed out by nature to calm the passions.

Satiety has a very different effect, and I have often been forcibly struck by an emphatical description of damnation:—when the spirit is represented as continually hovering with abortive eagerness round the defiled body, unable to enjoy any thing without the organs of sense. Yet, to their senses, are women made slaves, because it is by their sensibility that they obtain present power.

And will moralists pretend to assert, that this is the condition in which one half of the human race should be encouraged to remain with listless inactivity and stupid acquiescence? Kind instructors! what were we created for? To remain, it may be said, innocent; they mean in a state of childhood.—We might as well never have been

born, unless it were necessary that we should be created to enable man to acquire the noble privilege of reason, the power of discerning good from evil, whilst we lie down in the dust from whence we were taken, never to rise again.—

It would be an endless task to trace the variety of meannesses, cares, and sorrows, into which women are plunged by the prevailing opinion, that they were created rather to feel than reason, and that all the power they obtain, must be obtained by their charms and weakness:

<div style="text-align:center">'Fine by defect, and amiably weak!'*</div>

And, made by this amiable weakness entirely dependent, excepting what they gain by illicit sway, on man, not only for protection, but advice, is it surprising that, neglecting the duties that reason alone points out, and shrinking from trials calculated to strengthen their minds, they only exert themselves to give their defects a graceful covering, which may serve to heighten their charms in the eye of the voluptuary, though it sink them below the scale of moral excellence?

Fragile in every sense of the word, they are obliged to look up to man for every comfort. In the most trifling dangers they cling to their support, with parasitical tenacity, piteously demanding succour; and their *natural* protector extends his arm, or lifts up his voice, to guard the lovely trembler—from what? Perhaps the frown of an old cow, or the jump of a mouse; a rat, would be a serious danger. In the name of reason, and even common sense, what can save such beings from contempt; even though they be soft and fair?

These fears, when not affected, may produce some pretty attitudes; but they shew a degree of imbecility which degrades a rational creature in a way women are not aware of—for love and esteem are very distinct things.

I am fully persuaded that we should hear of none of these infantine airs, if girls were allowed to take sufficient exercise, and not confined in close rooms till their muscles are relaxed, and their powers of digestion destroyed. To carry the remark still further, if fear in girls, instead of being cherished, perhaps, created, were treated in the same manner as cowardice in boys, we should quickly see women with more dignified aspects. It is true, they could not then with equal propriety be termed the sweet flowers that smile in

the walk of man; but they would be more respectable members of society, and discharge the important duties of life by the light of their own reason. 'Educate women like men,' says Rousseau, 'and the more they resemble our sex the less power will they have over us.'* This is the very point I aim at. I do not wish them to have power over men; but over themselves.

In the same strain have I heard men argue against instructing the poor; for many are the forms that aristocracy assumes. 'Teach them to read and write,' say they, 'and you take them out of the station assigned them by nature.' An eloquent Frenchman has answered them, I will borrow his sentiments. But they know not, when they make man a brute, that they may expect every instant to see him transformed into a ferocious beast. Without knowledge there can be no morality!

Ignorance is a frail base for virtue! Yet, that it is the condition for which woman was organized, has been insisted upon by the writers who have most vehemently argued in favour of the superiority of man; a superiority not in degree, but essence; though, to soften the argument, they have laboured to prove, with chivalrous generosity, that the sexes ought not to be compared; man was made to reason, woman to feel: and that together, flesh and spirit, they make the most perfect whole, by blending happily reason and sensibility into one character.

And what is sensibility? 'Quickness of sensation; quickness of perception; delicacy.' Thus is it defined by Dr Johnson;* and the definition gives me no other idea than of the most exquisitely polished instinct. I discern not a trace of the image of God in either sensation or matter. Refined seventy times seven,* they are still material; intellect dwells not there; nor will fire ever make lead gold!

I come round to my old argument; if woman be allowed to have an immortal soul, she must have, as the employment of life, an understanding to improve. And when, to render the present state more complete, though every thing proves it to be but a fraction of a mighty sum, she is incited by present gratification to forget her grand destination, nature is counteracted, or she was born only to procreate and rot. Or, granting brutes, of every description, a soul, though not a reasonable one, the exercise of instinct and sensibility may be the step, which they are to take, in this life, towards the attainment of reason in the next; so that through all eternity they

will lag behind man, who, why we cannot tell, had the power given him of attaining reason in his first mode of existence.

When I treat of the peculiar duties of women, as I should treat of the peculiar duties of a citizen or father, it will be found that I do not mean to insinuate that they should be taken out of their families, speaking of the majority. 'He that hath wife and children,' says Lord Bacon, 'hath given hostages to fortune; for they are impediments to great enterprises, either of virtue or mischief. Certainly the best works, and of greatest merit for the public, have proceeded from the unmarried or childless men.'* I say the same of women. But, the welfare of society is not built on extraordinary exertions; and were it more reasonably organized, there would be still less need of great abilities, or heroic virtues.

In the regulation of a family, in the education of children, understanding, in an unsophisticated sense, is particularly required: strength both of body and mind; yet the men who, by their writings, have most earnestly laboured to domesticate women, have endeavoured, by arguments dictated by a gross appetite, which satiety had rendered fastidious, to weaken their bodies and cramp their minds. But, if even by these sinister methods they really *persuaded* women, by working on their feelings, to stay at home, and fulfil the duties of a mother and mistress of a family, I should cautiously oppose opinions that led women to right conduct, by prevailing on them to make the discharge of such important duties the main business of life, though reason were insulted. Yet, and I appeal to experience, if by neglecting the understanding they be as much, nay, more detached from these domestic employments, than they could be by the most serious intellectual pursuit, though it may be observed, that the mass of mankind will never vigorously pursue an intellectual object,[1] I may be allowed to infer that reason is absolutely necessary to enable a woman to perform any duty properly, and I must again repeat, that sensibility is not reason.

The comparison with the rich still occurs to me; for, when men neglect the duties of humanity, women will follow their example; a common stream hurries them both along with thoughtless celerity. Riches and honours prevent a man from enlarging his understanding, and enervate all his powers by reversing the order of nature,

[1] The mass of mankind are rather the slaves of their appetites than of their passions.

which has ever made true pleasure the reward of labour. Pleasure—enervating pleasure is, likewise, within women's reach without earning it. But, till hereditary possessions are spread abroad, how can we expect men to be proud of virtue? And, till they are, women will govern them by the most direct means, neglecting their dull domestic duties to catch the pleasure that sits lightly on the wing of time.

'The power of the woman,' says some author, 'is her sensibility';* and men, not aware of the consequence, do all they can to make this power swallow up every other. Those who constantly employ their sensibility will have most: for example; poets, painters, and composers.[1] Yet, when the sensibility is thus increased at the expence of reason, and even the imagination, why do philosophical men complain of their fickleness? The sexual attention of man particularly acts on female sensibility, and this sympathy has been exercised from their youth up. A husband cannot long pay those attentions with the passion necessary to excite lively emotions, and the heart, accustomed to lively emotions, turns to a new lover, or pines in secret, the prey of virtue or prudence. I mean when the heart has really been rendered susceptible, and the taste formed; for I am apt to conclude, from what I have seen in fashionable life, that vanity is oftener fostered than sensibility by the mode of education, and the intercourse between the sexes, which I have reprobated; and that coquetry more frequently proceeds from vanity than from that inconstancy, which overstrained sensibility naturally produces.

Another argument that has had great weight with me, must, I think, have some force with every considerate benevolent heart. Girls who have been thus weakly educated, are often cruelly left by their parents without any provision; and, of course, are dependent on, not only the reason, but the bounty of their brothers. These brothers are, to view the fairest side of the question, good sort of men, and give as a favour, what children of the same parents had an equal right to. In this equivocal humiliating situation, a docile female may remain some time, with a tolerable degree of comfort. But, when the brother marries, a probable circumstance, from being considered as the mistress of the family, she is viewed with averted

[1] Men of these descriptions pour it into their compositions, to amalgamate the gross materials; and, moulding them with passion, give to the inert body a soul; but, in woman's imagination, love alone concentrates these ethereal beams.

looks as an intruder, an unnecessary burden on the benevolence of the master of the house, and his new partner.

Who can recount the misery, which many unfortunate beings, whose minds and bodies are equally weak, suffer in such situations—unable to work, and ashamed to beg? The wife, a cold-hearted, narrow-minded, woman, and this is not an unfair supposition; for the present mode of education does not tend to enlarge the heart any more than the understanding, is jealous of the little kindness which her husband shews to his relations; and her sensibility not rising to humanity, she is displeased at seeing the property of *her* children lavished on an helpless sister.

These are matters of fact, which have come under my eye again and again. The consequence is obvious, the wife has recourse to cunning to undermine the habitual affection, which she is afraid openly to oppose; and neither tears nor caresses are spared till the spy is worked out of her home, and thrown on the world, unprepared for its difficulties; or sent, as a great effort of generosity, or from some regard to propriety, with a small stipend, and an uncultivated mind, into joyless solitude.

These two women may be much upon a par, with respect to reason and humanity; and changing situations, might have acted just the same selfish part; but had they been differently educated, the case would also have been very different. The wife would not have had that sensibility, of which self is the centre, and reason might have taught her not to expect, and not even to be flattered by, the affection of her husband, if it led him to violate prior duties. She would wish not to love him merely because he loved her, but on account of his virtues; and the sister might have been able to struggle for herself instead of eating the bitter bread of dependence.

I am, indeed, persuaded that the heart, as well as the understanding, is opened by cultivation; and by, which may not appear so clear, strengthening the organs; I am not now talking of momentary flashes of sensibility, but of affections. And, perhaps, in the education of both sexes, the most difficult task is so to adjust instruction as not to narrow the understanding, whilst the heart is warmed by the generous juices of spring, just raised by the electric fermentation of the season; nor to dry up the feelings by employing the mind in investigations remote from life.

With respect to women, when they receive a careful education, they are either made fine ladies, brimful of sensibility, and teeming with capricious fancies; or merely notable women. The latter are often friendly, honest creatures, and have a shrewd kind of good sense joined with worldly prudence, that often render them more useful members of society than the fine sentimental lady, though they possess neither greatness of mind nor taste. The intellectual world is shut against them; take them out of their family or neighbourhood, and they stand still; the mind finding no employment, for literature affords a fund of amusement which they have never sought to relish, but frequently to despise. The sentiments and taste of more cultivated minds appear ridiculous, even in those whom chance and family connections have led them to love; but in mere acquaintance they think it all affectation.

A man of sense can only love such a woman on account of her sex, and respect her, because she is a trusty servant. He lets her, to preserve his own peace, scold the servants, and go to church in clothes made of the very best materials. A man of her own size of understanding would, probably, not agree so well with her; for he might wish to encroach on her prerogative, and manage some domestic concerns himself. Yet women, whose minds are not enlarged by cultivation, or the natural selfishness of sensibility expanded by reflection, are very unfit to manage a family; for, by an undue stretch of power, they are always tyrannizing to support a superiority that only rests on the arbitrary distinction of fortune. The evil is sometimes more serious, and domestics are deprived of innocent indulgences, and made to work beyond their strength, in order to enable the notable woman to keep a better table, and outshine her neighbours in finery and parade. If she attend to her children, it is, in general, to dress them in a costly manner—and, whether this attention arise from vanity or fondness, it is equally pernicious.

Besides, how many women of this description pass their days; or, at least, their evenings, discontentedly. Their husbands acknowledge that they are good managers, and chaste wives; but leave home to seek for more agreeable, may I be allowed to use a significant French word, *piquant* society; and the patient drudge, who fulfils her task, like a blind horse in a mill, is defrauded of her just reward; for the wages due to her are the caresses of her husband; and women

who have so few resources in themselves, do not very patiently bear this privation of a natural right.

A fine lady, on the contrary, has been taught to look down with contempt on the vulgar employments of life; though she has only been incited to acquire accomplishments that rise a degree above sense; for even corporeal accomplishments cannot be acquired with any degree of precision unless the understanding has been strengthened by exercise. Without a foundation of principles taste is superficial, grace must arise from something deeper than imitation. The imagination, however, is heated, and the feelings rendered fastidious, if not sophisticated; or, a counterpoise of judgment is not acquired, when the heart still remains artless, though it becomes too tender.

These women are often amiable; and their hearts are really more sensible to general benevolence, more alive to the sentiments that civilize life, than the square-elbowed family drudge; but, wanting a due proportion of reflection and self-government, they only inspire love; and are the mistresses of their husbands, whilst they have any hold on their affections; and the platonic friends of his male acquaintance. These are the fair defects in nature; the women who appear to be created not to enjoy the fellowship of man, but to save him from sinking into absolute brutality, by rubbing off the rough angles of his character; and by playful dalliance to give some dignity to the appetite that draws him to them.—Gracious Creator of the whole human race! hast thou created such a being as woman, who can trace thy wisdom in thy works, and feel that thou alone art by thy nature exalted above her,—for no better purpose?—Can she believe that she was only made to submit to man, her equal, a being, who, like her, was sent into the world to acquire virtue?—Can she consent to be occupied merely to please him; merely to adorn the earth, when her soul is capable of rising to thee?—And can she rest supinely dependent on man for reason, when she ought to mount with him the arduous steeps of knowledge?—

Yet, if love be the supreme good, let women be only educated to inspire it, and let every charm be polished to intoxicate the senses; but, if they be moral beings, let them have a chance to become intelligent; and let love to man be only a part of that glowing flame of universal love, which, after encircling humanity, mounts in grateful incense to God.

To fulfil domestic duties much resolution is necessary, and a serious kind of perseverance that requires a more firm support than emotions, however lively and true to nature. To give an example of order, the soul of virtue, some austerity of behaviour must be adopted, scarcely to be expected from a being who, from its infancy, has been made the weathercock of its own sensations. Whoever rationally means to be useful must have a plan of conduct; and, in the discharge of the simplest duty, we are often obliged to act contrary to the present impulse of tenderness or compassion. Severity is frequently the most certain, as well as the most sublime proof of affection; and the want of this power over the feelings, and of that lofty, dignified affection, which makes a person prefer the future good of the beloved object to a present gratification, is the reason why so many fond mothers spoil their children, and has made it questionable whether negligence or indulgence be most hurtful: but I am inclined to think, that the latter has done most harm.

Mankind seem to agree that children should be left under the management of women during their childhood. Now, from all the observation that I have been able to make, women of sensibility are the most unfit for this task, because they will infallibly, carried away by their feelings, spoil a child's temper. The management of the temper, the first, and most important branch of education, requires the sober steady eye of reason; a plan of conduct equally distant from tyranny and indulgence: yet these are the extremes that people of sensibility alternately fall into; always shooting beyond the mark. I have followed this train of reasoning much further, till I have concluded, that a person of genius is the most improper person to be employed in education, public or private. Minds of this rare species see things too much in masses, and seldom, if ever, have a good temper. That habitual cheerfulness, termed good-humour, is, perhaps, as seldom united with great mental powers, as with strong feelings. And those people who follow, with interest and admiration, the flights of genius; or, with cooler approbation suck in the instruction which has been elaborately prepared for them by the profound thinker, ought not to be disgusted, if they find the former choleric, and the latter morose; because liveliness of fancy, and a tenacious comprehension of mind, are scarcely compatible with that pliant urbanity which leads a man, at least, to bend to the opinions and prejudices of others, instead of roughly confronting them.

But, treating of education or manners, minds of a superior class are not to be considered, they may be left to chance; it is the multitude, with moderate abilities, who call for instruction, and catch the colour of the atmosphere they breathe. This respectable concourse, I contend, men and women, should not have their sensations heightened in the hot-bed of luxurious indolence, at the expence of their understanding; for, unless there be a ballast of understanding, they will never become either virtuous or free: an aristocracy, founded on property, or sterling talents, will ever sweep before it, the alternately timid, and ferocious, slaves of feeling.

Numberless are the arguments, to take another view of the subject, brought forward with a shew of reason, because supposed to be deduced from nature, that men have used morally and physically, to degrade the sex. I must notice a few.

The female understanding has often been spoken of with contempt, as arriving sooner at maturity than the male. I shall not answer this argument by alluding to the early proofs of reason, as well as genius, in Cowley, Milton, and Pope,[1]* but only appeal to experience to decide whether young men, who are early introduced into company (and examples now abound), do not acquire the same precocity. So notorious is this fact, that the bare mentioning of it must bring before people, who at all mix in the world, the idea of a number of swaggering apes of men, whose understandings are narrowed by being brought into the society of men when they ought to have been spinning a top or twirling a hoop.

It has also been asserted, by some naturalists, that men do not attain their full growth and strength till thirty; but that women arrive at maturity by twenty.* I apprehend that they reason on false ground, led astray by the male prejudice, which deems beauty the perfection of woman—mere beauty of features and complexion, the vulgar acceptation of the word, whilst male beauty is allowed to have some connection with the mind. Strength of body, and that character of countenance, which the French term a *physionomie*, women do not acquire before thirty, any more than men. The little artless tricks of children, it is true, are particularly pleasing and attractive; yet, when the pretty freshness of youth is worn off, these artless graces become studied airs, and disgust every person of taste. In the

[1] Many other names might be added.

countenance of girls we only look for vivacity and bashful modesty; but, the spring-tide of life over, we look for soberer sense in the face, and for traces of passion, instead of the dimples of animal spirits; expecting to see individuality of character, the only fastener of the affections.[1] We then wish to converse, not to fondle; to give scope to our imaginations as well as to the sensations of our hearts.

At twenty the beauty of both sexes is equal; but the libertinism of man leads him to make the distinction, and superannuated coquettes are commonly of the same opinion; for, when they can no longer inspire love, they pay for the vigour and vivacity of youth. The French, who admit more of mind into their notions of beauty, give the preference to women of thirty. I mean to say that they allow women to be in their most perfect state, when vivacity gives place to reason, and to that majestic seriousness of character, which marks maturity;—or, the resting point. In youth, till twenty, the body shoots out, till thirty the solids are attaining a degree of density; and the flexible muscles, growing daily more rigid, give character to the countenance; that is, they trace the operations of the mind with the iron pen of fate, and tell us not only what powers are within, but how they have been employed.

It is proper to observe, that animals who arrive slowly at maturity, are the longest lived, and of the noblest species. Men cannot, however, claim any natural superiority from the grandeur of longevity; for in this respect nature has not distinguished the male.

Polygamy is another physical degradation; and a plausible argument for a custom, that blasts every domestic virtue, is drawn from the well-attested fact, that in the countries where it is established, more females are born than males. This appears to be an indication of nature, and to nature, apparently reasonable speculations must yield. A further conclusion obviously presented itself; if polygamy be necessary, woman must be inferior to man, and made for him.

With respect to the formation of the fetus in the womb, we are very ignorant; but it appears to me probable, that an accidental physical cause may account for this phenomenon, and prove it not to be a law of nature. I have met with some pertinent observations on the subject in Forster's Account of the Isles of the South-Sea, that

[1] The strength of an affection is, generally, in the same proportion as the character of the species in the object beloved, is lost in that of the individual.

will explain my meaning. After observing that of the two sexes amongst animals, the most vigorous and hottest constitution always prevails, and produces its kind; he adds,—'If this be applied to the inhabitants of Africa, it is evident that the men there, accustomed to polygamy, are enervated by the use of so many women, and therefore less vigorous; the women, on the contrary, are of a hotter constitution, not only on account of their more irritable nerves, more sensible organization, and more lively fancy; but likewise because they are deprived in their matrimony of that share of physical love which, in a monogamous condition, would all be theirs; and thus, for the above reasons, the generality of children are born females.*

'In the greater part of Europe it has been proved by the most accurate lists of mortality, that the proportion of men to women is nearly equal, or, if any difference takes place, the males born are more numerous, in the proportion of 105 to 100.'

The necessity of polygamy, therefore, does not appear; yet when a man seduces a woman, it should, I think be termed a *left-handed* marriage, and the man should be *legally* obliged to maintain the woman and her children, unless adultery, a natural divorcement, abrogated the law. And this law should remain in force as long as the weakness of women caused the word seduction to be used as an excuse for their frailty and want of principle; nay, while they depend on man for a subsistence, instead of earning it by the exertion of their own hands or heads. But these women should not, in the full meaning of the relationship, be termed wives, or the very purpose of marriage would be subverted, and all those endearing charities that flow from personal fidelity, and give a sanctity to the tie, when neither love nor friendship unites the hearts, would melt into selfishness. The woman who is faithful to the father of her children demands respect, and should not be treated like a prostitute; though I readily grant that if it be necessary for a man and woman to live together in order to bring up their offspring, nature never intended that a man should have more than one wife.

Still, highly as I respect marriage, as the foundation of almost every social virtue, I cannot avoid feeling the most lively compassion for those unfortunate females who are broken off from society, and by one error torn from all those affections and relationships that improve the heart and mind. It does not frequently even deserve the

name of error; for many innocent girls become the dupes of a sincere, affectionate heart, and still more are, as it may emphatically be termed, *ruined* before they know the difference between virtue and vice:—and thus prepared by their education for infamy, they become infamous. Asylums and Magdalens* are not the proper remedies for these abuses. It is justice, not charity, that is wanting in the world!

A woman who has lost her honour, imagines that she cannot fall lower, and as for recovering her former station, it is impossible; no exertion can wash this stain away. Losing thus every spur, and having no other means of support, prostitution becomes her only refuge, and the character is quickly depraved by circumstances over which the poor wretch has little power, unless she possesses an uncommon portion of sense and loftiness of spirit. Necessity never makes prostitution the business of men's lives; though numberless are the women who are thus rendered systematically vicious. This, however, arises, in a great degree, from the state of idleness in which women are educated, who are always taught to look up to man for a maintenance, and to consider their persons as the proper return for his exertions to support them. Meretricious airs, and the whole science of wantonness, have then a more powerful stimulus than either appetite or vanity; and this remark gives force to the prevailing opinion, that with chastity all is lost that is respectable in woman. Her character depends on the observance of one virtue, though the only passion fostered in her heart—is love. Nay, the honour of a woman is not made even to depend on her will.

When Richardson[1] makes Clarissa tell Lovelace that he had robbed her of her honour,* he must have had strange notions of honour and virtue. For, miserable beyond all names of misery is the condition of a being, who could be degraded without its own consent! This excess of strictness I have heard vindicated as a salutary error. I shall answer in the words of Leibnitz—'Errors are often useful; but it is commonly to remedy other errors.'*

Most of the evils of life arise from a desire of present enjoyment that outruns itself. The obedience required of women in the marriage state comes under this description; the mind, naturally weak-

[1] Dr Young supports the same opinion, in his plays, when he talks of the misfortune that shunned the light of day.*

ened by depending on authority, never exerts its own powers, and the obedient wife is thus rendered a weak indolent mother. Or, supposing that this is not always the consequence, a future state of existence is scarcely taken into the reckoning when only negative virtues are cultivated. For, in treating of morals, particularly when women are alluded to, writers have too often considered virtue in a very limited sense, and made the foundation of it *solely* worldly utility; nay, a still more fragile base has been given to this stupendous fabric, and the wayward fluctuating feelings of men have been made the standard of virtue. Yes, virtue as well as religion, has been subjected to the decisions of taste.

It would almost provoke a smile of contempt, if the vain absurdities of man did not strike us on all sides, to observe, how eager men are to degrade the sex from whom they pretend to receive the chief pleasure of life; and I have frequently with full conviction retorted Pope's sarcasm on them; or, to speak explicitly, it has appeared to me applicable to the whole human race. A love of pleasure or sway* seems to divide mankind, and the husband who lords it in his little haram thinks only of his pleasure or his convenience. To such lengths, indeed, does an intemperate love of pleasure carry some prudent men, or worn out libertines, who marry to have a safe bedfellow, that they seduce their own wives.—Hymen banishes modesty, and chaste love takes its flight.

Love, considered as an animal appetite, cannot long feed on itself without expiring. And this extinction in its own flame, may be termed the violent death of love. But the wife who has thus been rendered licentious, will probably endeavour to fill the void left by the loss of her husband's attentions; for she cannot contentedly become merely an upper servant after having been treated like a goddess. She is still handsome, and, instead of transferring her fondness to her children, she only dreams of enjoying the sunshine of life. Besides there are many husbands so devoid of sense and parental affection, that during the first effervescence of voluptuous fondness they refuse to let their wives suckle their children. They are only to dress and live to please them: and love—even innocent love, soon sinks into lasciviousness when the exercise of a duty is sacrificed to its indulgence.

Personal attachment is a very happy foundation for friendship; yet, when even two virtuous young people marry, it would, perhaps,

be happy if some circumstances checked their passion; if the recollection of some prior attachment, or disappointed affection, made it on one side, at least, rather a match founded on esteem. In that case they would look beyond the present moment, and try to render the whole of life respectable, by forming a plan to regulate a friendship which only death ought to dissolve.

Friendship is a serious affection; the most sublime of all affections, because it is founded on principle, and cemented by time. The very reverse may be said of love. In a great degree, love and friendship cannot subsist in the same bosom; even when inspired by different objects they weaken or destroy each other, and for the same object can only be felt in succession. The vain fears and fond jealousies, the winds which fan the flame of love, when judiciously or artfully tempered, are both incompatible with the tender confidence and sincere respect of friendship.

Love, such as the glowing pen of genius has traced, exists not on earth, or only resides in those exalted, fervid imaginations that have sketched such dangerous pictures. Dangerous, because they not only afford a plausible excuse, to the voluptuary who disguises sheer sensuality under a sentimental veil; but as they spread affectation, and take from the dignity of virtue. Virtue, as the very word imports, should have an appearance of seriousness, if not of austerity; and to endeavour to trick her out in the garb of pleasure, because the epithet has been used as another name for beauty, is to exalt her on a quicksand; a most insidious attempt to hasten her fall by apparent respect. Virtue and pleasure are not, in fact, so nearly allied in this life as some eloquent writers* have laboured to prove. Pleasure prepares the fading wreath, and mixes the intoxicating cup; but the fruit which virtue gives, is the recompence of toil: and, gradually seen as it ripens, only affords calm satisfaction; nay, appearing to be the result of the natural tendency of things, it is scarcely observed. Bread, the common food of life, seldom thought of as a blessing, supports the constitution and preserves health; still feasts delight the heart of man, though disease and even death lurk in the cup or dainty that elevates the spirits or tickles the palate. The lively heated imagination likewise, to apply the comparison, draws the picture of love, as it draws every other picture, with those glowing colours, which the daring hand will steal from the rainbow that is directed by a mind, condemned in a world like this, to prove its noble origin by

panting after unattainable perfection; ever pursuing what it acknowledges to be a fleeting dream. An imagination of this vigorous cast can give existence to insubstantial forms, and stability to the shadowy reveries which the mind naturally falls into when realities are found vapid. It can then depict love with celestial charms, and dote on the grand ideal object—it can imagine a degree of mutual affection that shall refine the soul, and not expire when it has served as a 'scale to heavenly;'* and, like devotion, make it absorb every meaner affection and desire. In each others arms, as in a temple, with its summit lost in the clouds, the world is to be shut out, and every thought and wish, that do not nurture pure affection and permanent virtue.—Permanent virtue! alas! Rousseau, respectable visionary! thy paradise* would soon be violated by the entrance of some unexpected guest. Like Milton's it would only contain angels, or men sunk below the dignity of rational creatures. Happiness is not material, it cannot be seen or felt! Yet the eager pursuit of the good which every one shapes to his own fancy, proclaims man the lord of this lower world, and to be an intelligential creature, who is not to receive, but acquire happiness. They, therefore, who complain of the delusions of passion, do not recollect that they are exclaiming against a strong proof of the immortality of the soul.

But leaving superior minds to correct themselves, and pay dearly for their experience, it is necessary to observe, that it is not against strong, persevering passions; but romantic wavering feelings that I wish to guard the female heart by exercising the understanding: for these paradisiacal reveries are oftener the effect of idleness than of a lively fancy.

Women have seldom sufficient serious employment to silence their feelings; a round of little cares, or vain pursuits frittering away all strength of mind and organs, they become naturally only objects of sense.—In short, the whole tenour of female education (the education of society) tends to render the best disposed romantic and inconstant; and the remainder vain and mean. In the present state of society this evil can scarcely be remedied, I am afraid, in the slightest degree; should a more laudable ambition ever gain ground they may be brought nearer to nature and reason, and become more virtuous and useful as they grow more respectable.

But, I will venture to assert that their reason will never acquire sufficient strength to enable it to regulate their conduct, whilst the

making an appearance in the world is the first wish of the majority of mankind. To this weak wish the natural affections, and the most useful virtues are sacrificed. Girls marry merely to *better themselves*, to borrow a significant vulgar phrase, and have such perfect power over their hearts as not to permit themselves to *fall in love* till a man with a superior fortune offers. On this subject I mean to enlarge in a future chapter; it is only necessary to drop a hint at present, because women are so often degraded by suffering the selfish prudence of age to chill the ardour of youth.

From the same source flows an opinion that young girls ought to dedicate great part of their time to needle-work; yet, this employment contracts their faculties more than any other that could have been chosen for them, by confining their thoughts to their persons. Men order their clothes to be made, and have done with the subject; women make their own clothes, necessary or ornamental, and are continually talking about them; and their thoughts follow their hands. It is not indeed the making of necessaries that weakens the mind; but the frippery of dress. For when a woman in the lower rank of life makes her husband's and children's clothes, she does her duty, this is her part of the family business; but when women work only to dress better than they could otherwise afford, it is worse than sheer loss of time. To render the poor virtuous they must be employed, and women in the middle rank of life, did they not ape the fashions of the nobility, without catching their ease, might employ them, whilst they themselves managed their families, instructed their children, and exercised their own minds. Gardening, experimental philosophy, and literature, would afford them subjects to think of and matter for conversation, that in some degree would exercise their understandings. The conversation of French women, who are not so rigidly nailed to their chairs to twist lappets,* and knot ribands, is frequently superficial; but, I contend, that it is not half so insipid as that of those English women whose time is spent in making caps, bonnets, and the whole mischief of trimmings, not to mention shopping, bargain-hunting, etc. etc.; and it is the decent, prudent women, who are most degraded by these practices; for their motive is simply vanity. The wanton who exercises her taste to render her passion alluring, has something more in view.

These observations all branch out of a general one, which I have before made, and which cannot be too often insisted upon, for,

speaking of men, women, or professions, it will be found that the employment of the thoughts shapes the character both generally and individually. The thoughts of women ever hover round their persons, and is it surprising that their persons are reckoned most valuable? Yet some degree of liberty of mind is necessary even to form the person; and this may be one reason why some gentle wives have so few attractions beside that of sex. Add to this, sedentary employments render the majority of women sickly—and false notions of female excellence make them proud of this delicacy, though it be another fetter, that by calling the attention continually to the body, cramps the activity of the mind.

Women of quality seldom do any of the manual part of their dress, consequently only their taste is exercised, and they acquire, by thinking less of the finery, when the business of their toilet is over, that ease, which seldom appears in the deportment of women, who dress merely for the sake of dressing. In fact, the observation with respect to the middle rank, the one in which talents thrive best, extends not to women; for those of the superior class, by catching, at least, a smattering of literature, and conversing more with men, on general topics, acquire more knowledge than the women who ape their fashions and faults without sharing their advantages. With respect to virtue, to use the word in a comprehensive sense, I have seen most in low life. Many poor women maintain their children by the sweat of their brow, and keep together families that the vices of the fathers would have scattered abroad; but gentlewomen are too indolent to be actively virtuous, and are softened rather than refined by civilization. Indeed, the good sense which I have met with, among the poor women who have had few advantages of education, and yet have acted heroically, strongly confirmed me in the opinion that trifling employments have rendered woman a trifler. Man, taking her[1] body, the mind is left to rust; so that while physical love enervates man, as being his favourite recreation, he will endeavour to enslave woman:—and, who can tell, how many generations may be necessary to give vigour to the virtue and talents of the freed posterity of abject slaves?[2]

[1] 'I take her body,' says Ranger.*

[2] 'Supposing that women are voluntary slaves—slavery of any kind is unfavourable to human happiness and improvement.' *Knox's Essays.**

In tracing the causes that, in my opinion, have degraded woman, I have confined my observations to such as universally act upon the morals and manners of the whole sex, and to me it appears clear that they all spring from want of understanding. Whether this arise from a physical or accidental weakness of faculties, time alone can determine; for I shall not lay any great stress on the example of a few women[1] who, from having received a masculine education, have acquired courage and resolution; I only contend that the men who have been placed in similar situations, have acquired a similar character—I speak of bodies of men, and that men of genius and talents have started out of a class, in which women have never yet been placed.

[1] Sappho, Eloisa, Mrs Macaulay, the Empress of Russia, Madame d'Eon,* etc. These, and many more, may be reckoned exceptions; and, are not all heroes, as well as heroines, exceptions to general rules? I wish to see women neither heroines nor brutes; but reasonable creatures.

CHAPTER V

ANIMADVERSIONS ON SOME OF THE WRITERS WHO HAVE RENDERED WOMEN OBJECTS OF PITY, BORDERING ON CONTEMPT

The opinions speciously supported, in some modern publications on the female character and education, which have given the tone to most of the observations made, in a more cursory manner, on the sex, remain now to be examined.

Section I

I shall begin with Rousseau, and give a sketch of his character of woman, in his own words, interspersing comments and reflections. My comments, it is true, will all spring from a few simple principles, and might have been deduced from what I have already said; but the artificial structure has been raised with so much ingenuity, that it seems necessary to attack it in a more circumstantial manner, and make the application myself.

Sophia, says Rousseau, should be as perfect a woman as Emilius is a man, and to render her so, it is necessary to examine the character which nature has given to the sex.*

He then proceeds to prove that woman ought to be weak and passive, because she has less bodily strength than man; and hence infers, that she was formed to please and to be subject to him; and that it is her duty to render herself *agreeable* to her master—this being the grand end of her existence.[1] Still, however, to give a little mock dignity to lust, he insists that man should not exert his strength, but depend on the will of the woman, when he seeks for pleasure with her.

'Hence we deduce a third consequence from the different constitutions of the sexes; which is, that the strongest should be master in appearance, and be dependent in fact on the weakest; and that not from any frivolous practice of gallantry or vanity of protectorship,

[1] I have already inserted the passage, page 117.

150

but from an invariable law of nature, which, furnishing woman with a greater facility to excite desires than she has given man to satisfy them, makes the latter dependent on the good pleasure of the former, and compels him to endeavour to please in his turn, *in order to obtain her consent that he should be strongest.*[1] On these occasions, the most delightful circumstance a man finds in his victory is, to doubt whether it was the woman's weakness that yielded to his superior strength, or whether her inclinations spoke in his favour: the females are also generally artful enough to leave this matter in doubt. The understanding of women answers in this respect perfectly to their constitution: so far from being ashamed of their weakness, they glory in it; their tender muscles make no resistance; they affect to be incapable of lifting the smallest burthens, and would blush to be thought robust and strong. To what purpose is all this? Not merely for the sake of appearing delicate, but through an artful precaution: it is thus they provide an excuse beforehand, and a right to be feeble when they think it expedient.'*

I have quoted this passage, lest my readers should suspect that I warped the author's reasoning to support my own arguments. I have already asserted that in educating women these fundamental principles lead to a system of cunning and lasciviousness.

Supposing woman to have been formed only to please, and be subject to man, the conclusion is just, she ought to sacrifice every other consideration to render herself agreeable to him: and let this brutal desire of self-preservation be the grand spring of all her actions, when it is proved to be the iron bed of fate, to fit which her character should be stretched or contracted, regardless of all moral or physical distinctions. But, if, as I think, may be demonstrated, the purposes, of even this life, viewing the whole, be subverted by practical rules built upon this ignoble base, I may be allowed to doubt whether woman were created for man: and, though the cry of irreligion, or even atheism, be raised against me, I will simply declare, that were an angel from heaven to tell me that Moses's beautiful, poetical cosmogony, and the account of the fall of man,* were literally true, I could not believe what my reason told me was derogatory to the character of the Supreme Being: and, having no fear of the devil before mine eyes, I venture to call this a suggestion

[1] What nonsense!

of reason, instead of resting my weakness on the broad shoulders of the first seducer of my frail sex.

'It being once demonstrated,' continues Rousseau, 'that man and woman are not, nor ought to be, constituted alike in temperament and character, it follows of course that they should not be educated in the same manner. In pursuing the directions of nature, they ought indeed to act in concert, but they should not be engaged in the same employments: the end of their pursuits should be the same, but the means they should take to accomplish them, and of consequence their tastes and inclinations, should be different.'

. .

'Whether I consider the peculiar destination of the sex, observe their inclinations, or remark their duties, all things equally concur to point out the peculiar method of education best adapted to them. Woman and man were made for each other; but their mutual dependence is not the same. The men depend on the women only on account of their desires; the women on the men both on account of their desires and their necessities: we could subsist better without them than they without us.'

. .

'For this reason, the education of the women should be always relative to the men. To please, to be useful to us, to make us love and esteem them, to educate us when young, and take care of us when grown up, to advise, to console us, to render our lives easy and agreeable: these are the duties of women at all times, and what they should be taught in their infancy. So long as we fail to recur to this principle, we run wide of the mark, and all the precepts which are given them contribute neither to their happiness nor our own.'

. .

'Girls are from their earliest infancy fond of dress. Not content with being pretty, they are desirous of being thought so; we see, by all their little airs, that this thought engages their attention; and they are hardly capable of understanding what is said to them, before they are to be governed by talking to them of what people will think of their behaviour. The same motive, however, indiscreetly made use of with boys, has not the same effect: provided they are let pursue their amusements at pleasure, they care very little what people think of them. Time and pains are necessary to subject boys to this motive.

'Whencesoever girls derive this first lesson, it is a very good one. As the body is born, in a manner, before the soul, our first concern should be to cultivate the former; this order is common to both sexes, but the object of that cultivation is different. In the one sex it is the development of corporeal powers; in the other, that of personal charms: not that either the quality of strength or beauty ought to be confined exclusively to one sex; but only that the order of the cultivation of both is in that respect reversed. Women certainly require as much strength as to enable them to move and act gracefully, and men as much address as to qualify them to act with ease.'

. .

'Children of both sexes have a great many amusements in common; and so they ought; have they not also many such when they are grown up? Each sex has also its peculiar taste to distinguish in this particular. Boys love sports of noise and activity; to beat the drum, to whip the top, and to drag about their little carts: girls, on the other hand, are fonder of things of show and ornament; such as mirrours, trinkets, and dolls: the doll is the peculiar amusement of the females; from whence we see their taste plainly adapted to their destination. The physical part of the art of pleasing lies in dress; and this is all which children are capacitated to cultivate of that art.'

. .

'Here then we see a primary propensity firmly established, which you need only to pursue and regulate. The little creature will doubtless be very desirous to know how to dress up her doll, to make its sleeve-knots, its flounces, its head-dress, etc. she is obliged to have so much recourse to the people about her, for their assistance in these articles, that it would be much more agreeable to her to owe them all to her own industry. Hence we have a good reason for the first lessons that are usually taught these young females: in which we do not appear to be setting them a task, but obliging them, by instructing them in what is immediately useful to themselves. And, in fact, almost all of them learn with reluctance to read and write; but very readily apply themselves to the use of their needles. They imagine themselves already grown up, and think with pleasure that such qualifications will enable them to decorate themselves.'*

This is certainly only an education of the body; but Rousseau is not the only man who has indirectly said that merely the person of a *young* woman, without any mind, unless animal spirits come under

that description, is very pleasing. To render it weak, and what some may call beautiful, the understanding is neglected, and girls forced to sit still, play with dolls and listen to foolish conversations;—the effect of habit is insisted upon as an undoubted indication of nature. I know it was Rousseau's opinion that the first years of youth should be employed to form the body,* though in educating Emilius he deviates from this plan; yet, the difference between strengthening the body, on which strength of mind in a great measure depends, and only giving it an easy motion, is very wide.

Rousseau's observations, it is proper to remark, were made in a country where the art of pleasing was refined only to extract the grossness of vice. He did not go back to nature, or his ruling appetite disturbed the operations of reason, else he would not have drawn these crude inferences.

In France boys and girls, particularly the latter, are only educated to please, to manage their persons, and regulate their exterior behaviour; and their minds are corrupted, at a very early age, by the worldly and pious cautions they receive to guard them against immodesty. I speak of past times. The very confessions which mere children were obliged to make, and the questions asked by the holy men, I assert these facts on good authority, were sufficient to impress a sexual character; and the education of society was a school of coquetry and art. At the age of ten or eleven; nay, often much sooner, girls began to coquet, and talked, unreproved, of establishing themselves in the world by marriage.

In short, they were treated like women, almost from their very birth, and compliments were listened to instead of instruction. These, weakening the mind, Nature was supposed to have acted like a step-mother, when she formed this after-thought of creation.

Not allowing them understanding, however, it was but consistent to subject them to authority independent of reason; and to prepare them for this subjection, he gives the following advice:

'Girls ought to be active and diligent; nor is that all; they should also be early subjected to restraint. This misfortune, if it really be one, is inseparable from their sex; nor do they ever throw it off but to suffer more cruel evils. They must be subject, all their lives, to the most constant and severe restraint, which is that of decorum: it is, therefore, necessary to accustom them early to such confinement, that it may not afterwards cost them too dear; and to the suppression

of their caprices, that they may the more readily submit to the will of others. If, indeed, they be fond of being always at work, they should be sometimes compelled to lay it aside. Dissipation, levity, and inconstancy, are faults that readily spring up from their first propensities, when corrupted or perverted by too much indulgence. To prevent this abuse, we should teach them, above all things, to lay a due restraint on themselves. The life of a modest woman is reduced, by our absurd institutions, to a perpetual conflict with herself: not but it is just that this sex should partake of the sufferings which arise from those evils it hath caused us.'*

And why is the life of a modest woman a perpetual conflict? I should answer, that this very system of education makes it so. Modesty, temperance, and self-denial, are the sober offspring of reason; but when sensibility is nurtured at the expence of the understanding, such weak beings must be restrained by arbitrary means, and be subjected to continual conflicts; but give their activity of mind a wider range, and nobler passions and motives will govern their appetites and sentiments.

'The common attachment and regard of a mother, nay, mere habit, will make her beloved by her children, if she do nothing to incur their hate. Even the constraint she lays them under, if well directed, will increase their affection, instead of lessening it; because a state of dependence being natural to the sex, they perceive themselves formed for obedience.'*

This is begging the question; for servitude not only debases the individual, but its effects seem to be transmitted to posterity. Considering the length of time that women have been dependent, is it surprising that some of them hug their chains, and fawn like the spaniel? 'These dogs,' observes a naturalist, 'at first kept their ears erect; but custom has superseded nature, and a token of fear is becoming a beauty.'*

'For the same reason,' adds Rousseau, 'women have, or ought to have, but little liberty; they are apt to indulge themselves excessively in what is allowed them. Addicted in every thing to extremes, they are even more transported at their diversions than boys.'*

The answer to this is very simple. Slaves and mobs have always indulged themselves in the same excesses, when once they broke loose from authority.—The bent bow recoils with violence, when the hand is suddenly relaxed that forcibly held it; and sensibility, the

play-thing of outward circumstances, must be subjected to author-
ity, or moderated by reason.

'There results,' he continues, 'from this habitual restraint a
tractableness which women have occasion for during their whole
lives, as they constantly remain either under subjection to the men,
or to the opinions of mankind; and are never permitted to set
themselves above those opinions. The first and most important
qualification in a woman is good-nature or sweetness of temper:
formed to obey a being so imperfect as man, often full of vices, and
always full of faults, she ought to learn betimes even to suffer
injustice, and to bear the insults of a husband without complaint; it
is not for his sake, but her own, that she should be of a mild
disposition. The perverseness and ill-nature of the women only
serve to aggravate their own misfortunes, and the misconduct of
their husbands; they might plainly perceive that such are not the
arms by which they gain the superiority.'*

Formed to live with such an imperfect being as man, they ought
to learn from the exercise of their faculties the necessity of for-
bearance; but all the sacred rights of humanity are violated by
insisting on blind obedience; or, the most sacred rights belong *only*
to man.

The being who patiently endures injustice, and silently bears
insults, will soon become unjust, or unable to discern right from
wrong. Besides, I deny the fact, this is not the true way to form or
meliorate the temper; for, as a sex, men have better tempers than
women, because they are occupied by pursuits that interest the head
as well as the heart; and the steadiness of the head gives a healthy
temperature to the heart. People of sensibility have seldom good
tempers. The formation of the temper is the cool work of reason,
when, as life advances, she mixes with happy art, jarring elements.
I never knew a weak or ignorant person who had a good temper,
though that constitutional good humour, and that docility, which
fear stamps on the behaviour, often obtains the name. I say behav-
iour, for genuine meekness never reached the heart or mind, unless
as the effect of reflection; and that simple restraint produces a
number of peccant humours in domestic life, many sensible men
will allow, who find some of these gentle irritable creatures, very
troublesome companions.

'Each sex,' he further argues, 'should preserve its peculiar tone and manner; a meek husband may make a wife impertinent; but mildness of disposition on the woman's side will always bring a man back to reason, at least if he be not absolutely a brute, and will sooner or later triumph over him.'* Perhaps the mildness of reason might sometimes have this effect; but abject fear always inspires contempt; and tears are only eloquent when they flow down fair cheeks.

Of what materials can that heart be composed, which can melt when insulted, and instead of revolting at injustice, kiss the rod? Is it unfair to infer that her virtue is built on narrow views and selfishness, who can caress a man, with true feminine softness, the very moment when he treats her tyrannically? Nature never dictated such insincerity;—and, though prudence of this sort be termed a virtue, morality becomes vague when any part is supposed to rest on falsehood. These are mere expedients, and expedients are only useful for the moment.

Let the husband beware of trusting too implicitly to this servile obedience; for if his wife can with winning sweetness caress him when angry, and when she ought to be angry, unless contempt had stifled a natural effervescence, she may do the same after parting with a lover. These are all preparations for adultery; or, should the fear of the world, or of hell, restrain her desire of pleasing other men, when she can no longer please her husband, what substitute can be found by a being who was only formed, by nature and art, to please man? what can make her amends for this privation, or where is she to seek for a fresh employment? where find sufficient strength of mind to determine to begin the search, when her habits are fixed, and vanity has long ruled her chaotic mind?

But this partial moralist recommends cunning systematically and plausibly.

'Daughters should be always submissive; their mothers, however, should not be inexorable. To make a young person tractable, she ought not to be made unhappy, to make her modest she ought not to be rendered stupid. On the contrary, I should not be displeased at her being permitted to use some art, not to elude punishment in case of disobedience, but to exempt herself from the necessity of obeying. It is not necessary to make her dependence burdensome, but only to let her feel it. Subtilty is a talent natural to the sex; and, as

I am persuaded, all our natural inclinations are right and good in themselves, I am of opinion this should be cultivated as well as the others: it is requisite for us only to prevent its abuse.'*

'Whatever is, is right,'* he then proceeds triumphantly to infer. Granted;—yet, perhaps, no aphorism ever contained a more paradoxical assertion. It is a solemn truth with respect to God. He, reverentially I speak, sees the whole at once, and saw its just proportions in the womb of time; but man, who can only inspect disjointed parts, finds many things wrong; and it is a part of the system, and therefore right, that he should endeavour to alter what appears to him to be so, even while he bows to the Wisdom of his Creator, and respects the darkness he labours to disperse.

The inference that follows is just, supposing the principle to be sound. 'The superiority of address, peculiar to the female sex, is a very equitable indemnification for their inferiority in point of strength: without this, woman would not be the companion of man; but his slave: it is by her superiour art and ingenuity that she preserves her equality, and governs him while she affects to obey. Woman has every thing against her, as well our faults, as her own timidity and weakness; she has nothing in her favour, but her subtilty and her beauty. Is it not very reasonable, therefore, she should cultivate both?'* Greatness of mind can never dwell with cunning, or address; for I shall not boggle about words, when their direct signification is insincerity and falsehood, but content myself with observing, that if any class of mankind be so created that it must necessarily be educated by rules not strictly deducible from truth, virtue is an affair of convention. How could Rousseau dare to assert, after giving this advice, that in the grand end of existence the object of both sexes should be the same, when he well knew that the mind, formed by its pursuits, is expanded by great views swallowing up little ones, or that it becomes itself little?

Men have superiour strength of body; but were it not for mistaken notions of beauty, women would acquire sufficient to enable them to earn their own subsistence, the true definition of independence; and to bear those bodily inconveniencies and exertions that are requisite to strengthen the mind.

Let us then, by being allowed to take the same exercise as boys, not only during infancy, but youth, arrive at perfection of body, that we may know how far the natural superiority of man extends. For

what reason or virtue can be expected from a creature when the seed-time of life is neglected? None—did not the winds of heaven casually scatter many useful seeds in the fallow ground.

'Beauty cannot be acquired by dress, and coquetry is an art not so early and speedily attained. While girls are yet young, however, they are in a capacity to study agreeable gesture, a pleasing modulation of voice, an easy carriage and behaviour; as well as to take the advantage of gracefully adapting their looks and attitudes to time, place, and occasion. Their application, therefore, should not be solely confined to the arts of industry and the needle, when they come to display other talents, whose utility is already apparent.'

'For my part, I would have a young Englishwoman cultivate her agreeable talents, in order to please her future husband, with as much care and assiduity as a young Circassian cultivates her's, to fit her for the Haram of an Eastern bashaw.'*

To render women completely insignificant, he adds—'The tongues of women are very voluble; they speak earlier, more readily, and more agreeably, than the men; they are accused also of speaking much more; but so it ought to be, and I should be very ready to convert this reproach into a compliment; their lips and eyes have the same activity, and for the same reason. A man speaks of what he knows, a woman of what pleases her; the one requires knowledge, the other taste; the principal object of a man's discourse should be what is useful, that of a woman's what is agreeable. There ought to be nothing in common between their different conversation but truth.'

'We ought not, therefore, to restrain the prattle of girls, in the same manner as we should that of boys, with that severe question; *To what purpose are you talking?* but by another, which is no less difficult to answer, *How will your discourse be received?* In infancy, while they are as yet incapable to discern good from evil, they ought to observe it, as a law, never to say any thing disagreeable to those whom they are speaking to: what will render the practice of this rule also the more difficult, is, that it must ever be subordinate to the former, of never speaking falsely or telling an untruth.'* To govern the tongue in this manner must require great address indeed; and it is too much practised both by men and women.—Out of the abundance of the heart how few speak!* So few, that I, who love simplicity, would gladly give up politeness for a quarter of the virtue that

has been sacrificed to an equivocal quality which at best should only be the polish of virtue.

But, to complete the sketch. 'It is easy to be conceived, that if male children be not in a capacity to form any true notions of religion, those ideas must be greatly above the conception of the females: it is for this very reason, I would begin to speak to them the earlier on this subject; for if we were to wait till they were in a capacity to discuss methodically such profound questions, we should run a risk of never speaking to them on this subject as long as they lived. Reason in women is a practical reason, capacitating them artfully to discover the means of attaining a known end, but which would never enable them to discover that end itself. The social relations of the sexes are indeed truly admirable: from their union there results a moral person, of which woman may be termed the eyes, and man the hand, with this dependence on each other, that it is from the man that the woman is to learn what she is to see, and it is of the woman that man is to learn what he ought to do. If woman could recur to the first principles of things as well as man, and man was capacitated to enter into their *minutiae* as well as woman, always independent of each other, they would live in perpetual discord, and their union could not subsist. But in the present harmony which naturally subsists between them, their different faculties tend to one common end; it is difficult to say which of them conduces the most to it: each follows the impulse of the other; each is obedient, and both are masters.'

'As the conduct of a woman is subservient to the public opinion, her faith in matters of religion should, for that very reason, be subject to authority. *Every daughter ought to be of the same religion as her mother, and every wife to be of the same religion as her husband: for, though such religion should be false, that docility which induces the mother and daughter to submit to the order of nature, takes away, in the sight of God, the criminality of their error.*[1] As they are not in a capacity to judge for themselves, they ought to abide by the decision

[1] What is to be the consequence, if the mother's and husband's opinion should *chance* not to agree? An ignorant person cannot be reasoned out of an error—and when *persuaded* to give up one prejudice for another the mind is unsettled. Indeed, the husband may not have any religion to teach her, though in such a situation she will be in great want of a support to her virtue, independent of worldly considerations.

of their fathers and husbands as confidently as by that of the church.'

'As authority ought to regulate the religion of the women, it is not so needful to explain to them the reasons for their belief, as to lay down precisely the tenets they are to believe: for the creed, which presents only obscure ideas to the mind, is the source of fanaticism; and that which presents absurdities, leads to infidelity.'*

Absolute, uncontroverted authority, it seems, must subsist somewhere: but is not this a direct and exclusive appropriation of reason? The *rights* of humanity have been thus confined to the male line from Adam downwards. Rousseau would carry his male aristocracy still further, for he insinuates, that he should not blame those, who contend for leaving woman in a state of the most profound ignorance, if it were not necessary in order to preserve her chastity and justify the man's choice, in the eyes of the world, to give her a little knowledge of men, and the customs produced by human passions; else she might propagate at home without being rendered less voluptuous and innocent by the exercise of her understanding: excepting, indeed, during the first year of marriage, when she might employ it to dress like Sophia. 'Her dress is extremely modest in appearance, and yet very coquettish in fact: she does not make a display of her charms, she conceals them; but in concealing them, she knows how to affect your imagination. Every one who sees her will say, There is a modest and discreet girl; but while you are near her, your eyes and affections wander all over her person, so that you cannot withdraw them; and you would conclude, that every part of her dress, simple as it seems, was only put in its proper order to be taken to pieces by the imagination.'* Is this modesty? Is this a preparation for immortality? Again.—What opinion are we to form of a system of education, when the author says of his heroine, 'that with her, doing things well, is but a *secondary* concern; her principal concern is to do them *neatly*.'*

Secondary, in fact, are all her virtues and qualities, for, respecting religion, he makes her parents thus address her, accustomed to submission—'Your husband will instruct you in *good time*.'*

After thus cramping a woman's mind, if, in order to keep it fair, he have not made it quite a blank, he advises her to reflect, that a reflecting man may not yawn in her company, when he is tired of

caressing her.—What has she to reflect about who must obey? and would it not be a refinement on cruelty only to open her mind to make the darkness and misery of her fate *visible?* Yet, these are his sensible remarks; how consistent with what I have already been obliged to quote, to give a fair view of the subject, the reader may determine.

'They who pass their whole lives in working for their daily bread, have no ideas beyond their business or their interest, and all their understanding seems to lie in their fingers' ends. This ignorance is neither prejudicial to their integrity nor their morals; it is often of service to them. Sometimes, by means of reflection, we are led to compound with our duty, and we conclude by substituting a jargon of words, in the room of things. Our own conscience is the most enlightened philosopher. There is no need to be acquainted with Tully's offices,* to make a man of probity: and perhaps the most virtuous woman in the world, is the least acquainted with the definition of virtue. But it is no less true, that an improved understanding only can render society agreeable; and it is a melancholy thing for a father of a family, who is fond of home, to be obliged to be always wrapped up in himself, and to have nobody about him to whom he can impart his sentiments.

'Besides, how should a woman void of reflection be capable of educating her children? How should she discern what is proper for them? How should she incline them to those virtues she is unacquainted with, or to that merit of which she has no idea? She can only sooth or chide them; render them insolent or timid; she will make them formal coxcombs, or ignorant blockheads; but will never make them sensible or amiable.'* How indeed should she, when her husband is not always at hand to lend her his reason?—when they both together make but one moral being. A blind will, 'eyes without hands,' would go a very little way; and perchance his abstract reason, that should concentrate the scattered beams of her practical reason, may be employed in judging of the flavour of wine, descanting on the sauces most proper for turtle; or, more profoundly intent at a card-table, he may be generalizing his ideas as he bets away his fortune, leaving all the *minutiae* of education to his helpmate, or to chance.

But, granting that woman ought to be beautiful, innocent, and silly, to render her a more alluring and indulgent companion;—

what is her understanding sacrificed for? And why is all this pre-
paration necessary only, according to Rousseau's own account, to
make her the mistress of her husband, a very short time? For no man
ever insisted more on the transient nature of love. Thus speaks the
philosopher. 'Sensual pleasures are transient. The habitual state of
the affections always loses by their gratification. The imagination,
which decks the object of our desires, is lost in fruition. Excepting
the Supreme Being, who is self-existent, there is nothing beautiful
but what is ideal.'*

But he returns to his unintelligible paradoxes again, when he thus
addresses Sophia. 'Emilius, in becoming your husband, is become
your master; and claims your obedience. Such is the order of nature.
When a man is married, however, to such a wife as Sophia, it is
proper he should be directed by her: this is also agreeable to the
order of nature: it is, therefore, to give you as much authority over
his heart as his sex gives him over your person, that I have made you
the arbiter of his pleasures. It may cost you, perhaps, some disagree-
able self-denial; but you will be certain of maintaining your empire
over him, if you can preserve it over yourself—what I have already
observed, also, shows me, that this difficult attempt does not surpass
your courage.

'Would you have your husband constantly at your feet? keep him
at some distance from your person. You will long maintain the
authority in love, if you know but how to render your favours rare
and valuable. It is thus you may employ even the arts of coquetry in
the service of virtue, and those of love in that of reason.'*

I shall close my extracts with a just description of a comfortable
couple. 'And yet you must not imagine, that even such management
will always suffice. Whatever precaution be taken, enjoyment will,
by degrees, take off the edge of passion. But when love hath lasted
as long as possible, a pleasing habitude supplies its place, and the
attachment of a mutual confidence succeeds to the transports of
passion. Children often form a more agreeable and permanent con-
nection between married people than even love itself. When you
cease to be the mistress of Emilius, you will continue to be his wife
and friend, you will be the mother of his children.'[1]

Children, he truly observes, form a much more permanent

[1] *Rousseau's Emilius.**

connexion between married people than love. Beauty, he declares, will not be valued, or even seen after a couple have lived six months together; artificial graces and coquetry will likewise pall on the senses: why then does he say that a girl should be educated for her husband with the same care as for an eastern haram?

I now appeal from the reveries of fancy and refined licentiousness to the good sense of mankind, whether, if the object of education be to prepare women to become chaste wives and sensible mothers, the method so plausibly recommended in the foregoing sketch, be the one best calculated to produce those ends? Will it be allowed that the surest way to make a wife chaste, is to teach her to practice the wanton arts of a mistress, termed virtuous coquetry, by the sensualist who can no longer relish the artless charms of sincerity, or taste the pleasure arising from a tender intimacy, when confidence is unchecked by suspicion, and rendered interesting by sense?

The man who can be contented to live with a pretty, useful companion, without a mind, has lost in voluptuous gratifications a taste for more refined enjoyments; he has never felt the calm satisfaction, that refreshes the parched heart, like the silent dew of heaven,—of being beloved by one who could understand him.—In the society of his wife he is still alone, unless when the man is sunk in the brute. 'The charm of life,' says a grave philosophical reasoner, is 'sympathy; nothing pleases us more than to observe in other men a fellow-feeling with all the emotions of our own breast.'*

But, according to the tenour of reasoning, by which women are kept from the tree of knowledge, the important years of youth, the usefulness of age, and the rational hopes of futurity, are all to be sacrificed to render women an object of desire for a *short* time. Besides, how could Rousseau expect them to be virtuous and constant when reason is neither allowed to be the foundation of their virtue, nor truth the object of their inquiries?

But all Rousseau's errors in reasoning arose from sensibility, and sensibility to their charms women are very ready to forgive! When he should have reasoned he became impassioned, and reflection inflamed his imagination instead of enlightening his understanding. Even his virtues also led him farther astray; for, born with a warm constitution and lively fancy, nature carried him toward the other sex with such eager fondness, that he soon became lascivious. Had

he given way to these desires, the fire would have extinguished itself in a natural manner; but virtue, and a romantic kind of delicacy, made him practise self-denial; yet, when fear, delicacy, or virtue, restrained him, he debauched his imagination, and reflecting on the sensations to which fancy gave force, he traced them in the most glowing colours, and sunk them deep into his soul.

He then sought for solitude, not to sleep with the man of nature; or calmly investigate the causes of things under the shade where Sir Isaac Newton indulged contemplation,* but merely to indulge his feelings. And so warmly has he painted, what he forcibly felt, that, interesting the heart and inflaming the imagination of his readers; in proportion to the strength of their fancy, they imagine that their understanding is convinced when they only sympathize with a poetic writer, who skilfully exhibits the objects of sense, most voluptuously shadowed or gracefully veiled—And thus making us feel whilst dreaming that we reason, erroneous conclusions are left in the mind.

Why was Rousseau's life divided between ecstasy and misery? Can any other answer be given than this, that the effervescence of his imagination produced both; but, had his fancy been allowed to cool, it is possible that he might have acquired more strength of mind. Still, if the purpose of life be to educate the intellectual part of man, all with respect to him was right; yet, had not death led to a nobler scene of action, it is probable that he would have enjoyed more equal happiness on earth, and have felt the calm sensations of the man of nature instead of being prepared for another stage of existence by nourishing the passions which agitate the civilized man.

But peace to his manes! I war not with his ashes, but his opinions. I war only with the sensibility that led him to degrade woman by making her the slave of love.

> ——'Curs'd vassalage,
> First idolliz'd till love's hot fire be o'er,
> Then slaves to those who courted us before.'
>
> *Dryden**

The pernicious tendency of those books, in which the writers insidiously degrade the sex whilst they are prostrate before their personal charms, cannot be too often or too severely exposed.

Let us, my dear contemporaries, arise above such narrow preju-
dices! If wisdom be desirable on its own account, if virtue, to deserve
the name, must be founded on knowledge; let us endeavour to
strengthen our minds by reflection, till our heads become a balance
for our hearts; let us not confine all our thoughts to the petty
occurrences of the day, or our knowledge to an acquaintance with
our lovers' or husbands' hearts; but let the practice of every duty be
subordinate to the grand one of improving our minds, and preparing
our affections for a more exalted state!

Beware then, my friends, of suffering the heart to be moved by
every trivial incident: the reed is shaken by a breeze, and annually
dies, but the oak stands firm, and for ages braves the storm!

Were we, indeed, only created to flutter our hour out and die—
why let us then indulge sensibility, and laugh at the severity of
reason.—Yet, alas! even then we should want strength of body and
mind, and life would be lost in feverish pleasures or wearisome
languor.

But the system of education, which I earnestly wish to see ex-
ploded, seems to pre-suppose what ought never to be taken for
granted, that virtue shields us from the casualities of life; and that
fortune, slipping off her bandage, will smile on a well-educated
female, and bring in her hand an Emilius or a Telemachus.* Whilst,
on the contrary, the reward which virtue promises to her votaries is
confined, it seems clear, to their own bosoms; and often must they
contend with the most vexatious worldly cares, and bear with the
vices and humours of relations for whom they can never feel a
friendship.

There have been many women in the world who, instead of being
supported by the reason and virtue of their fathers and brothers,
have strengthened their own minds by struggling with their vices
and follies; yet have never met with a hero, in the shape of a
husband; who, paying the debt that mankind owed them, might
chance to bring back their reason to its natural dependent state,
and restore the usurped prerogative, of rising above opinion, to
man.

Section II

Dr Fordyce's sermons* have long made a part of a young woman's
library; nay, girls at school are allowed to read them; but I should

instantly dismiss them from my pupil's, if I wished to strengthen her understanding, by leading her to form sound principles on a broad basis; or, were I only anxious to cultivate her taste; though they must be allowed to contain many sensible observations.

Dr Fordyce may have had a very laudable end in view; but these discourses are written in such an affected style, that were it only on that account, and had I nothing to object against his *mellifluous* precepts, I should not allow girls to peruse them, unless I designed to hunt every spark of nature out of their composition, melting every human quality into female meekness and artificial grace. I say artificial, for true grace arises from some kind of independence of mind.

Children, careless of pleasing, and only anxious to amuse themselves, are often very graceful; and the nobility who have mostly lived with inferiours, and always had the command of money, acquire a graceful ease of deportment, which should rather be termed habitual grace of body, than that superiour gracefulness which is truly the expression of the mind. This mental grace, not noticed by vulgar eyes, often flashes across a rough countenance, and irradiating every feature, shows simplicity and independence of mind.—It is then we read characters of immortality in the eye, and see the soul in every gesture, though when at rest, neither the face nor limbs may have much beauty to recommend them; or the behaviour, any thing peculiar to attract universal attention. The mass of mankind, however, look for more *tangible* beauty; yet simplicity is, in general, admired, when people do not consider what they admire; and can there be simplicity without sincerity? But, to have done with remarks that are in some measure desultory, though naturally excited by the subject—

In declamatory periods Dr Fordyce spins out Rousseau's eloquence; and in most sentimental rant, details his opinions respecting the female character, and the behaviour which woman ought to assume to render her lovely.

He shall speak for himself, for thus he makes Nature address man. 'Behold these smiling innocents, whom I have graced with my fairest gifts, and committed to your protection; behold them with love and respect; treat them with tenderness and honour. They are timid and want to be defended. They are frail; O do not take advantage of their weakness! Let their fears and blushes endear them. Let their confidence in you never be abused.—But is it pos-

sible, that any of you can be such barbarians, so supremely wicked, as to abuse it? Can you find in your hearts[1] to despoil the gentle, trusting creatures of their treasure, or do any thing to strip them of their native robe of virtue? Curst be the impious hand that would dare to violate the unblemished form of Chastity! Thou wretch! thou ruffian! forbear; nor venture to provoke heaven's fiercest vengeance.'* I know not any comment that can be made seriously on this curious passage, and I could produce many similar ones; and some, so very sentimental, that I have heard rational men use the word indecent, when they mentioned them with disgust.

Throughout there is a display of cold artificial feelings, and that parade of sensibility which boys and girls should be taught to despise as the sure mark of a little vain mind. Florid appeals are made to heaven, and to the *beauteous innocents*, the fairest images of heaven here below, whilst sober sense is left far behind.—This is not the language of the heart, nor will it ever reach it, though the ear may be tickled.

I shall be told, perhaps, that the public have been pleased with these volumes.—True—and Hervey's Meditations* are still read, though he equally sinned against sense and taste.

I particularly object to the lover-like phrases of pumped up passion, which are every where interspersed. If women be ever allowed to walk without leading-strings,* why must they be cajoled into virtue by artful flattery and sexual compliments?—Speak to them the language of truth and soberness, and away with the lullaby strains of condescending endearment! Let them be taught to respect themselves as rational creatures, and not led to have a passion for their own insipid persons. It moves my gall to hear a preacher descanting on dress and needle-work; and still more, to hear him address the *British fair, the fairest of the fair*,* as if they had only feelings.

Even recommending piety he uses the following argument. 'Never, perhaps, does a fine woman strike more deeply, than when, composed into pious recollection, and possessed with the noblest considerations, she assumes, without knowing it, superiour dignity and new graces; so that the beauties of holiness seem to radiate about

[1] Can you?—Can you? would be the most emphatical comment, were it drawled out in a whining voice.

her, and the by-standers are almost induced to fancy her already worshipping amongst her kindred angels!'* Why are women to be thus bred up with a desire of conquest? the very word, used in this sense, gives me a sickly qualm! Do religion and virtue offer no stronger motives, no brighter reward? Must they always be debased by being made to consider the sex of their companions? Must they be taught always to be pleasing? And when levelling their small artillery at the heart of man, is it necessary to tell them that a little sense is sufficient to render their attention *incredibly soothing*? 'As a small degree of knowledge entertains in a woman, so from a woman, though for a different reason, a small expression of kindness delights, particularly if she have beauty!'* I should have supposed for the same reason.

Why are girls to be told that they resemble angels; but to sink them below women? Or, that a gentle innocent female is an object that comes nearer to the idea which we have formed of angels than any other. Yet they are told, at the same time, that they are only like angels when they are young and beautiful; consequently, it is their persons, not their virtues, that procure them this homage.

Idle empty words! What can such delusive flattery lead to, but vanity and folly? The lover, it is true, has a poetical licence to exalt his mistress; his reason is the bubble of his passion, and he does not utter a falsehood when he borrows the language of adoration. His imagination may raise the idol of his heart, unblamed, above humanity; and happy would it be for women, if they were only flattered by the men who loved them; I mean, who love the individual, not the sex; but should a grave preacher interlard his discourses with such fooleries?

In sermons or novels, however, voluptuousness is always true to its text. Men are allowed by moralists to cultivate, as Nature directs, different qualities, and assume the different characters, that the same passions, modified almost to infinity, give to each individual. A virtuous man may have a choleric or a sanguine constitution, be gay or grave, unreproved; be firm till he is almost overbearing, or, weakly submissive, have no will or opinion of his own; but all women are to be levelled, by meekness and docility, into one character of yielding softness and gentle compliance.

I will use the preacher's own works. 'Let it be observed, that in your sex manly exercises are never graceful; that in them a tone and

figure, as well as an air and deportment, of the masculine kind, are always forbidding; and that men of sensibility desire in every woman soft features, and a flowing voice, a form, not robust, and demeanour delicate and gentle.'*

Is not the following portrait—the portrait of a house salve? 'I am astonished at the folly of many women, who are still reproaching their husbands for leaving them alone, for preferring this or that company to theirs, for treating them with this and the other mark of disregard or indifference; when, to speak the truth, they have themselves in a great measure to blame. Not that I would justify the men in any thing wrong on their part. But had you behaved to them with more *respectful observance*, and a more *equal tenderness; studying their humours, overlooking their mistakes, submitting to their opinions* in matters indifferent, passing by little instances of unevenness, caprice, or passion, giving *soft* answers to hasty words, complaining as seldom as possible, and making it your daily care to relieve their anxieties and prevent their wishes, to enliven the hour of dulness, and call up the ideas of felicity: had you pursued this conduct, I doubt not but you would have maintained and even increased their esteem, so far as to have secured every degree of influence that could conduce to their virtue, or your mutual satisfaction; and your house might at this day have been the abode of domestic bliss.'* Such a woman ought to be an angel—or she is an ass—for I discern not a trace of the human character, neither reason nor passion in this domestic drudge, whose being is absorbed in that of a tyrant's.

Still Dr Fordyce must have very little acquaintance with the human heart, if he really supposed that such conduct would bring back wandering love, instead of exciting contempt. No, beauty, gentleness, etc. etc. may gain a heart; but esteem, the only lasting affection, can alone be obtained by virtue supported by reason. It is respect for the understanding that keeps alive tenderness for the person.

As these volumes are so frequently put into the hands of young people, I have taken more notice of them than, strictly speaking, they deserve; but as they have contributed to vitiate the taste, and enervate the understanding of many of my fellow-creatures, I could not pass them silently over.

Section III

Such paternal solicitude pervades Dr Gregory's Legacy to his Daughters, that I enter on the task of criticism with affectionate respect; but as this little volume has many attractions to recommend it to the notice of the most respectable part of my sex, I cannot silently pass over arguments that so speciously support opinions which, I think, have had the most baneful effect on the morals and manners of the female world.

His easy familiar style is particularly suited to the tenor of his advice, and the melancholy tenderness which his respect for the memory of a beloved wife, diffuses through the whole work, renders it very interesting; yet there is a degree of concise elegance conspicuous in many passages that disturbs this sympathy; and we pop on the author, when we only expected to meet the—father.

Besides, having two objects in view, he seldom adhered steadily to either; for wishing to make his daughters amiable, and fearing lest unhappiness should only be the consequence, of instilling sentiments that might draw them out of the track of common life without enabling them to act with consonant independence and dignity, he checks the natural flow of his thoughts, and neither advises one thing nor the other.

In the preface he tells them a mournful truth, 'that they will hear, at least once in their lives, the genuine sentiments of a man who has no interest in deceiving them.'*

Hapless woman! what can be expected from thee when the beings on whom thou art said naturally to depend for reason and support, have all an interest in deceiving thee! This is the root of the evil that has shed a corroding mildew on all thy virtues; and blighting in the bud thy opening faculties, has rendered thee the weak thing thou art! It is this separate interest—this insidious state of warfare, that undermines morality, and divides mankind!

If love have made some women wretched—how many more has the cold unmeaning intercourse of gallantry rendered vain and useless! yet this heartless attention to the sex is reckoned so manly, so polite that, till society is very differently organized, I fear, this vestige of gothic manners will not be done away by a more reasonable and affectionate mode of conduct. Besides, to strip it of its

imaginary dignity, I must observe, that in the most uncivilized European states this lip-service prevails in a very great degree, accompanied with extreme dissoluteness of morals. In Portugal, the country that I particularly allude to, it takes place of the most serious moral obligations; for a man is seldom assassinated when in the company of a woman. The savage hand of rapine is unnerved by this chivalrous spirit; and, if the stroke of vengeance cannot be stayed—the lady is entreated to pardon the rudeness and depart in peace, though sprinkled, perhaps, with her husband's or brother's blood.*

I shall pass over his strictures on religion, because I mean to discuss that subject in a separate chapter.

The remarks relative to behaviour, though many of them very sensible, I entirely disapprove of, because it appears to me to be beginning, as it were, at the wrong end. A cultivated understanding, and an affectionate heart, will never want starched rules of decorum—something more substantial than seemliness will be the result; and, without understanding the behaviour here recommended, would be rank affectation. Decorum, indeed, is the one thing needful!—decorum is to supplant nature, and banish all simplicity and variety of character out of the female world. Yet what good end can all this superficial counsel produce? It is, however, much easier to point out this or that mode of behaviour, than to set the reason to work; but, when the mind has been stored with useful knowledge, and strengthened by being employed, the regulation of the behaviour may safely be left to its guidance.

Why, for instance, should the following caution be given when art of every kind must contaminate the mind; and why entangle the grand motives of action, which reason and religion equally combine to enforce, with pitiful worldly shifts and slight of hand tricks to gain the applause of gaping tasteless fools? 'Be even cautious in displaying your good sense.[1] It will be thought you assume a superiority over the rest of the company—But if you happen to have any learning, keep it a profound secret, especially from the men who generally look with a jealous and malignant eye on a woman of great parts, and a cultivated understanding.'* If men of real merit, as he

[1] Let women once acquire good sense—and if it deserve the name, it will teach them; or, of what use will it be? how to employ it.

afterwards observes, be superior to this meanness, where is the necessity that the behaviour of the whole sex should be modulated to please fools, or men, who having little claim to respect as individuals, choose to keep close in their phalanx. Men, indeed, who insist on their common superiority, having only this sexual superiority, are certainly very excusable.

There would be no end to rules for behaviour, if it be proper always to adopt the tone of the company; for thus, for ever varying the key, a *flat* would often pass for a *natural* note.

Surely it would have been wiser to have advised women to improve themselves till they rose above the fumes of vanity; and then to let the public opinion come round—for where are rules of accommodation to stop? The narrow path of truth and virtue inclines neither to the right nor left—it is a straightforward business, and they who are earnestly pursuing their road, may bound over many decorous prejudices, without leaving modesty behind. Make the heart clean, and give the head employment, and I will venture to predict that there will be nothing offensive in the behaviour.

The air of fashion, which many young people are so eager to attain, always strikes me like the studied attitudes of some modern pictures, copied with tasteless servility after the antiques;—the soul is left out, and none of the parts are tied together by what may properly be termed character. This varnish of fashion, which seldom sticks very close to sense, may dazzle the weak; but leave nature to itself, and it will seldom disgust the wise. Besides, when a woman has sufficient sense not to pretend to any thing which she does not understand in some degree, there is no need of determining to hide her talents under a bushel.* Let things take their natural course, and all will be well.

It is this system of dissimulation, throughout the volume, that I despise. Women are always to *seem* to be this and that—yet virtue might apostrophize them, in the words of Hamlet*—Seems! I know not seems!—Have that within that passeth show!—

Still the same tone occurs; for in another place, after recommending, without sufficiently discriminating delicacy, he adds, 'The men will complain of your reserve. They will assure you that a franker behaviour woud make you more amiable. But, trust me, they are not sincere when they tell you so.—I acknowledge that on some occasions it might render you more agreeable as companions, but it

would make you less amiable as women: an important distinction, which many of your sex are not aware of.'—*

This desire of being always women, is the very consciousness that degrades the sex. Excepting with a lover, I must repeat with emphasis, a former observation,—it would be well if they were only agreeable or rational companions.—But in this respect his advice is even inconsistent with a passage which I mean to quote with the most marked approbation.

'The sentiment, that a woman may allow all innocent freedoms, provided her virtue is secure, is both grossly indelicate and dangerous, and has proved fatal to many of your sex.'* With this opinion I perfectly coincide. A man, or a woman, of any feeling, must always wish to convince a beloved object that it is the caresses of the individual, not the sex, that are received and returned with pleasure; and, that the heart, rather than the senses, is moved. Without this natural delicacy, love becomes a selfish personal gratification that soon degrades the character.

I carry this sentiment still further. Affection, when love is out of the question, authorises many personal endearments, that naturally flowing from an innocent heart, give life to the behaviour; but the personal intercourse of appetite, gallantry, or vanity, is despicable. When a man squeezes the hand of a pretty woman, handing her to a carriage, whom he has never seen before, she will consider such an impertinent freedom in the light of an insult, if she have any true delicacy, instead of being flattered by this unmeaning homage to beauty. These are the privileges of friendship, or the momentary homage which the heart pays to virtue, when it flashes suddenly on the notice—mere animal spirits have no claim to the kindnesses of a affection!

Wishing to feed the affections with what is now the food of vanity, I would fain persuade my sex to act from simpler principles. Let them merit love, and they will obtain it, though they may never be told that—'The power of a fine woman over the hearts of men, of men of the finest parts, is even beyond what she conceives.'*

I have already noticed the narrow cautions with respect to duplicity, female softness, delicacy of constitution;* for these are the changes which he rings round without ceasing—in a more decorous manner, it is true, than Rousseau; but it all comes home to the same point, and whoever is at the trouble to analyze these sentiments, will find the first principles not quite so delicate as the superstructure.

The subject of amusements is treated in too cursory a manner; but with the same spirit.

When I treat of friendship, love, and marriage, it will be found that we materially differ in opinion; I shall not then forestall what I have to observe on these important subjects; but confine my remarks to the general tenor of them, to that cautious family prudence, to those confined views of partial unenlightened affection, which exclude pleasure and improvement, by vainly wishing to ward off sorrow and error—and by thus guarding the heart and mind, destroy also all their energy.—It is far better to be often deceived than never to trust; to be disappointed in love than never to love; to lose a husband's fondness than forfeit his esteem.

Happy would it be for the world, and for individuals, of course, if all this unavailing solicitude to attain worldly happiness, on a confined plan, were turned into an anxious desire to improve the understanding.—'Wisdom is the principal thing: *therefore* get wisdom; and with all thy gettings get understanding.'—'How long, ye simple ones, will ye love simplicity, and hate knowledge?' Saith Wisdom to the daughters of men!—*

Section IV

I do not mean to allude to all the writers who have written on the subject of female manners—it would, in fact, be only beating over the old ground, for they have, in general, written in the same strain; but attacking the boasted prerogative of man—the prerogative that may emphatically be called the iron sceptre of tyranny, the original sin of tyrants, I declare against all power built on prejudices, however hoary.

If the submission demanded be founded on justice—there is no appealing to a higher power—for God is Justice itself. Let us then, as children of the same parent, if not bastardized by being the younger born, reason together, and learn to submit to the authority of reason—when her voice is distinctly heard. But, if it be proved, that this throne of prerogative only rests on a chaotic mass of prejudices, that have no inherent principle of order to keep them together, or on an elephant, tortoise, or even the mighty shoulders of a son of the earth,* they may escape, who dare to brave the consequence, without any breach of duty, without sinning against the order of things.

Whilst reason raises man above the brutal herd, and death is big with promises, they alone are subject to blind authority who have no reliance on their own strength. They are free—who will be free!'—[1]

The being who can govern itself has nothing to fear in life; but if any thing be dearer than its own respect, the price must be paid to the last farthing. Virtue, like every thing valuable, must be loved for herself alone; or she will not take up her abode with us. She will not impart that peace, 'which passeth understanding',* when she is merely made the stilts of reputation; and respected, with pharisaical exactness, because 'honesty is the best policy.'

That the plan of life which enables us to carry some knowledge and virtue into another world, is the one best calculated to ensure content in this, cannot be denied; yet few people act according to this principle, though it be universally allowed that it admits not of dispute. Present pleasure, or present power, carry before it these sober convictions; and it is for the day, not for life, that man bargains with happiness. How few!—how very few! have sufficient foresight, or resolution, to endure a small evil at the moment, to avoid a greater hereafter.

Woman in particular, whose virtue[2] is built on mutable prejudices, seldom attains to this greatness of mind; so that, becoming the slave of her own feelings, she is easily subjugated by those of others. Thus degraded, her reason, her misty reason! is employed rather to burnish than to snap her chains.

Indignantly have I heard women argue in the same track as men, and adopt the sentiments that brutalize them, with all the pertinacity of ignorance.

I must illustrate my assertion by a few examples. Mrs. Piozzi,* who often repeated by rote, what she did not understand, comes forward with Johnsonian periods.

'Seek not for happiness in singularity; and dread a refinement of wisdom as a deviation into folly.' Thus she dogmatically addresses a new married man; and to elucidate this pompous exordium, she adds, 'I said that the person of your lady would not grow more pleasing to you, but pray let her never suspect that it grows less so: that a woman will pardon an affront to her understanding much

[1] 'He is the free man, whom the *truth* makes free!' *Cowper*.*
[2] I mean to use a word that comprehends more than chastity the sexual virtue.

sooner than one to her person, is well known; nor will any of us contradict the assertion. All our attainments, all our arts, are employed to gain and keep the heart of man; and what mortification can exceed the disappointment, if the end be not obtained? There is no reproof however pointed, no punishment however severe, that a woman of spirit will not prefer to neglect; and if she can endure it without complaint, it only proves that she means to make herself amends by the attention of others for the slights of her husband!'*

These are truly masculine sentiments.—'All our *arts* are employed to gain and keep the heart of man:'—and what is the inference?—if her person, and was there ever a person, though formed with Medicean* symmetry, that was not slighted? be neglected, she will make herself amends by endeavouring to please other men. Noble morality! But thus is the understanding of the whole sex affronted, and their virtue deprived of the common basis of virtue. A woman must know, that her person cannot be as pleasing to her husband as it was to her lover, and if she be offended with him for being a human creature, she may as well whine about the loss of his heart as about any other foolish thing.—And this very want of discernment or unreasonable anger, proves that he could not change his fondness for her person into affection for her virtues or respect for her understanding.

Whilst women avow, and act up to such opinions, their understandings, at least, deserve the contempt and obloquy that men, *who never* insult their persons, have pointedly levelled at the female mind. And it is the sentiments of these polite men, who do not wish to be encumbered with mind, that vain women thoughtlessly adopt. Yet they should know, that insulted reason alone can spread that *sacred* reserve about the person, which renders human affections, for human affections have always some base alloy, as permanent as is consistent with the grand end of existence—the attainment of virtue.

The Baroness de Stael* speaks the same language as the lady just cited, with more enthusiasm. Her eulogium on Rousseau was accidentally put into my hands, and her sentiments, the sentiments of too many of my sex, may serve as the text for a few comments. 'Though Rousseau,' she observes, 'has endeavoured to prevent women from interfering in public affairs, and acting a brilliant part in the theatre of politics; yet in speaking of them, how much has he

done it to their satisfaction! If he wished to deprive them of some rights foreign to their sex, how has he for ever restored to them all those to which it has a claim! And in attempting to diminish their influence over the deliberations of men, how sacredly has he established the empire they have over their happiness! In aiding them to descend from an usurped throne, he has firmly seated them upon that to which they were destined by nature; and though he be full of indignation against them when they endeavour to resemble men, yet when they come before him with all the *charms, weaknesses, virtues* and *errors*, of their sex, his respect for their *persons* amounts almost to adoration.'* True!—For never was there a sensualist who paid more fervent adoration at the shrine of beauty. So devout, indeed, was his respect for the person, that excepting the virtue of chastity, for obvious reasons, he only wished to see it embellished by charms, weaknesses, and errors. He was afraid lest the austerity of reason should disturb the soft playfulness of love. The master wished to have a meretricious slave to fondle, entirely dependent on his reason and bounty; he did not want a companion, whom he should be compelled to esteem, or a friend to whom he could confide the care of his children's education, should death deprive them of their father, before he had fulfilled the sacred task. He denies woman reason, shuts her out from knowledge, and turns her aside from truth; yet his pardon is granted, because 'he admits the passion of love.'* It would require some ingenuity to shew why women were to be under such an obligation to him for thus admitting love; when it is clear that he admits it only for the relaxation of men, and to perpetuate the species; but he talked with passion, and that powerful spell worked on the sensibility of a young encomiast. 'What signifies it,' pursues this rhapsodist, 'to women, that his reason disputes with them the empire, when his heart is devotedly theirs.'* It is not empire,—but equality, that they should contend for. Yet, if they only wished to lengthen out their sway, they should not entirely trust to their persons, for though beauty may gain a heart, it cannot keep it, even while the beauty is in full bloom, unless the mind lend, at least, some graces.

When women are once sufficiently enlightened to discover their real interest, on a grand scale, they will, I am persuaded, be very ready to resign all the prerogatives of love, that are not mutual,

speaking of them as lasting prerogatives, for the calm satisfaction of friendship, and the tender confidence of habitual esteem. Before marriage they will not assume any insolent airs, or afterwards abjectly submit; but endeavouring to act like reasonable creatures, in both situations, they will not be tumbled from a throne to a stool.

Madame Genlis* has written several entertaining books for children; and her Letters on Education afford many useful hints, that sensible parents will certainly avail themselves of; but her views are narrow, and her prejudices as unreasonable as strong.

I shall pass over her vehement argument in favour of the eternity of future punishments, because I blush to think that a human being should ever argue vehemently in such a cause, and only make a few remarks on her absurd manner of making the parental authority supplant reason. For every where does she inculcate not only *blind* submission to parents; but to the opinion of the world.[1]

She tells a story* of a young man engaged by his father's express desire to a girl of fortune. Before the marriage could take place, she is deprived of her fortune, and thrown friendless on the world. The father practises the most infamous arts to separate his son from her, and when the son detects his villany, and following the dictates of honour marries the girl, nothing but misery ensues, because forsooth he married *without* his father's consent. On what ground can religion or morality rest when justice is thus set at defiance? With the same view she represents an accomplished young woman,* as ready to marry any body that her *mamma* pleased to recommend; and, as actually marrying the young man of her own choice, without feeling any emotions of passion, because that a well educated girl had not time to be in love. Is it possible to have much respect for a system of education that thus insults reason and nature?

Many similar opinions occur in her writings, mixed with sentiments that do honour to her head and heart. Yet so much superstition is mixed with her religion, and so much worldly wisdom with

[1] A person is not to act in this or that way, though convinced they are right in so doing, because some equivocal circumstances may lead the world to *suspect* that they acted from different motives.—This is sacrificing the substance for a shadow. Let people but watch their own hearts, and act rightly, as far as they can judge, and they may patiently wait till the opinion of the world comes round. It is best to be directed by a simple motive—for justice has too often been sacrificed to propriety;—another word for convenience.

her morality, that I should not let a young person read her works, unless I could afterwards converse on the subjects, and point out the contradictions.

Mrs Chapone's Letters* are written with such good sense, and unaffected humility, and contain so many useful observations, that I only mention them to pay the worthy writer this tribute of respect. I cannot, it is true, always coincide in opinion with her; but I always respect her.

The very word respect brings Mrs Macaulay to my remembrance. The woman of the greatest abilities, undoubtedly, that this country has ever produced.—And yet this woman has been suffered to die without sufficient respect being paid to her memory.*

Posterity, however, will be more just; and remember that Catharine Macaulay was an example of intellectual acquirements supposed to be incompatible with the weakness of her sex. In her style of writing, indeed, no sex appears, for it is like the sense it conveys, strong and clear.

I will not call hers a masculine understanding, because I admit not of such an arrogant assumption of reason; but I contend that it was a sound one, and that her judgment, the matured fruit of profound thinking, was a proof that a woman can acquire judgment, in the full extent of the word. Possessing more penetration than sagacity, more understanding than fancy, she writes with sober energy and argumentative closeness; yet sympathy and benevolence give an interest to her sentiments, and that vital heat to arguments, which forces the reader to weigh them.[1]

When I first thought of writing these strictures I anticipated Mrs Macaulay's approbation, with a little of that sanguine ardour, which it has been the business of my life to depress; but soon heard with the sickly qualm of disappointed hope; and the still seriousness of regret—that she was no more!

Section V

Taking a view of the different works which have been written on education, Lord Chesterfield's Letters must not be silently passed

[1] Coinciding in opinion with Mrs Macaulay relative to many branches of education, I refer to her valuable work, instead of quoting her sentiments to support my own.

over. Not that I mean to analyze his unmanly, immoral system, or even to cull any of the useful, shrewd remarks which occur in his epistles—No, I only mean to make a few reflections on the avowed tendency of them—the art of acquiring an early knowledge of the world. An art, I will venture to assert, that preys secretly, like the worm in the bud,* on the expanding powers, and turns to poison the generous juices which should mount with vigour in the youthful frame, inspiring warm affections and great resolves.[1]

For every thing, saith the wise man, there is a season;*—and who would look for the fruits of autumn during the genial months of spring? But this is mere declamation, and I mean to reason with those worldly-wise instructors, who, instead of cultivating the judgment, instill prejudices, and render hard the heart that gradual experience would only have cooled. An early acquaintance with human infirmities; or, what is termed knowledge of the world, is the surest way, in my opinion, to contract the heart and damp the natural youthful ardour which produces not only great talents, but great virtues. For the vain attempt to bring forth the fruit of experience, before the sapling has thrown out its leaves, only exhausts its strength, and prevents its assuming a natural form; just as the form and strength of subsiding metals are injured when the attraction of cohesion is disturbed.

Tell me, ye who have studied the human mind, is it not a strange way to fix principles by showing young people that they are seldom stable? And how can they be fortified by habits when they are proved to be fallacious by example? Why is the ardour of youth thus to be damped, and the luxuriancy of fancy cut to the quick? This dry caution may, it is true, guard a character from worldly mischances; but will infallibly preclude excellence in either virtue or knowledge.[2] The stumbling-block thrown across every path by suspicion, will prevent any vigorous exertions of genius or benevolence, and life will be stripped of its most alluring charm long before its calm

[1] That children ought to be constantly guarded against the vices and follies of the world, appears, to me, a very mistaken opinion; for in the course of my experience, and my eyes have looked abroad, I never knew a youth educated in this manner, who had early imbibed these chilling suspicions, and repeated by rote the hesitating *if* of age, that did not prove a selfish character.

[2] I have already observed* that an early knowledge of the world, obtained in a natural way, by mixing in the world, has the same effect: instancing officers and women.

evening, when man should retire to contemplation for comfort and support.

A young man who has been bred up with domestic friends, and led to store his mind with as much speculative knowledge as can be acquired by reading and the natural reflections which youthful ebullitions of animal spirits and instinctive feelings inspire, will enter the world with warm and erroneous expectations. But this appears to be the course of nature; and in morals, as well as in works of taste, we should be observant of her sacred indications, and not presume to lead when we ought obsequiously to follow.

In the world few people act from principle; present feelings, and early habits, are the grand springs: but how would the former be deadened, and the latter rendered iron corroding fetters, if the world were shewn to young people just as it is; when no knowledge of mankind or their own hearts, slowly obtained by experience, rendered them forbearing? Their fellow creatures would not then be viewed as frail beings; like themselves, condemned to struggle with human infirmities, and sometimes displaying the light, and sometimes the dark side of their character; extorting alternate feelings of love and disgust; but guarded against as beasts of prey, till every enlarged social feeling, in a word,—humanity, was eradicated.

In life, on the contrary, as we gradually discover the imperfections of our nature, we discover virtues, and various circumstances attach us to our fellow creatures, when we mix with them, and view the same objects, that are never thought of in acquiring a hasty unnatural knowledge of the world. We see a folly swell into a vice, by almost imperceptible degrees, and pity while we blame; but, if the hideous monster burst suddenly on our sight, fear and disgust rendering us more severe than man ought to be, might lead us with blind zeal to usurp the character of omnipotence, and denounce damnation on our fellow mortals, forgetting that we cannot read the heart, and that we have seeds of the same vices lurking in our own.

I have already remarked that we expect more from instruction, than mere instruction can produce: for, instead of preparing young people to encounter the evils of life with dignity, and to acquire wisdom and virtue by the exercise of their own faculties, precepts are heaped upon precepts, and blind obedience required, when conviction should be brought home to reason.

Suppose, for instance, that a young person in the first ardour of friendship deifies the beloved object—what harm can arise from this mistaken enthusiastic attachment? Perhaps it is necessary for virtue first to appear in a human form to impress youthful hearts; the ideal model, which a more matured and exalted mind looks up to, and shapes for itself, would elude their sight. He who loves not his brother whom he hath seen, how can he love God? asked the wisest of men.*

It is natural for youth to adorn the first object of its affection with every good quality, and the emulation produced by ignorance, or, to speak with more propriety, by inexperience, brings forward the mind capable of forming such an affection, and when, in the lapse of time, perfection is found not to be within the reach of mortals, virtue, abstractedly, is thought beautiful, and wisdom sublime. Admiration then gives place to friendship, properly so called, because it is cemented by esteem; and the being walks alone only dependent on heaven for that emulous panting after perfection which ever glows in a noble mind. But this knowledge a man must gain by the exertion of his own faculties; and this is surely the blessed fruit of disappointed hope! for He who delighteth to diffuse happiness and shew mercy to the weak creatures, who are learning to know him, never implanted a good propensity to be a tormenting ignis fatuus.

Our trees are now allowed to spread with wild luxuriance, nor do we expect by force to combine the majestic marks of time with youthful graces; but wait patiently till they have struck deep their root, and braved many a storm.—Is the mind then, which, in proportion to its dignity, advances more slowly towards perfection, to be treated with less respect? To argue from analogy, every thing around us is in a progressive state; and when an unwelcome knowledge of life produces almost a satiety of life, and we discover by the natural course of things that all that is done under the sun is vanity,* we are drawing near the awful close of the drama. The days of activity and hope are over, and the opportunities which the first stage of existence has afforded of advancing in the scale of intelligence, must soon be summed up.—A knowledge at this period of the futility of life, or earlier, if obtained by experience, is very useful, because it is natural; but when a frail being is shewn the follies and vices of man, that he may be taught prudently to guard against the

common casualties of life by sacrificing his heart—surely it is not speaking harshly to call it the wisdom of this world, contrasted with the nobler fruit of piety and experience.

I will venture a paradox, and deliver my opinion without reserve; if men were only born to form a circle of life and death, it would be wise to take every step that foresight could suggest to render life happy. Moderation in every pursuit would then be supreme wisdom; and the prudent voluptuary might enjoy a degree of content, though he neither cultivated his understanding nor kept his heart pure. Prudence, supposing we were mortal, would be true wisdom, or, to be more explicit, would procure the greatest portion of happiness, considering the whole of life, but knowledge beyond the conveniences of life would be a curse.

Why should we injure our health by close study? The exalted pleasure which intellectual pursuits afford would scarcely be equivalent to the hours of languor that follow; especially, if it be necessary to take into the reckoning the doubts and disappointments that cloud our researches. Vanity and vexation close every inquiry: for the cause which we particularly wished to discover flies like the horizon before us as we advance. The ignorant, on the contrary, resemble children, and suppose, that if they could walk straight forward they should at last arrive where the earth and clouds meet. Yet, disappointed as we are in our researches, the mind gains strength by the exercise, sufficient, perhaps, to comprehend the answers which, in another step of existence, it may receive to the anxious questions it asked, when the understanding with feeble wing was fluttering round the visible effects to dive into the hidden cause.

The passions also, the winds of life, would be useless, if not injurious, did the substance which composes our thinking being, after we have thought in vain, only become the support of vegetable life, and invigorate a cabbage, or blush in a rose. The appetites would answer every earthly purpose, and produce more moderate and permanent happiness. But the powers of the soul that are of little use here, and, probably, disturb our animal enjoyments, even while conscious dignity makes us glory in possessing them, prove that life is merely an education, a state of infancy, to which the only hopes worth cherishing should not be sacrificed. I mean, therefore, to infer, that we ought to have a precise idea of what we wish to

attain by education, for the immortality of the soul is contradicted by the actions of many people who firmly profess the belief.

If you mean to secure ease and prosperity on earth as the first consideration, and leave futurity to provide for itself; you act prudently in giving your child an early insight into the weaknesses of his nature. You may not, it is true, make an Inkle* of him; but do not imagine that he will stick to more than the letter of the law, who has very early imbibed a mean opinion of human nature; nor will he think it necessary to rise much above the common standard. He may avoid gross vices, because honesty is the best policy; but he will never aim at attaining great virtues. The example of writers and artists will illustrate this remark.

I must therefore venture to doubt whether what has been thought an axiom in morals may not have been a dogmatical assertion made by men who have coolly seen mankind through the medium of books, and say, in direct contradiction to them, that the regulations of the passions is not, always, wisdom.—On the contrary, it should seem, that one reason why men have superior judgment, and more fortitude than women, is undoubtedly this, that they give a freer scope to the grand passions, and by more frequently going astray enlarge their minds. If then by the exercise of their own[1] reason they fix on some stable principle, they have probably to thank the force of their passions, nourished by *false* views of life, and permitted to overleap the boundary that secures content. But if, in the dawn of life, we could soberly survey the scenes before as in perspective, and see every thing in its true colours, how could the passions gain sufficient strength to unfold the faculties?

Let me now as from an eminence survey the world stripped of all its false delusive charms. The clear atmosphere enables me to see each object in its true point of view, while my heart is still. I am calm as the prospect in a morning when the mists, slowly dispersing, silently unveil the beauties of nature, refreshed by rest.

In what light will the world now appear?—I rub my eyes and think, perchance, that I am just awakening from a lively dream.

I see the sons and daughters of men pursuing shadows, and anxiously wasting their powers to feed passions which have no adequate object—if the very excess of these blind impulses, pam-

[1] 'I find that all is but lip-wisdom which wants experience,' says Sidney.*

pered by that lying, yet constantly trusted guide, the imagination, did not, by preparing them for some other state, render short-sighted mortals wiser without their own concurrence; or, what comes to the same thing, when they were pursuing some imaginary present good.

After viewing objects in this light, it would not be very fanciful to imagine that this world was a stage on which a pantomime is daily performed for the amusement of superior beings. How would they be diverted to see the ambitious man consuming himself by running after a phantom, and, 'pursuing the bubble fame in the cannon's mouth'* that was to blow him to nothing: for when consciousness is lost, it matters not whether we mount in a whirlwind or descend in rain. And should they compassionately invigorate his sight and shew him the thorny path which led to eminence, that like a quicksand sinks as he ascends, disappointing his hopes when almost within his grasp, would he not leave to others the honour of amusing them, and labour to secure the present moment, though from the constitution of his nature he would not find it very easy to catch the flying stream? Such slaves are we to hope and fear!

But, vain as the ambitious man's pursuits would be, he is often striving for something more substantial than fame—that indeed would be the veriest meteor, the wildest fire that could lure a man to ruin.—What! renounce the most trifling gratification to be ap-plauded when he should be no more! Wherefore this struggle, whether man be mortal or immortal, if that noble passion did not really raise the being above his fellows?—

And love! What diverting scenes would it produce—Pantaloon's tricks* must yield to more egregious folly. To see a mortal adorn an object with imaginary charms, and then fall down and worship the idol which he had himself set up—how ridiculous! But what serious consequences ensue to rob man of that portion of happiness, which the Deity by calling him into existence has (or, on what can his attributes rest!) indubitably promised: would not all the purposes of life have been much better fulfilled if he had only felt what has been termed physical love? And, would not the sight of the object, not seen through the medium of the imagination, soon reduce the pas-sion to an appetite, if reflection, the noble distinction of man, did not give it force, and make it an instrument to raise him above this earthy dross, by teaching him to love the centre of all perfection;

whose wisdom appears clearer and clearer in the works of nature, in proportion as reason is illuminated and exalted by contemplation, and by acquiring that love of order which the struggles of passion produce?

The habit of reflection, and the knowledge attained by fostering any passion, might be shewn to be equally useful, though the object be proved equally fallacious; for they would all appear in the same light, if they were not magnified by the governing passion implanted in us by the Author of all good, to call forth and strengthen the faculties of each individual, and enable it to attain all the experience that an infant can obtain, who does certain things, it cannot tell why.

I descend from my height, and mixing with my fellow-creatures, feel myself hurried along the common stream; ambition, love, hope, and fear, exert their wonted power, though we be convinced by reason that their present and most attractive promises are only lying dreams; but had the cold hand of circumspection damped each generous feeling before it had left any permanent character, or fixed some habit, what could be expected, but selfish prudence and reason just rising above instinct? Who that has read Dean Swift's disgusting description of the Yahoos, and insipid one of Houyhnhnm* with a philosophical eye, can avoid seeing the futility of degrading passions, or making man rest in contentment?

The youth should *act*; for had he the experience of a grey head he would be fitter for death than life, though his virtues, rather residing in his head than his heart, could produce nothing great, and his understanding, prepared for this world, would not, by its noble flights, prove that it had a title to a better.

Besides, it is not possible to give a young person a just view of life; he must have struggled with his own passions before he can estimate the force of the temptation which betrayed his brother into vice. Those who are entering life, and those who are departing, see the world from such very different points of view, that they can seldom think alike, unless the unfledged reason of the former never attempted a solitary flight.

When we hear of some daring crime—it comes full on us in the deepest shade of turpitude, and raises indignation; but the eye that gradually saw the darkness thicken, must observe it with more compassionate forbearance. The world cannot be seen by an unmoved spectator, we must mix in the throng, and feel as men feel

before we can judge of their feelings. If we mean, in short, to live in the world to grow wiser and better, and not merely to enjoy the good things of life, we must attain a knowledge of others at the same time that we become acquainted with ourselves—knowledge acquired any other way only hardens the heart and perplexes the understanding.

I may be told, that the knowledge thus acquired, is sometimes purchased at too dear a rate. I can only answer that I very much doubt whether any knowledge can be attained without labour and sorrow; and those who wish to spare their children both, should not complain, if they are neither wise nor virtuous. They only aimed at making them prudent; and prudence, early in life, is but the cautious craft of ignorant self-love.

I have observed that young people, to whose education particular attention has been paid, have, in general, been very superficial and conceited, and far from pleasing in any respect, because they had neither the unsuspecting warmth of youth, nor the cool depth of age. I cannot help imputing this unnatural appearance principally to that hasty premature instruction, which leads them presumptuously to repeat all the crude notions they have taken upon trust, so that the careful education which they received, makes them all their lives the slaves of prejudices.

Mental as well as bodily exertion is, at first, irksome, so much so, that the many would fain let others both work and think for them. An obsveration which I have often made will illustrate my meaning. When in a circle of strangers, or acquaintances, a person of moderate abilities asserts an opinion with heat, I will venture to affirm, for I have traced this fact home, very often, that it is a prejudice. These echoes have a high respect for the understanding of some relation or friend, and without fully comprehending the opinions, which they are so eager to retail, they maintain them with a degree of obstinacy, that would surprise even the person who concocted them.

I know that a kind of fashion now prevails of respecting prejudices; and when any one dares to face them, though actuated by humanity and armed by reason, he is superciliously asked whether his ancestors were fools. No, I should reply; opinions, at first, of every description, were all, probably, considered, and therefore were founded on some reason; yet not unfrequently, of course, it was rather a local expedient than a fundamental principle, that would be reasonable at all times. But, moss-covered opinions as-

sume the disproportioned form of prejudices, when they are indolently adopted only because age has given them a venerable aspect, though the reason on which they were built ceases to be a reason, or cannot be traced. Why are we to love prejudices, merely because they are prejudices?[1] A prejudice is a fond obstinate persuasion for which we can give no reason; for the moment a reason can be given for an opinion, it ceases to be a prejudice, though it may be an error in judgment: and are we then advised to cherish opinions only to set reason at defiance? This mode of arguing, if arguing it may be called, reminds me of what is vulgarly termed a woman's reason. For women sometimes declare that they love, or believe, certain things, *because* they love, or believe them.

It is impossible to converse with people to any purpose, who only use affirmatives and negatives. Before you can bring them to a point, to start fairly from, you must go back to the simple principles that were antecedent to the prejudices broached by power; and it is ten to one but you are stopped by the philosophical assertion, that certain principles are as practically false as they are abstractly true.[2] Nay, it may be inferred, that reason has whispered some doubts, for it generally happens that people assert their opinions with the greatest heat when they begin to waver; striving to drive out their own doubts by convincing their opponent, they grow angry when those gnawing doubts are thrown back to prey on themselves.

The fact is, that men expect from education, what education cannot give. A sagacious parent or tutor may strengthen the body and sharpen the instruments by which the child is to gather knowledge; but the honey must be the reward of the individual's own industry. It is almost as absurd to attempt to make a youth wise by the experience of another, as to expect the body to grow strong by the exercise which is only talked of, or seen.[3] Many of those children whose conduct has been most narrowly watched, become the weakest men, because their instructors only instil certain notions into their minds, that have no other foundation than their authority; and if they be loved or respected, the mind is cramped in its exertions and wavering in its advances. The business of education in this case,

[1] Vide Mr Burke.*

[2]
> 'Convince a man against his will,
> He's of the same opinion still.'*

[3] 'One sees nothing when one is content to contemplate only; it is necessary to act oneself to be able to see how others act.' *Rousseau.*

is only to conduct the shooting tendrils to a proper pole; yet after laying precept upon precept, without allowing a child to acquire judgment itself, parents expect them to act in the same manner by this borrowed fallacious light, as if they had illuminated it themselves; and be, when they enter life, what their parents are at the close. They do not consider that the tree, and even the human body, does not strengthen its fibres till it has reached its full growth.

There appears to be something analogous in the mind. The senses and the imagination give a form to the character, during a childhood and youth; and the understanding, as life advances, gives firmness to the first fair purposes of sensibility—till virtue, arising rather from the clear conviction of reason than the impulse of the heart, morality is made to rest on a rock against which the storms of passion vainly beat.

I hope I shall not be misunderstood when I say, that religion will not have this condensing energy, unless it be founded on reason. If it be merely the refuge of weakness or wild fanaticism, and not a governing principle of conduct, drawn from self-knowledge, and a rational opinion respecting the attributes of God, what can it be expected to produce? The religion which consists in warming the affections, and exalting the imagination, is only the poetical part, and may afford the individual pleasure without rendering it a more moral being. It may be a substitute for worldly pursuits; yet narrow, instead of enlarging the heart: but virtue must be loved as in itself sublime and excellent, and not for the advantages it procures or the evils it averts, if any great degree of excellence be expected. Men will not become moral when they only build airy castles in a future world to compensate for the disappointments which they meet with in this; if they turn their thoughts from relative duties to religious reveries.

Most prospects in life are marred by the shuffling worldly wisdom of men, who, forgetting that they cannot serve God and mammon,* endeavour to blend contradictory things.—If you wish to make your son rich, pursue one course—if you are only anxious to make him virtuous, you must take another; but do not imagine that you can bound from one road to the other without losing your way.[1]

[1] See an excellent essay on this subject by Mrs Barbauld, in *Miscellaneous Pieces in Prose*.*

CHAPTER VI

THE EFFECT WHICH AN EARLY ASSOCIATION
OF IDEAS HAS UPON THE CHARACTER

Educated in the enervating style recommended by the writers on whom I have been animadverting; and not having a chance, from their subordinate state in society, to recover their lost ground, is it surprising that women every where appear a defect in nature? Is it surprising, when we consider what a determinate effect an early association of ideas has on the character, that they neglect their understandings, and turn all their attention to their persons?

The great advantages which naturally result from storing the mind with knowledge, are obvious from the following considerations. The association of our ideas is either habitual or instantaneous; and the latter mode seems rather to depend on the original temperature of the mind than on the will. When the ideas, and matters of fact, are once taken in, they lie by for use, till some fortuitous circumstance makes the information dart into the mind with illustrative force, that has been received at very different periods of our lives. Like the lightning's flash are many recollections; one idea assimilating and explaining another, with astonishing rapidity. I do not now allude to that quick perception of truth, which is so intuitive that it baffles research, and makes us at a loss to determine whether it is reminiscence or ratiocination, lost sight of in its celerity, that opens the dark cloud. Over those instantaneous associations we have little power; for when the mind is once enlarged by excursive flights, or profound reflection, the raw materials will, in some degree, arrange themselves. The understanding, it is true, may keep us from going out of drawing when we group our thoughts, or transcribe from the imagination the warm sketches of fancy; but the animal spirits, the individual character, give the colouring. Over this subtile electric fluid,[1] how little power do we

[1] I have sometimes, when inclined to laugh at materialists,* asked whether, as the most powerful effects in nature are apparently produced by fluids, the magnetic, etc. the passions might not be fine volatile fluids that embraced humanity, keeping the more refractory elementary parts together—or whether they were simply a liquid fire that pervaded the more sluggish materials, giving them life and heat?

possess, and over it how little power can reason obtain! These fine intractable spirits appear to be the essence of genius, and beaming in its eagle eye, produce in the most eminent degree the happy energy of associating thoughts that surprise, delight, and instruct. These are the glowing minds that concentrate pictures for their fellow-creatures; forcing them to view with interest the objects reflected from the impassioned imagination, which they passed over in nature.

I must be allowed to explain myself. The generality of people cannot see or feel poetically, they want fancy, and therefore fly from solitude in search of sensible objects; but when an author lends them his eyes they can see as he saw, and be amused by images they could not select, though lying before them.

Education thus only supplies the man of genius with knowledge to give variety and contrast to his associations; but there is an habitual association of ideas, that grows 'with our growth,'* which has a great effect on the moral character of mankind; and by which a turn is given to the mind that commonly remains throughout life. So ductile is the understanding, and yet so stubborn, that the associations which depend on adventitious circumstances, during the period that the body takes to arrive at maturity, can seldom be disentangled by reason. One idea calls up another, its old associate, and memory, faithful to the first impressions, particularly when the intellectual powers are not employed to cool our sensations, retraces them with mechanical exactness.

This habitual slavery, to first impressions, has a more baneful effect on the female than the male character, because business and other dry employments of the understanding, tend to deaden the feelings and break associations that do violence to reason. But females, who are made women of when they are mere children, and brought back to childhood when they ought to leave the go-cart for ever, have not sufficient strength of mind to efface the superinductions of art that have smothered nature.

Every thing that they see or hear serves to fix impressions, call forth emotions, and associate ideas, that give a sexual character to the mind. False notions of beauty and delicacy stop the growth of their limbs and produce a sickly soreness, rather than delicacy of organs; and thus weakened by being employed in unfolding instead of examining the first associations, forced on them by every sur-

rounding object, how can they attain the vigour necessary to enable them to throw off that factitious character?—where find strength to recur to reason and rise superiour to a system of oppression, that blasts the fair promises of spring? This cruel association of ideas, which every thing conspires to twist into all their habits of thinking, or, to speak with more precision, of feeling, receives new force when they begin to act a little for themselves; for they then perceive that it is only through their address to excite emotions in men, that pleasure and power are to be obtained. Besides, the books profess-edly written for their instruction, which make the first impression on their minds, all inculcate the same opinions. Educated then in worse than Egyptian bondage,* it is unreasonable, as well as cruel, to upbraid them with faults that can scarcely be avoided, unless a degree of native vigour be supposed, that falls to the lot of very few amongst mankind.

For instance, the severest sarcasms have been levelled against the sex, and they have been ridiculed for repeating 'a set of phrases learnt by rote,'* when nothing could be more natural, considering the education they receive, and that their 'highest praise is to obey, unargued'*—the will of man. If they be not allowed to have reason sufficient to govern their own conduct—why, all they learn—must be learned by rote! And when all their ingenuity is called forth to adjust their dress, 'a passion for a scarlet coat,'* is so natural, that it never surprised me; and, allowing Pope's summary of their charac-ter to be just, 'that every woman is at heart a rake,'* why should they be bitterly censured for seeking a congenial mind, and preferring a rake to a man of sense?

Rakes know how to work on their sensibility, whilst the modest merit of reasonable men has, of course, less effect on their feelings, and they cannot reach the heart by the way of the understanding, because they have few sentiments in common.

It seems a little absurd to expect women to be more reasonable than men in their *likings*, and still to deny them the uncontrouled use of reason. When do men *fall-in-love* with sense? When do they, with their superiour powers and advantages, turn from the person to the mind? And how can they then expect women, who are only taught to observe behaviour, and acquire manners rather than mor-als, to despise what they have been all their lives labouring to attain? Where are they suddenly to find judgment enough to weigh pa-

tiently the sense of an awkward virtuous man, when his manners, of which they are made critical judges, are rebuffing, and his conversation cold and dull, because it does not consist of pretty repartees, or well turned compliments? In order to admire or esteem any thing for a continuance, we must, at least, have our curiosity excited by knowing, in some degree, what we admire; for we are unable to estimate the value of qualities and virtues, above our comprehension. Such a respect, when it is felt, may be very sublime; and the confused consciousness of humility may render the dependent creature an interesting object, in some points of view; but human love must have grosser ingredients; and the person very naturally will come in for its share—and, an ample share it mostly has!

Love is, in a great degree, an arbitrary passion, and will reign, like some other stalking mischiefs, by its own authority, without deigning to reason; and it may also be easily distinguished from esteem, the foundation of friendship, because it is often excited by evanescent beauties and graces, though, to give an energy to the sentiment, something more solid must deepen their impression and set the imagination to work, to make the most fair—the first good.

Common passions are excited by common qualities.—Men look for beauty and the simper of good-humoured docility: women are captivated by easy manners; a gentleman-like man seldom fails to please them, and their thirsty ears eagerly drink the insinuating nothings of politeness, whilst they turn from the unintelligible sounds of the charmer—reason, charm he never so wisely. With respect to superficial accomplishments, the rake certainly has the advantage; and of these females can form an opinion, for it is their own ground. Rendered gay and giddy by the whole tenor of their lives, the very aspect of wisdom, or the severe graces of virtue, must have a lugubrious appearance to them; and produce a kind of restraint from which they and love, sportive child, naturally revolt. Without taste, excepting of the lighter kind, for taste is the offspring of judgment, how can they discover that true beauty and grace must arise from the play of the mind? and how can they be expected to relish in a lover what they do not, or very imperfectly, possess themselves? The sympathy that unites hearts, and invites to confidence, in them is so very faint, that it cannot take fire, and thus mount to passion. No, I repeat it, the love cherished by such minds, must have grosser fewel!

The inference is obvious; till women are led to exercise their understandings, they should not be satirized for their attachment to rakes; or even for being rakes at heart, when it appears to be the inevitable consequence of their education. They who live to please—must find their enjoyments, their happiness, in pleasure! It is a trite, yet true remark, that we never do any thing well, unless we love it for its own sake.

Supposing, however, for a moment, that women were, in some future revolution of time, to become, what I sincerely wish them to be, even love would acquire more serious dignity, and be purified in its own fires; and virtue giving true delicacy to their affections, they would turn with disgust from a rake. Reasoning then, as well as feeling, the only province of woman, at present, they might easily guard against exteriour graces, and quickly learn to despise the sensibility that had been excited and hackneyed in the ways of women, whose trade was vice; and allurements, wanton airs. They would recollect that the flame, one must use appropriated expressions, which they wished to light up, had been exhausted by lust, and that the sated appetite, losing all relish for pure and simple pleasures, could only be roused by licentious arts or variety. What satisfaction could a woman of delicacy promise herself in a union with such a man, when the very artlessnes of her affection might appear insipid? Thus does Dryden describe the situation,

> ——'Where love is duty, on the female side,
> On theirs mere sensual gust, and sought with surly pride.'*

But one grand truth women have yet to learn, though much it imports them to act accordingly. In the choice of a husband, they should not be led astray by the qualities of a lover—for a lover the husband, even supposing him to be wise and virtuous, cannot long remain.

Were women more rationally educated, could they take a more comprehensive view of things, they would be contented to love but once in their lives; and after marriage calmly let passion subside into friendship—into that tender intimacy, which is the best refuge from care; yet is built on such pure, still affections, that idle jealousies would not be allowed to disturb the discharge of the sober duties of life, or to engross the thoughts that ought to be otherwise employed. This is a state in which many men live; but few, very few women.

And the difference may easily be accounted for, without recurring to a sexual character. Men, for whom we are told women were made, have too much occupied the thoughts of women; and this association has so entangled love with all their motives of action; and, to harp a little on an old string, having been solely employed either to prepare themselves to excite love, or actually putting their lessons in practice, they cannot live without love. But, when a sense of duty, or fear of shame, obliges them to restrain this pampered desire of pleasing beyond certain lengths, too far for delicacy, it is true, though far from criminality, they obstinately determine to love, I speak of the passion, their husbands to the end of the chapter—and then acting the part which they foolishly exacted from their lovers, they become abject woers, and fond slaves.

Men of wit and fancy are often rakes; and fancy is the food of love. Such men will inspire passion. Half the sex, in its present infantine state, would pine for a Lovelace;* a man so witty, so graceful, and so valiant: and can they *deserve* blame for acting according to principles so constantly inculcated? They want a lover, and protector; and behold him kneeling before them—bravery prostrate to beauty! The virtues of a husband are thus thrown by love into the back ground, and gay hopes, or lively emotions, banish reflection till the day of reckoning come; and come it surely will, to turn the sprightly lover into a surly suspicious tyrant, who contemptuously insults the very weakness he fostered. Or, supposing the rake reformed, he cannot quickly get rid of old habits. When a man of abilities is first carried away by his passions, it is necessary that sentiment and taste varnish the enormities of vice, and give a zest to brutal indulgences; but when the gloss of novelty is worn off, and pleasure palls upon the sense, lasciviousness becomes barefaced, and enjoyment only the desperate effort of weakness flying from reflection as from a legion of devils. Oh! virtue, thou art not an empty name! All that life can give—thou givest!

If much comfort cannot be expected from the friendship of a reformed rake of superiour abilities, what is the consequence when he lacketh sense, as well as principles? Verily misery, in its most hideous shape. When the habits of weak people are consolidated by time, a reformation is barely possible; and actually makes the beings miserable who have not sufficient mind to be amused by innocent pleasure; like the tradesman who retires from the hurry of business,

nature presents to them only a universal blank;* and the restless thoughts prey on the damped spirits.[1] Their reformation, as well as his retirement, actually makes them wretched because it deprives them of all employment, by quenching the hopes and fears that set in motion their sluggish minds.

If such be the force of habit; if such be the bondage of folly, how carefully ought we to guard the mind from storing up vicious associations; and equally careful should we be to cultivate the understanding, to save the poor wight from the weak dependent state of even harmless ignorance. For it is the right use of reason alone which makes us independent of every thing—excepting the unclouded Reason—'Whose service is perfect freedom.'*

[1] I have frequently seen this exemplified in women whose beauty could no longer be repaired. They have retired from the noisy scenes of dissipation; but, unless they became methodists, the solitude of the select society of their family conncetions or acquaintance, has presented only a fearful void; consequently, nervous complaints, and all the vapourish train of idleness, rendered them quite as useless, and far more unhappy, than when they joined the giddy throng.

CHAPTER VII

MODESTY—COMPREHENSIVELY CONSIDERED, AND NOT AS A SEXUAL VIRTUE

Modesty! Sacred offspring of sensibility and reason!—true delicacy of mind!—may I unblamed presume to investigate thy nature, and trace to its covert the mild charm, that mellowing each harsh feature of a character, renders what would otherwise only inspire cold admiration—lovely!—Thou that smoothest the wrinkles of wisdom, and softenest the tone of the sublimest virtues till they all melt into humanity;—thou that spreadest the ethereal cloud that, surrounding love, heightens every beauty, it half shades, breathing those coy sweets that steal into the heart, and charm the senses—modulate for me the language of persuasive reason, till I rouse my sex from the flowery bed, on which they supinely sleep life away!*

In speaking of the association of our ideas, I have noticed two distinct modes; and in defining modesty, it appears to me equally proper to discriminate that purity of mind, which is the effect of chastity, from a simplicity of character that leads us to form a just opinion of ourselves, equally distant from vanity or presumption, though by no means incompatible with a lofty consciousness of our own dignity. Modesty, in the latter signification of the term, is, that soberness of mind which teaches a man not to think more highly of himself than he ought to think, and should be distinguished from humility, because humility is a kind of self-abasement.

A modest man often conceives a great plan, and tenaciously adheres to it, conscious of his own strength, till success gives it a sanction that determines its character. Milton was not arrogant when he suffered a suggestion of judgment to escape him that proved a prophecy;* nor was General Washington when he accepted the command of the American forces.* The latter has always been characterized as a modest man; but had he been merely humble, he would probably have shrunk back irresolute, afraid of trusting to himself the direction of an enterprise, on which so much depended.

A modest man is steady, an humble man timid, and a vain one presumptuous:—this is the judgment, which the observation of many characters, has led me to form. Jesus Christ was modest, Moses was humble, and Peter vain.

Thus, discriminating modesty from humility in one case, I do not mean to confound it with bashfulness in the other. Bashfulness, in fact, is so distinct from modesty, that the most bashful lass, or raw country lout, often become the most impudent; for their bashfulness being merely the instinctive timidity of ignorance, custom soon changes it into assurance.[1]

The shameless behaviour of the prostitutes, who infest the streets of this metropolis, raising alternate emotions of pity and disgust, may serve to illustrate this remark. They trample on virgin bashfulness with a sort of bravado, and glorying in their shame, become more audaciously lewd than men, however depraved, to whom this sexual quality has not been gratuitously granted, ever appear to be. But these poor ignorant wretches never had any modesty to lose, when they consigned themselves to infamy; for modesty is a virtue, not a quality. No, they were only bashful, shame-faced innocents; and losing their innocence, their shame-facedness was rudely brushed off; a virtue would have left some vestiges in the mind, had it been sacrificed to passion, to make us respect the grand ruin.

Purity of mind, or that genuine delicacy, which is the only virtuous support of chastity, is near akin to that refinement of humanity, which never resides in any but cultivated minds. It is something nobler than innocence, it is the delicacy of reflection, and not the coyness of ignorance. The reserve of reason, which, like habitual cleanliness, is seldom seen in any great degree, unless the soul is active, may easily be distinguished from rustic shyness or wanton skittishness; and, so far from being incompatible with knowledge, it

[1]
> 'Such is the country-maiden's fright,
> When first a red-coat is in sight;
> Behind the door she hides her face;
> Next time at distance eyes the lace:
> She now can all his terrors stand,
> Nor from his squeeze withdraws her hand.
> She plays familiar in his arms,
> And ev'ry soldier hath his charms;
> From tent to tent she spreads her flame;
> For custom conquers fear and shame.'
> *Gay**

is its fairest fruit. What a gross idea of modesty had the writer of the following remark! 'The lady who asked the question whether women may be instructed in the modern system of botany, consistently with female delicacy?—was accused of ridiculous prudery: nevertheless, if she had proposed the question to me, I should certainly have answered—They cannot.'* Thus is the fair book of knowledge to be shut with an everlasting seal! On reading similar passages I have reverentially lifted up my eyes and heart to Him who liveth for ever and ever, and said, O my Father, hast Thou by the very constitution of her nature forbid Thy child to seek Thee in the fair forms of truth? And, can her soul be sullied by the knowledge that awfully calls her to Thee?

I have then philosophically pursued these reflections till I inferred that those women who have most improved their reason must have the most modesty—though a dignified sedateness of deportment may have succeeded the playful, bewitching bashfulness of youth.[1]

And thus have I argued. To render chastity the virtue from which unsophisticated modesty will naturally flow, the attention should be called away from employments which only exercise the sensibility; and the heart made to beat time to humanity, rather than to throb with love. The woman who has dedicated a considerable portion of her time to pursuits purely intellectual, and whose affections have been exercised by humane plans of usefulness, must have more purity of mind, as a natural consequence, than the ignorant beings whose time and thoughts have been occupied by gay pleasures or schemes to conquer hearts.[2] The regulation of the behaviour is not modesty, though those who study rules of decorum are, in general, termed modest women. Make the heart clean, let it expand and feel

[1] Modesty, is the graceful calm virtue of maturity; bashfulness, the charm of vivacious youth.

[2] I have conversed, as man with man, with medical men, on anatomical subjects; and compared the proportions of the human body with artists—yet such modesty did I meet with, that I was never reminded by word or look of my sex, of the absurd rules which make modesty a pharisaical cloak of weakness. And I am persuaded that in the pursuit of knowledge women would never be insulted by sensible men, and rarely by men of any description, if they did not by mock modesty remind them that they were women: actuated by the same spirit as the Portugueze ladies, who would think their charms insulted, if, when left alone with a man, he did not, at least, attempt to be grossly familiar with their persons. Men are not always men in the company of women, nor would women always remember that they are women, if the were allowed to acquire more understanding.

for all that is human, instead of being narrowed by selfish passions; and let the mind frequently contemplate subjects that exercise the understanding, without heating the imagination, and artless modesty will give the finishing touches to the picture.

She who can discern the dawn of immortality, in the streaks that shoot athwart the misty night of ignorance, promising a clearer day, will respect, as a sacred temple, the body that enshrines such an improvable soul. True love, likewise, spreads this kind of mysterious sanctity round the beloved object, making the lover most modest when in her presence.[1] So reserved is affection that, receiving or returning personal endearments, it wishes, not only to shun the human eye, as a kind of profanation; but to diffuse an encircling cloudy obscurity to shut out even the saucy sparkling sunbeams. Yet, that affection does not deserve the epithet of chaste, which does not receive a sublime gloom of tender melancholy, that allows the mind for a moment to stand still and enjoy the present satisfaction, when a consciousness of the Divine presence is felt—for this must ever be the food of joy!

As I have always been fond of tracing to its source in nature any prevailing custom, I have frequently thought that it was a sentiment of affection for whatever had touched the person of an absent or lost friend, which gave birth to that respect for relicks, so much abused by selfish priests. Devotion, or love, may be allowed to hallow the garments as well as the person; for the lover must want fancy who has not a sort of sacred respect for the glove or slipper of his mistress. He could not confound them with vulgar things of the same kind. This fine sentiment, perhaps, would not bear to be analyzed by the experimental philosopher—but of such stuff is human rapture made up!—A shadowy phantom glides before us, obscuring every other object; yet when the soft cloud is grasped, the form melts into common air, leaving a solitary void, or sweet perfume, stolen from the violet, that memory long holds dear. But, I have tripped unawares on fairy ground, feeling the balmy gale of spring stealing on me, though november frowns.

As a sex, women are more chaste than men, and as modesty is the effect of chastity, they may deserve to have this virtue ascribed to them in rather an appropriated sense; yet, I must be allowed to add

[1] Male or female; for the world contains many modest men.

an hesitating if:—for I doubt whether chastity will produce modesty, though it may propriety of conduct, when it is merely a respect for the opinion of the world,[1] and when coquetry and the love-lorn tales of novelists employ the thoughts. Nay, from experience, and reason, I should be led to expect to meet with more modesty amongst men than women, simply because men exercise their understandings more than women.

But, with respect to propriety of behaviour, excepting one class of females, women have evidently the advantage. What can be more disgusting than that impudent dross of gallantry, thought so manly, which makes many men stare insultingly at every female they meet? Can it be termed respect for the sex? No, this loose behaviour shews such habitual depravity, such weakness of mind, that it is vain to expect much public or private virtue, till both men and women grow more modest—till men, curbing a sensual fondness for the sex, or an affectation of manly assurance, more properly speaking, impudence, treat each other with respect—unless appetite or passion give the tone, peculiar to it, to their behaviour. I mean even personal respect—the modest respect of humanity, and fellow-feeling—not the libidinous mockery of gallantry, nor the insolent condescension of protectorship.

To carry the observation still further, modesty must heartily disclaim, and refuse to dwell with that debauchery of mind, which leads a man coolly to bring forward, without a blush, indecent allusions, or obscene witticisms, in the presence of a fellow creature; women are now out of the question, for then it is brutality. Respect for man, as man, is the foundation of every noble sentiment. How much more modest is the libertine who obeys the call of appetite or fancy, than the lewd joker who sets the table in a roar!

This is one of the many instances in which the sexual distinction respecting modesty has proved fatal to virtue and happiness. It is, however, carried still further, and woman, weak woman! made by her education the slave of sensibility, is required, on the most trying occasions, to resist that sensibility. 'Can any thing,' says Knox, 'be more absurd than keeping women in a state of ignorance, and yet so vehemently to insist on their resisting temptation?'*—Thus when

[1] The immodest behaviour of many married women, who are nevertheless faithful to their husbands' beds, will illustrate this remark.

virtue or honour make it proper to check a passion, the burden is thrown on the weaker shoulders, contrary to reason and true modesty, which, at least, should render the self-denial mutual, to say nothing of the generosity of bravery, supposed to be a manly virtue.

In the same strain runs Rousseau's and Dr Gregory's advice respecting modesty, strangely miscalled! for they both desire a wife to leave it in doubt whether sensibility or weakness led her to her husband's arms.—The woman is immodest who can let the shadow of such a doubt remain in her husband's mind a moment.

But to state the subject in a different light.—The want of modesty, which I principally deplore as subversive of morality, arises from the state of warfare so strenuously supported by voluptuous men as the very essence of modesty, though, in fact, its bane; because it is a refinement on lust, that men fall into who have not sufficient virtue to relish the innocent pleasures of love. A man of delicacy carries his notions of modesty still further, for neither weakness nor sensibility will gratify him—he looks for affection.

Again; men boast of their triumphs over women, what do they boast of? Truly the creature of sensibility was surprised by her sensibility into folly—into vice;[1] and the dreadful reckoning falls heavily on her own weak head, when reason wakes. For where art thou to find comfort, forlorn and disconsolate one? He who ought to have directed thy reason, and supported thy weakness, has betrayed thee! In a dream of passion thou consented to wander through flowery lawns, and heedlessly stepping over the precipice to which thy guide, instead of guarding, lured thee, thou startest from thy dream only to face a sneering, frowning world, and to find thyself alone in a waste, for he that triumphed in thy weakness is now pursuing new conquests; but for thee—there is no redemption on this side the grave!—And what resource hast thou in an enervated mind to raise a sinking heart?

But, if the sexes be really to live in a state of warfare, if nature have pointed it out, let them act nobly, or let pride whisper to them, that the victory is mean when they merely vanquish sensibility. The real conquest is that over affection not taken by surprise—when, like Heloisa,* a woman gives up all the world, deliberately, for love. I do not now consider the wisdom or virtue of such a sacrifice, I only

[1] The poor moth fluttering round a candle, burns its wings.

contend that it was a sacrifice to affection, and not merely to sensibility, though she had her share.—And I must be allowed to call her a modest woman, before I dismiss this part of the subject, by saying, that till men are more chaste women will be immodest. Where, indeed, could modest women find husbands from whom they would not continually turn with disgust? Modesty must be equally cultivated by both sexes, or it will ever remain a sickly hothouse plant, whilst the affectation of it, the fig leaf borrowed by wantonness, may give a zest to voluptuous enjoyments.

Men will probably still insist that woman ought to have more modesty than man; but it is not dispassionate reasoners who will most earnestly oppose my opinion. No, they are the men of fancy, the favourites of the sex, who outwardly respect and inwardly despise the weak creatures whom they thus sport with. They cannot submit to resign the highest sensual gratification, nor even to relish the epicurism of virtue—self-denial.

To take another view of the subject, confining my remarks to women.

The ridiculous falsities[1] which are told to children, from mistaken notions of modesty, tend very early to inflame their imaginations and set their little minds to work, respecting subjects, which nature never intended they should think of till the body arrived at some degree of maturity; then the passions naturally begin to take place of the senses, as instruments to unfold the understanding, and form the moral character.

In nurseries, and boarding-schools, I fear, girls are first spoiled; particularly in the latter. A number of girls sleep in the same room, and wash together. And, though I should be sorry to contaminate an innocent creature's mind by instilling false delicacy, or those indecent prudish notions, which early cautions respecting the other sex naturally engender, I should be very anxious to prevent their acquir-

[1] Children very early see cats with their kittens, birds with their young ones, etc. Why then are they not to be told that their mothers carry and nourish them in the same way? As there would then be no appearance of mystery they would never think of the subject more. Truth may always be told to children, if it be told gravely; but it is the immodesty of affected modesty, that does all the mischief; and this smoke heats the imagination by vainly endeavouring to obscure certain objects. If, indeed, children could be kept entirely from improper company, we should never allude to any such subjects; but as this is impossible, it is best to tell them the truth, especially as such information, not interesting them, will make no impression on their imagination.

ing nasty, or immodest habits; and as many girls have learned very nasty tricks, from ignorant servants, the mixing them thus indiscriminately together, is very improper.

To say the truth women are, in general, too familiar with each other, which leads to that gross degree of familiarity that so frequently renders the marriage state unhappy. Why in the name of decency are sisters, female intimates, or ladies and their waiting-women, to be so grossly familiar as to forget the respect which one human creature owes to another? That squeamish delicacy which shrinks from the most disgusting offices when affection[1] or humanity lead us to watch at a sick pillow, is despicable. But, why women in health should be more familiar with each other than men are, when they boast of their superior delicacy, is a solecism in manners which I could never solve.

In order to preserve health and beauty, I should earnestly recommend frequent ablutions, to dignify my advice that it may not offend the fastidious ear; and, by example, girls ought to be taught to wash and dress alone, without any distinction of rank; and if custom should make them require some little assistance, let them not require it till that part of the business is over which ought never to be done before a fellow-creature; because it is an insult to the majesty of human nature. Not on the score of modesty, but decency; for the care which some modest women take, making at the same time a display of that care, not to let their legs be seen, is as childish as immodest.[2]

I could proceed still further, till I animadverted on some still more nasty customs, which men never fall into. Secrets are told—where silence ought to reign; and that regard to cleanliness, which some religious sects have, perhaps, carried too far, especially the Essenes,* amongst the Jews, by making that an insult to God which is only an insult to humanity, is violated in a beastly manner. How can *delicate* women obtrude on notice that part of the animal oeconomy, which is so very disgusting? And is it not very rational to

[1] Affection would rather make one choose to perform these offices, to spare the delicacy of a friend, by still keeping a veil over them, for the personal helplessness, produced by sickness, is of an humbling nature.

[2] I remember to have met with a sentence, in a book of education, that made me smile. 'It would be needless to caution you against putting your hand, by chance, under your neckhandkerchief; for a modest woman never did so!'

conclude, that the women who have not been taught to respect the human nature of their own sex, in these particulars, will not long respect the mere difference of sex in their husbands? After their maidenish bashfulness is once lost, I, in fact, have generally observed, that women fall into old habits; and treat their husbands as they did their sisters or female acquaintance.

Besides, women from necessity, because their minds are not cultivated, have recourse very often to what I familiarly term bodily wit; and their intimacies are of the same kind. In short, with respect to both mind and body, they are too intimate. That decent personal reserve which is the foundation of dignity of character, must be kept up between woman and woman, or their minds will never gain strength or modesty.

On this account also, I object to many females being shut up together in nurseries, schools, or convents. I cannot recollect without indignation, the jokes and hoiden tricks, which knots of young women indulge themselves in, when in my youth accident threw me, an awkward rustic, in their way. They were almost on a par with the double meanings, which shake the convivial table when the glass has circulated freely. But, it is vain to attempt to keep the heart pure, unless the head is furnished with ideas, and set to work to compare them, in order to acquire judgment, by generalizing simple ones; and modesty, by making the understanding damp the sensibility.

It may be thought that I lay too great a stress on personal reserve; but it is ever the handmaid of modesty. So that were I to name the graces that ought to adorn beauty, I should instantly exclaim, cleanliness, neatness, and personal reserve. It is obvious, I suppose, that the reserve I mean, has nothing sexual in it, and that I think it *equally* necessary in both sexes. So necessary, indeed, is that reserve and cleanliness which indolent women too often neglect, that I will venture to affirm that when two or three women live in the same house, the one will be most respected by the male part of the family, who reside with them, leaving love entirely out of the question, who pays this kind of habitual respect to her person.

When domestic friends meet in a morning, there will naturally prevail an affectionate seriousness, especially, if each look forward to the discharge of daily duties; and it may be reckoned fanciful, but this sentiment has frequently risen spontaneously in my mind, I

have been pleased after breathing the sweet-bracing morning air, to see the same kind of freshness in the countenances I particularly loved; I was glad to see them braced, as it were, for the day, and ready to run their course with the sun. The greetings of affection in the morning are by these means more respectful than the familiar tenderness which frequently prolongs the evening talk. Nay, I have often felt hurt, not to say disgusted, when a friend has appeared, whom I parted with full dressed the evening before, with her clothes huddled on, because she chose to indulge herself in bed till the last moment.

Domestic affection can only be kept alive by these neglected attentions; yet if men and women took half as much pains to dress habitually neat, as they do to ornament, or rather to disfigure, their persons, much would be done towards the attainment of purity of mind. But women only dress to gratify men of gallantry; for the lover is always best pleased with the simple garb that fits close to the shape. There is an impertinence in ornaments that rebuffs affection; because love always clings round the idea of home.

As a sex, women are habitually indolent; and every thing tends to make them so. I do not forget the spurts of activity which sensibility produces; but as these flights of feelings only increase the evil, they are not to be confounded with the slow, orderly walk of reason. So great in reality is their mental and bodily indolence, that till their body be strengthened and their understanding enlarged by active exertions, there is little reason to expect that modesty will take place of bashfulness. They may find it prudent to assume its semblance; but the fair veil will only be worn on gala days.

Perhaps, there is not a virtue that mixes so kindly with every other as modesty.—It is the pale moon-beam that renders more interesting every virtue it softens, giving mild grandeur to the contracted horizon. Nothing can be more beautiful than the poetical fiction, which makes Diana with her silver crescent, the goddess of chastity. I have sometimes thought, that wandering with sedate step in some lonely recess, a modest dame of antiquity must have felt a glow of conscious dignity when, after contemplating the soft shadowy landscape, she has invited with placid fervour the mild reflection of her sister's beams to turn to her chaste bosom.

A Christian has still nobler motives to incite her to preserve her chastity and acquire modesty, for her body has been called the

Temple of the living God;* of the God who requires more than modesty of mien. His eye searcheth the heart; and let her remember, that if she hope to find favour in the sight of purity itself, her chastity must be founded on modesty, and not on worldly prudence; or verily a good reputation will be her only reward; for that awful intercourse, that sacred communication, which virtue establishes between man and his Maker, must give rise to the wish of being pure as he is pure!

After the foregoing remarks, it is almost superfluous to add, that I consider all those feminine airs of maturity, which succeed bashfulness, to which truth is sacrificed, to secure the heart of a husband, or rather to force him to be still a lover when nature would, had she not been interrupted in her operations, have made love give place to friendship, as immodest. The tenderness which a man will feel for the mother of his children is an excellent substitute for the ardour of unsatisfied passion; but to prolong that ardour it is indelicate, not to say immodest, for women to feign an unnatural coldness of constitution. Women as well as men ought to have the common appetites and passions of their nature, they are only brutal when unchecked by reason: but the obligation to check them is the duty of mankind, not a sexual duty. Nature, in these respects, may safely be left to herself; let women only acquire knowledge and humanity, and love will teach them modesty.[1] There is no need of falsehoods, disgusting as futile, for studied rules of behaviour only impose on shallow observers; a man of sense soon sees through, and despises the affectation.

The behaviour of young people, to each other, as men and women, is the last thing that should be thought of in education. In fact, behaviour in most circumstances is now so much thought of, that simplicity of character is rarely to be seen: yet, if men were only anxious to cultivate each virtue, and let it take root firmly in the mind, the grace resulting from it, its natural exterior mark, would soon strip affectation of its flaunting plumes; because, fallacious as unstable, is the conduct that is not founded upon truth!

Would ye, O my sisters, really possess modesty, ye must remember that the possession of virtue, of any denomination, is incompat-

[1] The behaviour of many newly married women has often disgusted me. They seem anxious never to let their husbands forget the privilege of marriage; and to find no pleasure in his society unless he is acting the lover. Short, indeed, must be the reign of love, when the flame is thus constantly blown up, without its receiving any solid fewel!

ible with ignorance and vanity! ye must acquire that soberness of mind, which the exercise of duties, and the pursuit of knowledge, alone inspire, or ye will still remain in a doubtful dependent situation, and only be loved whilst ye are fair! The downcast eye, the rosy blush, the retiring grace, are all proper in their season; but modesty, being the child of reason, cannot long exist with the sensibility that is not tempered by reflection. Besides, when love, even innocent love, is the whole employ of your lives, your hearts will be too soft to afford modesty that tranquil retreat, where she delights to dwell, in close union with humanity.

It has long since occurred to me that advice respecting behaviour, and all the various modes of preserving a good reputation, which have been so strenuously inculcated on the female world, were specious poisons, that incrusting morality eat away the substance. And, that this measuring of shadows produced a false calculation, because their length depends so much on the height of the sun, and other adventitious circumstances.

Whence arises the easy fallacious behaviour of a courtier? From his situation, undoubtedly: for standing in need of dependents, he is obliged to learn the art of denying without giving offence, and, of evasively feeding hope with the chameleon's food:* thus does politeness sport with truth, and eating away the sincerity and humanity natural to man, produce the fine gentleman.

Women likewise acquire, from a supposed necessity, an equally artificial mode of behaviour. Yet truth is not with impunity to be sported with, for the practised dissembler, at last, become the dupe of his own arts, loses that sagacity, which has been justly termed common sense; namely, a quick perception of common truths: which are constantly received as such by the unsophisticated mind, though it might not have had sufficient energy to discover them itself, when obscured by local prejudices. The greater number of people take their opinions on trust to avoid the trouble of exercising their own minds, and these indolent beings naturally adhere to the letter, rather than the spirit of a law, divine or human. 'Women,' says some author, I cannot recollect who, 'mind not what only heaven sees.' Why, indeed, should they? it is the eye of man that they have been taught to dread—and if they can lull their Argus to sleep,* they seldom think of heaven or themselves, because their reputation is safe; and it is reputation, not chastity and all its fair train, that they are employed to keep free from spot, not as a virtue, but to preserve their station in the world.

To prove the truth of this remark, I need only advert to the intrigues of married women, particularly in high life, and in countries where women are suitably married, according to their respective ranks, by their parents. If an innocent girl become a prey to love, she is degraded for ever, though her mind was not polluted by the arts which married women, under the convenient cloke of marriage, practise; nor has she violated any duty—but the duty of respecting herself. The married woman, on the contrary, breaks a most sacred engagement, and becomes a cruel mother when she is a false and faithless wife. If her husband have still an affection for her, the arts which she must practise to deceive him, will render her the most contemptible of human beings; and, at any rate, the contrivances necessary to preserve appearances, will keep her mind in that childish, or vicious, tumult, which destroys all its energy. Besides, in time, like those people who habitually take cordials to raise their spirits, she will want an intrigue to give life to her thoughts, having lost all relish for pleasures that are not highly seasoned by hope or fear.

Sometimes married women act still more audaciously; I will mention an instance.

A woman of quality, notorious for her gallantries, though as she still lived with her husband, nobody chose to place her in the class where she ought to have been placed, made a point of treating with the most insulting contempt a poor timid creature, abashed by a sense of her former weakness, whom a neighbouring gentleman had seduced and afterwards married. This woman had actually confounded virtue with reputation; and, I do believe, valued herself on the propriety of her behaviour before marriage, though when once settled to the satisfaction of her family, she and her lord were equally faithless,—so that the half alive heir to an immense estate came from heaven knows where!

To view this subject in another light.

I have known a number of women who, if they did not love their husbands, loved nobody else, give themselves entirely up to vanity and dissipation, neglecting every domestic duty; nay, even squandering away all the money which should have been saved for their helpless younger children, yet have plumed themselves on their unsullied reputation, as if the whole compass of their duty as wives and mothers was only to preserve it. Whilst other indolent women, neglecting every personal duty, have thought that they deserved

their husbands' affection, because, forsooth, they acted in this re-
spect with propriety.

Weak minds are always fond of resting in the ceremonials of duty,
but morality offers much simpler motives; and it were to be wished
that superficial moralists had said less respecting behaviour, and
outward observances, for unless virtue, of any kind, be built on
knowledge, it will only produce a kind of insipid decency. Respect
for the opinion of the world, has, however, been termed the princi-
pal duty of woman in the most express words, for Rousseau de-
clares, 'that reputation is no less indispensable than chastity.'* 'A
man,' adds he, 'secure in his own good conduct, depends only on
himself, and may brave the public opinion: but a woman, in behav-
ing well, performs but half her duty; as what is thought of her, is as
important to her as what she really is. It follows hence, that the
system of a woman's education should, in this respect, be directly
contrary to that of ours. Opinion is the grave of virtue among the
men; but its throne among women.'* It is strictly logical to infer that
the virtue that rests on opinion is merely worldly, and that it is the
virtue of a being to whom reason has been denied. But, even with
respect to the opinion of the world, I am convinced that this class of
reasoners are mistaken.

This regard for reputation, independent of its being one of the
natural rewards of virtue, however, took its rise from a cause that I
have already deplored as the grand source of female depravity, the
impossibility of regaining respectability by a return to virtue,
though men preserve theirs during the indulgence of vice. It was
natural for women then to endeavour to preserve what once lost—
was lost for ever, till this care swallowing up every other care,
reputation for chastity, became the one thing needful to the sex. But
vain is the scrupulosity of ignorance, for neither religion nor virtue,
when they reside in the heart, require such a puerile attention to
mere ceremonies, because the behaviour must, upon the whole, be
proper, when the motive is pure.

To support my opinion I can produce very respectable authority;
and the authority of a cool reasoner ought to have weight to enforce
consideration, though not to establish a sentiment. Speaking of the
general laws of morality, Dr Smith observes,—'That by some very
extraordinary and unlucky circumstance, a good man may come to
be suspected of a crime of which he was altogether incapable, and

upon that account be most unjustly exposed for the remaining part of his life to the horror and aversion of mankind. By an accident of this kind he may be said to lose his all, notwithstanding his integrity and justice, in the same manner as a cautious man, notwithstanding his utmost circumspection, may be ruined by an earthquake or an inundation. Accidents of the first kind, however, are perhaps still more rare, and still more contrary to the common course of things than those of the second; and it still remains true, that the practice of truth, justice, and humanity, is a certain and almost infallible method of acquiring what those virtues chiefly aim at, the confidence and love of those we live with. A person may be easily misrepresented with regard to a particular action; but it is scarce possible that he should be so with regard to the general tenor of his conduct. An innocent man may be believed to have done wrong: this, however, will rarely happen. On the contrary, the established opinion of the innocence of his manners will often lead us to absolve him where he has really been in the fault, notwithstanding very strong presumptions.'*

I perfectly coincide in opinion with this writer, for I verily believe that few of either sex were ever despised for certain vices without deserving to be despised. I speak not of the calumny of the moment, which hovers over a character, like one of the dense morning fogs of November, over this metropolis, till it gradually subsides before the common light of day, I only contend that the daily conduct of the majority prevails to stamp their character with the impression of truth. Quietly does the clear light, shining day after day, refute the ignorant surmise, or malicious tale, which has thrown dirt on a pure character. A false light distorted, for a short time, its shadow—reputation; but it seldom fails to become just when the cloud is dispersed that produced the mistake in vision.

Many people, undoubtedly, in several respects obtain a better reputation than, strictly speaking, they deserve; for unremitting industry will mostly reach its goal in all races. They who only strive for this paltry prize, like the Pharisees, who prayed at the corners of streets, to the seen of men,* verily obtain the reward they seek; for the heart of man cannot be read by man! Still the fair fame that is naturally reflected by good actions, when the man is only employed to direct his steps aright, regardless of the lookers-on, is, in general, not only more true, but more sure.

There are, it is true, trials when the good man must appeal to God from the injustice of man; and amidst the whining candour or hissings of envy, erect a pavilion in his own mind to retire to till the rumour be overpast; nay, the darts of undeserved censure may pierce an innocent tender bosom through with many sorrows; but these are all exceptions to general rules. And it is according to common laws that human behaviour ought to be regulated. The eccentric orbit of the comet never influences astronomical calculations respecting the invariable order established in the motion of the principal bodies of the solar system.

I will then venture to affirm, that after a man is arrived at maturity, the general outline of his character in the world is just, allowing for the before-mentioned exceptions to the rule. I do not say that a prudent, worldly-wise man, with only negative virtues and qualities, may not sometimes obtain a smoother reputation than a wiser or a better man. So far from it, that I am apt to conclude from experience, that where the virtue of two people is nearly equal, the most negative character will be liked best by the world at large, whilst the other may have more friends in private life. But the hills and dales, clouds and sunshine, conspicuous in the virtues of great men, set off each other; and though they afford envious weakness a fairer mark to shoot at, the real character will still work its way to light, though bespattered by weak affection, or ingenious malice.[1]

With respect to that anxiety to preserve a reputation hardly earned, which leads sagacious people to analyze it, I shall not make the obvious comment; but I am afraid that morality is very insidiously undermined, in the female world, by the attention being turned to the shew instead of the substance. A simple thing is thus made strangely complicated; nay, sometimes virtue and its shadow are set at variance. We should never, perhaps, have heard of Lucretia,* had she died to preserve her chastity instead of her reputation. If we really deserve our own good opinion we shall commonly be respected in the world; but if we pant after higher improvement and higher attainments, it is not sufficient to view ourselves as we suppose that we are viewed by others, though this has been ingeniously argued, as the foundation of our moral sentiments.[2] Because each bystander may have his own prejudices, beside

[1] I allude to various biographical writings, but particularly to Boswell's Life of Johnson.
[2] Smith.*

the prejudices of his age or country. We should rather endeavour to view ourselves as we suppose that Being views us who seeth each thought ripen into action, and whose judgment never swerves from the eternal rule of right. Righteous are all his judgments—just as merciful!

The humble mind that seeketh to find favour in His sight, and calmly examines its conduct when only His presence is felt, will seldom form a very erroneous opinion of its own virtues. During the still hour of self-collection the angry brow of offended justice will be fearfully deprecated, or the tie which draws man to the Diety will be recognized in the pure sentiment of reverential adoration, that swells the heart without exciting any tumultuous emotions. In these solemn moments man discovers the germ of those vices, which like the Java tree* shed a pestiferous vapour around—death is in the shade! and he perceives them without abhorrence, because he feels himself drawn by some cord of love to all his fellow-creatures, for whose follies he is anxious to find every extenuation in their nature—in himself. If I, he may thus argue, who exercise my own mind, and have been refined by tribulation, find the serpent's egg* in some fold of my heart, and crush it with difficulty, shall not I pity those who have stamped with less vigour, or who have heedlessly nurtured the insidious reptile till it poisoned the vital stream it sucked? Can I, conscious of my secret sins, throw off my fellow-creatures, and calmly see them drop into the chasm of perdition, that yawns to receive them.—No! no! The agonized heart will cry with suffocating impatience—I too am a man! and have vices, hid, perhaps, from human eye, that bend me to the dust before God, and loudly tell me, when all is mute, that we are formed of the same earth, and breathe the same element. Humanity thus rises naturally out of humility, and twists the cords of love that in various convolutions entangle the heart.

This sympathy extends still further, till a man well pleased observes force in arguments that do not carry convinction to his own bosom, and he gladly places in the fairest light, to himself, the shews of reason that have led others astray, rejoiced to find some reason in all the errors of man; though before convinced that he who rules the day makes his sun to shine on all. Yet, shaking hands thus as it were with corruption, one foot on earth, the other with bold stride mounts to heaven, and claims kindred with superiour natures. Virtues, unobserved by man, drop their balmy fragrance at this cool

hour, and the thirsty land, refreshed by the pure streams of comfort that suddenly gush out, is crowned with smiling verdure; this is the living green on which that eye may look with complacency that is too pure to behold iniquity!

But my spirits flag; and I must silently indulge the reverie these reflections lead to, unable to describe the sentiments, that have calmed my soul, when watching the rising sun, a soft shower drizzling through the leaves of neighbouring trees, seemed to fall on my languid, yet tranquil spirits, to cool the heart that had been heated by the passions which reason laboured to tame.

The leading principles which run through all my disquisitions, would render it unnecessary to enlarge on this subject, if a constant attention to keep the varnish of the character fresh, and in good condition, were not often inculcated as the sum total of female duty; if rules to regulate the behaviour, and to preserve the reputation, did not too frequently supersede moral obligations. But, with respect to reputation, the attention is confined to a single virtue—chastity. If the honour of a woman, as it is absurdly called, be safe, she may neglect every social duty; nay, ruin her family by gaming and extravagance; yet still present a shameless front—for truly she is an honourable women!

Mrs Macaulay has justly observed, that 'there is but one fault which a woman of honour may not commit with impunity.'* She then justly and humanely adds—'This has given rise to the trite and foolish observation, that the first fault against chastity in woman has a radical power to deprave the character. But no such frail beings come out of the hands of nature. The human mind is built of nobler materials than to be easily corrupted; and with all their disadvantages of situation and education, women seldom become entirely abandoned till they are thrown into a state of desperation, by the venomous rancour of their own sex.'*

But, in proportion as this regard for the reputation of chastity is prized by women, it is despised by men: and the two extremes are equally destructive to morality.

Men are certainly more under the influence of their appetites than women; and their appetites are more depraved by unbridled indulgence and the fastidious contrivances of satiety. Luxury has introduced a refinement in eating, that destroys the constitution; and, a degree of gluttony which is so beastly, that a perception of

seemliness of behaviour must be worn out before one being could eat immoderately in the presence of another, and afterwards complain of the oppression that his intemperance naturally produced. Some women, particularly French women, have also lost a sense of decency in this respect; for they will talk very calmly of an indigestion. It were to be wished that idleness was not allowed to generate, on the rank soil of wealth, those swarms of summer insects that feed on putrefaction, we should not then be disgusted by the sight of such brutal excesses.

There is one rule relative to behaviour that, I think, ought to regulate every other; and it is simply to cherish such an habitual respect for mankind as may prevent us from disgusting a fellow-creature for the sake of a present indulgence. The shameful indolence of many married women, and others a little advanced in life, frequently leads them to sin against delicacy. For, though convinced that the person is the band of union between the sexes, yet, how often do they from sheer indolence, or, to enjoy some trifling indulgence, disgust?

The depravity of the appetite which brings the sexes together, has had a still more fatal effect. Nature must ever be the standard of taste, the gauge of appetite—yet how grossly is nature insulted by the voluptuary. Leaving the refinements of love out of the question; nature, by making the gratification of an appetite, in this respect, as well as every other, a natural and imperious law to preserve the species, exalts the appetite, and mixes a little mind and affection with a sensual gust. The feelings of a parent mingling with an instinct merely animal, give it dignity; and the man and woman often meeting on account of the child, a mutual interest and affection is excited by the exercise of a common sympathy. Women then having necessarily some duty to fulfil, more noble than to adorn their persons, would not contentedly be the slaves of casual lust; which is now the situation of a very considerable number who are, literally speaking, standing dishes to which every glutton may have access.

I may be told that great as this enormity is, it only affects a devoted part of the sex—devoted for the salvation of the rest. But, false as every assertion might easily be proved, that recommends the sanctioning a small evil to produce a greater good; the mischief does not stop here, for the moral character, and peace of mind, of the

chaster part of the sex, is undermined by the conduct of the very women to whom they allow no refuge from guilt: whom they inexorably consign to the exercise of arts that lure their husbands from them, debauch their sons, and force them, let not modest women start, to assume, in some degree, the same character themselves. For I will venture to assert, that all the causes of female weakness, as well as depravity, which I have already enlarged on, branch out of one grand cause—want of chastity in men.

This intemperance, so prevalent, depraves the appetite to such a degree, that a wanton stimulus is necessary to rouse it; but the parental design of nature is forgotten, and the mere person, and that for a moment, alone engrosses the thoughts. So voluptuous, indeed, often grows the lustful prowler, that he refines on female softness. Something more soft than woman is then sought for; till, in Italy and Portugal, men attend the levees of equivocal beings,* to sigh for more than female languor.

To satisfy this genus of men, women are made systematically voluptuous, and though they may not all carry their libertinism to the same height, yet this heartless intercourse with the sex, which they allow themselves, depraves both sexes, because the taste of men is vitiated; and women, of all classes, naturally square their behaviour to gratify the taste by which they obtain pleasure and power. Women becoming, consequently, weaker, in mind and body, than they ought to be, were one of the grand ends of their being taken into the account, that of bearing and nursing children, have not sufficient strength to discharge the first duty of a mother; and sacrificing to lasciviousness the parental affection, that ennobles instinct, either destroy the embryo in the womb, or cast it off when born. Nature in every thing demands respect, and those who violate her laws seldom violate them with impunity. The weak enervated women who particularly catch the attention of libertines, are unfit to be mothers, though they may conceive; so that the rich sensualist, who has rioted among women, spreading depravity and misery, when he wishes to perpetuate his name, receives from his wife only an half-formed being that inherits both its father's and mother's weakness.

Contrasting the humanity of the present age with the barbarism of antiquity, great stress has been laid on the savage custom of exposing the children whom their parents could not maintain;

whilst the man of sensibility, who thus, perhaps, complains, by his promiscuous amours produces a most destructive barrenness and contagious flagitiousness of manners. Surely nature never intended that women, by satisfying an appetite, should frustrate the very purpose for which it was implanted?

I have before observed, that men ought to maintain the women whom they have seduced; this would be one means of reforming female manners, and stopping an abuse that has an equally fatal effect on population and morals. Another, no less obvious, would be to turn the attention of woman to the real virtue of chastity; for to little respect has that woman a claim, on the score of modesty, though her reputation may be white as the driven snow, who smiles on the libertine whilst she spurns the victims of his lawless appetites and their own folly.

Besides, she has a taint of the same folly, pure as she esteems herself, when she studiously adorns her person only to be seen by men, to excite respectful sighs, and all the idle homage of what is called innocent gallantry. Did women really respect virtue for its own sake, they would not seek for a compensation in vanity, for the self-denial which they are obliged to practise to preserve their reputation, nor would they associate with men who set reputation at defiance.

The two sexes mutually corrupt and improve each other. This I believe to be an indisputable truth, extending it to every virtue. Chastity, modesty, public spirit, and all the noble train of virtues, on which social virtue and happiness are built, should be understood and cultivated by all mankind, or they will be cultivated to little effect. And, instead of furnishing the vicious or idle with a pretext for violating some sacred duty, by terming it a sexual one, it would be wiser to shew that nature has not made any difference, for that the unchaste man doubly defeats the purpose of nature, by rendering women barren, and destroying his own constitution, though he avoids the shame that pursues the crime in the other sex. These are the physical consequences, the moral are still more alarming; for virtue is only a nominal distinction when the duties of citizens, husbands, wives, fathers, mothers, and directors of families, become merely the selfish ties of convenience.

Why then do philosophers look for public spirit? Public spirit must be nurtured by private virtue, or it will resemble the factitious

sentiment which makes women careful to preserve their reputation, and men their honour. A sentiment that often exists unsupported by virtue, unsupported by that sublime morality which makes the habitual breach of one duty a breach of the whole moral law.

CHAPTER IX

OF THE PERNICIOUS EFFECTS WHICH ARISE FROM THE UNNATURAL DISTINCTIONS ESTABLISHED IN SOCIETY

From the respect paid to property flow, as from a poisoned fountain, most of the evils and vices which render this world such a dreary scene to the contemplative mind. For it is in the most polished society that noisome reptiles and venomous serpents lurk under the rank herbage; and there is voluptuousness pampered by the still sultry air, which relaxes every good disposition before it ripens into virtue.

One class presses on another; for all are aiming to procure respect on account of their property: and property, once gained, will procure the respect due only to talents and virtue. Men neglect the duties incumbent on man, yet are treated like demi-gods; religion is also separated from morality by a ceremonial veil, yet men wonder that the world is almost literally speaking, a den of sharpers or oppressors.

There is a homely proverb, which speaks a shrewd truth, that whoever the devil finds idle he will employ. And what but habitual idleness can hereditary wealth and titles produce? For man is so constituted that he can only attain a proper use of his faculties by exercising them, and will not exercise them unless necessity, of some kind, first set the wheels in motion. Virtue likewise can only be acquired by the discharge of relative duties; but the importance of these sacred duties will scarcely be felt by the being who is cajoled out of his humanity by the flattery of sycophants. There must be more equality established in society, or morality will never gain ground, and this virtuous equality will not rest firmly even when founded on a rock, if one half of mankind be chained to its bottom by fate, for they will be continually undermining it through ignorance or pride.

It is vain to expect virtue from women till they are, in some degree, independent of men; nay, it is vain to expect that strength of natural affection, which would make them good wives and mothers.

Whilst they are absolutely dependent on their husbands they will be cunning, mean, and selfish, and the men who can be gratified by the fawning fondness of spaniel-like affection, have not much delicacy, for love is not to be bought, in any sense of the words, its silken wings are instantly shrivelled up when any thing beside a return in kind is sought. Yet whilst wealth enervates men; and women live, as it were, by their personal charms, how can we expect them to discharge those ennobling duties which equally require exertion and self-denial. Hereditary property sophisticates the mind, and the unfortunate victims to it, if I may so express myself, swathed from their birth, seldom exert the locomotive faculty of body or mind; and, thus viewing every thing through one medium, and that a false one, they are unable to discern in what true merit and happiness consist. False, indeed, must be the light when the drapery of situation hides the man, and makes him stalk in masquerade, dragging from one scene of dissipation to another the nerveless limbs that hang with stupid listlessness, and rolling round the vacant eye which plainly tells us that there is no mind at home.

I mean, therefore, to infer that the society is not properly organized which does not compel men and women to discharge their respective duties, by making it the only way to acquire that countenance from their fellow-creatures, which every human being wishes some way to attain. The respect, consequently, which is paid to wealth and mere personal charms, is a true north-east blast, that blights the tender blossoms of affection and virtue. Nature has wisely attached affections to duties, to sweeten toil, and to give that vigour to the exertions of reason which only the heart can give. But, the affection which is put on merely because it is the appropriated insignia of a certain character, when its duties are not fulfilled, is one of the empty compliments which vice and folly are obliged to pay to virtue and the real nature of things.

To illustrate my opinion, I need only observe, that when a woman is admired for her beauty, and suffers herself to be so far intoxicated by the admiration she receives, as to neglect to discharge the indispensable duty of a mother, she sins against herself by neglecting to cultivate an affection that would equally tend to make her useful and happy. True happiness, I mean all the contentment, and virtuous satisfaction, that can be snatched in this imperfect state, must arise from well regulated affections; and an affection includes a duty.

Men are not aware of the misery they cause, and the vicious weakness they cherish, by only inciting women to render themselves pleasing; they do not consider that they thus make natural and artificial duties clash, by sacrificing the comfort and respectability of a woman's life to voluptuous notions of beauty, when in nature they all harmonize.

Cold would be the heart of a husband, were he not rendered unnatural by early debauchery, who did not feel more delight at seeing his child suckled by its mother, than the most artful wanton tricks could ever raise; yet this natural way of cementing the matrimonial tie, and twisting esteem with fonder recollections, wealth leads women to spurn.* To preserve their beauty, and wear the flowery crown of the day, which gives them a kind of right to reign for a short time over the sex, they neglect to stamp impressions on their husbands' hearts, that would be remembered with more tenderness when the snow on the head began to chill the bosom, than even their virgin charms. The maternal solicitude of a reasonable affectionate woman is very interesting, and the chastened dignity with which a mother returns the caresses that she and her child receive from a father who has been fulfilling the serious duties of his station, is not only a respectable, but a beautiful sight. So singular, indeed, are my feelings, and I have endeavoured not to catch factitious ones, that after having been fatigued with the sight of insipid grandeur and the slavish ceremonies that with cumberous pomp supplied the place of domestic affections, I have turned to some other scene to relieve my eye by resting it on the refreshing green every where scattered by nature. I have then viewed with pleasure a woman nursing her children, and discharging the duties of her station with, perhaps, merely a servant maid to take off her hands the servile part of the household business. I have seen her prepare herself and children, with only the luxury of cleanliness, to receive her husband, who returning weary home in the evening found smiling babes and a clean hearth. My heart has loitered in the midst of the group, and has even throbbed with sympathetic emotion, when the scraping of the well known foot has raised a pleasing tumult.

Whilst my benevolence has been gratified by contemplating this artless picture, I have thought that a couple of this description, equally necessary and independent of each other, because each ful-

filled the respective duties of their station, possessed all that life could give.—Raised sufficiently above abject poverty not to be obliged to weigh the consequence of every farthing they spend, and having sufficient to prevent their attending to a frigid system of oeconomy, which narrows both heart and mind. I declare, so vulgar are my conceptions, that I know not what is wanted to render this the happiest as well as the most respectable situation in the world, but a taste for literature, to throw a little variety and interest into social converse, and some superfluous money to give to the needy and to buy books. For it is not pleasant when the heart is opened by compassion and the head active in arranging plans of usefulness, to have a prim urchin continually twitching back the elbow to prevent the hand from drawing out an almost empty purse, whispering at the same time some prudential maxim about the priority of justice.

Destructive, however, as riches and inherited honours are to the human character, women are more debased and cramped, if possible, by them, than men, because men may still, in some degree, unfold their faculties by becoming soldiers and statesmen.

As soldiers, I grant, they can now only gather, for the most part, vain glorious laurels, whilst they adjust to a hair the European balance, taking especial care that no bleak northern nook or sound incline the beam.* But the days of true heroism are over, when a citizen fought for his country like a Fabricius or a Washington,* and then returned to his farm to let his virtuous fervour run in a more placid, but not a less salutary, stream. No, our British heroes are oftener sent from the gaming table than from the plow; and their passions have been rather inflamed by hanging with dumb suspense on the turn of a die, than sublimated by panting after the adventurous march of virtue in the historic page.

The statesman, it is true, might with more propriety quit the Faro Bank,* or card-table, to guide the helm, for he has still but to shuffle and trick. The whole system of British politics, if system it may courteously be called, consisting in multiplying dependents and contriving taxes which grind the poor to pamper the rich; thus a war, or any wild goose chace, is, as the vulgar use the phrase, a lucky turn-up of patronage for the minister, whose chief merit is the art of keeping himself in place. It is not necessary then that he should have bowels* for the poor, so he can secure for his family the odd trick. Or should some shew of respect, for what is termed with ignorant

ostentation an Englishman's birth-right, be expedient to bubble*
the gruff mastiff that he has to lead by the nose, he can make an
empty shew, very safely, by giving his single voice, and suffering his
light squadron to file off to the other side. And when a question of
humanity is agitated he may dip a sop in the milk of human kind-
ness,* to silence Cerberus,* and talk of the interest which his heart
takes in an attempt to make the earth no longer cry for vengeance as
it sucks in its children's blood, though his cold hand may at the very
moment rivet their chains, by sanctioning the abominable traffick.*
A minister is no longer a minister, than while he can carry a point,
which he is determined to carry.—Yet it is not necessary that a
minister should feel like a man, when a bold push might shake his
seat.

But, to have done with these episodical observations, let me
return to the more specious slavery which chains the very soul of
woman, keeping her for ever under the bondage of ignorance.

The preposterous distinctions of rank, which render civilization a
curse, by dividing the world between voluptuous tyrants, and cun-
ning envious dependents, corrupt, almost equally, every class of
people, because respectability is not attached to the discharge of the
relative duties of life, but to the station, and when the duties are not
fulfilled the affections cannot gain sufficient strength to fortify the
virtue of which they are the natural reward. Still there are some
loop-holes out of which a man may creep, and dare to think and act
for himself; but for a woman it is an herculean task, because she has
difficulties peculiar to her sex to overcome, which require almost
superhuman powers.

A truly benevolent legislator always endeavours to make it the
interest of each individual to be virtuous; and thus private virtue
becoming the cement of public happiness, an orderly whole is con-
solidated by the tendency of all the parts towards a common centre.
But, the private or public virtue of woman is very problematical; for
Rousseau, and a numerous list of male writers, insist that she should
all her life be subjected to a severe restraint, that of propriety. Why
subject her to propriety—blind propriety, if she be capable of acting
from a nobler spring, if she be an heir of immortality? Is sugar
always to be produced by vital blood? Is one half of the human
species, like the poor African slaves, to be subject to prejudices that
brutalize them, when principles would be a surer guard, only to

sweeten the cup of man? Is not this indirectly to deny woman reason? for a gift is a mockery, if it be unfit for use.

Women are, in common with men, rendered weak and luxurious by the relaxing pleasures which wealth procures; but added to this they are made slaves to their persons, and must render them alluring that man may lend them his reason to guide their tottering steps aright. Or should they be ambitious, they must govern their tyrants by sinister tricks, for without rights there cannot be any incumbent duties. The laws respecting woman, which I meant to discuss in a future part, make an absurd unit of a man and his wife; and then, by the easy transition of only considering him as responsible, she is reduced to a mere cypher.*

The being who discharges the duties of its station is independent; and, speaking of women at large, their first duty is to themselves as rational creatures, and the next, in point of importance, as citizens, is that, which includes so many, of a mother. The rank in life which dispenses with their fulfilling this duty, necessarily degrades them by making them mere dolls. Or, should they turn to something more important than merely fitting drapery upon a smooth block, their minds are only occupied by some soft platonic attachment; or, the actual management of an intrigue may keep their thoughts in motion; for when they neglect domestic duties, they have it not in their power to take the field and march and counter-march like soldiers, or wrangle in the senate to keep their faculties from rusting.

I know that, as a proof of the inferiority of the sex, Rousseau has exultingly exclaimed, How can they leave the nursery for the camp!*—And the camp has by some moralists been termed the school of the most heroic virtues; though, I think, it would puzzle a keen casuist to prove the reasonableness of the greater number of wars that have dubbed heroes. I do not mean to consider this question critically; because, having frequently viewed these freaks of ambition as the first natural mode of civilization, when the ground must be torn up, and the woods cleared by fire and sword, I do not choose to call them pests; but surely the present system of war has little connection with virtue of any denomination, being rather the school of *finesse* and effeminacy, than of fortitude.

Yet, if defensive war, the only justifiable war, in the present advanced state of society, where virtue can shew its face and ripen amidst the rigours which purify the air on the mountain's top, were

alone to be adopted as just and glorious, the true heroism of antiquity might again animate female bosoms.—But fair and softly, gentle reader, male or female, do not alarm thyself, for though I have compared the character of a modern soldier with that of a civilized woman, I am not going to advise them to turn their distaff into a musket, though I sincerely wish to see the bayonet converted into a pruninghook. I only recreated an imagination, fatigued by contemplating the vices and follies which all proceed from a feculent stream of wealth that has muddied the pure rills of natural affection, by supposing that society will some time or other be so constituted, that man must necessarily fulfil the duties of a citizen, or be despised, and that while he was employed in any of the departments of civil life, his wife, also an active citizen, should be equally intent to manage her family, educate her children, and assist her neighbours.

But, to render her really virtuous and useful, she must not, if she discharge her civil duties, want, individually, the protection of civil laws; she must not be dependent on her husband's bounty for her subsistence during his life, or support after his death—for how can a being be generous who has nothing of its own? or virtuous, who is not free? The wife, in the present state of things, who is faithful to her husband, and neither suckles nor educates her children, scarcely deserves the name of a wife, and has no right to that of a citizen. But take away natural rights, and duties become null.

Women then must be considered as only the wanton solace of men, when they become so weak in mind and body, that they cannot exert themselves, unless to pursue some frothy pleasure, or to invent some frivolous fashion. What can be a more melancholy sight to a thinking mind, than to look into the numerous carriages that drive helter-skelter about this metropolis in a morning full of pale-faced creatures who are flying from themselves. I have often wished, with Dr Johnson, to place some of them in a little shop with half a dozen children looking up to their languid countenances for support. I am much mistaken, if some latent vigour would not soon give health and spirit to their eyes, and some lines drawn by the exercise of reason on the blank cheeks, which before were only undulated by dimples, might restore lost dignity to the character, or rather enable it to attain the true dignity of its nature. Virtue is not to be acquired even by speculation, much less by the negative supineness that wealth naturally generates.

Besides, when poverty is more disgraceful than even vice, is not morality cut to the quick? Still to avoid misconstruction, though I consider that women in the common walks of life are called to fulfil the duties of wives and mothers, by religion and reason, I cannot help lamenting that women of a superiour cast have not a road open by which they can pursue more extensive plans of usefulness and independence. I may excite laughter, by dropping an hint, which I mean to pursue, some future time, for I really think that women ought to have representatives, instead of being arbitrarily governed without having any direct share allowed them in the deliberations of government.

But, as the whole system of representation is now, in this country, only a convenient handle for despotism, they need not complain, for they are as well represented as a numerous class of hard working mechanics, who pay for the support of royalty when they can scarcely stop their children's mouths with bread. How are they represented whose very sweat supports the splendid stud of an heir apparent, or varnishes the chariot of some female favourite who looks down on shame? Taxes on the very necessaries of life, enable an endless tribe of idle princes and princesses to pass with stupid pomp before a gaping crowd, who almost worship the very parade which costs them so dear. This is mere gothic grandeur, something like the barbarous useless parade of having sentinels on horseback at Whitehall, which I could never view without a mixture of contempt and indignation.

How strangely must the mind be sophisticated when this sort of state impresses it! But, till these monuments of folly are levelled by virtue, similar follies will leaven the whole mass. For the same character, in some degree, will prevail in the aggregate of society: and the refinements of luxury, or the vicious repinings of envious poverty, will equally banish virtue from society, considered as the characteristic of that society, or only allow it to appear as one of the stripes of the harlequin coat, worn by the civilized man.

In the superiour ranks of life, every duty is done by deputies, as if duties could ever be waved, and the vain pleasures which consequent idleness forces the rich to pursue, appear so enticing to the next rank, that the numerous scramblers for wealth sacrifice every thing to tread on their heels. The most sacred trusts are then considered as sinecures, because they were procured by interest, and only

sought to enable a man to keep *good company*. Women, in particular, all want to be ladies. Which is simply to have nothing to do, but listlessly to go they scarcely care where, for they cannot tell what.

But what have women to do in society? I may be asked, but to loiter with easy grace; surely you would not condemn them all to suckle fools and chronicle small beer!* No. Women might certainly study the art of healing, and be physicians as well as nurses. And midwifery, decency seems to allot to them, though I am afraid the word midwife, in our dictionaries, will soon give place to *accoucheur*,* and one proof of the former delicacy of the sex be effaced from the language.

They might, also, study politics, and settle their benevolence on the broadest basis; for the reading of history will scarcely be more useful than the perusal of romances, if read as mere biography; if the character of the times, the political improvements, arts, etc. be not observed. In short, if it be not considered as the history of man; and not of particular men, who filled a niche in the temple of fame, and dropped into the black rolling stream of time, that silently sweeps all before it, into the shapeless void called—eternity.—For shape, can it be called, 'that shape hath none?'*

Business of various kinds, they might likewise pursue, if they were educated in a more orderly manner, which might save many from common and legal prostitution. Women would not then marry for a support, as men accept of places under government, and neglect the implied duties; nor would an attempt to earn their own subsistence, a most laudable one! sink them almost to the level of those poor abandoned creatures who live by prostitution. For are not milliners and mantua-makers* reckoned the next class? The few employments open to women, so far from being liberal, are menial; and when a superior education enables them to take charge of the education of children as governesses, they are not treated like the tutors of sons, though even clerical tutors are not always treated in a manner calculated to render them respectable in the eyes of their pupils, to say nothing of the private comfort of the individual. But as women educated like gentlewomen, are never designed for the humiliating situation which necessity sometimes forces them to fill; these situations are considered in the light of a degradation; and they know little of the human heart, who need to be told, that nothing so painfully sharpens sensibility as such a fall in life.

Some of these women might be restrained from marrying by a proper spirit or delicacy, and others may not have had it in their power to escape in this pitiful way from servitude; is not that government then very defective, and very unmindful of the happiness of one half of its members, that does not provide for honest, independent women, by encouraging them to fill respectable stations? But in order to render their private virtue a public benefit, they must have a civil existence in the state, married or single; else we shall continually see some worthy woman, whose sensibility has been rendered painfully acute by undeserved contempt, droop like 'the lily broken down by a plow-share.'*

It is a melancholy truth; yet such is the blessed effect of civilization! the most respectable women are the most oppressed; and, unless they have understandings far superiour to the common run of understandings, taking in both sexes, they must, from being treated like contemptible beings, become contemptible. How many women thus waste life away the prey of discontent, who might have practised as physicians, regulated a farm, managed a shop, and stood erect, supported by their own industry, instead of hanging their heads surcharged with the dew of sensibility, that consumes the beauty to which it at first gave lustre; nay, I doubt whether pity and love are so near akin as poets feign, for I have seldom seen much compassion excited by the helplessness of females, unless they were fair; then, perhaps, pity was the soft handmaid of love, or the harbinger of lust.

How much more respectable is the woman who earns her own bread by fulfilling any duty, than the most accomplished beauty!— beauty did I say?—so sensible am I of the beauty of moral loveliness, or the harmonious propriety that attunes the passions of a well-regulated mind, that I blush at making the comparison; yet I sigh to think how few women aim at attaining this respectability by withdrawing from the giddy whirl of pleasure, or the indolent calm that stupifies the good sort of women it sucks in.

Proud of their weakness, however, they must always be protected, guarded from care, and all the rough toils that dignify the mind.— If this be the fiat of fate, if they will make themselves, insignificant and contemptible, sweetly to waste 'life away,' let them not expect to be valued when their beauty fades, for it is the fate of the fairest flowers to be admired and pulled to pieces by the careless hand that

plucked them. In how many ways do I wish, from the purest bene-
volence, to impress this truth on my sex; yet I fear that they will
not listen to a truth that dear bought experience has brought home
to many an agitated bosom, nor willingly resign the privileges of
rank and sex for the privileges of humanity, to which those have no
claim who do not discharge its duties.

Those writers are particularly useful, in my opinion, who make
man feel for man, independent of the station he fills, or the drapery
of factitious sentiments. I then would fain convince reasonable men
of the importance of some of my remarks; and prevail on them to
weigh dispassionately the whole tenor of my observations.—I ap-
peal to their understandings; and, as a fellow-creature, claim, in the
name of my sex, some interest in their hearts. I entreat them to assist
to emancipate their companion, to make her a *help meet* for them!

Would men but generously snap our chains, and be content with
rational fellowship instead of slavish obedience, they would find us
more observant daughters, more affectionate sisters, more faithful
wives, more reasonable mothers—in a word, better citizens. We
should then love them with true affection, because we should learn
to respect ourselves; and the peace of mind of a worthy man would
not be interrupted by the idle vanity of his wife, nor the babes sent
to nestle in a strange bosom, having never found a home in their
mother's.

CHAPTER X

PARENTAL AFFECTION

Parental affection is, perhaps, the blindest modification of perverse self-love; for we have not, like the French,[1] two terms to distinguish the pursuit of a natural and reasonable desire, from the ignorant calculations of weakness. Parents often love their children in the most brutal manner, and sacrifice every relative duty to promote their advancement in the world.—To promote, such is the perversity of unprincipled prejudices, the future welfare of the very beings whose present existence they imbitter by the most despotic stretch of power. Power, in fact, is ever true to its vital principle, for in every shape it would reign without controul or inquiry. Its throne is built across a dark abyss, which no eye must dare to explore, lest the baseless fabric* should totter under investigation. Obedience, unconditional obedience, is the catch-word of tyrants of every description, and to render 'assurance doubly sure,'* one kind of despotism supports another. Tyrants would have cause to tremble if reason were to become the rule of duty in any of the relations of life, for the light might spread till perfect day appeared. And when it did appear, how would men smile at the sight of the bugbears at which they started during the night of ignorance, or the twilight of timid inquiry.

Parental affection, indeed, in many minds, is but a pretext to tyrannize where it can be done with impunity, for only good and wise men are content with the respect that will bear discussion. Convinced that they have a right to what they insist on, they do not fear reason, or dread the sifting of subjects that recur to natural justice: because they firmly believe that the more enlightened the human mind becomes the deeper root will just and simple principles take. They do not rest in expedients, or grant that what is metaphysically true can be practically false; but disdaining the shifts of the moment they calmly wait till time, sanctioning innovation, silences the hiss of selfishness or envy.

[1] *L'amour propre. L'amour de soi même.**

If the power of reflecting on the past, and darting the keen eye of contemplation into futurity, be the grand privilege of man, it must be granted that some people enjoy this prerogative in a very limited degree. Every thing new appears to them wrong; and not able to distinguish the possible from the monstrous, they fear where no fear should find a place, running from the light of reason, as if it were a firebrand; yet the limits of the possible have never been defined to stop the sturdy innovator's hand.

Woman, however, a slave in every situation to prejudice, seldom exerts enlightened maternal affection; for she either neglects her children, or spoils them by improper indulgence. Besides, the affection of some women for their children is, as I have before termed it, frequently very brutish; for it eradicates every spark of humanity. Justice, truth, every thing is sacrificed by these Rebekah's,* and for the sake of their *own* children they violate the most sacred duties, forgetting the common relationship that binds the whole family on earth together. Yet, reason seems to say, that they who suffer one duty, or affection, to swallow up the rest, have not sufficient heart or mind to fulfil that one conscientiously. It then loses the venerable aspect of a duty, and assumes the fantastic form of a whim.

As the care of children in their infancy is one of the grand duties annexed to the female character by nature, this duty would afford many forcible arguments for strengthening the female understanding, if it were properly considered.

The formation of the mind must be begun very early, and the temper, in particular, requires the most judicious attention—an attention which women cannot pay who only love their children because they are their children, and seek no further for the foundation of their duty, than in the feelings of the moment. It is this want of reason in their affections which makes women so often run into extremes, and either be the most fond or most careless and unnatural mothers.

To be a good mother—a woman must have sense, and that independence of mind which few women possess who are taught to depend entirely on their husbands. Meek wives are, in general, foolish mothers; wanting their children to love them best, and take their part, in secret, against the father, who is held up as a scarecrow. When chastisement is necessary, though they have offended the mother, the father must inflict the punishment; he must be the

judge in all disputes: but I shall more fully discuss this subject when I treat of private education,* I now only mean to insist, that unless the understanding of woman be enlarged, and her character rendered more firm, by being allowed to govern her own conduct, she will never have sufficient sense or command of temper to manage her children properly. Her parental affection, indeed, scarcely deserves the name, when it does not lead her to suckle her children, because the discharge of this duty is equally calculated to inspire maternal and filial affection: and it is the indispensable duty of men and women to fulfil the duties which give birth to affections that are the surest preservatives against vice. Natural affection, as it is termed, I believe to be a very faint tie, affections must grow out of the habitual exercise of a mutal sympathy; and what sympathy does a mother exercise who sends her babe to a nurse, and only takes it from a nurse to send it to a school?

In the exercise of their maternal feelings providence has furnished women with a natural substitute for love, when the lover becomes only a friend, and mutual confidence takes place of overstrained admiration—a child then gently twists the relaxing cord, and a mutual care produces a new mutual sympathy.—But a child, though a pledge of affection, will not enliven it, if both father and mother be content to transfer the charge to hirelings; for they who do their duty by proxy should not murmur if they miss the reward of duty—parental affection produces filial duty.

CHAPTER XI

DUTY TO PARENTS

There seems to be an indolent propensity in man to make prescription always take place of reason, and to place every duty on an arbitrary foundation. The rights of kings are deduced in a direct line from the King of kings; and that of parents from our first parent.

Why do we thus go back for principles that should always rest on the same base, and have the same weight to-day that they had a thousand years ago—and not a jot more? If parents discharge their duty they have a strong hold and sacred claim on the gratitude of their children; but few parents are willing to receive the respectful affection of their offspring on such terms. They demand blind obedience, because they do not merit a reasonable service: and to render these demands of weakness and ignorance more binding, a mysterious sanctity is spread round the most arbitrary principle; for what other name can be given to the blind duty of obeying vicious or weak beings merely because they obeyed a powerful instinct?

The simple definition of the reciprocal duty, which naturally subsists between parent and child, may be given in a few words: The parent who pays proper attention to helpless infancy has a right to require the same attention when the feebleness of age comes upon him. But to subjugate a rational being to the mere will of another, after he is of age to answer to society for his own conduct, is a most cruel and undue stretch of power; and, perhaps, as injurious to morality as those religious systems which do not allow right and wrong to have any existence, but in the Divine will.

I never knew a parent who had paid more than common attention to his children, disregarded;[1] on the contrary, the early habit of relying almost implicitly on the opinion of a respected parent is not easily shook, even when matured reason convinces the child that his father is not the wisest man in the world. This weakness, for a weakness it is, though the epithet amiable may be tacked to it, a reasonable man must steel himself against; for the absurd duty, too

[1] Dr Johnson makes the same observation.*

235

often inculcated, of obeying a parent only on account of his being a parent, shackles the mind, and prepares it for a slavish submission to any power but reason.

I distinguish between the natural and accidental duty due to parents.

The parent who sedulously endeavours to form the heart and enlarge the understanding of his child, has given that dignity to the discharge of a duty, common to the whole animal world, that only reason can give. This is the parental affection of humanity, and leaves instinctive natural affection far behind. Such a parent acquires all the rights of the most sacred friendship, and his advice, even when his child is advanced in life, demands serious consideration.

With respect to marriage, though after one and twenty a parent seems to have no right to withhold his consent on any account; yet twenty years of solicitude call for a return, and the son ought, at least, to promise not to marry for two or three years, should the object of his choice not entirely meet with the approbation of his first friend.

But, respect for parents is, generally speaking, a much more debasing principle; it is only a selfish respect for property. The father who is blindly obeyed, is obeyed from sheer weakness, or from motives that degrade the human character.

A great proportion of the misery that wanders, in hideous forms, around the world, is allowed to rise from the negligence of parents; and still these are the people who are most tenacious of what they term a natural right, though it be subversive of the birth-right of man, the right of acting according to the direction of his own reason.

I have already very frequently had occasion to observe, that vicious or indolent people are always eager to profit by enforcing arbitrary privileges; and, generally, in the same proportion as they neglect the discharge of the duties which alone render the privileges reasonable. This is at the bottom a dictate of common sense, or the instinct of self-defence, peculiar to ignorant weakness; resembling that instinct, which makes a fish muddy the water it swims in to elude its enemy, instead of boldly facing it in the clear stream.

From the clear stream of argument, indeed, the supporters of prescription, of every denomination, fly; and, taking refuge in the darkness, which, in the language of sublime poetry, has been sup-

posed to surround the throne of Omnipotence, they dare to demand that implicit respect which is only due to His unsearchable ways. But, let me not be thought presumptuous, the darkness which hides our God from us, only respects speculative truths—it never obscures moral ones, they shine clearly, for God is light, and never, by the constitution of our nature, requires the discharge of a duty, the reasonableness of which does not beam on us when we open our eyes.

The indolent parent of high rank may, it is true, extort a shew of respect from his child, and females on the continent are particularly subject to the views of their families, who never think of consulting their inclination, or providing for the comfort of the poor victims of their pride. The consequence is notorious; these dutiful daughters become adulteresses, and neglect the education of their chidren, from whom they, in their turn, exact the same kind of obedience.

Females, it is true, in all countries, are too much under the dominion of their parents; and few parents think of addressing their children in the following manner, though it is in this reasonable way that Heaven seems to command the whole human race. It is your interest to obey me till you can judge for yourself; and the Almighty Father of all has implanted an affection in me to serve as a guard to you whilst your reason is unfolding; but when your mind arrives at maturity, you must only obey me, or rather respect my opinions, so far as they coincide with the light that is breaking in on your own mind.

A slavish bondage to parents cramps every faculty of the mind; and Mr Locke very judiciously observes, that 'if the mind be curbed and humbled too much in children; if their spirits be abased and broken much by too strict an hand over them; they lose all their vigour and industry.'* This strict hand may in some degree account for the weakness of women; for girls, from various causes, are more kept down by their parents, in every sense of the word, than boys. The duty expected from them is, like all the duties arbitrarily imposed on women, more from a sense of propriety, more out of respect for decorum, than reason; and thus taught slavishly to submit to their parents, they are prepared for the slavery of marriage. I may be told that a number of women are not slaves in the marrriage state. True, but they then become tyrants; for it is not rational freedom, but a lawless kind of power resembling the authority exer-

cised by the favourites of absolute monarchs, which they obtain by debasing means. I do not, likewise, dream of insinuating that either boys or girls are always slaves, I only insist that when they are obliged to submit to authority blindly, their faculties are weakened, and their tempers rendered imperious or abject. I also lament that parents, indolently availing themselves of a supposed privilege, damp the first faint glimmering of reason, rendering at the same time the duty, which they are so anxious to enforce, an empty name; because they will not let it rest on the only basis on which a duty can rest securely: for unless it be founded on knowledge, it cannot gain sufficient strength to resist the squalls of passion, or the silent sapping of self-love. But it is not the parents who have given the surest proof of their affection for their children, or, to speak more properly, who by fulfilling their duty, have allowed a natural parental affection to take root in their hearts, the child of exercised sympathy and reason, and not the over-weening offspring of selfish pride, who most vehemently insist on their children submitting to their will merely because it is their will. On the contrary, the parent, who sets a good example, patiently lets that example work; and it seldom fails to produce its natural effect—filial reverence.

Children cannot be taught too early to submit to reason, the true definition of that necessity, which Rousseau insisted on, without defining it; for to submit to reason is to submit to the nature of things, and to that God, who formed them so, to promote our real interest.

Why should the minds of children be warped as they just begin to expand, only to favour the indolence of parents, who insist on a privilege without being willing to pay the price fixed by nature? I have before had occasion to observe, that a right always includes a duty, and I think it may, likewise, fairly be inferred, that they forfeit the right, who do not fulfil the duty.

It is easier, I grant, to command than reason; but it does not follow from hence that children cannot comprehend the reason why they are made to do certain things habitually: for, from a steady adherence to a few simple principles of conduct flows that salutary power which a judicious parent gradually gains over a child's mind. And this power becomes strong indeed, if tempered by an even display of affection brought home to the child's heart. For, I believe, as a general rule, it must be allowed that the affection which we

inspire always resembles that we cultivate; so that natural affections, which have been supposed almost distinct from reason, may be found more nearly connected with judgment than is commonly allowed. Nay, as another proof of the necessity of cultivating the female understanding, it is but just to observe, that the affections seem to have a kind of animal capriciousness when they merely reside in the heart.

It is the irregular exercise of parental authority that first injures the mind, and to these irregularities girls are more subject than boys. The will of those who never allow their will to be disputed, unless they happen to be in a good humour, when they relax proportionally, is almost always unreasonable. To elude this arbitrary authority girls very early learn the lessons which they afterwards practice on their husbands; for I have frequently seen a little sharp-faced miss rule a whole family, excepting that now and then mamma's angry will burst out of some accidental cloud;—either her hair was ill dressed,[1] or she had lost more money at cards, the night before, than she was willing to own to her husband; or some such moral cause of anger.

After observing sallies of this kind, I have been led into a melancholy train of reflection respecting females, concluding that when their first affection must lead them astray, or make their duties clash till they rest on mere whims and customs, little can be expected from them as they advance in life. How indeed can an instructor remedy this evil? for to teach them virtue on any solid principle is to teach them to despise their parents. Children cannot, ought not, to be taught to make allowance for the faults of their parents, because every such allowance weakens the force of reason in their minds, and makes them still more indulgent to their own. It is one of the most sublime virtues of maturity that leads us to be severe with respect to ourselves, and forbearing to others; but children should only be taught the simple virtues, for if they begin too early to make allowance for human passions and manners, they wear off the fine edge of the criterion by which they should regulate their own, and become unjust in the same proportion as they grow indulgent.

[1] I myself heard a little girl once say to a servant, 'My mamma has been scolding me finely this morning, because her hair was not dressed to please her.' Though this remark was pert, it was just. And what respect could a girl acquire for such a parent without doing violence to reason?

The affections of children, and weak people, are always selfish; they love their relatives, because they are beloved by them, and not on account of their virtues. Yet, till esteem and love are blended together in the first affection, and reason made the foundation of the first duty, morality will stumble at the threshold. But, till society is very differently constituted, parents, I fear, will still insist on being obeyed, because they will be obeyed, and constantly endeavour to settle that power on a Divine right which will not bear the investigation of reason.

CHAPTER XII

ON NATIONAL EDUCATION

The good effects resulting from attention to private education will ever be very confined, and the parent who really puts his own hand to the plow, will always, in some degree, be disappointed, till education becomes a grand national concern. A man cannot retire into a desert with his child, and if he did he could not bring himself back to childhood, and become the proper friend and play-fellow of an infant or youth. And when children are confined to the society of men and women, they very soon acquire that kind of premature manhood which stops the growth of every vigorous power of mind or body. In order to open their faculties they should be excited to think for themselves; and this can only be done by mixing a number of children together, and making them jointly pursue the same objects.

A child very soon contracts a benumbing indolence of mind, which he has seldom sufficient vigour afterwards to shake off, when he only asks a question instead of seeking for information, and then relies implicitly on the answer he receives. With his equals in age this could never be the case, and the subjects of inquiry, though they might be influenced, would not be entirely under the direction of men, who frequently damp, if not destroy, abilities, by bringing them forward too hastily: and too hastily they will infallibly be brought forward, if the child be confined to the society of a man, however sagacious that man may be.

Besides, in youth the seeds of every affection should be sown, and the respectful regard, which is felt for a parent, is very different from the social affections that are to constitute the happiness of life as it advances. Of these equality is the basis, and an intercourse of sentiments unclogged by that observant seriousness which prevents disputation, though it may not inforce submission. Let a child have ever such an affection for his parent, he will always languish to play and prattle with children; and the very respect he feels, for filial esteem always has a dash of fear mixed with it, will, if it do not teach him cunning, at least prevent him from pouring out the little secrets

241

which first open the heart to friendship and confidence, gradually leading to more expansive benevolence. Added to this, he will never acquire that frank ingenuousness of behaviour, which young people can only attain by being frequently in society where they dare to speak what they think; neither afraid of being reproved for their presumption, nor laughed at for their folly.

Forcibly impressed by the reflections which the sight of schools, as they are at present conducted, naturally suggested, I have formerly delivered my opinion rather warmly in favour of a private education; but further experience has led me to view the subject in a different light. I still, however, think schools, as they are now regulated, the hot-beds of vice and folly, and the knowledge of human nature, supposed to be attained there, merely cunning selfishness.

At school boys become gluttons and slovens, and, instead of cultivating domestic affections, very early rush into libertinism which destroys the constitution before it is formed; hardening the heart as it weakens the understanding.

I should, in fact, be averse to boarding-schools, if it were for no other reason than the unsettled state of mind which the expectation of the vacations produce. On these the children's thoughts are fixed with eager anticipating hopes, for, at least, to speak with moderation, half of the time, and when they arrive they are spent in total dissipation and beastly indulgence.

But, on the contrary, when they are brought up at home, though they may pursue a plan of study in a more orderly manner than can be adopted when near a fourth part of the year is actually spent in idleness, and as much more in regret and anticipation; yet they there acquire too high an opinion of their own importance, from being allowed to tyrannize over servants, and from the anxiety expressed by most mothers, on the score of manners, who, eager to teach the accomplishments of a gentleman, stifle, in their birth, the virtues of a man. Thus brought into company when they ought to be seriously employed, and treated like men when they are still boys, they become vain and effeminate.

The only way to avoid two extremes equally injurious to morality, would be to contrive some way of combining a public and private education. Thus to make men citizens two natural steps might be taken, which seem directly to lead to the desired point; for the

domestic affections, that first open the heart to the various modifications of humanity, would be cultivated, whilst the children were nevertheless allowed to spend great part of their time, on terms of equality, with other children.

I still recollect, with pleasure, the country day school; where a boy trudged in the morning, wet or dry, carrying his books, and his dinner, if it were at a considerable distance; a servant did not then lead master by the hand, for, when he had once put on coat and breeches, he was allowed to shift for himself, and return alone in the evening to recount the feats of the day close at the parental knee. His father's house was his home, and was ever after fondly remembered; nay, I appeal to many superiour men, who were educated in this manner, whether the recollection of some shady lane where they conned their lesson: or, of some stile, where they sat making a kite, or mending a bat, has not endeared their country to them?

But, what boy ever recollected with pleasure the years he spent in close confinement, at an academy near London? unless, indeed, he should, by chance, remember the poor scare-crow of an usher,* whom he tormented; or, the tartman, from whom he caught a cake, to devour it with a cattish appetite of selfishness. At boarding-schools of every description, the relaxation of the junior boys is mischief; and of the senior, vice. Besides, in great schools, what can be more prejudicial to the moral character than the system of tyranny and abject slavery which is established amongst the boys, to say nothing of the slavery to forms, which makes religion worse than a farce? For what good can be expected from the youth who receives the sacrament of the Lord's supper, to avoid forfeiting half a guinea, which he probably afterwards spends in some sensual manner? Half the employment of the youths is to elude the necessity of attending public worship; and well they may, for such a constant repetition of the same thing must be a very irksome restraint on their natural vivacity. As these ceremonies have the most fatal effect on their morals, and as a ritual performed by the lips, when the heart and mind are far away, is not now stored up by our church as a bank to draw on for the fees of the poor souls in purgatory, why should they not be abolished?

But the fear of innovation, in this country, extends to every thing.—This is only a covert fear, the apprehensive timidity of indolent slugs, who guard, by sliming it over, the snug place, which

they consider in the light of an hereditary estate; and eat, drink, and enjoy themselves, instead of fulfilling the duties, excepting a few empty forms, for which it was endowed. These are the people who most strenuously insist on the will of the founder being observed, crying out against all reformation, as if it were a violation of justice. I am now alluding particularly to the relicks of popery retained in our colleges, when the protestant members seem to be such sticklers for the established church; but their zeal never makes them lose sight of the spoil of ignorance, which rapacious priests of superstitious memory have scraped together. No, wise in their generation,* they venerate the prescriptive right of possession, as a strong hold, and still let the sluggish bell tinkle to prayers, as during the days when the elevation of the host was supposed to atone for the sins of the people, lest one reformation should lead to another, and the spirit kill the letter. These Romish customs have the most baneful effect on the morals of our clergy; for the idle vermin who two or three times a day perform in the most slovenly manner a service which they think useless, but call their duty, soon lose a sense of duty. At college, forced to attend or evade public worship, they acquire an habitual contempt for the very service, the performance of which is to enable them to live in idleness. It is mumbled over as an affair of business, as a stupid boy repeats his task, and frequently the college cant escapes from the preacher the moment after he has left the pulpit, and even whilst he is eating the dinner which he earned in such a dishonest manner.

Nothing, indeed, can be more irreverent than the cathedral service as it is now performed in this country, neither does it contain a set of weaker men than those who are the slaves of this childish routine. A disgusting skeleton of the former state is still exhibited; but all the solemnity that interested the imagination, if it did not purify the heart, is stripped off. The performance of high mass on the continent must impress every mind, where a spark of fancy glows, with that awful melancholy, that sublime tenderness, so near akin to devotion. I do not say that these devotional feelings are of more use, in a moral sense, than any other emotion of taste; but I contend that the theatrical pomp which gratifies our senses, is to be preferred to the cold parade that insults the understanding without reaching the heart.

Amongst remarks on national education, such observations cannot be misplaced, especially as the supporters of these establish-

ments, degenerated into puerilities, affect to be the champions of religion.—Religion, pure source of comfort in this vale of tears! how has thy clear stream been muddied by the dabblers, who have presumptuously endeavoured to confine in one narrow channel, the living waters that ever flow towards God—the sublime ocean of existence! What would life be without that peace which the love of God, when built on humanity, alone can impart? Every earthly affection turns back, at intervals, to prey upon the heart that feeds it; and the purest effusions of benevolence, often rudely damped by man, must mount as a freewill offering to Him who gave them birth, whose bright image they faintly reflect.

In public schools, however, religion, confounded with irksome ceremonies and unreasonable restraints, assumes the most ungracious aspect: not the sober austere one that commands respect whilst it inspires fear; but a ludicrous cast, that serves to point a pun. For, in fact, most of the good stories and smart things which enliven the spirits that have been concentrated at whist, are manufactured out of the incidents to which the very men labour to give a droll turn who countenance the abuse to live on the spoil.

There is not, perhaps, in the kingdom, a more dogmatical, or luxurious set of men, than the pedantic tyrants who reside in colleges and preside at public schools. The vacations are equally injurious to the morals of the masters and pupils, and the intercourse, which the former keep up with the nobility, introduces the same vanity and extravagance into their families, which banish domestic duties and comforts from the lordly mansion, whose state is awkwardly aped. The boys, who live at a great expence with the masters and assistants, are never domesticated, though placed there for that purpose; for, after a silent dinner, they swallow a hasty glass of wine, and retire to plan some mischievous trick, or to ridicule the person or manners of the very people they have just been cringing to, and whom they ought to consider as the representatives of their parents.

Can it then be a matter of surprise that boys become selfish and vicious who are thus shut out from social converse? or that a mitre often graces the brow of one of these diligent pastors?

The desire of living in the same style, as the rank just above them, infects each individual and every class of people, and meanness is the concomitant of this ignoble ambition; but those professions are most debasing whose ladder is patronage; yet, out of one of these professions the tutors of youth are, in general, chosen. But, can they

be expected to inspire independent sentiments, whose conduct must be regulated by the cautious prudence that is ever on the watch for preferment?

So far, however, from thinking of the morals of boys, I have heard several masters of schools argue, that they only undertook to teach Latin and Greek; and that they had fulfilled their duty, by sending some good scholars to college.

A few good scholars, I grant, may have been formed by emulation and discipline; but, to bring forward these clever boys, the health and morals of a number have been sacrificed. The sons of our gentry and wealthy commoners are mostly educated at these seminaries, and will any one pretend to assert that the majority, making every allowance, come under the description of tolerable scholars?

It is not for the benefit of society that a few brilliant men should be brought forward at the expence of the multitude. It is true, that great men seem to start up, as great revolutions occur, at proper intervals, to restore order, and to blow aside the clouds that thicken over the face of truth; but let more reason and virtue prevail in society, and these strong winds would not be necessary. Public education, of every denomination, should be directed to form citizens; but if you wish to make good citizens, you must first exercise the affections of a son and a brother, This is the only way to expand the heart; for public affections, as well as public virtues, must ever grow out of the private character, or they are merely meteors that shoot athwart a dark sky, and disappear as they are gazed at and admired.

Few, I believe, have had much affection for mankind, who did not first love their parents, their brothers, sisters, and even the domestic brutes, whom they first played with. The exercise of youthful sympathies forms the moral temperature; and it is the recollection of these first affections and pursuits that gives life to those that are afterwards more under the direction of reason. In youth, the fondest friendships are formed, the genial juices mounting at the same time, kindly mix; or, rather the heart, tempered for the reception of friendship, is accustomed to seek for pleasure in something more noble than the churlish gratification of appetite.

In order then to inspire a love of home and domestic pleasures, children ought to be educated at home, for riotous holidays only make them fond of home for their own sakes. Yet, the vacations,

which do not foster domestic affections, continually disturb the course of study, and render any plan of improvement abortive which includes temperance; still, were they abolished, children would be entirely separated from their parents, and I question whether they would become better citizens by sacrificing the preparatory affections, by destroying the force of relationships that render the marriage state as necessary as respectable. But, if a private education produce self-importance, or insulate a man in his family, the evil is only shifted, not remedied.

This train of reasoning brings me back to a subject, on which I mean to dwell, the necessity of establishing proper day-schools.

But, these should be national establishments, for whilst schoolmasters are dependent on the caprice of parents, little exertion can be expected from them, more than is necessary to please ignorant people. Indeed, the necessity of a master's giving the parents some sample of the boys abilities, which during the vacation is shewn to every visitor,[1] is productive of more mischief than would at first be supposed. For it is seldom done entirely, to speak with moderation, by the child itself; thus the master countenances falsehood, or winds the poor machine up to some extraordinary exertion, that injures the wheels, and stops the progress of gradual improvement. The memory is loaded with unintelligible words, to make a shew of, without the understanding's acquiring any distinct ideas: but only that education deserves emphatically to be termed cultivation of mind, which teaches young people how to begin to think. The imagination should not be allowed to debauch the understanding before it gained strength, or vanity will become the forerunner of vice: for every way of exhibiting the acquirements of a child is injurious to its moral character.

How much time is lost in teaching them to recite what they do not understand? whilst, seated on benches, all in their best array, the mammas listen with astonishment to the parrot-like prattle, uttered in solemn cadences, with all the pomp of ignorance and folly. Such exhibitions only serve to strike the spreading fibres of vanity through the whole mind; for they neither teach children to speak fluently, nor behave gracefully. So far from it, that these frivolous

[1] I now particularly allude to the numerous academies in and about London, and to the behaviour of the trading part of this great city.

pursuits might comprehensively be termed the study of affectation; for we now rarely see a simple, bashful boy, though few people of taste were ever disgusted by that awkward sheepishness so natural to the age, which schools and an early introduction into society, have changed into impudence and apish grimace.

Yet, how can these things be remedied whilst school-masters depend entirely on parents for a subsistence; and, when so many rival schools hang out their lures, to catch the attention of vain fathers and mothers, whose parental affection only leads them to wish that their children should outshine those of their neighbours?

Without great good luck, a sensible, conscientious man, would starve before he could raise a school, if he disdained to bubble weak parents by practising the secret tricks of the craft.

In the best regulated schools, however, where swarms are not crammed together, many bad habits must be acquired; but, at common schools, the body, heart, and understanding, are equally stunted, for parents are often only in quest of the cheapest school, and the master could not live, if he did not take a much greater number than he could manage himself; nor will the scanty pittance, allowed for each child, permit him to hire ushers sufficient to assist in the discharge of the mechanical part of the business. Besides, whatever appearance the house and garden may make, the children do not enjoy the comfort of either, for they are continually reminded by irksome restrictions that they are not at home, and the staterooms, garden, etc. must be kept in order for the recreation of the parents; who, of a Sunday, visit the school, and are impressed by the very parade that renders the situation of their children uncomfortable.

With what disgust have I heard sensible women, for girls are more restrained and cowed than boys, speak of the wearisome confinement, which they endured at school. Not allowed, perhaps, to step out of one broad walk in a superb garden, and obliged to pace with steady deportment stupidly backwards and forwards, holding up their heads and turning out their toes, with shoulders braced back, instead of bounding, as nature directs to complete her own design, in the various attitudes so conducive to health.[1] The pure

[1] I remember a circumstance that once came under my own observation, and raised my indignation. I went to visit a little boy at a school where young children were prepared for a larger one. The master took me into the school-room, etc. but whilst I walked down a broad

animal spirits, which make both mind and body shoot out, and unfold the tender blossoms of hope, are turned sour, and vented in vain wishes or pert repinings, that contract the faculties and spoil the temper; else they mount to the brain, and sharpening the understanding before it gains proportionable strength, produce that pitiful cunning which disgracefully characterizes the female mind— and I fear will ever characterize it whilst women remain the slaves of power!

The little respect paid to chastity in the male world is, I am persuaded, the grand source of many of the physical and moral evils that torment mankind, as well as of the vices and follies that degrade and destroy women; yet at school, boys infallibly lose that decent bashfulness, which might have ripened into modesty, at home.

And what nasty indecent tricks do they not also learn from each other, when a number of them pig together in the same bedchamber, not to speak of the vices, which render the body weak, whilst they effectually prevent the acquisition of any delicacy of mind.* The little attention paid to the cultivation of modesty, amongst men, produces great depravity in all the relationships of society; for, not only love—love that ought to purify the heart, and first call forth all the youthful powers, to prepare the man to discharge the benevolent duties of life, is sacrificed to premature lust; but, all the social affections are deadened by the selfish gratifications, which very early pollute the mind, and dry up the generous juices of the heart. In what an unnatural manner is innocence often violated; and what serious consequences ensue to render private vices a public pest. Besides, an habit of personal order, which has more effect on the moral character, than is, in general, supposed, can only be acquired at home, where that respectable reserve is kept up which checks the familiarity, that sinking into beastliness, undermines the affection it insults.

I have already animadverted on the bad habits which females acquire when they are shut up together; and, I think, that the

gravel walk, I could not help observing that the grass grew very luxuriantly on each side of me. I immediately asked the child some questions, and found that the poor boys were not allowed to stir off the walk, and that the master sometimes permitted sheep to be turned in to crop the untrodden grass. The tyrant of this domain used to sit by a window that overlooked the prison yard, and one nook turning from it, where the unfortunate babes could sport freely, he enclosed, and planted it with potatoes. The wife likewise was equally anxious to keep the children in order, lest they should dirty or tear their clothes.

observation may fairly be extended to the other sex, till the natural inference is drawn which I have had in view throughout—that to improve both sexes they ought, not only in private families, but in public schools, to be educated together. If marriage be the cement of society, mankind should all be educated after the same model, or the intercourse of the sexes will never deserve the name of fellowship, nor will women ever fulfil the peculiar duties of their sex, till they become enlightened citizens, till they become free by being enabled to earn their own subsistence, independent of men; in the same manner, I mean, to prevent misconstruction, as one man is independent of another. Nay, marriage will never be held sacred till women, by being brought up with men, are prepared to be their companions rather than their mistresses; for the mean doublings of cunning will ever render them contemptible, whilst oppression renders them timid. So convinced am I of this truth, that I will venture to predict that virtue will never prevail in society till the virtues of both sexes are founded on reason; and, till the affections common to both are allowed to gain their due strength by the discharge of mutual duties.

Were boys and girls permitted to pursue the same studies together, those graceful decencies might early be inculcated which produce modesty without those sexual distinctions that taint the mind. Lessons of politeness, and that formulary of decorum, which treads on the heels of falsehood, would be rendered useless by habitual propriety of behaviour. Not, indeed, put on for visitors like the courtly robe of politeness, but the sober effect of cleanliness of mind. Would not this simple elegance of sincerity be a chaste homage paid to domestic affections, far surpassing the meretricious compliments that shine with false lustre in the heartless intercourse of fashionable life? But, till more understanding preponderates in society, there will ever be a want of heart and taste, and the harlot's *rouge* will supply the place of that celestial suffusion which only virtuous affections can give to the face. Gallantry, and what is called love, may subsist without simplicity of character; but the main pillars of friendship, are respect and confidence—esteem is never founded on it cannot tell what!

A taste for the fine arts requires great cultivation; but not more than a taste for the virtuous affections; and both suppose that enlargement of mind which opens so many sources of mental pleasure.

Why do people hurry to noisy scenes, and crowded circles? I should answer, because they want activity of mind, because they have not cherished the virtues of the heart. They only, therefore, see and feel in the gross, and continually pine after variety, finding every thing that is simple insipid.

This argument may be carried further than philosophers are aware of, for if nature destined woman, in particular, for the discharge of domestic duties, she made her susceptible of the attached affections in a great degree. Now women are notoriously fond of pleasure; and, naturally must be so according to my definition, because they cannot enter into the minutiae of domestic taste; lacking judgment, the foundation of all taste. For the understanding, in spite of sensual cavillers, reserves to itself the privilege of conveying pure joy to the heart.

With what a languid yawn have I seen an admirable poem thrown down, that a man of true taste returns to, again and again with rapture; and, whilst melody has almost suspended respiration, a lady has asked me where I bought my gown. I have seen also an eye glanced coldly over a most exquisite picture, rest, sparkling with pleasure, on a caricature rudely sketched; and whilst some terrific feature in nature has spread a sublime stillness through my soul, I have been desired to observe the pretty tricks of a lap-dog, that my perverse fate forced me to travel with. Is it surprising that such a tasteless being should rather caress this dog than her children? Or, that she should prefer the rant of flattery to the simple accents of sincerity?

To illustrate this remark I must be allowed to observe, that men of the first genius, and most cultivated minds, have appeared to have the highest relish for the simple beauties of nature; and they must have forcibly felt, what they have so well described, the charm which natural affections, and unsophisticated feelings spread round the human character. It is this power of looking into the heart, and responsively vibrating with each emotion, that enables the poet to personify each passion, and the painter to sketch with a pencil of fire.

True taste is ever the work of the understanding employed in observing natural effects; and till women have more understanding, it is vain to expect them to possess domestic taste. Their lively senses will ever be at work to harden their hearts, and the emotions

struck out of them will continue to be vivid and transitory, unless a proper education store their mind with knowledge.

It is the want of domestic taste, and not the acquirement of knowledge, that takes women out of their families, and tears the smiling babe from the breast that ought to afford it nourishment. Women have been allowed to remain in ignorance, and slavish dependence, many, very many years, and still we hear of nothing but their fondness of pleasure and sway, their preference of rakes and soldiers, their childish attachment to toys, and the vanity that makes them value accomplishments more than virtues.

History brings forward a fearful catalogue of the crimes which their cunning has produced, when the weak slaves have had sufficient address to over-reach their masters. In France, and in how many other countries, have men been the luxurious despots, and women the crafty ministers?*—Does this prove that ignorance and dependence domesticate them? Is not their folly the by-word of the libertines, who relax in their society; and do not men of sense continually lament that an immoderate fondness for dress and dissipation carries the mother of a family for ever from home? Their hearts have not been debauched by knowledge, or their minds led astray by scientific pursuits; yet, they do not fulfil the peculiar duties which as women they are called upon by nature to fulfil. On the contrary, the state of warfare which subsists between the sexes, makes them employ those wiles, that often frustrate the more open designs of force.

When, therefore, I call women slaves, I mean in a political and civil sense; for, indirectly they obtain too much power, and are debased by their exertions to obtain illicit sway.

Let an enlightened nation[1] then try what effect reason would have to bring them back to nature, and their duty; and allowing them to share the advantages of education and government with man, see whether they will become better, as they grow wiser and become free. They cannot be injured by the experiment; for it is not in the power of man to render them more insignificant than they are at present.

To render this practicable, day schools, for particular ages, should be established by government, in which boys and girls might

[1] France.

be educated together. The school for the younger children, from five to nine years of age, ought to be absolutely free and open to all classes.[1] A sufficient number of masters should also be chosen by a select committee, in each parish, to whom any complaint of negligence, etc. might be made, if signed by six of the children's parents.

Ushers would then be unnecessary; for I believe experience will ever prove that this kind of subordinate authority is particularly injurious to the morals of youth. What, indeed, can tend to deprave the character more than outward submission and inward contempt? Yet how can boys be expected to treat an usher with respect, when the master seems to consider him in the light of a servant, and almost to countenance the ridicule which becomes the chief amusement of the boys during the play hours?

But nothing of this kind could occur in an elementary day-school, where boys and girls, the rich and poor, should meet together. And to prevent any of the distinctions of vanity, they should be dressed alike, and all obliged to submit to the same discipline, or leave the school. The school-room ought to be surrounded by a large piece of ground, in which the children might be usefully exercised, for at this age they should not be confined to any sedentary employment for more than an hour at a time. But these relaxations might all be rendered a part of elementary education, for many things improve and amuse the senses, when introduced as a kind of show, to the principles of which, dryly laid down, children would turn a deaf ear. For instance, botany, mechanics, and astronomy. Reading, writing, arithmetic, natural history, and some simple experiments in natural philosophy, might fill up the day; but these pursuits should never encroach on gymnastic plays in the open air. The elements of religion, history, the history of man, and politics, might also be taught by conversations, in the socratic form.

After the age of nine, girls and boys, intended for domestic employments, or mechanical trades, ought to be removed to other schools, and receive instruction, in some measure appropriated to the destination of each individual, the two sexes being still together in the morning; but in the afternoon, the girls should attend a

[1] Treating this part of the subject, I have borrowed some hints from a very sensible pamphlet, written by the late bishop of Autun on Public Education.

school, where plain-work, mantua-making, millinery, etc. would be their employment.

The young people of superior abilities, or fortune, might now be taught, in another school, the dead and living languages, the elements of science, and continue the study of history and politics, on a more extensive scale, which would not exclude polite literature.

Girls and boys still together? I hear some readers ask: yes. And I should not fear any other consequence than that some early attachment might take place; which, whilst it had the best effect on the moral character of the young people, might not perfectly agree with the views of the parents, for it will be a long time, I fear, before the world will be so far enlightened that parents, only anxious to render their children virtuous, shall allow them to choose companions for life themselves.

Besides, this would be a sure way to promote early marriages, and from early marriages the most salutary physical and moral effects naturally flow. What a different character does a married citizen assume from the selfish coxcomb, who lives, but for himself, and who is often afraid to marry lest he should not be able to live in a certain style. Great emergencies excepted, which would rarely occur in a society of which equality was the basis, a man can only be prepared to discharge the duties of public life, by the habitual practice of those inferiour ones which form the man.

In this plan of education the constitution of boys would not be ruined by the early debaucheries, which now make men so selfish, or girls rendered weak and vain, by indolence, and frivolous pursuits. But, I presuppose, that such a degree of equality should be established between the sexes as would shut out gallantry and coquetry, yet allow friendship and love to temper the heart for the discharge of higher duties.

These would be schools of morality—and the happiness of man, allowed to flow from the pure springs of duty and affection, what advances might not the human mind make? Society can only be happy and free in proportion as it is virtuous; but the present distinctions, established in society, corrode all private, and blast all public virtue.

I have already inveighed against the custom of confining girls to their needle, and shutting them out from all political and civil

employments; for by thus narrowing their minds they are rendered unfit to fulfil the peculiar duties which nature has assigned them.

Only employed about the little incidents of the day, they necessarily grow up cunning. My very soul has often sickened at observing the sly tricks practised by women to gain some foolish thing on which their silly hearts were set. Not allowed to dispose of money, or call any thing their own, they learn to turn the market penny;* or, should a husband offend, by staying from home, or give rise to some emotions of jealousy—a new gown, or any pretty bawble, smooths Juno's angry brow.*

But these *littlenesses* would not degrade their character, if women were led to respect themselves, if political and moral subjects were opened to them; and, I will venture to affirm, that this is the only way to make them properly attentive to their domestic duties.—An active mind embraces the whole circle of its duties, and finds time enough for all. It is not, I assert, a bold attempt to emulate masculine virtues; it is not the enchantment of literary pursuits, or the steady investigation of scientific subjects, that leads women astray from duty. No, it is indolence and vanity—the love of pleasure and the love of sway,* that will reign paramount in an empty mind. I say empty emphatically, because the education which women now receive scarcely deserves the name. For the little knowledge that they are led to acquire, during the important years of youth, is merely relative to accomplishments; and accomplishments without a bottom, for unless the understanding be cultivated, superficial and monotonous is every grace. Like the charms of a made up face, they only strike the senses in a crowd; but at home, wanting mind, they want variety. The consequence is obvious; in gay scenes of dissipation we meet the artificial mind and face, for those who fly from solitude dread, next to solitude, the domestic circle; not having it in their power to amuse or interest, they feel their own insignificance, or find nothing to amuse or interest themselves.

Besides, what can be more indelicate than a girl's *coming out* in the fashionable world? Which, in other words, is to bring to market a marriageable miss, whose person is taken from one public place to another, richly caparisoned. Yet, mixing in the giddy circle under restraint, these butterflies long to flutter at large, for the first affection of their souls is their own persons, to which their attention has been called with the most sedulous care whilst they were preparing

for the period that decides their fate for life. Instead of pursuing this idle routine, sighing for tasteless shew, and heartless state, with what dignity would the youths of both sexes form attachments in the schools that I have cursorily pointed out; in which, as life advanced, dancing, music, and drawing, might be admitted as relaxations, for at these schools young people of fortune ought to remain, more or less, till they were of age. Those, who were designed for particular professions, might attend, three or four mornings in the week, the schools appropriated for their immediate instruction.

I only drop these observations at present, as hints; rather, indeed, as an outline of the plan I mean, than a digested one; but I must add, that I highly approve of one regulation mentioned in the pamphlet[1] already alluded to, that of making the children and youths independent of the masters respecting punishments. They should be tried by their peers, which would be an admirable method of fixing sound principles of justice in the mind, and might have the happiest effect on the temper, which is very early soured or irritated by tyranny, till it becomes peevishly cunning, or ferociously overbearing.

My imagination darts forward with benevolent fervour to greet these amiable and respectable groups, in spite of the sneering of cold hearts, who are at liberty to utter, with frigid self-importance, the damning epithet—romantic; the force of which I shall endeavour to blunt by repeating the words of an eloquent moralist.—'I know not whether the allusions of a truly humane heart, whose zeal renders every thing easy, be not preferable to that rough and repulsing reason, which always finds an indifference for the public good, the first obstacle to whatever would promote it.'

I know that libertines will also exclaim, that woman would be unsexed by acquiring strength of body and mind, and that beauty, soft bewitching beauty! would no longer adorn the daughters of men. I am of a very different opinion, for I think that, on the contrary, we should then see dignified beauty, and true grace; to produce which, many powerful physical and moral causes would concur.—Not relaxed beauty, it is true, or the graces of helplessness; but such as appears to make us respect the human body as

[1] The Bishop of Autun's.

a majestic pile fit to receive a noble inhabitant, in the relics of antiquity.

I do not forget the popular opinion that the Grecian statues were not modelled after nature. I mean, not according to the proportions of a particular man; but that beautiful limbs and features were selected from various bodies to form an harmonious whole. This might, in some degree, be true. The fine ideal picture of an exalted imagination might be superiour to the materials which the statuary found in nature, and thus it might with propriety be termed rather the model of mankind than of a man. It was not, however, the mechanical selection of limbs and features; but the ebullition of an heated fancy that burst forth, and the fine senses and enlarged understanding of the artist selected the solid matter, which he drew into this glowing focus.

I observed that it was not mechanical, because a whole was produced—a model of that grand simplicity, of those concurring energies, which arrest our attention and command our reverence. For only insipid lifeless beauty is produced by a servile copy of even beautiful nature. Yet, independent of these observations, I believe that the human form must have been far more beautiful than it is at present, because extreme indolence, barbarous ligatures, and many causes, which forcibly act on it, in our luxurious state of society, did not retard its expansion, or render it deformed. Exercise and cleanliness appear to be not only the surest means of preserving health, but of promoting beauty, the physical causes only considered; yet, this is not sufficient, moral ones must concur, or beauty will be merely of that rustic kind which blooms on the innocent, wholesome, countenances of some country people, whose minds have not been exercised. To render the person perfect, physical and moral beauty ought to be attained at the same time; each lending and receiving force by the combination. Judgment must reside on the brow, affection and fancy beam in the eye, and humanity curve the cheek, or vain is the sparkling of the finest eye or the elegantly turned finish of the fairest features: whilst in every motion that displays the active limbs and well-knit joints, grace and modesty should appear. But this fair assemblange is not to be brought together by chance; it is the reward of exertions calculated to support each other; for judgment can only be acquired by reflection, affec-

tion by the discharge of duties, and humanity by the exercise of compassion to every living creature.

Humanity to animals should be particularly inculcated as a part of national education, for it is not at present one of our national virtues. Tenderness for their humble dumb domestics, amongst the lower class, is oftener to be found in a savage than a civilized state. For civilization prevents that intercourse which creates affection in the rude hut, or mud hovel, and leads uncultivated minds who are only depraved by the refinements which prevail in the society, where they are trodden under foot by the rich, to domineer over them to revenge the insults that they are obliged to bear from their superiours.

This habitual cruelty is first caught at school, where it is one of the rare sports of the boys to torment the miserable brutes that fall in their way. The transition, as they grow up, from barbarity to brutes to domestic tyranny over wives, children, and servants, is very easy. Justice, or even benevolence, will not be a powerful spring of action unless it extend to the whole creation; nay, I believe that it may be delivered as an axiom, that those who can see pain, unmoved, will soon learn to inflict it.

The vulgar are swayed by present feelings, and the habits which they have accidentally acquired; but on partial feelings much dependence cannot be placed, though they be just; for, when they are not invigorated by reflection, custom weakens them, till they are scarcely perceptible. The sympathies of our nature are strengthened by pondering cogitations, and deadened by thoughtless use. Macbeth's heart smote him more for one murder, the first, than for a hundred subsequent ones, which were necessary to back it. But, when I used the epithet vulgar, I did not mean to confine my remark to the poor, for partial humanity, founded on present sensations, or whim, is quite as conspicuous, if not more so, amongst the rich.

The lady who sheds tears for the bird starved in a snare, and execrates the devils in the shape of men, who goad to madness the poor ox, or whip the patient ass, tottering under a burden above its strength, will, nevertheless, keep her coachman and horses whole hours waiting for her, when the sharp frost bites, or the rain beats against the well-closed windows which do not admit a breath of air to tell her how roughly the wind blows without. And she who takes her dogs to bed, and nurses them with a parade of sensibility, when

sick, will suffer her babes to grow up crooked in a nursery. This illustration of my argument is drawn from a matter of fact. The woman whom I allude to was handsome, reckoned very handsome, by those who do not miss the mind when the face is plump and fair; but her understanding had not been led from female duties by literature, nor her innocence debauched by knowledge. No, she was quite feminine, according to the masculine acceptation of the word; and, so far from loving these spoiled brutes that filled the place which her children ought to have occupied, she only lisped out a pretty mixture of French and English nonsense, to please the men who flocked round her. The wife, mother, and human creature, were all swallowed up by the factitious character which an improper education and the selfish vanity of beauty had produced.

I do not like to make a distinction without a difference, and I own that I have been as much disgusted by the fine lady who took her lap-dog to her bosom instead of her child; as by the ferocity of a man, who, beating his horse, declared, that he knew as well when he did wrong, as a Christian.

This brood of folly shews how mistaken they are who, if they allow women to leave their harams, do not cultivate their understandings, in order to plant virtues in their hearts. For had they sense, they might acquire that domestic taste which would lead them to love with reasonable subordination their whole family, from their husband to the house-dog; nor would they ever insult humanity in the person of the most menial servant by paying more attention to the comfort of a brute, than to that of a fellow-creature.

My observations on national education are obviously hints; but I principally wish to enforce the necessity of educating the sexes together to perfect both, and of making children sleep at home that they may learn to love home; yet to make private support, instead of smothering, public affections, they should be sent to school to mix with a number of equals, for only by the jostlings of equality can we form a just opinion of ourselves.

To render mankind more virtuous, and happier of course, both sexes must act from the same principle; but how can that be expected when only one is allowed to see the reasonableness of it? To render also the social compact truly equitable, and in order to spread those enlightening principles, which alone can meliorate the fate of man, women must be allowed to found their virtue on knowledge,

which is scarcely possible unless they be educated by the same pursuits as men. For they are now made so inferiour by ignorance and low desires, as not to deserve to be ranked with them; or, by the serpentine wrigglings of cunning they mount the tree of knowledge, and only acquire sufficient to lead men astray.

It is plain from the history of all nations, that women cannot be confined to merely domestic pursuits, for they will not fulfil family duties, unless their minds take a wider range, and whilst they are kept in ignorance they become in the same proportion the slaves of pleasure as they are the slaves of man. Nor can they be shut out of great enterprises, though the narrowness of their minds often make them mar, what they are unable to comprehend.

The libertinism, and even the virtues of superiour men, will always give women, of some description, great power over them; and these weak women, under the influence of childish passions and selfish vanity, will throw a false light over the objects which the very men view with their eyes, who ought to enlighten their judgment. Men of fancy, and those sanguine characters who mostly hold the helm of human affairs, in general, relax in the society of women; and surely I need not cite to the most superficial reader of history the numerous examples of vice and oppression which the private intrigues of female favourites have produced; not to dwell on the mischief that naturally arises from the blundering interposition of well-meaning folly. For in the transactions of business it is much better to have to deal with a knave than a fool, because a knave adheres to some plan; and any plan of reason may be seen through much sooner than a sudden flight of folly. The power which vile and foolish women have had over wise men, who possessed sensibility, is notorious; I shall only mention one instance.

Who ever drew a more exalted female character than Rousseau?* though in the lump he constantly endeavoured to degrade the sex. And why was he thus anxious? Truly to justify to himself the affection which weakness and virtue had made him cherish for that fool Theresa.* He could not raise her to the common level of her sex; and therefore he laboured to bring woman down to her's. He found her a convenient humble companion, and pride made him determine to find some superiour virtues in the being whom he chose to live with; but did not her conduct during his life, and after his death, clearly shew how grossly he was mistaken who called her

a celestial innocent.* Nay, in the bitterness of his heart, he himself laments, that when his bodily infirmities made him no longer treat her like a woman, she ceased to have an affection for him.* And it was very natural that she should, for having so few sentiments in common, when the sexual tie was broken, what was to hold her? To hold her affection whose sensibility was confined to one sex, nay, to one man, it requires sense to turn sensibility into the broad channel of humanity; many women have not mind enough to have an affection for a woman, or a friendship for a man. But the sexual weakness that makes woman depend on man for a subsistence, produces a kind of cattish affection which leads a wife to purr about her husband as she would about any man who fed and caressed her.

Men are, however, often gratified by this kind of fondness, which is confined in a beastly manner to themselves; but should they ever become more virtuous, they will wish to converse at their fire-side with a friend, after they cease to play with a mistress.

Besides, understanding is necessary to give variety and interest to sensual enjoyments, for low, indeed, in the intellectual scale, is the mind that can continue to love when neither virtue nor sense give a human appearance to an animal appetite. But sense will always preponderate; and if women be not, in general, brought more on a level with men, some superiour women, like the Greek courtezans, will assemble the men of abilities around them, and draw from their families many citizens, who would have stayed at home had their wives had more sense, or the graces which result from the exercise of the understanding and fancy, the legitimate parents of taste. A woman of talents, if she be not absolutely ugly, will always obtain great power, raised by the weakness of her sex; and in proportion as men acquire virtue and delicacy, by the exertion of reason, they will look for both in women, but they can only acquire them in the same way that men do.

In France or Italy, have the women confined themselves to domestic life? though they have not hitherto had a political existence, yet, have they not illicitly had great sway? corrupting themselves and the men with whose passions they played. In short, in whatever light I view the subject, reason and experience convince me that the only method of leading women to fulfil their peculiar duties, is to free them from all restraint by allowing them to participate the inherent rights of mankind.

Make them free, and they will quickly become wise and virtuous, as men become more so; for the improvement must be mutual, or the injustice which one half of the human race are obliged to submit to, retorting on their oppressors, the virtue of man will be worm-eaten by the insect whom he keeps under his feet.

Let men take their choice, man and woman were made for each other, though not to become one being; and if they will not improve women, they will deprave them!

I speak of the improvement and emancipation of the whole sex, for I know that the behaviour of a few women, who, by accident, or following a strong bent of nature, have acquired a portion of knowledge superiour to that of the rest of their sex, has often been over-bearing; but there have been instances of women who, attaining knowledge, have not discarded modesty, nor have they always pedantically appeared to despise the ignorance which they laboured to disperse in their own minds. The exclamations then which any advice respecting female learning, commonly produces, especially from pretty women, often arise from envy. When they chance to see that even the lustre of their eyes, and the flippant sportiveness of refined coquetry will not always secure them attention, during a whole evening, should a woman of a more cultivated understanding endeavour to give a rational turn to the conversation, the common source of consolation is, that such women seldom get husbands. What arts have I not seen silly women use to interrupt by *flirtation*, a very significant word to describe such a manoeuvre, a rational conversation which made the men forget that they were pretty women.

But, allowing what is very natural to man, that the possession of rare abilities is really calculated to excite over-weening pride, disgusting in both men and women—in what a state of inferiority must the female faculties have rusted when such a small portion of knowledge as those women attained, who have sneeringly been termed learned women, could be singular?—Sufficiently so to puff up the possessor, and excite envy in her contemporaries, and some of the other sex. Nay, has not a little rationality exposed many women to the severest censure? I advert to well known facts, for I have frequently heard women ridiculed, and every little weakness exposed, only because they adopted the advice of some medical men, and deviated from the beaten track in their mode of treating their in-

fants.* I have actually heard this barbarous aversion to innovation carried still further, and a sensible woman stigmatized as an unnatural mother, who has thus been wisely solicitous to preserve the health of her children, when in the midst of her care she has lost one by some of the casualties of infancy, which no prudence can ward off. Her acquaintance have observed, that this was the consequence of new-fangled notions—the new-fangled notions of ease and cleanliness. And those who pretending to experience, though they have long adhered to prejudices that have, according to the opinion of the most sagacious physicians, thinned the human race, almost rejoiced at the disaster after that gave a kind of sanction to prescription.

Indeed, if it were only on this account, the national education of women is of the utmost consequence, for what a number of human sacrifices are made to that moloch* prejudice! And in how many ways are children destroyed by the lasciviousness of man? The want of natural affection, in many women, who are drawn from their duty by the admiration of men, and the ignorance of others, render the infancy of man a much more perilous state than that of brutes; yet men are unwilling to place women in situations proper to enable them to acquire sufficient understanding to know how even to nurse their babes.

So forcibly does this truth strike me, that I would rest the whole tendency of my reasoning upon it, for whatever tends to incapacitate the maternal character, takes woman out of her sphere.

But it is vain to expect the present race of weak mothers either to take that reasonable care of a child's body, which is necessary to lay the foundation of a good constitution, supposing that it do not suffer for the sins of its fathers;* or, to manage its temper so judiciously that the child will not have, as it grows up, to throw off all that its mother, its first instructor, directly or indirectly taught; and unless the mind have uncommon vigour, womanish follies will stick to the character throughout life. The weakness of the mother will be visited on the children! And whilst women are educated to rely on their husbands for judgment, this must ever be the consequence, for there is no improving an understanding by halves, nor can any being act wisely from imitation, because in every circumstance of life there is a kind of individuality, which requires an exertion of judgment to modify general rules. The being who can think justly in one track, will soon extend its intellectual empire; and she who has sufficient

judgment to manage her children, will not submit, right or wrong, to her husband, or patiently to the social laws which make a nonentity of a wife.

In public schools women, to guard against the errors of ignorance, should be taught the elements of anatomy and medicine, not only to enable them to take proper care of their own health, but to make them rational nurses of their infants, parents, and husbands; for the bills of mortality* are swelled by the blunders of self-willed old women, who give nostrums of their own without knowing any thing of the human frame. It is likewise proper only in a domestic view, to make women acquainted with the anatomy of the mind, by allowing the sexes to associate together in every pursuit; and by leading them to observe the progress of the human understanding in the improvement of the sciences and arts; never forgetting the science of morality, or the study of the political history of mankind.

A man has been termed a microcosm; and every family might also be called a state. States, it is true, have mostly been governed by arts that disgrace the character of man; and the want of a just constitution, and equal laws, have so perplexed the notions of the worldly wise, that they more than question the reasonableness of contending for the rights of humanity. Thus morality, polluted in the national reservoir, sends off streams of vice to corrupt the constituent parts of the body politic; but should more noble, or rather, more just principles regulate the laws, which ought to be the government of society, and not those who execute them, duty might become the rule of private conduct.

Besides, by the exercise of their bodies and minds women would acquire that mental activity so necessary in the maternal character, united with the fortitude that distinguishes steadiness of conduct from the obstinate perverseness of weakness. For it is dangerous to advise the indolent to be steady, because they instantly become rigorous, and to save themselves trouble, punish with severity faults that the patient fortitude of reason might have prevented.

But fortitude presupposes strength of mind; and is strength of mind to be acquired by indolent acquiescence? by asking advice instead of exerting the judgment? by obeying through fear, instead of practising the forbearance, which we all stand in need of ourselves?—The conclusion which I wish to draw, is obvious; make women rational creatures, and free citizens, and they will quickly

become good wives, and mothers; that is—if men do not neglect the duties of husbands and fathers.

Discussing the advantages which a public and private education combined, as I have sketched, might rationally be expected to produce, I have dwelt most on such as are particularly relative to the female world, because I think the female world oppressed; yet the gangrene, which the vices engendered by oppression have produced, is not confined to the morbid part, but pervades society at large: so that when I wish to see my sex become more like moral agents, my heart bounds with the anticipation of the general diffusion of that sublime contentment which only morality can diffuse.

CHAPTER XIII

SOME INSTANCES OF THE FOLLY WHICH THE
IGNORANCE OF WOMEN GENERATES; WITH CONCLUDING
REFLECTIONS ON THE MORAL IMPROVEMENT
THAT A REVOLUTION IN FEMALE MANNERS
MIGHT NATURALLY BE EXPECTED TO PRODUCE

There are many follies, in some degree, peculiar to women: sins against reason of commission as well as of omission; but all flowing from ignorance or prejudice, I shall only point out such as appear to be particularly injurious to their moral character. And in animadverting on them, I wish especially to prove, that the weakness of mind and body, which men have endeavoured, impelled by various motives, to perpetuate, prevents their discharging the peculiar duty of their sex: for when weakness of body will not permit them to suckle their children, and weakness of mind makes them spoil their tempers—is woman in a natural state?

Section I

One glaring instance of the weakness which proceeds from ignorance, first claims attention, and calls for severe reproof.

In this metropolis a number of lurking leeches infamously gain a subsistence by practising on the credulity of women, pretending to cast nativities,* to use the technical phrase; and many females who, proud of their rank and fortune, look down on the vulgar with sovereign contempt, shew by this credulity, that the distinction is arbitrary, and that they have not sufficiently cultivated their minds to rise above vulgar prejudices. Women, because they have not been led to consider the knowledge of their duty as the one thing necessary to know, or, to live in the present moment by the discharge of it, are very anxious to peep into futurity, to learn what they have to expect to render life interesting, and to break the vacuum of ignorance.

I must be allowed to expostulate seriously with the ladies who follow these idle inventions; for ladies, mistresses of families, are not

ashamed to drive in their own carriages to the door of the cunning man.[1] And if any of them should peruse this work, I entreat them to answer to their own hearts the following questions, not forgetting that they are in the presence of God.

Do you believe that there is but one God, and that he is powerful, wise, and good?

Do you believe that all things were created by him, and that all beings are dependent on him?

Do you rely on his wisdom, so conspicuous in his works, and in your own frame, and are you convinced that he has ordered all things which do not come under the cognizance of your senses, in the same perfect harmony, to fulfil his designs?

Do you acknowledge that the power of looking into futurity, and seeing things that are not, as if they were, is an attribute of the Creator? And should he, by an impression on the minds of his creatures, think fit to impart to them some event hid in the shades of time yet unborn, to whom would the secret be revealed by immediate inspiration? The opinion of ages will answer this question—to reverend old men, to people distinguished for eminent piety.

The oracles of old were thus delivered by priests dedicated to the service of the God who was supposed to inspire them. The glare of worldly pomp which surrounded these impostors, and the respect paid to them by artful politicians, who knew how to avail themselves of this useful engine to bend the necks of the strong under the dominion of the cunning, spread a sacred mysterious veil of sanctity over their lies and abominations. Impressed by such solemn devotional parade, a Greek, or Roman lady might be excused, if she inquired of the oracle, when she was anxious to pry into futurity, or inquire about some dubious event: and her inquiries, however contrary to reason, could not be reckoned impious.—But, can the professors of Christianity ward off that imputation? Can a Christian suppose that the favourites of the most High, the highly favoured, would be obliged to lurk in disguise, and practise the most dishonest tricks to cheat silly women out of the money—which the poor cry for in vain?

[1] I once lived in the neighbourhood of one of these men, a *handsome* man, and saw with surprise and indignation, women, whose appearance and attendance bespoke that rank in which females are supposed to receive a superior education, flock to his door.

Say not that such questions are an insult to common sense—for it is your own conduct, O ye foolish women! which throws an odium on your sex! And these reflections should make you shudder at your thoughtlessness, and irrational devotion.—For I do not suppose that all of you laid aside your religion, such as it is, when you entered those mysterious dwellings. Yet, as I have throughout supposed myself talking to ignorant women, for ignorant ye are in the most emphatical sense of the word, it would be absurd to reason with you on the egregious folly of desiring to know what the Supreme Wisdom has concealed.

Probably you would not understand me, were I to attempt to shew you that it would be absolutely inconsistent with the grand purpose of life, that of rendering human creatures wise and virtuous: and that, were it sanctioned by God, it would disturb the order established in creation; and if it be not sanctioned by God, do you expect to hear truth? Can events be foretold, events which have not yet assumed a body to become subject to mortal inspection, can they be foreseen by a vicious worldling, who pampers his appetites by preying on the foolish ones?

Perhaps, however, you devoutly believe in the devil, and imagine, to shift the question, that he may assist his votaries; but, if really respecting the power of such a being, an enemy to goodness and to God, can you go to church after having been under such an obligation to him?

From these delusions to those still more fashionable deceptions, practised by the whole tribe of magnetisers,* the transition is very natural. With respect to them, it is equally proper to ask women a few questions.

Do you know any thing of the construction of the human frame? If not, it is proper that you should be told what every child ought to know, that when its admirable oeconomy has been disturbed by intemperance or indolence, I speak not of violent disorders, but of chronical diseases, it must be brought into a healthy state again, by slow degrees, and if the functions of life have not been materially injured, regimen, another word for temperance, air, exercise, and a few medicines, prescribed by persons who have studied the human body, are the only human means, yet discovered, of recovering that inestimable blessing health, that will bear investigation.

Do you then believe that these magnetisers, who, by hocus pocus tricks, pretend to work a miracle, are delegated by God, or assisted by the solver of all these kind of difficulties—the devil?

Do they, when they put to flight, as it is said, disorders that have baffled the powers of medicine, work in conformity to the light of reason? or, do they effect these wonderful cures by supernatural aid?

By a communication, an adept may answer, with the world of spirits. A noble privilege, it must be allowed. Some of the ancients mention familiar daemons, who guarded them from danger by kindly intimating, we cannot guess in what manner, when any danger was nigh; or, pointed out what they ought to undertake. Yet the men who laid claim to this privilege, out of the order of nature, insisted that it was the reward, or consequence, of superiour temperance and piety. But the present workers of wonders are not raised above their fellows by superiour temperance or sanctity. They do not cure for the love of God, but money. These are the priests of quackery, though it is true they have not the convenient expedient of selling masses for souls in purgatory, or churches where they can display crutches, and models of limbs made sound by a touch or a word.

I am not conversant with the technical terms, or initiated into the arcana, therefore, I may speak improperly; but it is clear that men who will not conform to the law of reason, and earn a subsistence in an honest way, by degrees, are very fortunate in becoming acquainted with such obliging spirits. We cannot, indeed, give them credit for either great sagacity or goodness, else they would have chosen more noble instruments, when they wished to shew themselves the benevolent friends of man.

It is, however, little short of blasphemy to pretend to such powers!

From the whole tenour of the dispensations of Providence, it appears evident to sober reason, that certain vices produce certain effects; and can any one so grossly insult the wisdom of God, as to suppose that a miracle will be allowed to disturb his general laws, to restore to health the intemperate and vicious, merely to enable them to pursue the same course with impunity? Be whole, and sin no more, said Jesus.* And, are greater miracles to be performed by

those who do not follow his footsteps, who healed the body to reach the mind?

The mentioning of the name of Christ, after such vile impostors, may displease some of my readers—I respect their warmth; but let them not forget that the followers of these delusions bear his name, and profess to be the disciples of him, who said, by their works we should know who were the children of God or the servants of sin. I allow that it is easier to touch the body of a saint, or to be magnetised, than to restrain our appetites or govern our passions; but health of body or mind can only be recovered by these means, or we make the Supreme Judge partial and revengeful.

Is he a man that he should change, or punish out of resentment? He—the common father, wounds but to heal, says reason, and our irregularities producing certain consequences, we are forcibly shewn the nature of vice; that thus learning to know good from evil, by experience, we may hate one and love the other, in proportion to the wisdom which we attain. The poison contains the antidote; and we either reform our evil habits and cease to sin against our own bodies, to use the forcible language of scripture, or a premature death, the punishment of sin, snaps the thread of life.

Here an awful stop is put to our inquiries.—But, why should I conceal my sentiments? Considering the attributes of God, I believe that whatever punishment may follow, will tend, like the anguish of disease, to shew the malignity of vice, for the purpose of reformation. Positive punishment appears so contrary to the nature of God, discoverable in all his works, and in our own reason, that I could sooner believe that the Deity paid no attention to the conduct of men, than that he punished without the benevolent design of reforming.

To suppose only that an all-wise and powerful Being, as good as he is great, should create a being foreseeing, that after fifty or sixty years of feverish existence, it would be plunged into never ending woe—is blasphemy. On what will the worm feed that is never to die? On folly, on ignorance, say ye—I should blush indignantly at drawing the natural conclusion could I insert it, and wish to withdraw myself from the wing of my God! On such a supposition, I speak with reverence, he would be a consuming fire. We should wish, though vainly, to fly from his presence when fear absorbed love, and darkness involved all his counsels!

I know that many devout people boast of submitting to the Will of God blindly, as to an arbitrary sceptre or rod, on the same principle as the Indians worship the devil. In other words, like people in the common concerns of life, they do homage to power, and cringe under the foot that can crush them. Rational religion, on the contrary, is a submission to the will of a being so perfectly wise, that all he wills must be directed by the proper motive—must be reasonable.

And, if thus we respect God, can we give credit to the mysterious insinuations, which insult his laws? can we believe, though it should stare us in the face, that he would work a miracle to authorize confusion by sanctioning an error? Yet we must either allow these impious conclusions, or treat with contempt every promise to restore health to a diseased body by supernatural means, or to foretell the incidents that can only be foreseen by God.

Section II

Another instance of that feminine weakness of character, often produced by a confined education, is a romantic twist of the mind, which has been very properly termed *sentimental*.

Women subjected by ignorance to their sensations, and only taught to look for happiness in love, refine on sensual feelings, and adopt metaphysical notions respecting that passion, which lead them shamefully to neglect the duties of life, and frequently in the midst of these sublime refinements they plump into actual vice.

These are the women who are amused by the reveries of the stupid novelists, who, knowing little of human nature, work up stale tales, and describe meretricious scenes, all retailed in a sentimental jargon, which equally tend to corrupt the taste, and draw the heart aside from its daily duties. I do not mention the understanding, because never having been exercised, like the lurking particles of fire* which are supposed universally to pervade matter.

Females, in fact, denied all political privileges, and not allowed, as married women, excepting in criminal cases, a civil existence, have their attention naturally drawn from the interest of the whole community to that of the minute parts, though the private duty of any member of society must be very imperfectly performed when not connected with the general good. The mighty business of female life

is to please, and restrained from entering into more important concerns by political and civil oppression, sentiments become events, and reflection deepens what it should, and would have effaced, if the understanding had been allowed to take a wider range.

But, confined to trifling employments, they naturally imbibe opinions which the only kind of reading calculated to interest an innocent frivolous mind, inspires. Unable to grasp any thing great, is it surprising that they find the reading of history a very dry task, and disquisitions addressed to the understanding intolerably tedious, and almost unintelligible? Thus are they necessarily dependent on the novelist for amusement. Yet, when I exclaim against novels, I mean when contrasted with those works which exercise the understanding and regulate the imagination.—For any kind of reading I think better than leaving a blank still a blank, because the mind must receive a degree of enlargement and obtain a little strength by a slight exertion of its thinking powers; besides, even the productions that are only addressed to the imagination, raise the reader a little above the gross gratification of appetites, to which the mind has not given a shade of delicacy.

This observation is the result of experience; for I have known several notable women, and one in particular, who was a very good woman—as good as such a narrow mind would allow her to be, who took care that her daughters (three in number) should never see a novel. As she was a woman of fortune and fashion, they had various masters to attend them, and a sort of menial governess to watch their footsteps. From their masters they learned how tables, chairs, etc. were called in French and Italian; but as the few books thrown in their way were far above their capacities, or devotional, they neither acquired ideas nor sentiments, and passed their time, when not compelled to repeat *words*, in dressing, quarrelling with each other, or conversing with their maids by stealth, till they were brought into company as marriageable.

Their mother, a widow, was busy in the mean time in keeping up her connections, as she termed a numerous acquaintance, lest her girls should want a proper introduction into the great world. And these young ladies, with minds vulgar in every sense of the word, and spoiled tempers, entered life puffed up with notions of their own consequence, and looking down with contempt on those who could not vie with them in dress and parade.

With respect to love, nature, or their nurses, had taken care to teach them the physical meaning of the word; and, as they had few topics of conversation, and fewer refinements of sentiment, they expressed their gross wishes not in very delicate phrases, when they spoke freely, talking of matrimony.

Could these girls have been injured by the perusal of novels? I almost forgot a shade in the character of one of them; she affected a simplicity bordering on folly, and with a simper would utter the most immodest remarks and questions, the full meaning of which she had learned whilst secluded from the world, and afraid to speak in her mother's presence, who governed with a high hand: they were all educated, as she prided herself, in a most exemplary manner; and read their chapters and psalms before breakfast, never touching a silly novel.

This is only one instance; but I recollect many other women who, not led by degrees to proper studies, and not permitted to choose for themselves, have indeed been overgrown children; or have obtained, by mixing in the world, a little of what is termed common sense: that is, a distinct manner of seeing common occurrences, as they stand detached: but what deserves the name of intellect, the power of gaining general or abstract ideas, or even intermediate ones, was out of the question. Their minds were quiescent, and when they were not roused by sensible objects and employments of that kind, they were low-spirited, would cry, or go to sleep.

When, therefore, I advise my sex not to read such flimsy works, it is to induce them to read something superiour; for I coincide in opinion with a sagacious man, who, having a daughter and niece under his care, pursued a very different plan with each.

The niece, who had considerable abilities, had, before she was left to his guardianship, been indulged in desultory reading. Her he endeavoured to lead, and did lead to history and moral essays; but his daughter, whom a fond weak mother had indulged, and who consequently was averse to every thing like application, he allowed to read novels: and used to justify his conduct by saying, that if she ever attained a relish for reading them, he should have some foundation to work upon; and that erroneous opinions were better than none at all.

In fact the female mind has been so totally neglected, that knowledge was only to be acquired from this muddy source, till from

reading novels some women of superiour talents learned to despise them.

The best method, I believe, that can be adopted to correct a fondness for novels is to ridicule them: not indiscriminately, for then it would have little effect; but, if a judicious person, with some turn for humour, would read several to a young girl, and point out both by tones, and apt comparisons with pathetic incidents and heroic characters in history, how foolishly and ridiculously they caricatured human nature, just opinions might be substituted instead of romantic sentiments.

In one respect, however, the majority of both sexes resemble, and equally shew a want of taste and modesty. Ignorant women, forced to be chaste to preserve their reputation, allow their imagination to revel in the unnatural and meretricious scenes sketched by the novel writers of the day, slighting as insipid the sober dignity, and matron graces of history,[1] whilst men carry the same vitiated taste into life, and fly for amusement to the wanton, from the unsophisticated charms of virtue, and the grave respectability of sense.

Besides, the reading of novels makes women, and particularly ladies of fashion, very fond of using strong expressions and superlatives in conversation; and, though the dissipated artificial life which they lead prevents their cherishing any strong legitimate passion, the language of passion in affected tones slips for ever from their glib tongues, and every trifle produces those phosphoric bursts which only mimick in the dark the flame of passion.

Section III

Ignorance and the mistaken cunning that nature sharpens in weak heads as a principle of self-preservation, render women very fond of dress, and produce all the vanity which such a fondness may naturally be expected to generate, to the exclusion of emulation and magnanimity.

I agree with Rousseau that the physical part of the art of pleasing consists in ornaments, and for that very reason I should guard girls

[1] I am not now alluding to that superiority of mind which leads to the creation of ideal beauty, when he, surveyed with a penetrating eye, appears a tragi-comedy, in which little can be seen to satisfy the heart without the help of fancy.

against the contagious fondness for dress so common to weak women, that they may not rest in the physical part. Yet, weak are the women who imagine that they can long please without the aid of the mind, or, in other words, without the moral art of pleasing. But the moral art, if it be not a profanation to use the word art, when alluding to the grace which is an effect of virtue, and not the motive of action, is never to be found with ignorance; the sportiveness of innocence, so pleasing to refined libertines of both sexes, is widely different in its essence from this superiour gracefulness.

A strong inclination for external ornaments ever appears in barbarous states, only the men not the women adorn themselves; for where women are allowed to be so far on a level with men, society has advanced, at least, one step in civilization.

The attention to dress, therefore, which has been thought a sexual propensity, I think natural to mankind. But I ought to express myself with more precision. When the mind is not sufficiently opened to take pleasure in reflection, the body will be adorned with sedulous care; and ambition will appear in tattooing or painting it.

So far is this first inclination carried, that even the hellish yoke of slavery cannot stifle the savage desire of admiration which the black heroes inherit from both their parents, for all the hardly earned savings of a slave are commonly expended in a little tawdry finery. And I have seldom known a good male or female servant that was not particularly fond of dress. Their clothes were their riches; and, I argue from analogy, that the fondness for dress, so extravagant in females, arises from the same cause—want of cultivation of mind. When men meet they converse about business, politics, or literature; but, says Swift, 'how naturally do women apply their hands to each others lappets and ruffles.'* And very natural is it—for they have not any business to interest them, have not a taste for literature, and they find politics dry, because they have not acquired a love for mankind by turning their thoughts to the grand pursuits that exalt the human race, and promote general happiness.

Besides, various are the paths to power and fame which by accident or choice men pursue, and though they jostle against each other, for men of the same profession are seldom friends, yet there is a much greater number of their fellow-creatures with whom they never clash. But women are very differently situated with respect to each other—for they are all rivals.

Before marriage it is their business to please men; and after, with a few exceptions, they follow the same scent with all the persevering pertinacity of instinct. Even virtuous women never forget their sex in company, for they are for ever trying to make themselves *agreeable*. A female beauty, and a male wit, appear to be equally anxious to draw the attention of the company to themselves; and the animosity of contemporary wits is proverbial.

Is it then surprising that when the sole ambition of woman centres in beauty, and interest gives vanity additional force, perpetual rivalships should ensue? They are all running the same race, and would rise above the virtue of mortals, if they did not view each other with a suspicious and even envious eye.

An immoderate fondness for dress, for pleasure, and for sway,* are the passions of savages; the passions that occupy those uncivilized beings who have not yet extended the dominion of the mind, or even learned to think with the energy necessary to concatenate that abstract train of thought which produces principles. And that women from their education and the present state of civilized life, are in the same condition, cannot, I think, be controverted. To laugh at them then, or satirize the follies of a being who is never to be allowed to act freely from the light of her own reason, is as absurd as cruel; for, that they who are taught blindly to obey authority, will endeavour cunningly to elude it, is most natural and certain.

Yet let it be proved that they ought to obey man implicitly, and I shall immediately agree that it is woman's duty to cultivate a fondness for dress, in order to please, and a propensity to cunning for her own preservation.

The virtues, however, which are supported by ignorance must ever be wavering—the house built on sand could not endure a storm. It is almost unnecessary to draw the inference.—If women are to be made virtuous by authority, which is a contradiction in terms, let them be immured in seraglios and watched with a jealous eye.—Fear not that the iron will enter into their souls—for the souls that can bear such treatment are made of yielding materials, just animated enough to give life to the body.

> 'Matter too soft a lasting mark to bear,
> And best distinguish'd by black, brown, or fair.'*

The most cruel wounds will of course soon heal, and they may still people the world, and dress to please man—all the purposes which

certain celebrated writers have allowed that they were created to fulfil.

Section IV

Women are supposed to possess more sensibility, and even humanity, than men, and their strong attachments and instantaneous emotions of compassion are given as proofs; but the clinging affection of ignorance has seldom any thing noble in it, and may mostly be resolved into selfishness, as well as the affection of children and brutes. I have known many weak women whose sensibility was entirely engrossed by their husbands; and as for their humanity, it was very faint indeed, or rather it was only a transient emotion of compassion. Humanity does not consist 'in a squeamish ear,' says an eminent orator. 'It belongs to the mind as well as the nerves.'

But this kind of exclusive affection, though it degrades the individual, should not be brought forward as a proof of the inferiority of the sex, because it is the natural consequence of confined views: for even women of superior sense, having their attention turned to little employments, and private plans, rarely rise to heroism, unless when spurred on by love! and love, as an heroic passion, like genius, appears but once in an age. I therefore agree with the moralist who asserts, 'that women have seldom so much generosity as men;'* and that their narrow affections, to which justice and humanity are often sacrificed, render the sex apparently inferior, especially, as they are commonly inspired by men; but I contend that the heart would expand as the understanding gained strength, if women were not depressed from their cradles.

I know that a little sensibility, and great weakness, will produce a strong sexual attachment, and that reason must cement friendship; consequently, I allow that more friendship is to be found in the male than the female world, and that men have a higher sense of justice. The exclusive affections of women seem indeed to resemble Cato's most unjust love for his country. He wished to crush Carthage,* not to save Rome, but to promote its vain-glory; and, in general, it is to similar principles that humanity is sacrificed, for genuine duties support each other.

Besides, how can women be just or generous, when they are the slaves of injustice?

Section V

As the rearing of children, that is, the laying a foundation of sound health both of body and mind in the rising generation, has justly been insisted on as the peculiar destination of woman, the ignorance that incapacitates them must be contrary to the order of things. And I contend that their minds can take in much more, and ought to do so, or they will never become sensible mothers. Many men attend to the breeding of horses, and overlook the management of the stable, who would, strange want of sense and feeling! think themselves degraded by paying any attention to the nursery; yet, how many children are absolutely murdered by the ignorance of women! But when they escape, and are destroyed neither by unnatural negligence nor blind fondness, how few are managed properly with respect to the infant mind! So that to break the spirit, allowed to become vicious at home, a child is sent to school; and the methods taken there, which must be taken to keep a number of children in order, scatter the seeds of almost every vice in the soil thus forcibly torn up.

I have sometimes compared the struggles of these poor children, who ought never to have felt restraint, nor would, had they been always held in with an even hand, to the despairing plunges of a spirited filly, which I have seen breaking on a strand: its feet sinking deeper and deeper in the sand every time it endeavoured to throw its rider, till at last it sullenly submitted.

I have always found horses, animals I am attached to, very tractable when treated with humanity and steadiness, so that I doubt whether the violent methods taken to break them, do not essentially injure them; I am, however, certain that a child should never be thus forcibly tamed after it had injudiciously been allowed to run wild; for every violation of justice and reason, in the treatment of children, weakens their reason. And, so early do they catch a character, that the base of the moral character, experience leads me to infer, is fixed before their seventh year, the period during which women are allowed the sole management of children. Afterwards it too often happens that half the business of education is to correct, and very imperfectly is it done, if done hastily, the faults, which they would never have acquired if their mothers had had more understanding.

One striking instance of the folly of women must not be omitted.—The manner in which they treat servants in the presence of children, permitting them to suppose that they ought to wait on them, and bear their humours. A child should always be made to receive assistance from a man or woman as a favour; and, as the first lesson of independence, they should practically be taught, by the example of their mother, not to require that personal attendance, which it is an insult to humanity to require, when in health; and instead of being led to assume airs of consequence, a sense of their own weakness should first make them feel the natural equality of man. Yet, how frequently have I indignantly heard servants imperiously called to put children to bed, and sent away again and again, because master or miss hung about mamma, to stay a little longer. Thus made slavishly to attend the little idol, all those most disgusting humours were exhibited which characterize a spoiled child.

In short, speaking of the majority of mothers, they leave their children entirely to the care of servants; or, because they are their children, treat them as if they were little demi-gods, though I have always observed, that the women who thus idolize their children, seldom shew common humanity to servants, or feel the least tenderness for any children but their own.

It is, however, these exclusive affections, and an individual manner of seeing things, produced by ignorance, which keep women for ever at a stand, with respect to improvement, and make many of them dedicate their lives to their children only to weaken their bodies and spoil their tempers, frustrating also any plan of education that a more rational father may adopt; for unless a mother concur, the father who restrains will ever be considered as a tyrant.

But, fulfilling the duties of a mother, a woman with a sound constitution, may still keep her person scrupulously neat, and assist to maintain her family, if necessary, or by reading and conversations with both sexes, indiscriminately, improve her mind. For nature has so wisely ordered things, that did women suckle their children, they would preserve their own health, and there would be such an interval between the birth of each child, that we should seldom see a houseful of babes. And did they pursue a plan of conduct, and not waste their time in following the fashionable vagaries of dress, the management of their household and children need not shut them out from literature, or prevent their attaching themselves to a sci-

ence, with that steady eye which strengthens the mind, or practising one of the fine arts that cultivate the taste.

But, visiting to display finery, card-playing, and balls, not to mention the idle bustle of morning trifling, draw women from their duty to render them insignificant, to render them pleasing, according to the present acceptation of the word, to every man, but their husband. For a round of pleasures in which the affections are not exercised, cannot be said to improve the understanding, though it be erroneously called seeing the world; yet the heart is rendered cold and averse to duty, by such a senseless intercourse, which becomes necessary from habit even when it has ceased to amuse.

But, we shall not see women affectionate till more equality be established in society, till ranks are confounded and women freed, neither shall we see that dignified domestic happiness, the simple grandeur of which cannot be relished by ignorant or vitiated minds; nor will the important task of education ever be properly begun till the person of a woman is no longer preferred to her mind. For it would be as wise to expect corn from tares, or figs from thistles,* as that a foolish ignorant woman should be a good mother.

Section VI

It is not necessary to inform the sagacious reader, now I enter on my concluding reflections, that the discussion of this subject merely consists in opening a few simple principles, and clearing away the rubbish which obscured them. But, as all readers are not sagacious, I must be allowed to add some explanatory remarks to bring the subject home to reason—to that sluggish reason, which supinely takes opinions on trust, and obstinately supports them to spare itself the labour of thinking.

Moralists have unanimously agreed, that unless virtue be nursed by liberty, it will never attain due strength—and what they say of man I extend to mankind, insisting that in all cases morals must be fixed on immutable principles; and, that the being cannot be termed rational or virtuous, who obeys any authority, but that of reason.

To render women truly useful members of society, I argue that they should be led, by having their undertakings cultivated on a large scale, to acquire a rational affection for their country, founded on knowledge, because it is obvious that we are little interested

about what we do not understand. And to render this general knowledge of due importance, I have endeavoured to shew that private duties are never properly fulfilled unless the understanding enlarges the heart; and that public virtue is only an aggregate of private. But, the distinctions established in society undermine both, by beating out the solid gold of virtue, till it becomes only the tinsel-covering of vice; for whilst wealth renders a man more respectable than virtue, wealth will be sought before virtue; and, whilst women's persons are caressed, when a childish simper shews an absence of mind—the mind will lie fallow. Yet, true voluptuousness must proceed from the mind—for what can equal the sensations produced by mutual affection, supported by mutual respect? What are the cold, or feverish caresses of appetite, but sin embracing death, compared with the modest overflowings of a pure heart and exalted imagination? Yes, let me tell the libertine of fancy when he despises understanding in woman—that the mind, which he disregards, gives life to the enthusiastic affection from which rapture, short-lived as it is, alone can flow! And, that, without virtue, a sexual attachment must expire, like a tallow candle in the socket, creating intolerable disgust. To prove this, I need only observe, that men who have wasted great part of their lives with women, and with whom they have sought for pleasure with eager thirst, entertain the meanest opinion of the sex.—Virtue, true refiner of joy!—if foolish men were to fright thee from earth, in order to give loose to all their appetites without a check—some sensual wight of taste would scale the heavens to invite thee back, to give a zest to pleasure!

That women at present are by ignorance rendered foolish or vicious, is, I think, not to be disputed; and, that the most salutary effects tending to improve mankind might be expected from a REVOLUTION in female manners, appears, at least, with a face of probability, to rise out of the observation. For as marriage has been termed the parent of those endearing charities which draw man from the brutal herd, the corrupting intercourse that wealth, idleness, and folly, produce between the sexes, is more universally injurious to morality than all the other vices of mankind collectively considered. To adulterous lust the most sacred duties are sacrificed, because before marriage, men, by a promiscuous intimacy with women, learned to consider love as a selfish gratification—learned to separate it not only from esteem, but from the affection merely built on

habit, which mixes a little humanity with it. Justice and friendship are also set at defiance, and that purity of taste is vitiated which would naturally lead a man to relish an artless display of affection rather than affected airs. But that noble simplicity of affection, which dares to appear unadorned, has few attractions for the libertine, though it be the charm, which by cementing the matrimonial tie, secures to the pledges of a warmer passion the necessary parental attention; for children will never be properly educated till friendship subsists between parents. Virtue flies from a house divided against itself—and a whole legion of devils take up their residence there.

The affection of husbands and wives cannot be pure when they have so few sentiments in common, and when so little confidence is established at home, as must be the case when their pursuits are so different. That intimacy from which tenderness should flow, will not, cannot subsist between the vicious.

Contending, therefore, that the sexual distinction which men have so warmly insisted upon, is arbitrary, I have dwelt on an observation, that several sensible men, with whom I have conversed on the subject, allowed to be well founded; and it is simply this, that the little chastity to be found amongst men, and consequent disregard of modesty, tend to degrade both sexes; and further, that the modesty of women, characterized as such, will often be only the artful veil of wantonness instead of being the natural reflection of purity, till modesty be universally respected.

From the tyranny of man, I firmly believe, the greater number of female follies proceed; and the cunning, which I allow makes at present a part of their character, I likewise have repeatedly endeavoured to prove, is produced by oppression.

Were not dissenters, for instance, a class of people, with strict truth, characterized as cunning? And may I not lay some stress on this fact to prove, that when any power but reason curbs the free spirit of man, dissimulation is practised, and the various shifts of art are naturally called forth? Great attention to decorum, which was carried to a degree of scrupulosity, and all that puerile bustle about trifles and consequential solemnity, which Butler's caricature of a dissenter,* brings before the imagination, shaped their persons as well as their minds in the mould of prim littleness. I speak collectively, for I know how many ornaments to human nature have been enrolled amongst sectaries; yet, I assert, that the same narrow preju-

dice for their sect, which women have for their families, prevailed in the dissenting part of the community, however worthy in other respects; and also that the same timid prudence, or headstrong efforts, often disgraced the exertions of both. Oppression thus formed many of the features of their character perfectly to coincide with that of the oppressed half of mankind; for is it not notorious that dissenters were, like women, fond of deliberating together, and asking advice of each other, till by a complication of little contrivances, some little end was brought about? A similar attention to preserve their reputation was conspicuous in the dissenting and female world, and was produced by a similar cause.

Asserting the rights which women in common with men ought to contend for, I have not attempted to extenuate their faults; but to prove them to be the natural consequence of their education and station in society. If so, it is reasonable to suppose that they will change their character, and correct their vices and follies, when they are allowed to be free in a physical, moral, and civil sense.[1]

Let woman share the rights and she will emulate the virtues of man, for she must grow more perfect when emancipated, or justify the authority that chains such a weak being to her duty.——If the latter, it will be expedient to open a fresh trade with Russia for whips;* a present which a father should always make to his son-in-law on his wedding day, that a husband may keep his whole family in order by the same means; and without any violation of justice reign, wielding this sceptre, sole master of his house, because he is the only being in it who has reason:—the divine, indefeasible earthly sovereignty breathed into man by the Master of the universe. Allowing this position, women have not any inherent rights to claim; and, by the same rule, their duties vanish, for rights and duties are inseparable.

Be just then, O ye men of understanding! and mark not more severely what women do amiss, than the vicious tricks of the horse or the ass for whom ye provide provender—and allow her the privileges of ignorance, to whom ye deny the rights of reason, or ye will be worse than Egyptian task-masters, expecting virtue where nature has not given understanding!

[1] I had further enlarged on the advantages which might reasonably be expected to result from an improvement in female manners, towards the general reformation of society; but it appeared to me that such reflections would more properly close the last volume.*

An Historical and Moral View of the
Origin and Progress of the
French Revolution

BOOK I, CHAPTER I

When we contemplate the infancy of man, his gradual advance towards maturity, his miserable weakness as a solitary being, and the crudeness of his first notions respecting the nature of civil society, it will not appear extraordinary, that the acquirement of political knowledge has been so extremely slow; or that public happiness has not been more rapidly and generally diffused.

The perfection attained by the ancients, it is true, has ever afforded the imagination of the poetical historian a theme to deck with the choicest flowers of rhetoric; though the cool investigation of facts seems clearly to prove, that the civilization of the world, hitherto, has consisted rather in cultivating the taste, than in exercising the understanding. And were not these vaunted improvements also confined to a small corner of the globe, whilst, the political view of the wisest legislators seldom extending beyond the splendour and aggrandizement of their individual nation, they trampled with a ferocious affectation of patriotism on the most sacred rights of humanity? When the arts flourished in Greece, and literature began to shed it's blandishments on society, the world was mostly inhabited by barbarians, who waged eternal war with their more polished neighbours, the imperfection of whose government sapping it's foundation, the science of politics necessarily received a check in the bud—and when we find, likewise, the roman empire crumbling into atoms, from the germ of a deadly malady implanted in it's vitals; whilse voluptuousness stopped the progress of civilization, which makes the perfection of the arts the dawn of science; we shall be convinced, that it demanded ages of improving reason and experience in moral philosophy, to clear away the rubbish, and exhibit the first principles of social order.

We have probably derived our great superiority over those nations from the discovery of the polar attraction of the needle, the perfection which astronomy and mathematics have attained, and the fortunate invention of printing. For, whilst the revival of letters has added the collected wisdom of antiquity to the improvements of modern research, the latter most useful art has rapidly multiplied copies of the productions of genius and compilations of learning,

bringing them within the reach of all ranks of men: the scientific discoveries also have not only led us to new worlds; but, facilitating the communication between different nations, the friction of arts and commerce have given to society the transcendently pleasing polish of urbanity; and thus, by a gradual softening of manners, the complexion of social life has been completely changed. But the remains of superstition, and the unnatural distinction of privileged classes, which had their origin in barbarous folly, still fettered the opinions of man, and sullied his native dignity; till several distinguished english writers discussed political subjects with the energy of men, who began to feel their strength; and, whilst only a rumour of these sentiments roused the attention and exercised the minds of some men of letters in France, a number of staunch disputants, who had more thoroughly digested them, fled from oppression, to put them to the test of experience in America.

Locke, following the track of these bold thinkers, recommended in a more methodical manner religious toleration, and analyzed the principles of civil liberty:* for in his definition of liberty we find the elements of *The Declaration of the Rights of Man*,* which, in spite of the fatal errours of ignorance, and the perverse obstinacy of selfishness, is now converting sublime theories into practical truths.

The revolution, it is true, soon introduced the corruption, that has ever since been corroding british freedom.—Still, when the rest of Europe groaned under the weight of the most unjust and cruel laws, the life and property of englishmen were comparatively safe; and, if an impress-warrant* respected the distinction of ranks, when the glory of England was at stake, splendid victories hid this flaw in the best existing constitution; and all exultingly recollected, that the life or liberty of a man never depended on the will of an individual.

Englishmen were then, with reason, proud of their constitution; and, if this noble pride have degenerated into arrogance, when the cause became less conspicuous, it is only a venial lapse of human nature; to be lamented merely as it stops the progress of civilization, and leads the people to imagine, that their ancestors have done every thing possible to secure the happiness of society, and meliorate the condition of man, because they have done much.

When learning was confined to a small number of the citizens of a state, and the investigation of it's privileges was left to a number still smaller, governments seem to have acted, as if the people were

formed only for them; and, ingeniously confounding their rights with metaphysical jargon, the luxurious grandeur of individuals has been supported by the misery of the bulk of their fellow creatures, and ambition gorged by the butchery of millions of innocent victims.

The most artful chain of despotism has ever been supported by false notions of duty, enforced by those who were to profit by the cheat. Thus has the liberty of man been restrained; and the spontaneous flow of his feelings, which would have fertilized his mind, being choked at the source, he is rendered in the same degree unhappy as he is made unnatural. Yet, certain opinions, planted by superstition and despotism, hand in hand, have taken such deep root in our habits of thinking, it may appear daringly licentious, as well as presumptuous, to observe, that what is often termed virtue, is only want of courage to throw off prejudices, and follow the inclinations which fear not the eye of heaven, though they shrink from censure not founded on the natural principles of morality. But at no period has the scanty diffusion of knowledge permitted the body of the people to participate in the discussion of political science; and if philosophy at length have simplified the principles of social union, so as to render them easy to be comprehended by every sane and thinking being; it appears to me, that man may contemplate with benevolent complacency and becoming pride, the approaching reign of reason and peace.

Besides, if men have been rendered unqualified to judge with precision of their civil and political rights, from the involved state in which sophisticating ignorance has placed them, and thus reduced to surrender their reasoning powers to noble fools, and pedantic knaves, it is not surprizing, that superficial observers have formed opinions unfavourable to the degree of perfection, which our intellectual faculties are able to attain, or that despotism should attempt to check the spirit of inquiry, which, with colossian strides, seems to be hastening the overthrow of oppressive tyranny and contumelious ambition.

Nature having made men unequal, by giving stronger bodily and mental powers to one than to another, the end of government ought to be, to destroy this inequality by protecting the weak. Instead of which, it has always leaned to the opposite side, wearing itself out by disregarding the first principle of it's organization.

It appears to be the grand province of government, though scarcely acknowledged, so to hold the balance, that the abilities or riches of individuals may not interfere with the equilibrium of the whole. For, as it is vain to expect, that men should master their passions during the heat of action, legislators should have this perfection of laws ever in view, when, calmly grasping the interest of humanity, reason assures them, that their own is best secured by the security of the commonwealth. The first social systems were certainly founded by passion; individuals wishing to fence round their own wealth or power, and make slaves of their brothers to prevent encroachment. Their descendants have ever been at work to solder the chains they forged, and render the usurpations of strength secure, by the fraud of partial laws; laws that can be abrogated only by the exertions of reason, emancipating mankind, by making government a science, instead of a craft, and civilizing the grand mass, by exercising their understandings about the most important objects of inquiry.

After the revolution in 1688, however, political questions were no longer discussed in England on a broad scale; because that degree of liberty was enjoyed, which enabled thinking men to pursue without interruption their own business; or, if some men complained, they attached themselves to a party, and descanted on the unavoidable misery produced by contending passions.

But in France the bitterness of oppression was mingled in the daily cup, and the serious folly of superstition, pampered by the sweat of labour, stared every man of sense in the face. Against superstition then did the writers contending for civil liberty principally direct their force, though the tyranny of the court increased with it's viciousness.

Voltaire leading the way,* and ridiculing with that happy mixture of satire and gaiety, calculated to delight the french, the inconsistent puerilities of a puppet-show religion, had the art to attach the bells to the fool's cap, which tinkled on every side, rousing the attention and piquing the vanity of his readers. Rousseau also ranged himself on the same side; and, praising his fanciful state of nature, with that interesting eloquence, which embellishes reasoning with the charms of sentiment, forcibly depicted the evils of a priest-ridden society, and the sources of oppressive inequality,* inducing the men who were charmed with his language to consider his opinions.

The talents of these two writers were particularly formed to effect a change in the sentiments of the french, who commonly read to collect a fund for conversation; and their biting retorts, and flowing periods, were retained in each head, and continually slipped off the tongue in numerous sprightly circles.

In France, indeed, new opinions fly from mouth to mouth, with an electrical velocity, unknown in England; so that there is not such a difference between the sentiments of the various ranks in one country, as is observable in the originality of character to be found in the other. At our theatres, the boxes, pit, and galleries, relish different scenes; and some are condescendingly born by the more polished part of the audience, to allow the rest to have their portion of amusement. In France, on the contrary, a highly wrought sentiment of morality, probably rather romantic than sublime, produces a burst of applause, when one heart seems to agitate every hand.

But men are not content merely to laugh at oppression, when they can scarcely catch from his gripe the necessaries of life; so that from writing epigrams on superstition, the galled french began to compose philippics against despotism. The enormous and iniquitous taxes, which the nobles, the clergy, and the monarch, levied on the people, turned the attention of benevolence to this main branch of government, and the profound treatise of the humane M. Quesnai produced the sect of the *economists*,* the first champions for civil liberty.

On the eve of the american war, the enlightened administration of the comptroller general Turgot,* a man formed in this school, afforded France a glimpse of freedom, which, streaking the horizon of despotism, only served to render the contrast more striking. Eager to correct abuses, equally impolitic and cruel, this most excellent man, suffering his clear judgment to be clouded by his zeal, rouzed the nest of wasps, that rioted on the honey of industry in the sunshine of court favour; and he was obliged to retire from the office, which he so worthily filled. Disappointed in his noble plan of freeing France from the fangs of despotism, in the course of ten years, without the miseries of anarchy, which make the present generation pay very dear for the emancipation of posterity, he has nevertheless greatly contributed to produce that revolution in opinion, which, perhaps, alone can overturn the empire of tyranny.

The idle caprices of an effeminate court had long given the tone to the awe-struck populace, who, stupidly admiring what they did not understand, lived on a *vive le roi*, whilst his blood-sucking minions drained every vein, that should have warmed their honest hearts.

But the irresistible energy of the moral and political sentiments of half a century, at last kindled into a glaze the illuminating rays of truth, which, throwing new light on the mental powers of man, and giving a fresh spring to his reasoning faculties, completely undermined the strong holds of priestcraft and hypocrisy.

At this glorious era, the toleration of religious opinions in America, which the spirit of the times, when that continent was peopled with persecuted europeans, produced, aided, not a little, to diffuse these rational sentiments, and exhibited the phenomenon of a government established on the basis of reason and equality. The eyes of all Europe were watchfully fixed on the practical success of this experiment in political science; and whilst the crowns of the old world were drawing into their focus the hard-earned recompence of the toil and care of the simple citizens, who lived detached from courts, deprived of the comforts of life, the just reward of industry, or, palsied by oppression, pined in dirt and idleness; the anglo-americans appeared to be another race of beings, men formed to enjoy the advantages of society, and not merely to benefit those who governed; the use to which they had been appropriated in almost every state; considered only as the ballast which keeps the vessel steady, necessary, yet despised. So conspicuous in fact was the difference, that, when frenchmen became the auxiliaries of those brave people, during their noble struggle against the tyrannical and inhuman ambition of the british court, it imparted to them that stimulus, which alone was wanting to give wings to freedom, who, hovering over France, led her indignant votaries to wreak their vengeance on the tottering fabric of a government, the foundation of which had been laid by benighted ignorance, and it's walls cemented by the calamities of millions that mock calculation—and, in it's ruins a system was entombed, the most baneful to human happiness and virtue.

America fortunately found herself in a situation very different from all the rest of the world; for she had it in her power to lay the first stones of her government, when reason was venturing to can-

vass prejudice. Availing herself of the degree of civilization of the world, she has not retained those customs, which were only the expedients of barbarism; or thought that constitutions formed by chance, and continually patched up, were superiour to the plans of reason, at liberty to profit by experience.

When society was first regulated, the laws could not be adjusted so as to take in the future conduct of it's members, because the faculties of man are unfolded and perfected by the improvements made by society: consequently the regulations established as circumstances required were very imperfect. What then is to hinder man, at each epoch of civilization, from making a stand, and new modelling the materials, that have been hastily thrown into a rude mass, which time alone has consolidated and rendered venerable?

When society was first subjugated to laws, probably by the ambition of some, and the desire of safety in all, it was natural for men to be selfish, because they were ignorant how intimately their own comfort was connected with that of others; and it was also very natural, that humanity, rather the effect of feeling than of reason, should have a very limited range. But, when men once see, clear as the light of heaven,—and I hail the glorious day from afar!—that on the general happiness depends their own, reason will give strength to the fluttering wings of passion, and men will '*do unto others, what they wish they should do unto them.*'*

What has hitherto been the political perfection of the world? In the two most celebrated nations it has only been a polish of manners, an extension of that family love, which is rather the effect of sympathy and selfish passions, than reasonable humanity. And in what has ended their so much extolled patriotism? In vain glory and barbarity—every page of history proclaims. And why has the enthusiasm for virtue thus passed away like the dew of the morning, dazzling the eyes of it's admirers? Why?—because it was factitious virtue.

During the period they had to combat against oppression, and rear an infant state, what instances of heroism do not the annals of Greece and Rome display! But it was merely the blaze of passion, 'live smoke;' for after vanquishing their enemies, and making the most astonishing sacrifices to the glory of their country, they became civil tyrants, and preyed on the very society, for whose welfare it was easier to die, than to practise the sober duties of life, which insinuate through it the contentment that is rather felt than seen. Like the

parents who forgot all the dictates of justice and humanity, to aggrandize the very children whom they keep in a state of dependence, these heroes loved their country, because it was their country, ever showing by their conduct, that it was only a part of a narrow love of themselves.

It is time, that a more enlightened moral love of mankind should supplant, or rather support physical affections. It is time, that the youth approaching manhood should be led by principles, and not hurried along by sensations—and then we may expect, that the heroes of the present generation, still having their monsters to cope with, will labour to establish such rational laws throughout the world, that men will not rest in the dead letter, or become artificial beings as they become civilized.

We must get entirely clear of all the notions drawn from the wild traditions of original sin: the eating of the apple, the theft of Prometheus, the opening of Pandora's box, and the other fables, too tedious to enumerate, on which priests have erected their tremendous structures of imposition, to persuade us, that we are naturally inclined to evil: we shall then leave room for the expansion of the human heart, and, I trust, find, that men will insensibly render each other happier as they grow wiser. It is indeed the necessity of stifling many of it's most spontaneous desires, to obtain the factitious virtues of society, that makes man vicious, by depriving him of that dignity of character, which rests only on truth. For it is not paradoxical to assert, that the social virtues are nipt in the bud by the very laws of society. One principal of action is sufficient—Respect thyself—whether it be termed fear of God—religion; love of justice—morality; or, self-love—the desire of happiness. Yet, how can a man respect himself; and if not, how believe in the existence of virtue; when he is practising the daily shifts, which do not come under the cognisance of the law, in order to obtain a respectable situation in life? It seems, in fact, to be the business of a civilized man, to harden his heart, that on it he may sharpen the wit; which, assuming the appellation of sagacity, or cunning, in different characters, is only a proof, that the head is clear, because the heart is cold.

Besides, one great cause of misery in the present imperfect state of society is, that the imagination, continually tantalized, becomes the inflated wen of the mind, draining off the nourishment from the vital parts. Nor would it, I think, be stretching the inference too far,

to insist, that men become vicious in the same proportion as they are obliged, by the defects of society, to submit to a kind of self-denial, which ignorance, not morals, prescribes.

But these evils are passing away; a new spirit has gone forth, to organise the body-politic; and where is the criterion to be found, to estimate the means, by which the influence of this spirit can be confined, now enthroned in the hearts of half the inhabitants of the globe? Reason has, at last, shown her captivating face, beaming with benevolence; and it will be impossible for the dark hand of despotism again to obscure it's radiance, or the lurking dagger of subordinate tyrants to reach her bosom. The image of God implanted in our nature is now more rapidly expanding; and, as it opens, liberty with maternal wing seems to be soaring to regions far above vulgar annoyance, promising to shelter all mankind.

It is a vulgar errour, built on a superficial view of the subject, though it seems to have the sanction of experience, that civilization can only go as far as it has hitherto gone, and then must necessarily fall back into barbarism. Yet thus much appears certain, that a state will infallibly grow old and feeble, if hereditary riches support hereditary rank, under any description. But when courts and primogeniture are done away, and simple equal laws are established, what is to prevent each generation from retaining the vigour of youth?— What can weaken the body or mind, when the great majority of society must exercise both, to earn a subsistence, and acquire respectability?

The french revolution is strong proof how far things will govern men, when simple principles begin to act with one powerful spring against the complicated wheels of ignorance; numerous in proportion to their weakness, and constantly wanting repair, because expedients of the moment are ever the spawn of cowardly folly, or the narrow calculations of selfishness. To elucidate this truth, it is not necessary to rake among the ashes of barbarous ambition; to show the ignorance and consequent folly of the monarchs, who ruled with a rod of iron, when the hordes of european savages began to form their governments; though the review of this portion of history would clearly prove, that narrowness of mind naturally produces ferociousness of temper.

We may boast of the poetry of those ages, and of those charming flights of imagination, which, during the paroxysms of passion, flash out in those single acts of heroic virtue, that throw a lustre over a

whole thoughtless life; but the cultivation of the understanding, in spite of these northern lights, appears to be the only way to tame men, whose restlessness of spirit creates the vicious passions, that lead to tyranny and cruelty. When the body is strong, and the blood warm, men do not like to think, or adopt any plan of conduct, unless broken-in by degrees: the force that has often spent itself in fatal activity becomes a rich source of energy of mind.

Men exclaim, only noticing the evil, against the luxury introduced with the arts and sciences; when it is obviously the cultivation of these alone, emphatically termed the arts of peace, that can turn the sword into a ploughshare. War is the adventure naturally pursued by the idle, and it requires something of this species, to excite the strong emotions necessary to rouse inactive minds. Ignorant people, when they appear to reflect, exercise their imagination more than their understanding; indulging reveries, instead of pursuing a train of thinking; and thus grow romantic, like the croisaders; or like women, who are commonly idle and restless.

If we turn then with disgust from ensanguined regal pomp, and the childish raree-shows* that amuse the enslaved multitude, we shall feel still more contempt for the order of men, who cultivated their faculties, only to enable them to consolidate their power, by leading the ignorant astray; making the learning they concentrated in their cells, a more polished instrument of oppression. Struggling with so many impediments, the progress of useful knowledge for several ages was scarcely perceptible; though respect for the public opinion, that great softner of manners, and only substitute for moral principles, was gaining ground.

The croisades, however, gave a shake to society, that changed it's face; and the spirit of chivalry, assuming a new character during the reign of the gallant Francis the first,* began to meliorate the ferocity of the ancient gauls and franks. The *point d'honneur* being settled, the character of a *gentleman*, held ever since so dear in France, was gradually formed; and this kind of bastard morality, frequently the only substitute for all the ties that nature has rendered sacred, kept those men within bounds, who obeyed no other law.

The same spirit mixed with the sanguinary treachery of the Guises,* and gave support to the manly dignity of Henry the fourth,* on whom nature had bestowed that warmth of constitution, tenderness of heart, and rectitude of understanding, which naturally

produce an energetic character—A supple force, that, exciting love, commands esteem.

During the ministry of Richelieu,* when the dynasty of *favouritism* commenced, the arts were patronized, and the italian mode of governing by intrigue tended to weaken bodies, polished by the friction of continual finesse. Dissimulation imperceptibly slides into falshood, and Mazarin,* dissimulation personified, paved the way for the imposing pomp and false grandeur of the reign of the haughty and inflated Louis 14th;* which, by introducing a taste for majestic frivolity, accelerated the perfection of that species of civilization, which consists in the refining of the senses at the expence of the heart; the source of all real dignity, honour, virtue, and every noble quality of the mind. Endeavouring to make bigotry tolerate voluptuousness, and honour and licentiousness shake hands, sight was lost of the line of distinction, or vice was hid under the mask of it's correlative virtue. The glory of France, a bubble raised by the heated breath of the king, was the pretext for undermining happiness; whilst politeness took place of humanity, and created that sort of dependance, which leads men to barter their corn and wine, for unwholesome mixtures of they know not what, that, flattering a depraved appetite, destroy the tone of the stomach.

The feudal taste for tournaments and martial feasts was now naturally succeeded by a fondness for theatrical entertainments; when feats of valour became too great an exertion of the weakened muscles to afford pleasure, and men found that resource in cultivation of mind, which renders activity of body less necessary too keep the stream of life from stagnating.

All the pieces written at this period, except Moliere's,* reflected the manners of the court, and thus perverted the forming taste. That extraordinary man alone wrote on the grand scale of human passions, for mankind at large, leaving to inferiour authors the task of imitating the drapery of manners, which points out the *costume* of the age.

Corneille,* like our Dryden,* often tottering on the brink of absurdity and nonsense, full of noble ideas, which, crouding indistinctly on his fancy, he expresses obscurely, still delights his readers by sketching faint outlines of gigantic passions; and, whilst the charmed imagination is lured to follow him over enchanted ground,

the heart is sometimes unexpectedly touched by a sublime or pathetic sentiment, true to nature.

Racine,* soon after, in elegant harmonious language painted the manners of his time, and with great judgment gave a picturesque cast to many unnatural scenes and factitious sentiments: always endeavouring to make his characters amiable, he is unable to render them dignified; and the refined morality, scattered throughout, belongs to the code of politeness rather than to that of virtue.[1] Fearing to stray from courtly propriety of behaviour, and shock a fastidious audience, the gallantry of his heroes interests only the gallant, and literary people, whose minds are open to different species of amusement. He was, in fact, the father of the french stage. Nothing can equal the fondness which the french suck in with their milk for public places, particularly the theatre; and this taste, giving the tone to their conduct, has produced so many stage tricks on the grand theatre of the nation, where old principles vamped up with new scenes and decorations, are continually represented.

Their national character is, perhaps, more formed by their theatrical amusements, than is generally imagined: they are in reality the schools of vanity. And, after this kind of education, is it surprising, that almost every thing is said and done for stage effect? or that cold declamatory extasies blaze forth, only to mock the expectation with a show of warmth?

Thus sentiments spouted from the lips come oftner from the head than the heart. Indeed natural sentiments are only the characters given by the imagination to recollected sensations; but the french, by the continual gratification of their senses, stifle the reveries of their imagination, which always requires to be acted upon by outward objects; and seldom reflecting on their feelings, their sensations are ever lively and transitory; exhaled by every passing beam, and dissipated by the slightest storm.

If a relish for the broad mirth of *fun* characterize the lower class of english, the french of every denomination are equally delighted with a phosphorical, sentimental gilding. This is constantly observable at the theatres. The passions are deprived of all their radical strength, to give smoothness to the ranting sentiments, which, with mock

[1] What else could be expected from the courtier, who could write in these terms to madame de Maintenon: *God has been so gracious to me, madam, that, in whatever company I find myself, I never have occasion to blush for the gospel or the king.*

dignity, like the party-coloured rags on the shrivelled branches of the tree of liberty, stuck up in every village, are displayed as something very grand and significant.

The wars of Louis* were, likewise, theatrical exhibitions; and the business of his life was adjusting ceremonials, of which he himself became the dupe, when his grandeur was in the wane, and his animal spirits were spent.[1] But, towards the close even of his reign, the writings of Fénélon, and the conversation of his pupil, the duke of Burgundy,* gave rise to different political discussions, of which the theoretical basis was the happiness of the people—till death, spreading a huge pall over the family and glory of Louis, compassion draws his faults under the same awful canopy, and we sympathize with the man in adversity, whose prosperity was pestiferous.

Louis, by imposing on the senses of his people, gave a new turn to the chivalrous humour of the age: for, with the true spirit of quixotism, the french made a point of honour of adoring their king; and the glory of the *grand monarque* became the national pride, even when it cost them most dear.

As a proof of the perversion of mind at that period, and the false political opinions which prevailed, making the unhappy king the slave of his own despotism, it is sufficient to select one anecdote.

A courtier assures us,[2] that the most humiliating circumstance that ever happened to the king, and one of those which gave him most pain, was the publication of a memorial circulated with great diligence by his enemies throughout France. In this memorial the allies invited the french to demand the assembling of their ancient *states-general.** They tell them, 'that the ambition and pride of the king were the only causes of the wars during his reign; and that, to secure themselves a lasting peace, it was incumbent on them not to lay down their arms till the states-general were convoked.'*

It almost surpasses belief to add, that, in spite of the imprisonment, exile, flight, or execution of two millions of french, this memorial produced little effect. But the king, who was severely hurt, took care to have a reply written;[3]* though he might have comforted

[1] For example, the reception of a portuguese adventurer, under the character of a persian ambassador. A farce made by the court to rouze the blunted senses of the king.

[2] Mémoires du maréchal de Richelieu.

[3] In this reply will be found many of the reasons, that have been lately repeated; and some (a proof of the progress of reason), which no one had the audacity to repeat, when standing up in defence of privileges.

himself with the recollection, that, when they were last assembled, Louis XIII dismissed them with empty promises,* forgotten as soon as made.

The enthusiasm of the french, which, in general, hurries them from one extreme to another, at this time produced a total change of manners.

During the regency,* vice was not only barefaced, but audacious; and the tide completely turned: the hypocrites were now all ranged on the other side, the courtiers, labouring to show their abhorrence of religious hypocrisy, set decency at defiance, and did violence to the modesty of nature, when they wished to outrage the squeamish puerilities of superstition.

In the character of the regent we may trace all the vices and graces of false refinement; forming the taste by destroying the heart. Devoted to pleasure, he so soon exhausted the intoxicating cup of all it's sweets, that his life was spent in searching amongst the dregs, for the novelty that could give a gasp of life to enjoyment. The wit, which at first was the zest of his nocturnal orgies, soon gave place, as flat, to the grossest excesses, in which the principal variety was flagitious immorality. And what has he done to rescue his name from obloquy, but protect a few debauched artists and men of letters? His goodness of heart only appeared in sympathy. He pitied the distresses of the people, when before his eyes; and as quickly forgot these yearnings of heart in his sensual stye.

He often related, with great pleasure, an anecdote of the prior de Vendôme,* who chanced to please a mistress of Charles II, and the king could only get rid of his rival by requesting Louis XIV to recall him.

At those moments he would bestow the warmest praises on the english constitution; and seemed enamoured of liberty, though authorising at the time the most flagrant violations of property, and despotic arts of cruelty. The only good he did his country[1] arose from this frivolous circumstance; for introducing the fashion of admiring the english, he led men to read and translate some of their masculine writers, which greatly contributed to rouse the sleeping

[1] It is well known that for a long time he wished to convoke the states-general; and it was not without difficulty, that Dubois made him abandon this design. During the year 1789, a curious memorial* has been reprinted, which he wrote on this occasion; and it is, like the author, a model of impudence.

manhood of the french. His love of the fine arts, however, has led different authors to strew flowers over his unhallowed dust—fit emblem of the brilliant qualities, that ornamented only the soil on which they grew.

The latter part of the reign of Louis XV is notorious for the same atrocious debaucheries, unvarnished by wit, over which modesty would fain draw a veil, were it not necessary to give the last touches to the portrait of that vile despotism, under the lash of which twenty-five millions of people groaned; till, unable to endure the increasing weight of oppression, they rose like a vast elephant, terrible in his anger, treading down with blind fury friends as well as foes.

Impotence of body, and indolence of mind, rendered Louis XV the slave of his mistresses, who fought to forget his nauseous embraces in the arms of knaves, who found their account in caressing them. Every corner of the kingdom was ransacked to satiate these cormorants, who wrung the very bowels of industry, to give a new edge to sickly appetites; corrupting the morals whilst breaking the spirit of the nation.

BOOK I, CHAPTER II

During this general depravation of manners, the young and beautiful *dauphine** arrived; and was received with a kind of idolatrous adoration, only to be seen in France; for the inhabitants of the metropolis, literally speaking, could think and talk of nothing else; and in their eagerness to pay homage, or gratify affectionate curiosity, an immense number were killed.

In such a voluptuous atmosphere, how could she escape contagion? The profligacy of Louis XIV, when love and war were his amusements, was soberness, compared with the capricious intemperance of the inebriated imagination at this period. Madame du Barry* was then in the zenith of her power, which quickly excited the jealousy of this princess, whose strongest passion was that intolerable family pride, which heated the blood of the whole house of Austria. An inclination for court intrigue, under the mask of the most profound dissimulation, to preserve the favour of Louis XV, was instantly called into action; and it soon became the only business

of her life, either to gratify resentment, or cheat the satiety, which the continual and unrestrained indulgence of pleasure produced.

Her character thus formed, when she became absolute mistress, the court of the passive Louis,* not only the most dissolute and abandoned that ever displayed the folly of royalty, but audaciously negligent with respect to that attention to decency, which is necessary to delude the vulgar, was deserted by all persons, who had any regard for their moral character, or the decorum of appearances. Constrained by the *etiquette*, which made the principal part of the imposing grandeur of Louis XIV, the queen wished to throw aside the cumbersome brocade of ceremony, without having discernment enough to perceive, that it was necessary to lend mock dignity to a court, where there was not sufficient virtue, or native beauty, to give interest or respectability to simplicity. The harlot is seldom such a fool as to neglect her meretricious ornaments, unless she renounces her trade; and the pageantry of courts is the same thing on a larger scale. The lively predilection, likewise, of the queen for her native country, and love for her brother Joseph,* to whom she repeatedly sent considerable sums, purloined from the public, tended greatly to inspire the most ineffable contempt for royalty, now stript of the frippery which had concealed it's deformity: and the sovereign disgust excited by her ruinous vices, completely destroying all reverence for that majesty, to which power alone lent dignity, contempt soon produced hatred.

The infamous transaction of the necklace, in which she was probably the dupe of the knaves she fostered, exasperated also both the nobility and the clergy; and, with her messalinian feasts at *Trianon*,* made her the common mark of ridicule and satire.

The attention of the people once roused was not permitted to sleep; for fresh cirumstances daily occurred, to give a new spring to discussions, that the most iniquitous and heavy taxes brought home to every bosom; till the extravagance of the royal family became the general subject of sharpening execrations.

The king, who had not sufficient resolution to support the administration of Turgot, whom his disposition for moderation had chosen, being at a loss what measures to take, called to the helm the plausible Necker. He, only half comprehending the plans of his able predecessor, was led by his vanity cautiously to adopt them; first publishing his *Comte-rendu*,* to clear the way to popularity. This

work was read with astonishing rapidity by all ranks of men; and alarming the courtiers, Necker was, in his turn, dismissed. He retired to write his observations on the administration of the finances, which kept alive the spirit of inquiry, that afterwards broke the talisman of courts, and showed the disenchanted multitude, that those, whom they had been taught to respect as supernatural beings, were not indeed men—but monsters; deprived by their station of humanity, and even sympathy.

Several abortive attempts were then made by two succeeding ministers, to keep alive public credit, and find resources to supply the expenditure of the state, and the dissipation of the court, when the king was persuaded to place the specious Calonne* at the head of these embarrassed affairs.

During the prodigal administration of this man, who acted with an audacity peculiar to the arrogance common in men of superficial yet brilliant talents, every consideration was sacrificed to the court; the splendid folly and wanton prodigality of which eclipsing all that has been related in history, or told in romance, to amuse wondering fools, only served to accelerate the destruction of public credit, and hasten the revolution, by exciting the clamourous indignation of the people. Numberless destructive expedients of the moment brought money into the state coffers, only to be dissipated by the royal family, and it's train of parasites; till all failing, the wish of still supporting himself in a situation so desirable as that of comptroller general of the finances, determined him to convene an assembly of *notables*:* whose very appellation points them out as men in the aristocratical interest.

Louis XVI, with a considerable portion of common sense, and a desire to promote useful reformation, though always governed by those around him, gave without hesitation the necessary orders for calling together the assembly, that afforded the wearied nation the most pleasing prospect, because it was a new one; but conveyed to their astonished minds at the same time the knowledge of the enormity of a *deficit*, which a series of vice and folly had augmented beyond all precedent.

The immoralities of Calonne, however, had created a general distrust of all his designs: but with an overweening presumption, the characteristic of the man, he still thought, that he could dexterously obtain the supplies wanted to keep the wheels of government in

motion, and quiet the clamours of the nation, by proposing the equalization of taxes; which, humbling the nobility and dignified clergy, who were thus to be brought down from their privileged height, to the level of citizens, could not fail to be grateful to the rest of the nation. And the parliaments, he concluded, would not dare to oppose his system, lest they should draw on themselves the distrust and hatred of the public.

Without canvassing Calonne's intentions, which the most en-larged charity, after his former extravagance, can scarcely suppose to have been the interest of the people, moderate men imagined this project might have been productive of much good; giving the french all the liberty they were able to digest; and, warding off the tumults that have since produced so many disastrous events, whilst coolly preparing them for the reception of more, the effervescence of vanity and ignorance would not have rendered their heads giddy, or their hearts savage. Yet some sensible observers, on the contrary, rather adopted the opinion, that as the people had discovered the magnitude of the *deficit*, they were now persuaded, that a specific remedy was wanting, *a new constitution*; to cure the evils, which were the excrescences of a gigantic tyranny, that appeared to be draining away the vital juices of labour, to fill the insatiable jaws of thousands of fawning slaves and idle sycophants. But though the people might, for the present, have been satisfied with this salutary reform, which would gradually have had an effect, reasoning from analogy, that the financier did not take into his account, the nobility were not suffi-ciently enlightened to listen to the dictates of justice or prudence. It had been, indeed, the system of ministers, ever since Richelieu, to humble the nobles, to increase the power of the court; and as the ministry, the generals, and the bishops, were always noble, they aided to support the favourite, who depressed the whole body, only for the chance of individual preferment. But this bare-faced attempt to abolish their privileges raised a nest of hornets about his ears, eager to secure the plunder on which they lived; for by what other name can we call the pensions, places and even estates of those who, taxing industry, rioted in idleness duty free?[1]

[1] Since the constituent assembly equalized the impost, Calonne has boasted, that he proposed a mode of levying equal taxes; but that the nobility would not listen to any such motion, tenaciously maintaining their privileges. This blind obstinacy of opposing all re-form, that touched their exemptions, may be reckoned among the foremost causes, which, in

An approaching national bankruptcy was the ostensible reason assigned for the convening of the *notables* in 1787; but the convocation, in truth, ought to be ascribed to the voice of reason, sounded through the organ of twenty-five millions of human beings, who, though under the fetters of a detestable tyranny, felt, that the crisis was at hand, when the rights of man, and his dignity ascertained were to be enthroned on the eternal basis of justice and humanity.

The *notables*, once assembled, being sensible that their conduct would be inspected by an awakened public, now on the watch, scrupulously examined into every national concern; and seriously investigated the causes, that had produced *the deficit*, with something like the independent spirit of freemen. To their inquiries, however, the minister gave only the evasive reply, 'that he had acted in obedience to the pleasure of the king:'* when it was notorious to all Europe, that his majesty was merely a cypher at Versailles; and even the accusation brought against Calonne, by La Fayette,* of exchanging the national domains, and appropriating millions of it's revenue to gratify the queen, the count d'Artois,* and the rest of the cabal, who kept him in place, was generally believed. In fact, the state had been fleeced, to support the unremitting demands of the queen; who would have dismembered France, to aggrandize Austria, and pamper her favourites. Thus the court conniving at peculation, the minister played a sure game; whilst the honest labourer was groaning under a thousand abuses, and yielding the solace of his industry, or the hoards, which youthful strength had reserved for times of scarcity or decrepit age, to irritate the increasing wants of a

hurrying the removal of old abuses, tended to introduce violence and disorder.—And if it be kept in remembrance, that a conduct equally illiberal and disingenuous warped all their political sentiments, it must be clear, that the people, from whom they considered themselves as separated by immutable laws, had cogent grounds to conclude, that it would be next to impossible to effect a reform of the greater part of those perplexing exemptions and arbitrary customs, the weight of which made the peculiar urgency, and called with the most forcible energy for the revolution. Surely all the folly of the people taken together was less reprehensible, than this total want of discernment, this adherence to a prejudice, the jaundiced perception of contumelious ignorance, in a class of men, who from the opportunity they had of acquiring knowledge, ought to have acted with more judgment. For they were goaded into action by inhuman provocations, by acts of the most flagrant injustice, when they had neither rule nor experience to direct them, and after their temperance had been destroyed by years of sufferings, and an endless catalogue of reiterated and contemptuous privations.

thoughtless, treacherous princess, and the avarice of her unprincipled agents.

This artful, though weak, machiavelian politician suffered no other person to approach the king; who, seduced into confidence by his colloquial powers, could not avoid being dazzled by his plausible schemes. He had, nevertheless, a powerful enemy to contend with, in M. de Breteuil;* who, having gratified some of the little passions of the dauphine, during her first struggles for dominion, was now protected by the absolute power of the queen. Endeavouring to measure his strength with her's, the minister was discomfited; and the whole swarm of flatterers, who had partaken of the spoil of rapine, were instantly alert to open the eyes of Louis, over which they had long been scattering poppies, and soon convinced him of the perfidy of his favourite; whilst the two privileged orders joined their forces, to overwhelm their common enemy, attending to their vengeance at the very time they followed the dictates of prudence.

The accusations of La Fayette served, perhaps, as the ostensible reason with the public, and even with the king; yet it can hardly be supposed, that they had any effect on the cabal, who invented, or connived at the plans necessary to raise a continual supply for their pleasures. The fact is, that, most probably being found unequal to the task, or no longer choosing to be a docile instrument of mischief, he was thrown aside as unfit for use.

Disgraced, he quickly retired to his estate; but was not long permitted to struggle with the malady of exiled ministers, in the gloomy silence of inactivity; for, hearing that he had been denounced by the parliament, he fled in a transport of rage out of the kingdom,* covered with the execrations of an injured people, in whose hatred, or admiration, the mellowed shades of reflection are seldom seen.

The extravagance of his administration exceeded that of any other scourge of France; yet it does not appear, that he was actuated by a plan, or even desire, of enriching himself. So far from it, with wild prodigality he seems to have squandered away the vast sums he extorted by force or fraud, merely to gratify or purchase friends and dependents; till, quite exhausted, he was obliged to have recourse to Necker's scheme of loans. But not possessing like him the confidence of the public, he could not with equal facility obtain a present supply, the weight of which would be thrown forward to become a

stumbling-block to his successors. Necker, by the advantageous terms which he held out to money-holders, had introduced a pernicious system of stock-jobbing, that was slowly detected, because those who could best have opened the eyes of the people were interested to keep them closed.—Still Calonne could not induce the same body of men to trust to his offers; which, not choosing to accept, they made a point of discrediting, to secure the interest and exorbitant premiums that were daily becoming due.

With an uncommon quickness of comprehension, and audacity in pursuing crude schemes, rendered plausible by a rhetorical flow of words, Calonne, a strong representative of the national character, seems rather to have wanted principles than feelings of humanity; and to have been led astray more by vanity and the love of pleasure, which imperceptibly smooth away moral restraints, than by those deep plans of guilt, that force men to see the extent of the mischief they are hatching, whilst the crocodile is still in the egg. Yet, as mankind ever judge by events, the inconsiderate presumption, if not the turpitude of his conduct, brought on him universal censure: for, at a crisis when the general groans of an oppressed nation proclaimed the disease of the state, and even when the government was on the verge of dissolution, did he not waste the treasures of his country, forgetful not only of moral obligations, but the ties of honour, of that regard for the tacit confidence of it's citizens, which a statesman ought to hold sacred? since which he has been caressed at almost every court in Europe, and made one of the principal agents of despotism in the croisades against the infant liberty of France.

Reflecting on the conduct of the tools of courts, we are enabled in a great measure to account for the slavery of Europe; and to discover, that it's misery has not arisen more from the imperfection of civilization, than from the fallacy of those political systems, which necessarily made the favourites of the day a knavish tyrant, eager to amass riches sufficient to save himself from oblivion, when the honours, so hardly wrestled for, should be torn from his brow. Besides, whilst ministers have found impunity in the omnipotence, which the seal of power gave them, and in the covert fear of those who hoped one day to enjoy the same emoluments, they have been led by the prevalence of depraved manners, to the commission of every atrocious folly. Kings have been the dupes of ministers, of

mistresses, and secretaries, not to notice sly valets and cunning waiting-maids, who are seldom idle; and these are most venal, because they have least independence of character to support; till in the circle of corruption no one can point out the first mover. Hence proceeds the great tenacity of courts to support them; hence originates their great objection to republican forms of government, which oblige their ministers to be accountable for delinquency; and hence, likewise, might be traced their agonizing fears of the doctrine of civil equality.

BOOK I, CHAPTER III

After the dismission of Calonne, M. de Brienne,* a man whose talents Turgot had overrated, was now chosen by the queen, because he had formerly seconded her views, and was still the obsequious slave of that power, which he had long been courting, to obtain the so much envied place of minister. Having taken more pains to gain the post than to prepare himself to fulfil it's functions, his weak and timid mind was in a continual tumult; and he adopted with headlong confusion the taxes proposed by his predecessor; because money must be had, and he knew not where to turn to procure it by an unhacknied mode of extortion.

The *notables* were now dissolved;* and it would have been a natural consequence of the dismission of the minister who assembled them, even if their spirited inquiries had not rendered their presence vexatious to the court. This, however, was an impolitic measure; for they returned highly disgusted to their respective abodes, to propagate the free opinions, to which resentment and argumentation had given birth.

Before the breaking up of the *notables*, they were nevertheless prevailed upon to recommend a land and stamp tax; and the edicts were sent to the parliament to be enregistered. But these magistrates, never forgetting that they enjoyed, in virtue of their office, the privileged exemption from taxes, to elude sanctioning the first, which was to have been an equal impost, took advantage of the public odiousness of the second; thus avoiding, with a show of patriotism, an avowed opposition to the interest of the people, that would clearly have proved, how much dearer they held their own.

The gaudy and meretricious pageantry of the court was now displayed, to intimidate the parliament, at what was termed a bed of justice, though in reality of all justice a solemn mockery; and, whilst pretending to consult them, the edicts were enregistered by a mandate of state. The parliament, in the mean time, making a merit of necessity, declared, that the right of sanctioning the impost belonged only to the states-general, the convocation of which they demanded. Provoked by their sturdy opposition, the court banished them to Troyes; and they compromised for their recall by enregistering the prolongation of the *deuxieme vingtieme,** a cowardly desertion of their former ground.

A century before (a proof of the progress of reason) the people, digesting their disappointment, would have submitted, with brutal acquiescence, to the majestic WILL of the king, without daring to scan it's import; but now, recognizing their own dignity, they insisted, that all authority, which did not originate with them, was illegal and despotic, and loudly resounded the grand truth—That it was necessary to convoke the states-general. The government, however, like a dying wretch cut off by intemperance, whilst the lust of enjoyment still remaining prompts him to exhaust his strength by struggling with death, sought some time longer inauspiciously for existence, depending on the succour of the court empirics, who vainly flattered themselves, that they could prevent it's dissolution. From the moment, indeed, that Brienne succeeded Calonne, all the machinery, which the demon of despotism could invent, was put in motion, to divert the current of opinion, bearing on it's fair bosom the new sentiments of liberty with irresistible force, and overwhelming, as it swelled, the perishing monuments of venerable folly, and the fragile barriers of superstitious ignorance.

But supplies were still wanting; and the court, being fruitful in stratagems to procure a loan, which was the necessary lever of it's insidious designs, coalesced with some of the members of the parliament, and the agreement was to have been ratified in a *séance royale.** Yet, as the parliament had determined to be governed by a clear majority, the scheme of the keeper of the seals,* who intended to have the business hurried over without telling the votes, was completely defeated.

The discovery of this unfair attempt made the indignant magistrates, glad to seize an occasion to recover their popularity, maintain

with boldness their own character, and the interest of the people. The duke of Orleans,* also, somewhat tauntingly suggesting to the king, that this was only another bed of justice,* was exiled, with two other members, who had remonstrated with courage. These magistrates, now become the objects of public adoration, were considered by the grateful public as their only bulwark against the attacks of the ministry; which continued to harrass invention, to contrive means to counteract a concurrence of circumstances, that were driving before them all opposition.

The court, for I consider the government, at this period, completely at an end, continued to stumble out of one blunder into another, till at last they rested all their hopes on the popular reforms projected by Brienne, in conjunction with Lamoignon, a man with more strength of character, to cajole the people and crush the parliament. Several strokes, the feeble blows of angry men, who wished still to retain the stolen sweets of office, were aimed at this body, calculated to mislead the people, who were also promised a reformed code of penal laws. But the time when partial remedies would have been eagerly swallowed was past, and the people saw distinctly, that their will would soon be law, and their power omnipotent. But the minister, Brienne, not aware of this, to steer clear of further opposition, proposed the plan of a *cour pléniere:** an heterogeneous assembly of princes, nobles, magistrates, and soldiers. A happy substitute, as he imagined, for the parliament; and which, by restoring the ancient forms of the kings of France, would awe and amuse the people. He did not consider, that their minds were now full of other objects, and their enthusiasm turned into another channel.

This conduct proved more destructive to the court than any former folly it's advisers had committed. Imbecility now characterized every measure. The parliament however fell into the snare, and forfeited the esteem and confidence of the people by opposing some popular edicts; particularly one in favour of the protestants,* which they themselves had demanded ten years before, and to which they now objected, only because it came from another quarter. Yet the court, regardless of experience, endeavoured to restore it's credit by persecution; whilst, making all the clashing movements that fear could dictate to manifest it's power and overawe the nation, it united all parties, and drew the whole kingdom to one point of action.

The despotic and extravagant steps taken, to give efficiency to the *cour plénière*, awakened the sensibility of the most torpid; and the vigilance of twenty-five millions of centinels was roused, to watch the movements of the court, and follow it's corrupt ministers, through all the labyrinths of sophistry and tergiversation, into the very dens of their nefarious machinations. To prevent the different parliaments from deliberating, and forming in consequence a plan of conduct together, the edict to sanction this packed cabinet was to be presented to them all on the same day; and a considerable force was assembled, to intimidate the members, who should dare to prove refractory. But, they were forewarned in time, to avoid being surprised into acquiescence: for, having received an intimation of the design, a copy of the edict had been purloined from the press, by means of the universal engine of corruption, money.

Warmed by the discovery of this surreptitious attempt to cheat them into blind obedience, they bound themselves by an oath, to act in concert; and not to enregister a decree, that had been obtained through a medium, which violated the privilege they had usurped of having a share in the legislation, by rendering their sanction of edicts necessary to give them force: a privilege that belonged only to the states-general. Still, as the government had often found it convenient to make the parliaments a substitute for a power they dreaded to see in action, these magistrates sometimes availed themselves of this weakness, to remonstrate against oppression; and thus, covering usurpation with a respectable veil, the twelve parliaments were considered by the people as the only barriers to resist the encroachments of despotism. Yet the sagacious chancellor L'Hôpital,* not deceived by their accidental usefulness, guarded the french against their illegal ambition: for was it not a dangerous courtesy of the people, to allow an aristocracy of lawyers, who brought their places, to be as it were the only representatives of the nation? Still their resistance had frequently been an impediment in the way of tyranny, and now provoked a discussion, which led to the most important of all questions—namely, in whose hands ought the sovereignty to rest?—who ought to levy the impost, and make laws?—and the answer was the universal demand of a fair representation, to meet at stated periods, without depending on the caprice of the executive power. Unable to effect their purpose by art or force, the weak ministry, stung by the disappointment,

determined at least to wreak their vengeance on two of the boldest of the members. But the united magistrates disputing the authority of the armed force, it was necessary to send to Versailles, to make the king sign an express order; and towards five o'clock the next morning the sanctuary of justice was profaned, and the two members dragged to prison,* in contempt of the visible indignation of the people. Soon after, to fill up the measure of provocations, a deputation sent by the province of Brittany, to remonstrate against the establishment of the *cour pléniere*, were condemned to silence in the Bastille.

Without money, and afraid to demand it, excepting in a circumlocutory manner, the court, like mad men, spent themselves in idle exertions of strength: for, whilst the citizens of Paris were burning in effigy the two obnoxious ministers, who thus outraged them in the person of their magistrates, they were delivered up to the fury of the hired slaves of despotism, and trampled under foot by the cavalry; who were called in to quell a riot purposely excited.

Cries of horrour and indignation resounded throughout the kingdom; and the nation, with one voice, demanded justice—Alas! justice had never been known in France. Retaliation and vengeance had been it's fatal substitutes. And from this epoch we may date the commencement of those butcheries, which have brought on that devoted country so many dreadful calamities, by teaching the people to avenge themselves with blood!

The hopes of the nation, it is true, were still turned towards the promised convocation of the states-general; which every day became more necessary. But the infatuated ministers, though unable to devise any scheme to extricate themselves out of the crowd of difficulties, into which they had heedlessly plunged, could not think of convening a power, which they foresaw, without any great stretch of sagacity, would quickly annihilate their own.

The ferment, mean time, continued, and the blood that had been shed served only to increase it; nay, the citizens of Grenoble prepared with calmness to resist force by force, and the myrmidons of tyranny might have found it a serious contest, if the intelligence of the dismission of the ministers had not produced one of those moments of enthusiasm, which by the most rapid operation of sympathy unites all hearts. Touched by it, the men who lived on the wages of slaughter threw down their arms, and melting into tears in

the embraces of the citizens whom they came to murder, remembered that they were countrymen, and groaned under the same oppression: and, their conduct, quickly applauded with that glow of sensibility which excites imitation, served as an example to the whole army, forcing the soldiers to think of their situation, and might have proved a salutary lesson to any court less depraved and insensible than that of Versailles.

BOOK I, CHAPTER IV

Such were the measures pursued to exasperate a people beginning to open their eyes, and now clamourously demanding the restitution of their long-estranged rights; when the court, having in vain attempted to terrify or deceive them, found it expedient to still the storm by recalling Necker.* This man had the confidence of France, which he in some degree merited for the light he had thrown on the state of the revenue, and for the system of economy, that he had endeavoured to adopt during his former administration: but unfortunately he did not possess talents or political sagacity sufficient to pilot the state in this perilous season. Bred up in a counting-house, he acquired that knowledge of detail, and attention to little advantages, so necessary when a man desires to amass riches with what is termed a fair character: and, having accumulated a very large fortune by unremitting industry; or, to borrow the commercial phrase, *attention to the main chance*, his house became the resort of the men of letters of his day.

The foibles of a rich man are always fostered, sometimes perhaps insensibly, by his numerous dependents and visitants, who find his table amusing or convenient. It is not then surprizing, that, with the abilities of a tolerable financier, he was soon persuaded, that he was a great author,* and consummate statesman. Besides, when the manners of a nation are very depraved, the men who wish to appear, and even to be, more moral than the multitude, in general become pedantically virtuous; and, continually contrasting their morals with the thoughtless vices around them, the artificial, narrow character of a sectary is formed; the manners are rendered stiff, and the heart cold. The dupes also of their flimsey virtue, many men are harshly called hypocrites, who are only weak; and popularity often turns the

head giddy, that would have soberly fulfilled the common duties of a man in the shade of private life.

Having adopted with a timid hand many of the sagacious plans of his model, the clear headed, unaffected Turgot, Necker was considered by the greater part of the nation as a consummate politician: neither was it surprizing, that the people, snatched from despondency, should have mistaken the extent of his political knowledge, when they had estimated it by that of the greatest statesman, which France, or, perhaps, any other country, ever produced.

Having written on a subject, that naturally attracted the attention of the public, he had the vanity to believe, that he deserved the exaggerated applause he received, and the reputation of wise, when he was only shrewd. Not content with the fame he acquired by writing on a subject, which his turn of mind and profession enabled him to comprehend, he wished to obtain a higher degree of celebrity, by forming into a large book various metaphysical shreds of arguments, which he had collected from the conversation of men, fond of ingenious subtilties; and the style, excepting some declamatory passages, was as inflated and confused as the thoughts were far fetched and unconnected.[1]

As it is from this period, that we must date the commencement of those great events, which, outrunning expectation, have almost rendered observation breathless, it becomes necessary to enter on the task with caution; as it ought not to be more the object of the historian to fill up the sketch, than to trace the hidden springs and secret mechanism, which have put in motion a revolution, the most important that has ever been recorded in the annals of man. This was a crisis that demanded boldness and precision; and no man in France, excepting Necker, had the reputation of possessing extensive political talents; because the old system of government scarcely afforded a field, in which the abilities of men could be unfolded, and their judgment matured by experience. Yet, whilst the kingdom was in the greatest fermentation, he seems to have thought of none but those timid half-way measures, which always prove disastrous in desperate cases, when the wound requires to be probed to the quick.

The old government was then only a vast ruin; and whilst it's pillars were trembling on their baseless foundations, the eyes of all

[1] Importance of religious opinions.*

France were directed towards their admired minister. In this situation, with all his former empiricism he began his second career, like another Sangrado.* But the people could no longer bear bleeding— for their veins were already so lacerated, it was difficult to find room to make a fresh incision; and the emollient prescriptions, the practice of former times, were now insufficient to stop the progress of a deadly disease. In this situation, listening to the voice of the nation, because he was at a loss what step to take to maintain his popularity, he determined to hasten the convocation of the states-general: first recalling the exiled magistrates, and restoring the parliaments to the exercise of their functions. His next care was to dissipate all apprehension of a famine; a fear that had been artfully excited by the court agents, in order to have a pretext to form magazines of provision for an army, which they had previously resolved to assemble in the vicinity of Paris.

Thus far he seems to have acted with some degree of prudence, at least; but, inattentive to the robust strength which the public opinion had then acquired, he wavered as to the mode of constituting the states-general, whilst the parliament passed a decree to prevent their assembling in any other manner than they did in 1614.* This obstinate pretention to legislate for the nation was no longer to be tolerated, when they opposed the wishes of the people: yet, with the common instinct of corporate bodies, they wrapped themselves up in the precedents that proved their winding-sheet, provoking universal contempt; for the herculean force of the whole empire was now clearing away every obstacle to freedom.

At this critical moment, the minister, enjoying great popularity, had it in his power, could he have governed the court, to have suggested a system, which might ultimately have proved acceptable to all parties; and thus have prevented that dreadful convulsion, which has shook the kingdom from one extremity to the other. Instead of that, he convened a second time the *notables*,* to take their opinion on a subject, respecting which the public had already decided, not daring himself to sanction it's decision. The strongest proof he could give, that his mind was not sufficiently elastic to expand with the opening views of the people; and that he did not possess the eye of genius, which, quickly distinguishing what is possible, enables a statesman to act with firm dignity, resting on his own centre.

Carried away by the general impulsion, with the inconsiderate fervour of men, whose hearts always grow hard as they cool, when they have been warmed by some sudden glow of enthusiasm or sympathy, the *notables* showed, by their subsequent conduct, that, though they had been led by eloquence to support some questions of a patriotic tendency, they had not the principles necessary to impel them to give up local advantages, or personal prerogatives, for the good of the whole community, in which they were only eventually to share. Indeed romantic virtue, or friendship, seldom goes further than professions; because it is merely the effect of that fondness for imitating great, rather than acquiring moderate qualities, common to vain people.

The *notables* had now two essential points to settle; namely, to regulate the election of the deputies, and how they were afterwards to vote. The population and wealth of several provinces, from commercial advantages and other causes, had given a new face to the country since the former election; so much so, that, if the ancient division were adhered to, the representation could not fail to be very unequal. Yet if the natural order of population were followed, the grand question of voting by orders or by voices seemed to be prejudged by the great increase of the members of the *tiers-etat.**

The nobles and the clergy immediately rallied round the standard of privileges, insisting, that France would be ruined, if their *rights* were touched: and so true were they now to their insulated interest, that all the committees into which the *notables* were divided, excepting that of which *monsieur** was president, determined against allowing the *tiers-etat* that increase of power necessary to enable them to be useful. Whilst, however, these disputes and cabals seemed to promise no speedy determination, the people, weary of procrastination, and disgusted with the obstacles continually thrown in the way of the meeting of the states-general, by a court that was ever secretly at work, to regain the trifling privileges, which it pretended to sacrifice to the general good, began to assemble, and even to decide the previous question, by deliberating together in several places. Dauphine* set the example; and the three orders uniting sketched a plan for the organization of the whole kingdom, which served as a model for the other provincial states, and furnished grounds for the constituent assembly to work on when forming the constitution.

Though the rumour was spread abroad, the court, still so stupidly secure as not to see, that the people, who at this period dared to think for themselves, would not now be noosed like beasts, when strength is brought into subjection by reason, beheld with wonder the arrival of deputations from different quarters, and heard with astonishment the bold tones of men speaking of their rights, tracing society to it's origin, and painting with the most forcible colours the horrid depredations of the old government. For after the minds of men had been fatigued by the stratagems of the court, the feeble measures of the minister, and the narrow, selfish views of the parliaments, they examined with avidity the productions of a number of able writers, who were daily pouring pamphlets from the press, to excite the *tiers-etat*, to assert it's rights on enlarged principles, and to oppose vigorously the exorbitant claims of the privileged orders, who stood up for ancient usurpations, as if they were the natural rights of a particular *genus* of man. Those of the abbé Sieyes* and the marquis de Condorcet* were the most philosophical; whilst the unctuous eloquence of Mirabeau* softened these dry researches, and fed the flame of patriotism.

In this posture of affairs, Necker, perceiving that the people were grown resolute, prevailed on the council to decree, that the number of the deputies of the *tiers-etat* should be equal to that of the two other orders taken together: but whether they were to vote by chambers, or in the same body, was still left undetermined.

The people, whose patience had been worn out by injuries and insults, now only thought of preparing instructions for their representatives.—But, instead of looking for gradual improvement, letting one reform calmly produce another, they seemed determined to strike at the root of all their misery at once: the united mischiefs of a monarchy unrestrained, a priesthood unnecessarily numerous, and an overgrown nobility: and these hasty measures, become a subject worthy of philosophical investigation, naturally fall into two distinct subjects of inquiry.

1st. If, from the progress of reason, we be authorized to infer, that all governments will be meliorated, and the happiness of man placed on the solid basis, gradually prepared by the improvement of political science: if the degrading distinctions of rank born in barbarism, and nourished by chivalry, be really becoming in the estimation of all sensible people so contemptible, that a modest man, in the course

of fifty years would probably blush at being thus distinguished: if the complexion of manners in Europe be completely changed from what it was half a century ago, and the liberty of it's citizens tolerably secured: if every day extending freedom be more firmly established in consequence of the general dissemination of truth and knowledge: it then seems injudicious for statesmen to force the adoption of any opinion, by aiming at the speedy destruction of obstinate prejudices; because these premature reforms, instead of promoting, destroy the comfort of those unfortunate beings, who are under their dominion, affording at the same time to despotism the strongest arguments to urge in opposition to the theory of reason. Besides, the objects intended to be forwarded are probably retarded, whilst the tumult of internal commotion and civil discord leads to the most dreadful consequence—the immolating of human victims.

But, 2dly, it is necessary to observe, that, if the degeneracy of the higher orders of society be such, that no remedy less fraught with horrour can effect a radical cure; and if enjoying the fruits of usurpation, they domineer over the weak, and check by all the means in their power every humane effort, to draw man out of the state of degradation, into which the inequality of fortune has sunk him; the people are justified in having recourse to coercion, to repel coercion. And, further, if it can be ascertained, that the silent sufferings of the citizens of the world under the iron feet of oppression are greater, though less obvious, than the calamities produced by such violent convulsions as have happened in France; which, like hurricanes whirling over the face of nature, strip off all it's blooming graces; it may be politically just, to pursue such measures as were taken by that regenerating country, and at once root out those deleterious plants, which poison the better half of human happiness. For civilization hitherto, by producing the inequality of conditions, which makes wealth more desirable than either talents or virtue, has so weakened all the organs of the body-politic, and rendered man such a beast of prey, that the strong have always devoured the weak till the very signification of justice has been lost sight of, and charity, the most specious system of slavery, substituted in it's place. The rich have for ages tyrannized over the poor, teaching them how to act when possessed of power, and now must feel the consequence. People are rendered ferocious by misery; and misanthropy is ever

the offspring of discontent. Let not then the happiness of one half of mankind be built on the misery of the other, and humanity will take place of charity, and all the ostentatious virtues of an universal aristocracy. How, in fact, can we expect to see men live together like brothers, when we only see master and servant in society? For till men learn mutually to assist without governing each other, little can be done by political associations towards perfecting the condition of mankind.

Europe will probably be, for some years to come, in a state of anarchy; till a change of sentiments, gradually undermining the strongholds of custom, alters the manners, without rousing the little passions of men, a pack of yelping curs pampered by vanity and pride. It is in reality these minor passions, which during the summer of idleness mantle on the heart, and taint the atmosphere, because the understanding is still.

Several acts of ferocious folly have justly brought much obloquy on the grand revolution, which has taken place in France; yet, I feel confident of being able to prove, that the people are essentially good, and that knowledge is rapidly advancing to that degree of perfectibility, when the proud distinctions of sophisticating fools will be eclipsed by the mild rays of philosophy, and man be considered as man—acting with the dignity of an intelligent being.

From implicitly obeying their sovereigns, the french became suddenly all sovereigns; yet, because it is natural for men to run out of one extreme into another, we should guard against inferring, that the spirit of the moment will not evaporate, and leave the disturbed water more clear for the fermentation. Men without principle rise like foam during a storm sparkling on the top of the billow, in which it is soon absorbed when the commotion dies away. Anarchy is a fearful state, and all men of sense and benevolence have been anxiously attentive, to observe what use frenchmen would make of their liberty, when the confusion incident to the acquisition should subside: yet, whilst the heart sickens over a detail of crimes and follies, and the understanding is appalled by the labour of unravelling a black tissue of plots, which exhibits the human character in the most revolting point of view; it is perhaps, difficult to bring ourselves to believe, that out of this chaotic mass a fairer government is rising than has ever shed the sweets of social life on the world.—But things must have time to find their level.

FROM BOOK II, CHAPTER II

With respect to the improvement of society, since the destruction of the roman empire, England seems to have led the way, rendering certain obstinate prejudices almost null, by a gradual change of opinion. This observation, which facts will support, may be brought forward, to prove, that just sentiments gain footing only in proportion as the understanding is enlarged by cultivation, and freedom of thought, instead of being cramped by the dread of bastilles and inquisitions. In Italy and France, for example, where the mind dared to exercise itself only to form the taste, the nobility were, in the strictest sense of the word, a cast, keeping aloof from the people; whilst in England they intermingled with the commercial men, whose equal or superiour fortunes made the nobles overlook their inequality of birth: thus giving the first blow to the ignorant pride that retarded the formation of just opinions respecting true dignity of character. This monied interest, from which political improvement first emanates, was not yet formed in France; and the ridiculous pride of her nobles, which led them to believe, that the purity of their families would be sullied, if they agreed to act in the same sphere with the people, was a prevailing motive, that prevented their junction with the commons. But the more licentious part of the clergy, who followed with a truer scent their own interest, thought it expedient to espouse, in time, the cause of the power, from whence their influence derived its greatest force; and from which alone they could hope for support. This schism proved, as it promised, dangerous to the views of the court.

The desertion of the clergy rendered the nobility outrageous, and hastened the crisis when the important contest was to be brought to an issue.—When it was that the king perceived how contemptible his undecided conduct had been, and exclaiming, it is said confidently, 'that he remained ALONE in the midst of the nation, occupied with the establishment of concord.'* Vain words! and this affectation was particularly reprehensible, because he had already given orders for the assembling of the foreign troops: the object of which was to establish concord with the point of the bayonet.

This total want of character caused him to be flattered by all parties, and trusted by none. Insignificancy had distinguished his

manners in his own court. Actions without energy, and professions without sincerity, exhibiting a conduct destitute of steadiness, made the cabinet concert all their measures regardless of his opinion, leaving to the queen the task of persuading him to adopt them. The evil did not rest even here; for the different parties following separate views, the flexibility of his temper led him to sanction things the most at variance, and most dangerous to his future honour and safety. For it appears obvious, that whatever party had prevailed, he could only be considered as an instrument; which, becoming useless when the object should be achieved, would be treated with disrespect. Periods of revolution drawing into action the worst as well as the best of men; and as audacity, in general, triumphs over modest merit, when the political horizon is ruffled by tempest; it amounted to a moral certainty, that the line of conduct pursued by the king would lead to his disgrace and ruin.

Seeing, however, that the people were unanimous in their approbation of the conduct of their representatives, and watchful to discover the designs of their enemies; it could not but occur to the cabinet, that the only way to lull attention to sleep, was to affect to submit to necessity. Besides, fearing, if they continued to resort to their different chambers, that their plot would take wind before all the agents were assembled, a fresh instance of dissimulation evinced, that their depravity equalled their stupidity. For the king was now prevailed on to write to the presidents of the nobility, and the minority of the clergy, requesting them, to represent to those two orders the necessity of uniting with the third, to proceed to the discussion of his proposals, made at the *séance royale*.

The clergy immediately acquiesced; but the nobility continued to oppose a junction so humiliating, till the court invented a pretext of honour to save the credit of their mock dignity, by declaring, that the life of the king would be in imminent danger, should the nobles continue to resist the desire of the nation. Pretending to believe this report, for the secret of the cabinet was buzzed amongst them, and appearing to wish to bury all rivalry in royalty, they attended at the common hall, the 27th.* Yet even there, the first step they took was to enter a protest, in order to guard against this concession being made a precedent.

A general joy succeeded the terrour which had been engendered in the minds of the people by their contumelious perverseness;

and the parisians, cherishing the most sanguine expectations, reckoned, that an unity of exertions would secure to them a redress of grievances.

It is perhaps unnecessary to dwell, for a moment, on the insensibility of the court, and the credulity of the people; as they seem the only clues, that will lead us to a precise discrimination of the causes, which completely annihilated all confidence in the ministers, who have succeeded the directors of those infamous measures, that swept away the whole party; measures which involved thousands of innocent people in the same ruin, and have produced a clamour against the proceedings of the nation, that has obscured the glory of her labours. It is painful to follow, through all their windings, the crimes and follies produced by want of sagacity, and just principles of action. For instance, the *séance royale* was held on the 23d, when the king, not deigning to advise, commanded the deputies to repair to their different chambers; and only four days after he implored the nobility and clergy to wave every consideration, and accede to the wish of the people. Acting in this contradictory manner, it is clear, that the cabal thought only of rendering sure the decided blow, which was to level with the dust the power, that extorted such humiliating concessions.

But the people, easy of belief, and glad to be light-hearted again, no sooner heard that an union of the orders had taken place, by the desire of the king, than they hurried from all quarters, with good-humoured confidence, called for the king and queen, and testified, in their presence, the grateful joy this acquiescence had inspired. How different was this frankness of the people, from the close hypocritical conduct of the cabal!

The courtly, dignified politeness of the queen, with all those complacent graces which dance round flattered beauty, whose every charm is drawn forth by the consciousness of pleasing, promised all that a sanguine fancy had pourtrayed of future happiness and peace. From her fascinating smiles, indeed, was caught the careless hope, that, expanding the heart, makes the animal spirits vibrate, in every nerve, with pleasure:—yet, she smiled but to deceive; or, if she felt some touches of sympathy, it was only the unison of the moment.

It is certain, that education, and the atmosphere of manners in which a character is formed, change the natural laws of humanity; otherwise it would be unaccountable, how the human heart can be

so dead to the tender emotions of benevolence, which most forcibly teach us, that real or lasting felicity flows only from a love of virtue, and the practice of sincerity.

The unfortunate queen of France, beside the advantages of birth and station, possessed a very fine person; and her lovely face, sparkling with vivacity, hid the want of intelligence. Her complexion was dazzlingly clear; and, when she was pleased, her manners were bewitching; for she happily mingled the most insinuating voluptuous softness and affability, with an air of grandeur, bordering on pride, that rendered the contrast more striking. Independence also, of whatever kind, always gives a degree of dignity to the mien; so that monarchs and nobles, with most ignoble souls, from believing themselves superiour to others, have actually acquired a look of superiority.

But her opening faculties were poisoned in the bud; for before she came to Paris, she had already been prepared, by a corrupt, supple abbé,* for the part she was to play; and, young as she was, became so firmly attached to the aggrandizement of her house, that, though plunged deep in pleasure, she never omitted sending immense sums to her brother, on every occasion. The person of the king, in itself very disgusting, was rendered more so by gluttony, and a total disregard of delicacy, and even decency in his apartments: and, when jealous of the queen, for whom he had a kind of devouring passion, he treated her with great brutality, till she acquired sufficient finesse to subjugate him. Is it then surprizing, that a very desirable woman, with a sanguine constitution, should shrink abhorrent from his embraces; or that an empty mind should be employed only to vary the pleasures, which emasculated her circean court? And, added to this, the histories of the Julias and Messalinas* of antiquity, convincingly prove, that there is no end to the vagaries of the imagination, when power is unlimited, and reputation set at defiance.

Lost then in the most luxurious pleasures, or managing court intrigues, the queen became a profound dissembler; and her heart hardened by sensual enjoyments to such a degree, that when her family and favourites stood on the brink of ruin, her little portion of mind was employed only to preserve herself from danger. As a proof of the justness of this assertion, it is only necessary to observe, that, in the general wreck, not a scrap of her writing has been found to

criminate her; neither has she suffered a word to escape her to exasperate the people, even when burning with rage, and contempt. The effect that adversity may have on her choked understanding time will show;[1] but during her prosperity, the moments of languor, that glide into the interstices of enjoyment, were passed in the most childish manner; without the appearance of any vigour of mind, to palliate the wanderings of the imagination.—Still she was a woman of uncommon address; and though her conversation was insipid, her compliments were so artfully adapted to flatter the person she wished to please or dupe, and so eloquent is the beauty of a queen, in the eyes even of superiour men, that she seldom failed to carry her point when she endeavoured to gain an ascendency over the mind of an individual. Over that of the king she acquired unbounded sway, when, managing the disgust she had for his person, she made him pay a kingly price for her favours. A court is the best school in the world for actors; it was very natural then for her to become a complete actress, and an adept in all the arts of coquetry that debauch the mind, whilst they render the person alluring.

Had the hapless Louis possessed any decision of character, to support his glimmering sense of right, he would from this period have chosen a line of conduct, that might have saved his life by regulating his future politics. For this returning affection of the people alone was sufficient to prove to him, that it was not easy to eradicate their love for royalty; because, whilst they were contending for their rights with the nobility, they were happy to receive them as acts of beneficence from the king. But the education of the heir apparent of a crown must necessarily destroy the common sagacity and feelings of a man; and the education of this monarch, like that of Louis XV, only tended to make him a sensual bigot.

Priests have, in general, contrived to become the preceptors of kings; the more surely to support the church, by leaning it against the throne. Besides; kings, who without having their understandings enlarged, are set above attending to the forms of morality, which sometimes produce it's spirit, are always particularly fond of those religious systems, which, like a sponge, wipe out the crimes that haunt the terrified imagination of unsound minds.

[1] This was written some months before the death of the queen.*

It has been the policy of the court of France, to throw an odium on the understanding of the king, when it was lavishing praises on the goodness of his heart. Now it is certain, that he possessed a considerable portion of sense, and discernment; though he wanted that firmness of mind, which constitutes character; or, in more precise words, the power of acting according to the dictates of a man's own reason. He was a tolerable scholar; had sufficient patience to learn the english language; and was an ingenious mechanic. It is also well known, that in the council, when he followed only the light of his own reason, he often fixed on the most sage measures, which he was afterwards persuaded to abandon. But death seems to be the sport of kings, and, like the roman tyrant, whose solitary amusement was transfixing flies, this man, whose milkiness of heart has been perpetually contrasted with the pretended watriness of his head, was extremely fond of seeing those grimaces, made by tortured animals, which rouse to pleasure sluggish, gross sensations. The queen, however, prevailed on him not to attempt to amuse her, or raise a forced laugh, in a polite circle, by throwing a cat down the chimney, or shooting an harmless ass. Taught also to dissemble, from his cradle, he daily practised the despicable shifts of duplicity; though led by his indolence to take, rather than to give the tone to his domineering parasites.

The french nobility, perhaps, the most corrupt and ignorant set of men in the world, except in those objects of taste, which consist in giving variety to amusement, had never lived under the control of any law, but the authority of the king; and having only to dread the Bastille for a little time, should they commit any enormity, could not patiently brook the restraints, the better government of the whole society required. Haughtily then disregarding the suggestions of humanity, and even prudence, they determined to subvert every thing, sooner than resign their privileges; and this tenacity will not appear astonishing, if we call to mind, that they considered the people as beasts of burden, and trod them under foot with the mud. This is not a figure of rhetoric; but a melancholy truth! For it is notorious, that, in the narrow streets of Paris, where there are no footways to secure the walkers from danger, they were frequently killed, without slackening, by the least emotion of fellow-feeling, the gallop of the thoughtless being, whose manhood was buried in a factitious character.

I shall not now recapitulate the feudal tyrannies, which the progress of civilization has rendered nugatory; it is sufficient to observe, that, as neither the life nor property of the citizens was secured by equal laws, both were often wantonly sported with by those who could do it with impunity. Arbitrary decrees have too often assumed the sacred majesty of law; and when men live in continual fear, and know not what they have to apprehend, they always become cunning and pusillanimous. Thus the abject manners, produced by despotism of any species, seem to justify them, in the eyes of those who only judge of things from their present appearance. This leads, likewise, to an observation, that partly accounts for the want of industry and cleanliness in France; for people are very apt to sport away their time, when they cannot look forward, with some degree of certainty, to the consolidation of a plan of future ease.

Every precaution was taken to divide the nation, and prevent any ties of affection, such as ought always to unite man with man, in all the relationships of life, from bringing the two ranks together with any thing like equality to consolidate them. If, for instance, the son of a nobleman happened so far to forget his rank, as to marry a woman of low birth; what misery have not those unfortunate creatures endured!—confined in prisons, or hunted out of the common nest, as contagious intruders.* And if we remember also, that, while treated with contempt, only a twentieth part of the profit of his labour fell to the share of the husbandman, we shall cease to inquire, why the nobles opposed innovations, that must necessarily have overturned the fabric of despotism. . . .

[The Paris crowd was arming itself and
growing threatening; the court was at Versailles]

. . . Different sounds excited different emotions at Versailles; for there the heart, beating high with exultation, gave way to the most intemperate joy.—Already the courtiers imagined, that the whole mischief was crushed, and that they had the assembly at their mercy.

Intoxicated by success, a little too soon reckoned on, the queen, the count d'Artois, and their favourites, visited the haunt of the bribed ruffians, who were lurking in ambush, ready to fall upon their prey; encouraging them by an engaging affability of behaviour, and more substantial marks of favour, to forget every consideration,

but their commands. And so flattered were they by the honied words, and coquetish smiles of the queen, that they promised, as they drained the cup in her honour, not to sheath their swords, till France was compelled to obedience, and the national assembly dispersed. With savage ferocity they danced to the sound of music attuned to slaughter, whilst plans of death and devastation gave the zest to the orgies, that worked up their animal spirits to the highest pitch. After this account, any reflections on the baneful effects of power, or on the unrestrained indulgence of pleasure, that could thus banish tenderness from the female bosom, and harden the human heart, would be an insult to the reader's sensibility.

How silent is now Versailles!*—The solitary foot, that mounts the sumptuous stair-case, rests on each landing-place, whilst the eye traverses the void, almost expecting to see the strong images of fancy burst into life.—The train of the Louises, like the posterity of the Banquoes,* pass in solemn sadness, pointing at the nothingness of grandeur, fading away on the cold canvass, which covers the nakedness of the spacious walls—whilst the gloominess of the atmosphere gives a deeper shade to the gigantic figures, that seem to be sinking into the embraces of death.

Warily entering the endless apartments, half shut up, the fleeting shadow of the pensive wanderer, reflected in long glasses, that vainly gleam in every direction, slacken the nerves, without appalling the heart; though lascivious pictures, in which grace varnishes voluptuousness, no longer seductive, strike continually home to the bosom the melancholy moral, that anticipates the frozen lesson of experience. The very air is chill, seeming to clog the breath; and the wasting dampness of destruction appears to be stealing into the vast pile, on every side.

The oppressed heart seeks for relief in the garden; but even there the same images glide along the wide neglected walks—all is fearfully still; and, if a little rill creeping through the gathering moss down the cascade, over which it used to rush, bring to mind the description of the grand water works, it is only to excite a languid smile at the futile attempt to equal nature.

Lo! this was the palace of the great king!—the abode of magnificence! Who has broken the charm?—Why does it now inspire only pity?—Why;—because nature, smiling around, presents to the imagination materials to build farms, and hospitable mansions, where,

without raising idle admiration, that gladness will reign, which
opens the heart to benevolence, and that industry, which renders
innocent pleasure sweet.

Weeping—scarcely conscious that I weep, O France! over the
vestiges of thy former oppression; which, separating man from man
with a fence of iron, sophisticated all, and made many completely
wretched; I tremble, lest I should meet some unfortunate being,
fleeing from the despotism of licentious freedom, hearing the snap
of the *guillotine* at his heels; merely because he was once noble, or
has afforded an asylum to those, whose only crime is their name—
and, if my pen almost bound with eagerness to record the day, that
levelled the Bastille with the dust, making the towers of despair
tremble to their base; the recollection, that still the abbey is appro-
priated to hold the victims of revenge and suspicion, palsies the
hand that would fain do justice to the assault, which tumbled into
heaps of ruins walls that seemed to mock the resistless force of
time.—Down fell the temple of despotism; but—despotism has not
been buried in it's ruins!—Unhappy country!—when will thy chil-
dren cease to tear thy bosom?—When will a change of opinion,
producing a change of morals, render thee truly free?—When will
truth give life to real magnanimity, and justice place equality on a
stable seat?—When will thy sons trust, because they deserve to be
trusted; and private virtue become the guarantee of patriotism?
Ah!—when will thy government become the most perfect, because
thy citizens are the most virtuous!

BOOK II, CHAPTER IV

The effect produced by the duplicity of courts must be very great,
when the vicissitudes, which had happened at Versailles, could not
teach every person of common sense, that the moment was arrived,
when subterfuge and treachery could no longer escape detection and
punishment; and that the only possibility of obtaining the durable
confidence of the people was by that strict attention to justice, which
produces a dignified sincerity of action. For after the unravelling of
the plot, contrived to cheat the expectation of the people, it was
natural to suppose, that they would entertain the most wakeful
suspicion of every person who had been privy to it.

It would have been fortunate for France, and the unhappy Louis, if his counsellors could have profited by experience. But, still pursuing the old track, bounding over the mine, the bursting of which had for a moment disconcerted them, we shall find, that the continual dissimulation of the king, and the stratagems of his advisers, were the principal, though perhaps not the sole cause of his ruin. He appears to have sometimes mistrusted the cabal; yet, with that mixture of facility and obstinacy in his character, the concomitants of indolence of mind, he allowed himself to be governed without attempting to form any principle of action to regulate his conduct. For if he had ever really desired to be useful to his people, and to lighten their accumulated burdens, as has been continually insisted, he was astonishingly defective in judgment not to see, that he was surrounded with sycophants, who fattened on their hearts blood, using his own hand to brand his name with infamy. It may possibly be urged in reply, that this yielding temper was a proof of the king's benign desire to promote the felicity of his subjects, and prevent the horrours of anarchy. To confute such remarks, it is only necessary to state, that the preparations which had been made to dissolve the national assembly, and to reduce the people to entire subjection, if they were not his immediate contrivance, must have had his sanction, to give them efficiency; and that the tergiversation, which he employed on this occasion, was sufficient to make every other transaction of his reign suspected. And this will be found to be the case in all the steps he afterwards took to conciliate the people, which were little regarded after the evaporation of the lively emotions they excited; whilst the want of morals in the court, and even in the assembly, made a prevailing mistrust produce a capriciousness of conduct throughout the empire. Perhaps, it is vain to expect, that a depraved nation, whatever examples of heroism, and noble instances of disinterested conduct, it may exhibit on sudden emergencies, or at the first statement of an useful reform, will ever pursue with steadiness the great objects of public good, in the direct path of virtuous ambition.

If the calamities, however, which have followed in France the taking of the Bastille, a noble effort, be attributed partly to ignorance, or only to want of morals, the evils are in no degree lessened; neither does it justify the conduct of the virulent opposers of those manly exertions inspired by the voice of reason. The removal of a

thousand grinding oppressions had been demanded;—and prom-
ised, to delude the public; who finding, at last, that the hopes, which
had softened their misery, were likely to be blasted by the intrigues
of courtiers, can we wonder, that the worm these courtiers were
trying to crush, turned on the foot prepared to stamp it to nothing.

The complication of laws in every country has tended to bewilder
the understanding of man in the science of government; and whilst
artful politicians have taken advantage of the ignorance or credulity
of their fellow citizens, it was impossible to prevent a degeneracy of
morals, because impunity will always be a stimulus to the passions.
This has been the cause of the insincerity, which has so long dis-
graced the courts of Europe, and pervading every class of men in
their offices or employ, has extended it's poison throughout the
higher orders of society; and it will require a simplification of laws,
an establishment of equal rights, and the responsibility of ministers,
to secure a just and enlightened policy. But till this be effected, it
ought not to surprize us, should we hear the mock patriots of the day
declaiming about public reform, merely to answer sinister purposes;
or should we chance to discover, that the most extolled characters
have been actuated by a miserable selfishness, or prompted by cor-
roding resentment, to exertions for the public good; whilst histori-
ans have ignorantly attributed the political advantages, which have
been attained by a gradual improvement of manners, to their resolu-
tion, and the virtuous exercise of their talents.

And we ought not to be discouraged from attempting this simpli-
fication, because no country has yet been able to do it; since it seems
clear, that manners and government have been in a continual and
progressive state of improvement, and that the extension of knowl-
edge, a truth capable of demonstration, was never at any period so
general as at present.

If at one epocha of civilization we know, that all the improve-
ments which were made in arts and sciences were suddenly over-
turned, both in Greece and Rome, we need not inquire, why
superficial reasoners have been induced to think, that there is only a
certain degree of civilization to which men are capable of attaining,
without receding back to a state of barbarism, by the horrid conse-
quences of anarchy; though it may be necessary to observe, that the
causes which produced that event can never have the same effect
again:—because a degree of knowledge has been diffused through

society by the invention of printing, which no inundation of barbarians can eradicate. Besides, the improvement of governments do not now depend on the genius of particular men; but on the impetus given to the whole society by the discovery of useful truths. The opposers then of popular governments may tell us, if they please, that Themistocles had no motive in saving his country, but to gratify his ambition; that Cicero was vain, and Brutus only envious of the growing greatness of Caesar.*—Or, to approach our own times;—that, if the supercilious Wedderburne* had not offered an indignity to Franklin,* he never would have become an advocate for american independence;* and that, if Mirabeau had not suffered in prison,* he never would have written against the *lettres de cachet*, or espoused the cause of the people.—All of which assertions I am willing to admit, because they exactly prove what I wish to enforce; namely, that—though bad morals, and worse laws, have helped to deprave the passions of men to such a degree, as to make the benefits which society have derived from the talents or exertions of individuals to arise from selfish considerations, still it has been in a state of gradual improvement, and has arrived at such a pitch of comparative perfection, that the most arbitrary governments in Europe, Russia excepted, begin to treat their subjects as human beings, feeling like men, and with some powers of thinking.

The most high degree of civilization amongst the ancients, on the contrary, seems to have consisted in the perfection the arts, including language, attained; whilst the people, only domesticated brutes, were governed and amused by religious shows, that stand on record as the most egregious insult ever offered to the human understanding. Women were in a state of bondage; though the men, who gave way to the most unbridled excesses, even to the outraging of nature, expected that they should be chaste; and took the only method to render them so in such a depraved state of society, by ruling them with a rod of iron; making them, excepting the courtezans, merely household, breeding animals.

The state of slavery, likewise, of a large proportion of men, tended probably, more than any other circumstance, to degrade the whole circle of society. For whilst it gave that air of arrogance, which has falsely been called dignity, to one class, the other acquired the servile mien that fear always impresses on the relaxed countenance. It may be delivered, I should imagine, as an aphorism, that when one

leading principle of action is founded on injustice, it sophisticates the whole character.

In the systems of government of the ancients, in the perfection of the arts, and in the ingenious conjectures which supplied the place of science, we see, however, all that the human passions can do to give grandeur to the human character; but we only see the heroism that was the effect of passion, if we except Aristides.* For during this youth of the world, the imagination alone was cultivated, and the subordinate understanding merely exercised to regulate the taste, without extending to it's grand employ, the forming of principles.

The laws, made by ambition rather than reason, treated with contempt the sacred equality of man, anxious only to aggrandize, first the state and afterwards individuals: consequently, the civilization never extended beyond polishing the manners, often at the expence of the heart, or morals; for the two modes of expression have, I conceive, precisely the same signification, though the latter may have more extent. To what purpose then do semi-philosophers exultingly show, that the vices of one country are not the vices of another; as if this would prove, that morality has no solid foundation; when all their examples are taken from nations just emerging out of barbarism, regulating society on the narrow scale of opinions suggested by their passions, and the necessity of the moment? What, indeed, do these examples prove? Unless they be allowed to substantiate my observation, that civilization has hitherto been only a perfection of the arts; and a partial melioration of manners, tending more to embellish the superiour rank of society, than to improve the situation of all mankind. Sentiments were often noble, sympathies just—yet the life of most men of the first class was made up of a series of unjust acts, because the regulations thought expedient to cement society, did violence to natural justice. Venerable as age has rendered many of these regulations, cold substitutes for moral principles, it would be a kind of sacrilege not to strip them of their gothic vests. And where then will be found the man who will simply say— that a king can do no wrong; and that, committing the vilest crimes to sully his mind, his person still remains sacred?—Who will dare to assert, that the priest, who takes advantage of the dying fears of a vicious man, to cheat his heirs, is not more despicable than a highwayman?—or that obedience to parents should go one jot beyond the deference due to reason, enforced by affection?—And who will

coolly maintain, that it is just to deprive a woman, not to insist on her being treated as an outcast of society, of all the rights of a citizen, because her revolting heart turns from the man, whom, a husband only in name, and by the tyrannical power he has over her person and property, she can neither love nor respect, to find comfort in a more congenial or humane bosom? These are a few of the leading prejudices, in the present constitution of society, that blast the blossoms of hope, and render life wretched and useless—And, when such were tolerated, nay, reckoned sacred, who can find more than doubtful traces of the perfection of man in a system of association pervaded with such abuses? Voluptuousness alone softened the character down to tenderness of heart; and as taste was cultivated, peace was sought, rather because it was convenient, than because it was just. But, when war could not be avoided, men were hired by the rich to secure to them the quiet enjoyment of their luxuries; so that war, become a trade, did not render ferocious all those who directly, or indirectly waged it.

When, therefore, the improvements of civil life consisted almost entirely in polishing the manners, and exercising the transient sympathies of the heart, it is clear, that this partial civilization must have worn itself out by destroying all energy of mind. And the weakened character would then naturally fall back into barbarism, because the highest degree of sensual refinement violates all the genuine feelings of the soul, making the understanding the abject slave of the imagination. But, when the advances of knowledge shall make morality the real basis of social union, and not it's shadow the mask of selfishness, men cannot again lose the ground so surely taken, or forget principles, though they may accomplishments.

And that a civilization founded on reason and morality is, in fact, taking place in the world, will appear clear to all those, who have considered the atrocious vices and gigantic crimes, that sullied the polish of ancient manners. What nobleman, even in the states where they have the power of life and death, after giving an elegant entertainment, would now attract the detestation of his company, by ordering a domestic to be thrown into a pond to fatten the fish.[1]— What tyrant would dare, at this time, to poison his brother at his

[1] The cruelties of the half civilized romans, combined with their unnatural vices, even when literature and the arts were most cultivated, prove, that humanity is the offspring of the understanding, and that the progress of the sciences alone can make men wiser and happier.

own table; or stab his enemy's mother, not to mention his own, without colouring over the deed? and do not the exclamations against boxing matches, in England, also prove, that the amphitheatre would not now be tolerated, much less enjoyed? If the punishment of death be not yet abolished, tortures worse than twenty deaths are exploded, merely by the melioration of manners. A human being is not now forced to feed the lamp that consumes him; or allowed vainly to call for death, whilst the flesh is pinched off his quivering limbs. Are not, likewise, many of the vices, that formerly braved the face of day, now obliged to lurk, like beasts of prey, in concealment, till night allows them to roam at large. And the odium which now forces several vices, that then passed as merely the play of the imagination, to hide their heads, may chase them out of society, when justice is common to all, and riches no longer stand in the place of sense and virtue. Granting then to the ancients that savage grandeur of imagination, which, clashing with humanity, does not exclude tenderness of heart, we should guard against paying that homage to sentiment, only due to principles formed by reason.

Their tragedies, this is still but a cultivation of the passions and the taste, have been celebrated and imitated servilely; yet, touching the heart, they corrupted it; for many of the fictions, that produced the most striking stage effect, were absolutely immoral. The sublime terrour, with which they fill the mind, may amuse, nay, delight; but whence comes the improvement? Besides, uncultivated minds are the most subject to feel astonishment, which is often only another name for sublime sensations. What moral lesson, for example, can be drawn from the story of Oedipus, the favourite subject of such a number of tragedies?—The gods impel him on, and, led imperiously by blind fate, though perfectly innocent, he is fearfully punished, with all his hapless race, for a crime in which his will had no part.

Formerly kings and great men openly despised the justice they violated; but, at present, when a degree of reason, at least, regulates governments, men find it necessary to put a gloss of morality on their actions, though it may not be their spring. And even the jargon of crude sentiments, now introduced into conversation, shows to what side leans vanity, the true thermometer of the times.—An affectation of humanity is the affectation of the day; and men almost

always affect to possess the virtue, or quality, that is rising into estimation.

Formerly a man was safe only in one civilized patch of the globe, and even there his life hung by a thread. Such were the sudden vicissitudes, which, keeping the apprehension on the stretch, warmed the imagination, that clouded the intellect. At present a man may reasonably expect to be allowed tranquilly to follow any scientific pursuit; and when the understanding is calmly employed, the heart imperceptibly becomes indulgent. It is not the same with the cultivation of the arts. Artists have commonly irritable tempers; and, inflaming their passions as they warm their fancy, they are, generally speaking, licentious; acquiring the manners their productions tend to spread abroad, when taste, only the refinement of weakened sensations, stifles manly ardour.

Taste and refined manners, however, were swept away by hordes of uncivilized adventurers; and in Europe, where some of the seeds remained, the state of society slowly meliorating itself till the seventeenth century, nature seemed as much despised in the arts, as reason in the sciences. The different professions were much more knavish than at present, under the veil of solemn stupidity. Every kind of learning, as in the savage state, consisted chiefly in the art of tricking the vulgar, by impressing them with an opinion of powers, that did not exist in nature—The priest was to save their souls without morality; the physician to heal their bodies without medicine; and justice was to be administered by the immediate interposition of heaven:—all was to be done by a charm. Nothing, in short, was founded on philosophical principles; and the amusements being barbarous, the manners became formal and ferocious. The cultivation of the mind, indeed, consisted rather in acquiring languages, and loading the memory with facts, than in exercising the judgment; consequently, reason governed neither law, nor legislation; and literature was equally devoid of taste. The people were, strictly speaking, slaves; bound by feudal tenures, and still more oppressive ecclesiastical restraints; the lord of the domain leading them to slaughter, like flocks of sheep; and the ghostly father drawing the bread out of their mouths by the idlest impositions. The croisades, however, freed many of the vassals; and the reformation, forcing the clergy to take a new stand, and become more moral, and even wiser, produced a change of opinion, that soon appeared in

humanizing the manners, though not in improving the different governments.

But whilst all Europe was enslaved, suffering under the caprice or tyranny of despots, whose pride and restless ambition continually disturbed the tranquillity of their neighbours; the britons, in a great degree, preserved the liberty that they first recovered. This singular felicity was not more owing to the insular situation of their country, than to their spirited efforts; and national prosperity was the reward of their exertions. Whilst, therefore, englishmen were the only free people in existence, they appear to have been not only content, but charmed with their constitution; though perpetually complaining of the abuses of their government. It was then very natural, in such an elevated situation, for them to contemplate with graceful pride their comparative happiness; and taking for granted that it was the model of perfection, they never seem to have formed an idea of a system more simple, or better calculated to promote and maintain the freedom of mankind.

That system, so ingenious in theory, they thought the most perfect the human mind was capable of conceiving; and their contentions for it's support contributed more to persuade them, that they actually possessed an extensive liberty, and the best of all possible governments, than to secure the real possession. However, if it had no specific basis beside magna charta, till the habeas corpus act* passed; or before the revolution of 1688, but the temper of men; it is a sufficient demonstration, that it was a government resting on principles emanating from the consent, if not from the sense of the nation.

Whilst liberty had been consumed by the lascivious pleasures of the citizens of Venice and Genoa;*—corroded in Switzerland by a mercenary aristocracy;*—entombed in the dykes of the covetous Hollanders;*—driven out of Sweden by an association of the nobles;*—and hunted down in Corsica by the ambition of her neighbours;*—France was insensible to her value;—Italy, Spain, and Portugal, cowering under a contemptible bigotry,* which sapped the remains of the rude liberty they had enjoyed, formed no political plans;—and all Germany was not only enslaved, and groaning beneath the weight of the most insulting civil tyranny, but it's shackles were riveted by a redoubtable military phalanx.*— Despotism, in fact, had existed in that vast empire for a greater

length of time than in any other country;—whilst Russia stretched out her arms with mighty grasp, embracing Europe and Asia. Sullen as the amphibious bear of the north; and so chilled by her icy regions, as to be insensible to the charms of social life, she threatened alternate destruction to every state in her vicinity. Huge in her projects of ambition, as her empire is extensive, the despotism of her court seems as insatiable, as the manners of her boors are barbarous.—Arrived at that stage of civilization, when the grandeur and parade of a palace are mistaken for the improvement of manners, and the false glory of desolating provinces for wisdom and magnanimity, the tzarina would sooner have abandoned her favourite plan of imitating the conduct of Peter the great,* in labouring to civilize her kingdom, than have allowed freedom to find a firm seat in her dominions to assist her. She has vainly endeavoured, indeed, to make the sweet flowers of liberty grow under the poisonous shade of despotism; giving the russians a false taste for the luxuries of life before the attainment of it's conveniences. And this hasty attempt to alter the manners of a people has produced the worst effect on their morals: mixing the barbarism of one state of society, deprived of it's sincerity and simplicity, with the voluptuousness of the other, void of elegance and urbanity, the two extremes have prematurely met.

Thus pursued and mistaken, liberty, though still existing in the small island of England, yet continually wounded by the arbitrary proceedings of the british ministry, began to flap her wings, as if preparing for a flight to more auspicious regions—And the anglo-americans having carried with them to their place of refuge the principles of their ancestors, she appeared in the new world with renovated charms, and sober matron graces.

Freedom is, indeed, the natural and imprescriptible right of man; without the enjoyment of which, it is impossible for him to become either a reasonable or dignified being. Freedom he enjoys in a natural state, in it's full extent: but formed by nature for a more intimate society, to unfold his intellectual powers, it becomes necessary, for carrying into execution the main objects, which induces men to establish communities, that they should surrender a part of their natural privileges, more effectually to guard the most important.* But from the ignorance of men, during the infancy of society, it was easy for their leaders, by frequent usurpations, to create a despotism, which choking up the springs that would have invigorated their

minds, they seem to have been insensible to the deprivations under which they lived; and existing like mere animals, the tyrants of the world have continued to treat them only as machines to promote their purposes.

In the progress of knowledge, which however was very tardy in Europe, because the men who studied were content to see nature through the medium of books, without making any actual experiments themselves, the benefits of civil liberty began to be better understood: and in the same proportion we find the chains of despotism becoming lighter. Still the systematizing of pedants, the ingenious fallacy of priests, and the supercilious meanness of the literary sycophants of courts, who were the distinguished authors of the day, continued to perplex and confound the understandings of unlettered men. And no sooner had the republics of Italy* risen from the ashes of the roman jurisprudence, than their principles were attacked by the apostles of Machiavel,* and the efforts made for the revival of freedom were undermined by the insidious tenets which he gave to his prince.

The arts, it is true, were now recovering themselves, patronized by the family of the Medicis:* but the sciences, that is, whatever claimed the appellation, had still to struggle with aristotelean prejudices; till Descartes ventured to think for himself; and Newton,* following his example, explained the laws of motion and gravity, displaying the mechanism of the universe with wonderful perspicacity; for the analysis of ideas, which has since diffused such light through every branch of knowledge, was not before this period applied even to mathematics. The extension of analytical truths, including political, which at first were only viewed as splendid theories, now began to pervade every part of Europe; stealing into the very seminaries of learning in Germany, where formerly scholastic, dry theology, laborious compilations of the wanderings of the human understanding, and minute collations of the works of the ancients, had consumed the fervour of youth, and wasted the patience of age. The college and the court are always connected:—and literature beginning to attract the attention of several of the petty sovereigns of the empire, they were induced to patronize those daring men who were persecuted by the public for attacking religious or political prejudices; and allowing them an asylum at their courts,* they acquired a relish for their conversation. The amuse-

ments of the chace then yielding to the pleasures of colloquial disquisition on subjects of taste and morals, the ferocity of northern despotism began imperceptibly to wear away, and the condition of it's slaves to become more tolerable.

Education, in particular, has been studied; and the rational modes of instruction in useful knowledge, which are taking place of the exclusive attention formerly paid to the dead languages, promise to render the germans, in the course of half a century, the most enlightened people in Europe. Whilst their simplicity of manners, and honesty of heart are in a great degree preserved, even as they grow more refined, by the situation of their country; which prevents that inundation of riches by commercial sources, that destroys the morals of a nation before it's reason arrives at maturity.

Frederic the IId of Prussia,* with the most ardent ambition, was nevertheless as anxious to acquire celebrity as an author, as he was fame as a soldier. By writing an examination of Machiavel's Prince, and the encouragement he gave to literary talents and abilities, he contributed very much to promote the acquirement of knowledge in his dominions; whilst, by granting his confidence to the philosophical Hertzberg,* the administration of his government grew considerably milder.

His splendid reputation as a soldier continued to awe the restless ambition of the princes of the neighbouring states, which afforded an opportunity to the inhabitants of the empire to follow, during the reign of tranquillity, those literary pursuits, which became fashionable even at the half civilized court of Petersbourg.* It now, indeed, appeared certain, that Germany would gain in future important political advantages; for men were beginning to presume to think, and scanned the conduct of the supercilious Joseph* with freedom, treating his vanity with contempt.

It is by thus teaching men from their youth to think, that they will be enabled to recover their liberty; and useful learning is already so far advanced, that nothing can stop it's progress:—I say peremptorily nothing; for this is not the era hesitatingly to add, short of supernatural events. And though the unjustifiable proceeding of the english courts of justice, or rather of the arbitrary chief judge Mansfield,* who established it as a law precedent, that the greater the truth the greater the libel, tended materially to prevent the authors of the american war from being attacked for those tyrannical

steps, that ultimately tended to stop the progress of knowledge and the dissemination of political truth; yet the clamour which was raised against that unpopular war is a proof, that, if justice slept, liberty of thought had not forsaken the island.

The overweening presumption, however, of men ignorant of true political science; who beheld a nation prosperous beyond example, whilst all the neighbouring states were languishing, and knew not how to account for it; foolishly endeavouring to preserve this prosperity, by mad attempts to throw impediments in the way of those very principles, which had raised Great Britain to the elevated rank she has attained in Europe, served only to accelerate their diffusion. And France being the first among the nations on the continent, that had arrived at a civilization of manners, which they have termed the only art of living, we find was the first to throw off the yoke of her old prejudices.

It was at this crisis of things, that the despotism of France was completely overturned, and twenty-five millions of human beings unloosed from the odious bands, which had for centuries benumbed their faculties, and made them crouch under the most ignominious servitude*—And it now remains to observe the effect of this important revolution, which may fairly be dated from the taking of the Bastille.

FROM BOOK V, CHAPTER II

On the first of October,* in consequence of these fresh machinations, a magnificent entertainment was given in the name of the king's body-guards; but really by some of their principal officers, at the opera-house of the castle. The affectation of excluding the dragoons,* distinguished for their attachment to liberty, seemed to show, but too plainly, the end in view, rendered still more conspicuous by the unusual familiarity of persons of the first rank with the lowest soldiers.

When their heads were heated by a sumptuous banquet, by the tumult of an immense crowd, and the great profusion of delicious wines and *liqueurs*, the conversation, purposely turned into one channel, became unrestrained, and a chivalrous scene completed the folly. The queen, to testify her satisfaction for the homage paid to

her, and the wishes expressed in her favour, exhibited herself to this half-drunken multitude; carrying the dauphin in her arms, whom she regarded with a mixture of sorrow and tenderness, and seeming to implore in his favour the affection and zeal of the soldiers.

This acting, for it is clear that the whole was a preconcerted business, was still more intoxicating than the wine.—The exclamation *vive le roi, vive la reine*, resounded from all sides, and the royal healths were drunk over drawn swords, whilst that of the nation was rejected with contempt by the body-guards. The music, the choice could not have been the effect of chance, played the well known air—O Richard! O my king! the universe abandons thee![1] and during this moment of fascination some voices, perhaps bribed for the occasion, mingled execrations against the assembly. A grenadier even darted from the midst of his comrades, and accusing himself of having been unfaithful to his prince, endeavoured, several times, to plunge his sword into his bosom. His held arm was not indeed allowed to search for the disloyal heart; but some blood was permitted to flow—and this theatrical display of sensibility, carried to the highest pitch, produced emotions almost convulsive in the whole circle, of which an english reader can scarcely form an idea. The king, who is always represented as innocent, though always giving proofs that he more than connived at the attempts to recover his power, was likewise prevailed on to show himself at this entertainment. And some of the same soldiery. who had refused to second the former project of the cabal, were now induced to utter insults and menaces against the very authority, they then supported. 'The national cockade,' exclaimed Mirabeau, 'that emblem of the defenders of liberty, has been torn in pieces, and stamped under foot; and another ensign put in it's place.—Yes; even under the eye of the monarch, who allowed himself to be styled—*Restorer of the rights of his people*, they have dared to hoist a signal of faction.'*

The same scene was renewed two days after, though with less parade; and invitations for a similar treat were given for the following week.

The rumour respecting them, which reached Paris, contained many exaggerated circumstances; and was regarded as the com-

[1] 'O Richard, O mon roi,
L'univers t'abandonne!'*

mencement of fresh hostilities, on the part of the court. The cry now was, that the stunned aristocracy had again reared it's head; and that a number of old officers, chevaliers of St Louis,* had signed a promise to join the body-guards in a new attempt. This list was said to contain thirty thousand signatures; and idle as the tale was, it seemed to be confirmed by the appearance of white and black cockades, which inconsiderate individuals displayed at the risk of their lives. These, said the parisians, are the first indications of a projected civil war—the court wish only to have the king safe to head them before they speak out:—he ought, therefore, to be removed to Paris, inferred the politicians of the palais royal. The exasperating of the people in this manner was certainly the most absurd blundering folly that could have ruined a party, who apparently saw the necessity of dividing the people in order to conquer them. It was, in fact, a species of madness, and can be accounted for only by recollecting the ineffable contempt really felt by the court for the *canaille*,* which made them still imagine the revolution to be only a temporary convulsion, not believing it possible, in spite of the daily events, that they could be crushed by the mass they despised. Their presumption proceeded from their ignorance, and was incurable.

The queen was supposed to be at the head of this weak conspiracy, to withdraw the soldiery from siding with the people. She had presented colours to the national guards of Versailles, and when they waited on her to express their thanks, she replied, with the most winning affability, 'the nation and the army ought to be as well affected to the king as we ourselves are. I was quite charmed with what passed on thursday.'* This was the day of the feast.

A scarcity of bread, the common grievance of the revolution, aggravated the vague fears of the parisians, and made the people so desperate, that it was not difficult to persuade them to undertake any enterprize; and the torrent of resentment and enthusiasm required only to be directed to a point to carry every thing before it. Liberty was the constant watch word; though few knew in what it consisted.—It seems, indeed, to be necessary, that every species of enthusiasm should be fermented by ignorance to carry it to any height. Mystery alone gives full play to the imagination, men pursuing with ardour objects indistinctly seen or understood, because each man shapes them to his taste, and looks for something beyond even his own conception, when he is unable to form a just idea.

The parisians were now continually brooding over the wrongs they had heretofore only enumerated in a song; and changing ridicule into invective, all called for redress, looking for a degree of public happiness immediately, which could not be attained, and ought not to have been expected, before an alteration in the national character seconded the new system of government.

From the enjoyment of more freedom than the women of other parts of the world, those of France have acquired more independence of spirit than any others; it has, therefore, been the scheme of designing men very often since the revolution, to lurk behind them as a kind of safeguard, working them up to some desperate act, and then terming it a folly, because merely the rage of women, who were supposed to be actuated only by the emotions of the moment. Early then on the fifth of october a multitude of women by some impulse were collected together; and hastening to the *hôtel-de-ville* obliged every female they met to accompany them, even entering many houses to force others to follow in their train.

The concourse, at first, consisted mostly of market women, and the lowest refuse of the streets, women who had thrown off the virtues of one sex without having power to assume more than the vices of the other. A number of men also followed them, armed with pikes, bludgeons, and hatchets; but they were strictly speaking a mob, affixing all the odium to the appellation it can possibly import; and not to be confounded with the honest multitude, who took the Bastille.—In fact, such a rabble has seldom been gathered together; and they quickly showed, that their movement was not the effect of public spirit.

They first talked of addressing the committee appointed by the municipality to superintend the operations necessary to obtain provision for the city, and to remonstrate respecting their inattention or indifference to the public calamity. Mean time a new cord was fixed to the notorious lamp-iron, where the amusement of death was first tolerated. The national guards, forming a hedge of bayonets to prevent the women from entering the hotel, kept them in suspense a few moments.—When, uttering a loud and general cry, they hurled a volley of stones at the soldiers, who, unwilling, or ashamed, to fire on women, though with the appearance of furies, retreated into the hall, and left the passage free. They then sought for arms; and breaking open the doors of the magazines, soon procured fusils,

cannons, and ammunition; and even took advantage of the confusion to carry off money and notes belonging to the public. In the interim some went to search for the volunteers of the Bastille, and chose a commander from among them to conduct the party to Versailles; whilst others tied cords to the carriages of the cannons to drag them along.——But these, being mostly marine artillery, did not follow with the alacrity necessary to accord with their wishes; they, therefore, stopped several coaches, forcing the men to get out and the ladies to join them; fastening the cannons behind, on which a number of the most furious mounted, brandishing whatever weapon they had found, or the matches of the cannons. Some drove the horses, and others charged themselves with the care of the powder and ball, falling into ranks to facilitate their march. They took the road by the *Champs Elisées* about noon, to the number of four thousand, escorted by four or five hundred men, armed with every thing on which they could lay their hands.

Mean time the *tocsin* sounded from all parts; the french guards, still urged on by wounded pride, loudly declared, that the king ought to be brought to Paris; and many of the citizens, not on duty, concurred with the rest of the national guards in the same opinion, particularly those accustomed to attend the harangues at the Palais Royal. La Fayette, refusing to accompany, endeavoured to calm them. But finding, that the tumult increased, and that prayers were giving place to menaces, he offered to make known to the king, at their head, the wishes of the capital, if the municipality gave him orders to this effect. Their council was now assembled; yet prolonging the deliberation till between four and five o'clock in the afternoon, the people became so very impatient, that it was thought prudent to allow them to set out: and the exclamations of the populace proved how easy it was to govern, or lead them astray, by every fresh hope.

Few events have happened at Paris, that have not been attributed by the different parties to the machinations of the leaders on the other side; to blacken whose characters, when they had the upper hand, the most audacious falsehoods have been industriously circulated; the detection of which has induced many calm observers to believe, that all the accounts of plots and conspiracies were fabricated in the same manner; not considering , that even the universality of these suspicions was a proof of the intriguing character of the

people, who from a knowledge of themselves became thus mistrustful of others. It was currently reported, that very considerable sums had been distributed amongst the mob, before it marched to Versailles; and, though many fabulous stories of showers of gold have since been retailed by the credulous, this seems, from their subsequent conduct, to have had some foundation: for nothing like the heroism, the disinterestedness, appeared, which, in most other risings of the parisians, has formed a striking contrast with their barbarity; sometimes sufficient to oblige us, lamenting the delusions of ignorance, to give the soft name of enthusiasm to cruelty; respecting the intention, though detesting the effects. Now, on the contrary, acting like a gang of thieves, they gave colour to the report—that the first instigators of the riot were hired assassins.—And hired by whom?—The public voice repeats, on every side, the despicable duke of Orleans, whose immense estates had given him an undue influence in the bailliages,* and who still exercised all the means that cunning could devise, and wealth produce, to revenge himself on the royal family. He was particularly incensed against the queen, who having treated him with the contempt which he doubtless merited, and even influenced the king to banish him to one of his country seats, when he uttered some popular sentiments, he continued to nourish the most implacable hatred to her person, whilst the changing sentiments of the nation respecting the present branch of his family excited in him hopes, that would at once have gratified both his revenge and his ambition.

There is no calculating the mischief which may be produced by a revengeful cunning knave, possessing the forcible engine of gold to move his projects, and acting by agency, which, like a subterraneous fire, that for a long time has been putting the combustible matter into a state of fusion, bursts out unexpectedly, and the sudden eruption spreads around terrour and destruction.

The agents of despotism, and of vengeful ambition, employed the same means to agitate the minds of the parisians; and covered as they now are with foul stains, it is an acknowledgement due to their original good disposition, to note, that at this period they were so orderly it required considerable management to lead them into any gross irregularity of conduct. It was, therefore, necessary for the duke's instruments to put in motion a body of the most desperate women; some of whom were half famished for want of bread, which

had purposely been rendered scarce to facilitate the atrocious design of murdering both the king and queen in a broil, that would appear to be produced solely by the rage of famine.

The shameless manner in which the entertainment of the officers of the body-guards had been conducted; the indiscreet visit of the queen to interest the army in the cause of royalty, coming in artfully after the rabble of soldiers had been allowed to enter; together with the imprudent expressions of which she afterwards made use; served as pretexts, nay, may have been some of the causes of these women suspecting, that the dearth of bread in the capital was owing to the contrivance of the court, who had so often produced the same effect to promote their sinister purposes. They believed then, that the only sure way to remedy such a grievous calamity, in future, would be to implore the king to reside at Paris: and the national militia, composed of more orderly citizens, who thought the report of a premeditated escape was not without foundation, imagined, that they should nip a civil war in the bud, by preventing the king's departure, and separate him effectually from the cabal, to whom they attributed all his misconduct.

Whilst the multitude were advancing, the assembly were considering the king's reply to their request to sanction the declaration of rights, and the first articles of the constitution, before the supplies were granted. The reply was couched in terms somewhat vague, yet it's meaning could not be misunderstood.—He observed, that the articles of the constitution could be judged of only in their connection with the whole; nevertheless he thought it natural, that at the moment the nation was called upon to assist the government by a signal act of confidence and patriotism, they should expect to be reassured respecting their principal interest.—'Accordingly,' he continues, 'taking it for granted, that the first articles of the constitution, which you have presented to me, united to the completion of your labours, will satisfy the wishes of my people, and secure the happiness and prosperity of the kingdom, conformably to your desire I accept them; but with one positive condition, from which I will never depart; namely, that from the general result of your deliberations the executive power shall have it's entire effect in the hands of the monarch. Still it remains for me to assure you with frankness, that, if I give my sanction of acceptance to the several articles, which you have laid before me, it is not because they

indiscriminately give me an idea of perfection; but I believe it laudable in me to pay this respect to the wishes of the deputies of the nation, and to the alarming circumstances, which so earnestly press us to desire above all things the prompt re-establishment of peace, order, and confidence.

'I shall not deliver my sentiments of respecting your declaration of the rights of man and of citizens. It contains excellent maxims proper to direct your deliberations; but principles susceptible of application, and even of different interpretations, cannot be justly appreciated, and have only need of being so when their true sense is determined by the laws, to which they ought to be the basis.'*

In the subterfuge employed in this answer, the profound dissimulation of the king appears; and that 'pitiful respect for false honour,'* which makes a man boggle at a naked untruth, even when uttering a number of contemptible prevarications. Thus did he at first struggle against every concession, against granting any real freedom to the people; yet afterwards unable to maintain his ground, he impotently gave way before the storm he had raised, every time losing a part of the authority which depended on opinion.

The assembly manifested an universal discontent. One of the members remarked,* that the king withheld his acceptance of the declaration of rights; and only yielded to circumstances in accepting the constitutional articles: he, therefore, moved, that no taxes should be levied, before the declaration of rights and the constitution should be accepted, without any reservation.—Another asserted,* that the king's reply ought to have been counter-signed by one of the ministers. What an absurdity! yet the inviolability of the king standing in their way, it seemed to be necessary to secure ministerial responsibility, to render it null; not only to prevent the ministers from finding shelter behind it, but to make it utterly useless to the king, who was thus, literally speaking, reduced to a cipher. Mirabeau, however, after alluding with energy to the entertainment, which, out of derision, had been termed patriotic, made three or four motions. One was, 'that no act emanating from the king should be declared without the signature of a secretary of state.'—So inconsistent was the man, who argued with such eloquence for the absolute *veto*:—Another was, 'that his majesty would please to be explicit; and not by a conditional consent, extorted by circumstances, leave any doubt of his sincere concurrence in the mind of

the people.'* It was also noticed, to corroborate the inference, that the king was only yielding, for the moment, to opinions which he hoped to see exploded, that the decree for the circulation of grain had been altered before the publication, and the usual preamble, *for such is our pleasure*, formed a strange contrast with an acknowledgement of the legislative rights of the nation. Robespierre, particularly, maintained, that the nation had not any need of the assistance of the monarch to constitute itself—that the king's reply was not an acceptance, but a censure; and, consequently, an attack on the rights of the people.*

This seemed virtually the opinion of the assembly, though Mirabeau's soft style of expressing their will was adopted. It was particularly in this decision, that the deputies displayed a great degree of the weakness, which mistakes temerity for courage, and the shadow of justice for verity.—And affecting to say, to reconcile a contradiction, that the authority of kings is suspended as often as the sovereign is occupied in framing the elements of the constitution, or altering fundamental laws, they demonstrated the inconsistency of their own system, and acknowledged it's absurdity; which is still more flagrantly shown in Mirabeau's irrational declaration, that, 'by a pious fiction of the law, the king cannot himself deceive; but the grievances of the people demanding victims, these victims are the ministers.'*

At this juncture of the debate the tumultuous concourse of women arrived at Versailles: but it must not be unnoticed, that there was a number of men with them, disguised in women's clothes; which proves, that this was not, as has been asserted, a sudden impulse of necessity. There were besides men in their own garb armed like ruffians, with countenances answerable, who, swearing vengeance against the queen and the body-guards, seemed to be preparing to put their threats in execution. Some barbarians, volunteers in guilt, might perhaps have joined, spurred on solely by the hope of plunder, and a love of tumult; but it is clear, that the principal movers played a surer game.

The women had taken two routes; and one party, without arms, presented themselves at the gate of the assembly, whilst the other clustered round the palace waiting for them. The avenues were already filled with body-guards, the flanders regiment was drawn up in ranks; in short, the soldiers were gathered together quickly in one

quarter, though the people of Versailles were exceedingly alarmed, and particularly by the appearance of the vagabonds, who followed the female mob.

With some difficulty the women were prevailed on to allow a few to enter orderly into the assembly, with a spokesman to make known their demand; whilst crowds, taking refuge in the galleries from the rain, presented there the strange sight of pikes, fusils, and tremendous sticks bound with iron. Their orator represented the grievances of the people, and the necessity of continually providing for their subsistence: he expressed the concern of the parisians on account of the slow formation of the constitution, and attributed this delay to the opposition of the clergy. A bishop then presided in the absence of Mounier, the president, who had been dispatched by the assembly with their expostulatory petition to the king. A deputy, to spare him the embarrassment of a reply to the insinuation against his order, reprimanded the petitioner for calumniating that respectable body. He accordingly made an apology, yet justified himself by declaring, that he only reported the purport of the discontentment of Paris. They were informed, in reply, by the vice-president, that a deputation was already sent to the king, requesting his sanction of a decree to facilitate the interiour circulation of grain and flour: and finding, that it was impossible to attend to the business of the day, he adjourned the assembly, without waiting for the return of the president.

The women about the palace entered into conversation with the soldiers, some of whom said, 'that were the king to recover all his authority, the people would never want bread!' This indiscreet insinuation exasperated them; and they replied in the language, that is proverbial for being the most abusive. A fray also ensuing , brought on by a dispute relative to the affair of the cockades, one of the body-guards drew his sword, which provoked a national guard of Versailles to give him a blow with his musket, that broke his arm.

The national troops were eager to convince the mob, that they were equally offended at the disrespect paid to the emblem of liberty; and the flemish regiment, though they were in battle array, made the women let their rings drop into their guns, to be convinced that they were not charged: saying, 'It was true, they had drunk the wine of the body-guards; but what did that engage them to do? They had also cried, *vive le roi*, as the people themselves did every day;

and it was their intention to serve them faithfully, but not against the nation!'—with other speeches to the same effect;—adding, 'that one of their officers had ordered a thousand cockades; and they knew not why they were not distributed!' Enraged by the tenour of this discourse, a body-guard's man struck one of the soldiers talking thus, who, in return, fired on him, and fractured his arm. All was now confusion; and every thing tended to render the body-guards more odious to the populace.

The king arrived in the midst of it from hunting, and admitted at the same time the deputation from the national assembly, and an address from the women. He received the latter with great affability, testified his sorrow on account of the scarcity of bread at Paris, and immediately sanctioned the decree, relative to the free circulation of grain, which he had just received from the assembly. The woman who spoke, attempting to kiss his hand, he embraced her with politeness, and dismissed them in the most gentleman-like manner. They immediately rejoined their companions, charmed by the reception they had met with; and the king sent orders to the guards not to make use of their arms. The count d'Estaing,* the commander in chief, announced likewise to the militia of Versailles, that the body-guards would the next day take the oath of allegiance to the nation, and put on the patriotic cockade. 'They are not worthy,' was the indignant growl of the multitude.

Some women now returning to Paris, to report the gracious behaviour of the king, were unfortunately maltreated by a detachment of body-guards, commanded by a nobleman; and the volunteers of the Bastille coming to their assistance, two men, and three horses, were killed on the spot. These same irritated women meeting, likewise, the parisian militia, on their way to Versailles, gave them an exaggerated description of the conduct of the guards.

The court now taking the alarm, fearing that their plan would be defeated, by the king's being obliged to go to Paris, urged him immediately to set out for Metz,* and the carriages were actually prepared. It is scarcely credible that they would have gone so far without his concurrence.

One loaded coach had been permitted to go out of the gate; but the national troops beginning to suspect what was going forward, obliged it to re-enter. The king then, with his usual address, finding

his escape at that time impracticable, and not wishing to shed blood in forcing his way, made a merit of necessity, and declared he would rather perish than see the blood of frenchmen streaming in his quarrel! So easy is it for a man, versed in the language of duplicity, to impose on the credulous; and to impress on candid minds a belief of an opinion that they would gladly receive without any doubting allay, did not other circumstances more strongly contradict the persuasion. This declaration, however, which was re-echoed with great eagerness, was considered as a manifest proof of the purity of his intentions, and a mark of his fixed adherence to the cause which he affected to espouse. Yet, to prove the contrary, it is only necessary to observe, that he put off the acceptance of the declaration of rights, and the first articles of the constitution, till after the attempt to escape was frustrated: for it was near eleven o'clock* when he sent for the president, to put into his hands a simple acceptation, and to request him to convoke the assembly immediately, that he might avail himself of their counsel at this crisis; alarmed by the mob without, who, exposed to all the inclemency of the weather, it being a very wet and stormy night, were uttering the most horrid imprecations against the queen and the body-guards.

A drum instantly summoned the assembly; and La Fayette arriving with his army in less than an hour after, the president was again called for, who returned to the assembly with the king's assurance, that he had not even thought of leaving them, nor would he ever separate himself from the representatives of the people.

La Fayette had previously assured the king of the fidelity of the metropolis, and that he had been expressly sent by the municipality of Paris to guard his august person. A rumour had prevailed, ever since the arrival of the women, that the parisian militia were coming to second them; but as the *commune* of Paris* had not determined till late in the afternoon, the messenger from La Fayette to the palace could not have reached Versailles long before him: but the court supposing that they would come, and having heard of the wish of the parisians to bring the king to Paris, where they had always spies to give them the earliest notice of what was going forward, pressed him to set out without loss of time; still they were actuated solely by the desire of getting him away, and not from any apprehension that his life was in danger.

After tranquilizing the king, La Fayette joined the parisian militia in the avenue, to inform them, that the king had sanctioned the decree of the assembly for expediting the more speedy circulation of provisions; that he accepted, without any reservation, of the declaration of rights, with the first articles of the constitution, declaring at the same time his unshaken resolution to remain among his people; and that he consented also to have a detachment of the national troops of Paris to contribute to guard his person.

Joy now took place of dread at Versailles; and the citizens distributed their addresses amongst the soldiers, offering them lodgings; they having been previously requested, by the beating of a drum, to receive as many of the parisian militia as they possibly could. The rest, after passing several hours in arms round the palace, sought for shelter, as the morning began to dawn, in the churches. Every thing appearing quiet, the harassed king and queen were prevailed on to seek the repose they needed; and La Fayette, about five in the morning, retired to his chamber, to write to the municipality an account of his proceedings, before he likewise endeavoured to snatch a little rest.

Scarcely an hour after, the restless mob, great part of which had taken refuge in the hall and galleries of the assembly, began to prowl about. The most decent of the women, who had been pressed into the service, stole away during the night. The rest, with the whole gang of ruffians, rushed towards the palace, and finding its avenues unguarded, entered like a torrent; and some among them, most probably, conceived, that this was the moment to perpetrate the crime for which they had been drawn from their lurking-holes in Paris.

Insulting one of the body-guards who opposed their entrance, he fired, and killed a man. This was a fresh pretext for entering to search for the murderer, as he was termed by these rioters; and driving the guards before them up the grand stair-case, they began to break into the different apartments, vowing vengeance against the body-guards, in which were mingled the bitterest curses, all levelled at the queen.

Catching one unfortunate guard by himself, he was dragged down the stairs; and his head, instantly severed from his body, was mounted on a pike, which rather served to irritate than glut the fury of the monsters, who were still hunting after blood or plunder.

The most desperate found their way to the queen's chamber, and left for dead the man who courageously disputed their entrance. But she had been alarmed by the tumult, though the miscreants were not long in making their way good, and, throwing a wrapping-gown around her, ran, by a private passage, to the king's apartment, where she found the dauphin; but the king was gone in quest of her: he, however, quickly returning, they waited together in a horrid state of suspence. Several of the guards, who endeavoured to keep back the mob, were wounded; yet all this happened in a very short space of time.

The promptitude and rapidity of this movement, taking every circumstance into consideration, affords additional arguments in support of the opinion, that there had been a premeditated design to murder the royal family. The king had granted all they asked the evening before; sending away great part of the multitude delighted with his condescension; and they had received no fresh provocation to excite this outrage. The audacity of the most desperate mob has never led them, in the presence of a superiour force, to attempt to chastise their governors; and it is not even probable that banditti, who had been moved by the common causes of such insurrections, should have thought of murdering their sovereign, who, in the eyes of the greater number of frenchmen, was still shrouded by that divinity, tacitly allowed to hover round kings, much less have dared to attempt it.

La Fayette was quickly roused; and, sending his *aides-de-camp* to assemble the national guards, he followed the ruffians with equal celerity. They had actually forced the king's apartment at the moment he arrived; and the royal family were listening to the increasing tumult as the harbinger of death,—when all was hushed,—and the door opening a moment after, the national guards entered respectfully, saying they came to save the king;—'and we will save you too, gentlemen,' added they, addressing the body-guards, who were in the chamber.

The vagabonds were now pursued in their turn, and driven from room to room, in the midst of their pillage, for they had already begun to ransack that sumptuously furnished palace. From the palace they repaired to the stables, still intent on plunder, and carried away some horses, which were as quickly retaken. Every where they pursued the body-guards, and every where the generous

parisian troops, forgetting their piqued pride and personal animosity, hazarded their lives to save them.—Till, at length, order was perfectly established. . . .

FROM BOOK V, CHAPTER III

. . . The economy of government had been so ably treated by the writers of the present age, that it was impossible for them, acting on the great scale of public good, not to lay the foundations of many useful plans, as they reformed many grievous and grinding abuses.—Accordingly we find, though they had not sufficient penetration to foresee the dreadful consequences of years of anarchy, the probable result of their manner of proceeding, still by following, in some degree, the instructions of their constituents, who had digested, from the bright lines of philosophical truths, the prominent rules of political science, they, in laying the main pillars of the constitution, established beyond a possibility of obliteration, the great principles of liberty and equality.

It is allowed by all parties, that civilization is a blessing, so far as it gives security to person and property, and the milder graces of taste to society and manners. If, therefore, the polishing of man, and the improvement of his intellect, become necessary to secure these advantages, it follows, of course, that the more general such improvement grows, the greater the extension of human happiness.

In a savage state man is distinguished only by superiority of genius, prowess, and eloquence. I say eloquence, for I believe, that in this stage of society he is most eloquent, because most natural. For it is only in the progress of governments, that hereditary distinctions, cruelly abridging rational liberty, have prevented man from rising to his just point of elevation, by the exercise of his improveable faculties.

That there is a superiority of natural genius among men does not admit of dispute; and that in countries the most free there will always be distinctions proceeding from superiority of judgment, and the power of acquiring more delicacy of taste, which may be the effect of the peculiar organization, or whatever cause produces it, is an incontestible truth. But it is a palpable errour to suppose, that men of every class are not equally susceptible of common improve-

ment: if therefore it be the contrivance of any government, to preclude from a chance of improvement the greater part of the citizens of the state, it can be considered in no other light than as a monstrous tyranny, a barbarous oppression, equally injurious to the two parties, though in different ways. For all the advantages of civilization cannot be felt, unless it pervades the whole mass, humanizing every description of men—and then it is the first of blessings, the true perfection of man.

The melioration of the old government of France arose entirely from a degree of urbanity acquired by the higher class, which insensibly produced, by a kind of natural courtesy, a small portion of civil liberty. But, as for political liberty, there was not the shadow of it; or could it ever have been generated under such a system: because, whilst men were prevented not only from arriving at public offices, or voting for the nomination of others to fill them, but even from attaining any distinct idea of what was meant by liberty in a practical sense, the great bulk of the people were worse than savages; retaining much of the ignorance of barbarians, after having poisoned the noble qualities of nature by imbibing some of the habits of degenerate refinement. To the national assembly it is, that France is indebted for having prepared a simple code of instruction, containing all the truths necessary to give a comprehensive perception of political science; which will enable the ignorant to climb the mount of knowledge, whence they may view the ruins of the ingenious fabric of despotism, that had so long disgraced the dignity of man by it's odious and debasing claims.

The declaration of rights contains an aggregate of principles the most beneficial; yet so simple, that the most ordinary capacity cannot fail to comprehend their import. It begins by asserting, that the rights of men are equal, and that no distinctions can exist in a wholesome government, but what are founded on public utility. Then showing, that political associations are intended only for the preservation of the natural and imprescriptible rights of man, which are his liberty, security of property, and resistance against oppression; and asserting also, that the nation is the source of all sovereignty; it delineates, in a plain and perspicuous manner, in what these rights, and this sovereignty, consist. In this delineation men may learn, that, in the exercise of their natural rights, they have the power of doing whatever does not injure another; and that this

power has no limits, which are not determined by law—the laws being at the same time an expression of the will of the community, because all the citizens of the state, either personally, or by their representatives, have a right to concur in the formation.

Thus, having taught the citizens the fundamental principles of a legitimate government, it proceeds to show how the opinion of each may be ascertained; which he has a right to give personally, or by his representatives, to determine the necessity of public contributions, their appropriation, mode of assessment, and duration.

The simplicity of these principles, promulged by the men of genius of the last and present ages, and their justness, acknowledged by every description of unprejudiced men, had not been recognised by any senate or government in Europe; and it was an honour worthy to be reserved for the representatives of twenty-five millions of men, rising to the sense and feeling of rational beings, to be the first to dare to ratify such sacred and beneficial truths—truths, the existence of which had been eternal; and which required only to be made known, to be generally acknowledged—truths, which have been fostered by the genius of philosophy, whilst hereditary wealth and the bayonet of despotism have continually been opposed to their establishment.

The publicity of a government acting conformably to the principles of reason, in contradistinction to the maxims of oppression, affords the people an opportunity, or at least a chance, of judging of the wisdom and moderation of their ministers; and the eye of discernment, when permitted to make known it's observations, will always prove a check on the profligacy or dangerous ambition of aspiring men.—So that in contemplating the extension of representative systems of polity, we have solid ground on which to rest the expectation—that wars and their calamitous effects will become less frequent, in proportion as the people, who are obliged to support them with their sweat and blood, are consulted respecting their necessity and consequences.

Such consultations can take place under representative systems of government only—under systems which demand the responsibility of their ministers, and secure the publicity of their political conduct. The mysteries of courts, and the intrigues of their parasites, have continually deluged Europe with the blood of it's most worthy and heroic citizens, and there is no specific cure for such evils, but by

enabling the people to form and opinion respecting the subject of dispute.

The court of Versailles, with powers the most ample, was the most busy and insidious of any in Europe; and the horrours which she has occasioned, at different periods, were as incalculable, as her ambition was unbounded, and her councils base, unprincipled, and dishonourable. If, then, it were only for abolishing her sway, Europe ought to be thankful for a change, that, by altering the political systems of the most improved quarter of the globe, must ultimately lead to universal freedom, virtue, and happiness.

But it is to be presumed, when the effervescence, which now agitates the prejudices of the whole continent, subsides, the justness of the principles brought forward in the declaration of the rights of men and citizens will be generally granted; and that governments, in future, acquiring reason and dignity, feeling for the sufferings of the people, whilst reprobating the sacrilege of tyranny, will make it their principal object, to counteract it's baneful tendency, by restraining within just bounds the ambition of individuals.

BOOK V, CHAPTER IV

People thinking for themselves have more energy in their voice, than any government, which it is possible for human wisdom to invent; and every government not aware of this sacred truth will, at some period, be suddenly overturned. Whilst men in a savage state preserve their independence, they adopt no regular system of policy, nor ever attempt to digest their rude code of laws into a constitution, to ensure political liberty. Consequently we find in every country, after it's civilization has arrived at a certain height, that the people, the moment they are displeased with their rules, begin to clamour against them; and, finally rejecting all authority but their own will, in breaking the shackles of folly or tyranny, they glut their resentment by the mischievous destruction of the works of ages, only considering them as the moments of their servitude.

From the social disposition of man, in proportion as he becomes civilized, he will mingle more and more with society. The first interest he takes in the business of his fellow-men is in that of his neighbour; next he contemplates the comfort, misery, and happi-

ness of the nation to which he belongs, investigates the degree of wisdom and justice in the political system, under which he lives, and, striding into the regions of science, his researches embrace all human kind. Thus he is enabled to estimate the portion of evil or good which the government of his country produces, compared with that of others; and the comparison, granting him superior powers of mind, leads him to conceive a model of a more perfect form.

This spirit of inquiry first manifests itself in hamlets; when his views of improvement are confined to local advantages: but the approximation of different districts leading to further intercourse, roads of communication are opened, until a central or favourite spot becomes the vortex of men and things. Then the rising spires, pompous domes, and majestic monuments, point out the capital; the focus of information, the reservoir of genius, the school of arts, the seat of voluptuous gratification, and the hot-bed of vice and immorality.

The centrifugal rays of knowledge and science now stealing through the empire, the whole intellectual faculties of man partake of their influence, and one general sentiment governs the civil and political body. In the progress of these improvements the state undergoing a variety of changes, the happiness or misery produced occasions a diversity of opinions; and to prevent confusion, absolute governments have been tolerated by the most enlightened part of the people. But, probably, this toleration was merely the effect of the strong social feelings of men; who preferred tranquillity, and the prosperity of their country, to a resistance, which, judging from the ignorance of their fellow citizens, they believed would bring more harm than good in it's train. In short, however long a combination of tyranny has retarded the progress, it has been one of the advantages of the large cities of Europe, to light up the sparks of reason, and to extend the principles of truth.

Such is the good and evil flowing from the capitals of states, that during the infancy of governments, though they tend to corrupt and enervate the mind, they accelerate the introduction of science, and give the tone to the national sentiments and taste.

But this influence is extremely gradual; and it requires a great length of time, for the remote corners of the empire to experience either the one, or the other of these effects. Hence we have seen the

inhabitants of a metropolis feeble and vitiated, and those of the provinces robust and virtuous. Hence we have seen oppositions in a city (riots as they are called) to illegal governments instantly defeated, and their leaders hanged or tortured; because the judgment of the state was not sufficiently matured to support the struggle of the unhappy victims in a righteous cause. And hence it has happened, that the despots of the world have found it necessary to maintain large standing armies, in order to counteract the effects of truth and reason.

The continuation of the feudal system, however, for a great length of time, by giving an overgrown influence to the nobility of France, had contributed, in no small degree, to counteract the despotism of her kings. Thus it was not until after the arbitrary administration of Richelieu, who had terrified the whole order by a tyranny peculiar to himself, that the insidious Mazarine broke the independent spirit of the nation by introducing the sale of honours;* and that Louis XIV, by the magnificence of his follies, and the meretricious decorations of stars, crosses, and other marks of distinction, or badges of slavery, drew the nobles from their castles; and, by concentrating the pleasures and wealth of the kingdom in Paris, the luxury of the court became commensurate to the product of the nation. Besides, the encouragement given to enervating pleasures, and the vebality of titles, purchased either with money, or ignoble services, soon rendered the nobility as notorious for effeminacy as they had been illustrious for heroism in the days of the gallant Henry.*

The arts had already formed a school, and men of science and literature were hurrying from every part of the kingdom to the metropolis, in search of employment and of honour; and whilst it was giving it's tone to the empire, the parisian taste was pervading Europe.

The vanity of leading the fashions, in the higher orders of society, is not the smallest weakness produced by the sluggishness into which people of quality naturally fell. The depravity of manners, and the sameness of pleasure, which compose a life of idleness, are sure to produce an insupportable *ennui*; and, in proportion to the stupidity of the man, or as his sensibility becomes deadened, he has recourse to variety, finding a zest only from a new creation of charms; and commonly the most unnatural are necessary to rouse

sickly, fastidious senses. Still in the same degree as the refinement of sentiment, and the improvement of taste advance, the company of celebrated literary characters is sought after with avidity; and from the prevalence of fashion, the empire of wit succeeds the reign of formal insipidity, after the squeamish palate has been rendered delicate even by the nauseous banquets of voluptuousness.

This is the natural consequence of the improvement of manners, the harbinger of reason; and from the ratio of it's advancement throughout society, we are enabled to estimate the progress of political science. For no sooner had the disquisition of philosophical subjects become general in the select parties of amusement, extending by degrees to every class of society, than the rigour of the ancient government of France began to soften; till it's mildness became so considerable, that superficial observers have attributed the exercise of lenity in the administration to the wisdom and excellence of the system itself.

A confederacy of philosophers, whose opinions furnished the food of colloquial entertainment, gave a turn for instructive and useful reading to the leaders of circles, and drew the attentions of the nation to the principles of political and civil government. Whilst by the compilation of the Encyclopedia,* the repository of their thoughts, as an abstract work, they eluded the dangerous vigilance of absolute ministers; thus in a body disseminating those truths in the economy of finance, which, perhaps, they would not have had sufficient courage separately to have produced in individual publications; or, if they had, they would most probably have been suppressed.

This is one of the few instances of an association of men becoming useful, instead of being cramped by joint exertions. And the cause is clear:—the work did not require a little party spirit; but each had a distinct subject of investigation to pursue with solitary energy. His destination was traced upon a calm sea, which could not expose him to the Scylla or Charybdis* of vanity or interest.

The economists,* carrying away the palm from their opponents, showed that the prosperity of a state depends on the freedom of industry; that talents should be permitted to find their level; that the unshackling of commerce is the only secret to render it flourishing, and answer more effectually the ends for which it is politically necessary; and that the imposts should be laid upon the surplus

remaining, after the husbandman has been reimbursed for his labour and expences.

Ideas so new, and yet so just and simple, could not fail to produce a great effect on the minds of frenchmen; who, constitutionally attached to novelty and ingenious speculations, were sure to be enamoured with a prospect of consolidating the great advantages of such a novel and enlightened system; and without calculating the danger of attacking old prejudices; nay, without ever considering, that it was a much easier task to pull down than to build up, they gave themselves little trouble to examine the gradual steps by which other countries have attained their degree of political improvement.

The many vexatious taxes, which under the french government not only enervated the exertions of unprivileged persons, stagnating the live stream of trade, but were extremely teasing, inconveniences to every private man, who could not travel from one place to another without being stopped at barriers, and searched by officers of different descriptions, were almost insuperable impediments in the way of the improvements of industry: and the abridgment of liberty was not more grievous in it's pecuniary consequences, than in the personal mortification of being compelled to observe regulations as troublesome as they were at variance with sound policy.

Irritations of the temper produce more poignant sensations of disgust than serious injuries. Frenchmen, indeed, had been so long accustomed to these vexatious forms, that, like the ox who is daily yoked, they were no longer galled in spirit, or exhaled their angry ebullitions in a song. Still it might have been supposed, that after reflecting little, and talking much, about the sublimity and superiour excellence of the plans of *french* writers above those of other nations, they would become as passionate for liberty, as a man restrained by some idle religious vow is to possess a mistress, to whose charms the imagination has lent all it's own world of graces.

Besides, the very manner of living in France gives a lively turn to the character of the people; for by the destruction of the animal juices, in dressing their food, they are subject to none of that dulness, the effect of more nutritive diet in other countries; and this gaiety is increased by the moderate quantity of weak wine, which they drink at their meals, bidding defiance to phlegm. The people also living entirely in villages and towns are more social; so that the tone of the capital, the instant it had a note distinct from that of the

court, became the key of the nation; though the inhabitants of the provinces polished their manners with less danger to their morals, or natural simplicity of character. But this mode of peopling the country tended more to civilize the inhabitants, than to change the face of the soil, or lead to agricultural improvements. For it is by residing in the midst of their land, that farmers make the most of it, in every sense of the word—so that the rude state of husbandry, and the awkwardness of the implements used by these ingenious people, may be imputed solely to this cause.

The situation of France was likewise very favourable for collecting the information, acquired in other parts of the world. Paris, having been made a thoroughfare to all the kingdoms on the continent, received in it's bosom strangers from every quarter; and itself resembling a full hive, the very drones buzzed into every corner all the sentiments of liberty, which it is possible for a people to possess, who have never been enlightened by the broad sunshine of freedom; yet more romantically enthusiastic, probably, for that very reason. Paris, therefore, having not only disseminated information, but presented herself as a bulwark to oppose the despotism of the court, standing the brunt of the fray, seems with some reason, to pride herself on being the author of the revolution.

Though the liberty of the press had not existed in any part of the world, England and America excepted, still the disquisition of political questions had long occupied the intelligent parts of Europe; and in France, more than in any other country, books written with licentious freedom were handed from house to house, with the circumspection that irritates curiosity. Not to lay great stress on the universality of the language, which made one general opinion on the benefits arising from the advancement of science and reason pervade the neighbouring states, particularly Germany; where original compositions* began to take place of that laborious erudition, which being employed only in the elucidation of ancient writers, the judgment lies dormant, or is merely called into action to weigh the import of words rather than to estimate the value of things. In Paris, likewise, a knot of ingenious, if not profound writers,* twinkled their light into every circle; for being caressed by the great, they did not inhabit the homely recesses of indigence, rusticating their manners as they cultivated their understandings; on the contrary, the finesse required to convey their free sentiments in

their books, broken into the small shot of innuendoes, gave an oiliness to their conversation, and enabled them to take the lead at tables, the voluptuousness of which was grateful to philosophers, rather of the epicurean than the stoic sect.

It had long been the fashion to talk of liberty, and to dispute on hypothetical and logical points of political economy; and these disputations disseminated gleams of truth, and generated more demagogues than had ever appeared in any modern city.—The number exceeded, perhaps, any comparison with that of Athens itself.

The habit also of passing a part of most of their evenings at some theatre gave them an ear for harmony of language, and a fastidious taste for sheer declamation, in which a sentimental jargon extinguishes all the simplicity and fire of passion: the great number of play-houses,[1] and the moderate prices of the pit and different ranges of boxes, bringing it within the compass of every citizen to frequent the amusement so much beloved by the french.

The arrangement of sounds, and the adjustment of masculine and feminine rhymes, being the secrets of their poetry, the pomp of diction gives a semblance of grandeur to common observations and hackneyed sentiments; because the french language, though copious in the phrases that give each shade of sentiment, has not, like the italian, the english, the german, a phraseology peculiar to poetry; yet it's happy turns, equivocal, nay even concise expressions, and numerous epithets, which, when ingeniously applied, convey a sentence, or afford matter for half a dozen, make it better adapted to oratorical flourishes than that of any other nation. The french therefore are all rhetoricians, and they have a singular fund of superficial knowledge, caught in the tumult of pleasure from the shallow stream of conversation; so that if they have not the depth of thought which is obtained only by contemplation, they have all the shrewdness of sharpened wit; and their acquirements are so near their tongue's end, that they never miss an opportunity of saying a pertinent thing, or tripping up, by a smart retort, the arguments with which they have not strength fairly to wrestle.

Every political good carried to the extreme must be productive of evil; yet every poison has it's antidote; and there is a pitch of luxury and refinement, which, when reached, will overturn all the absolute

[1] There are upwards of thirty scattered throughout the city.

governments in the world. The ascertainment of these antidotes is a task the most dificult; and whilst it remains imperfect, a number of men will continue to be the victims of mistaken applications. Like the empirics, who bled a patient to death to prevent a mortification from becoming fatal, the tyrants of the earth have had recourse to cutting off the heads, or torturing the bodies, of those persons who have attempted to check their sway, or doubt their omnipotence. But, though thousands have perished the victims of empirics, and of despots, yet the improvements made both in medicine and moral philosophy have kept a sure, though gradual pace.—And, if men have not clearly discovered a specific remedy for every evil, physical, moral, and political, it is to be presumed, that the accumulation of experimental facts will greatly tend to lessen them in future.

Whilst, therefore, the sumptuous galas of the court of France were the grand source of the refinement of the arts, taste became the antidote of *ennui*; and when sentiments had taken place of chivalrous and gothic tournaments, the reign of philosophy succeeded that of the imagination. And though the government, enveloped in precedents, adjusted still the idle ceremonials, which were no longer imposing, blind to the imperceptible change of things and opinions, as if their faculties were bound by an eternal frost, the progress was invariable; till, reaching a certain point, Paris, which from the particular formation of the empire had been such an useful head to it, began to be the cause of dreadful calamities, extending from individuals to the nation, and from the nation to Europe. Thus it is, that we are led to blame those, who insist, that, because a state of things has been productive of good, it is always respectable; when, on the contrary, the endeavouring to keep alive any hoary establishment, beyond it's natural date, is often pernicious and always useless.

In the infancy of governments, or rather of civilization, courts seem to be necessary to accelerate the improvement of arts and manners, to lead to that of science and morals. Large capitals are the obvious consequences of the riches and luxury of courts; but as, after they have arrived at a certain magnitude and degree of refinement, they become dangerous to the freedom of the people, and incompatible with the safety of a republican government, it may be questioned whether Paris will not occasion more disturbance in settling the new order of things, than is equivalent to the good she produced by accelerating the epocha of the revolution.

However, it appears very certain, that should a republican government be consolidated, Paris must rapidly crumble into decay. It's rise and splendour were owing chiefly, if not entirely, to the old system of government; and since the foundation of it's luxury has been shaken, and it is not likely that the disparting structure will ever again rest securely on it's basis, we may fairly infer, that, in proportion as the charms of solitary reflection and agricultural recreations are felt, the people, by leaving the villages and cities, will give a new complexion to the face of the country—and we may then look for a turn of mind more solid, principles more fixed, and a conduct more consistent and virtuous.

The occupations and habits of life have a wonderful influence on the forming mind; so great, that the superinductions of art stop the growth of the spontaneous shoots of nature, till it is difficult to distinguish natural from factitious morals and feelings; and as the energy of thinking will always proceed, in a great measure, either from our education or manner of living, the frivolity of the french character may be accounted for, without taking refuge in the old hiding place of ignorance—occult causes.

When it is the object of education to prepare the pupil to please every body, and of course to deceive, accomplishments are the one thing needful; and the desire to be admired ever being uppermost, the passions are subjugated, or all drawn into the whirlpool of egotism.[1] This gives to each person, however different the temper, a tincture of vanity, and that weak vacillation of opinion, which is incompatible with what we term character.

Thus a frenchman, like most women, may be said to have no character distinguishable from that of the nation; unless little shades, and casual lights, be allowed to constitute an essential characteristic. What then could have been expected, when their ambition was mostly confined to dancing gracefully, entering a room with easy assurance, and smiling on and complimenting the very persons whom they meant to ridicule at the next fashionable assembly? The learning to fence with skill, it is true, was useful to a people, whose false notions of honour required that at least a drop of blood should atone for the shadow of an affront. The knack also of uttering

[1] I use this word according to the french acceptation, because we have not one to express so forcibly the same signification.*

sprightly repartees became a necessary art, to supply the place of that real interest only to be nourished in the affectionate intercourse of domestic intimacy, where confidence enlarges the heart it opens. Besides, the desire of eating dish at table, no matter if there were fifty, and the custom of separating immediately after the repast, destroy the social affections, reminding a stranger of the vulgar saying—'every man for himself, and God for us all.'* After these cursory observations, it is not going too far to advance, that the french were in some respects the most unqualified of any people in Europe to undertake the important work in which they are embarked.

Whilst pleasure was the sole object of living among the higher orders of society, it was the business of the lower to give life to their joys, and convenience to their luxury. This cast-like division, by destroying all strength of character in the former, and debasing the latter to machines, taught frenchmen to be more ingenious in their contrivances for pleasure and show, than the men of any other country; whilst, with respect to the abridgment of labour in the mechanic arts, or to promote the comfort of common life, they were far behind. They had never, in fact, acquired an idea of that independent, comfortable situation, in which contentment is sought rather than happiness; because the slaves of pleasure or power can be roused only by lively emotions and extravagant hopes. Indeed they have no word in their vocabulary to express *comfort**— that state of existence, in which reason renders serene and useful the days, which passion would only cheat with flying dreams of happiness.

A change of character cannot be so sudden as some sanguine calculators expect: yet by the destruction of the rights of primogeniture, a greater degree of equality of property is sure to follow; and as Paris cannot maintain it's splendour, but by the trade of luxury, which can never be carried to the same height it was formerly, the opulent having strong motives to induce them to live more in the country, they must acquire new inclinations and opinions.—As a change also of the system of education and domestic manners will be a natural consequence of the revolution, the french will insensibly rise to a dignity of character far above that of the present race; and then the fruit of their liberty, ripening gradually, will have a relish not to be expected during it's crude and forced state.

The late arrangement of things seems to have been the common effect of an absolute government, a domineering priesthood, and a great inequality of fortune; and whilst it completely destroyed the most important end of society, the comfort and independence of the people, it generated the most shameful depravity and weakness of intellect; so that we have seen the french engaged in a business the most sacred to mankind, giving, by their enthusiasm, splendid examples of their fortitude at one moment, and at another, by their want of firmness and deficiency of judgment, affording the most glaring and fatal proofs of the just estimate, which all nations have formed of their character.

Men so thoroughly sophisticated, it was to be supposed, would never conduct any business with steadiness and moderation: but it required a knowledge of the nation and their manners, to form a distinct idea of their disgusting conceit and wretched egotism; so far surpassing all the calculations of reason, that, perhaps, should not a faithful picture be now sketched, posterity would be at loss to account for their folly; and attribute to madness, what arose from imbecility.

The natural feelings of man seldom become so contaminated and debased as not sometimes to let escape a gleam of the generous fire, an ethereal spark of the soul; and it is these glowing emotions, in the inmost recesses of the heart, which have continued to feed feelings, that on sudden occasions manifest themselves with all their pristine purity and vigour. But, by the habitual slothfulness of rusty intellects, or the depravity of the heart, lulled into hardness on the lascivious couch of pleasure, those heavenly beams are obscured, and man appears either an hideous monster, a devouring beast; or a spiritless reptile, without dignity or humanity.

Those miserable wretches who crawl under the feet of others are seldom to be found among savages, where men accustomed to exercise and temperance are, in general, brave, hospitable, and magnanimous; and it is only as they surrender their rights, that they lose those noble qualities of the heart. The ferocity of the savage is of a distinct nature from that of the degenerate slaves of tyrants. One murders from mistaken notions of courage; yet he respects his enemy in proportion to his fortitude, and contempt of death: the other assassinates without remorse, whilst his trembling nerves betray the weakness of his affrighted soul at every appearance of

danger. Among the former, men are respected according to their abilities; consequently idle drones are driven out of this society; but among the latter, men are raised to honours and employments in proportion as a talent for intrigue, the sure proof of littleness of mind, has rendered them servile. The most melancholy reflections are produced by a retrospective glance over the rise and progress of the governments of different countries, when we are compelled to remark, that flagrant follies and atrocious crimes have been more common under the governments of modern Europe, than in any of the ancient nations, if we except the jews. Sanguinary tortures, insidious poisonings, and dark assassinations, have alternately exhibited a race of monsters in human shape, the contemplation of whose ferocity chills the blood, and darkens every enlivening expectation of humanity: but we ought to observe, to reanimate the hopes of benevolence, that the perpetration of these horid deeds has arisen from a despotism in the government, which reason is teaching us to remedy. Sometimes, it is true, restrained by an iron police, the people appear peaceable, when they are only stunned; so that we find, whenever the mob has broken loose, the fury of the populace has been shocking and calamitous. These considerations account for the contradictions in the french character, which must strike a stranger: for robberies are very rare in France, where daily frauds and sly pilfering prove, that the lower class have as little honesty as sincerity. Besides, murder and cruelty almost always show the dastardly ferocity of fear in France; whilst in England, where the spirit of liberty has prevailed, it is useful for an highwayman, demanding your money, not only to avoid barbarity, but to behave with humanity, and even complaisance.

Degeneracy of morals, with polished manners, produces the worst of passions, which floating through the social body, the genial current of natural feelings has been poisoned; and, committing crimes with trembling inquietude, the culprits have not only drawn on themselves the vengeance of the law, but thrown an odium on their nature, that has blackened the face of humanity. And whilst it's temple has been sacrilegiously profaned by the drops of blood, which have issued from the very hearts of the sad victims of their folly; a hardness of temper, under the veil of sentiment, calling it vice, has prevented our sympathy from leading us to examine into

the sources of the atrocity of our species, and obscured the true cause of disgraceful and vicious habits.

Since the existence of courts, whose aggrandisement has been conspicuous in the same degree as the miseries of the debased people have accumulated, the convenience and comfort of men have been sacrificed to the ostentatious display of pomp and ridiculous pageantry. For every order of men, from the beggar to the king, has tended to introduce that extravagance into society, which equally blasts domestic virtue and happiness. The prevailing custom of living beyond their income has had the most baneful effect on the independence of individuals of every class in England, as well as in France; so that whilst they have lived in habits of idleness, they have been drawn into excesses, which, proving ruinous, produced conse-quences equally pernicious to the community, and degrading to the private character. Extravagance forces the peer to prostitute his talents and influence for a place, to repair his broken fortune; and the country gentleman becomes venal in the senate, to enable him-self to live on a par with him, or reimburse himself for the expences of electioneering, into which he was led by sheer vanity. The profes-sions, on the same account, become equally unprincipled. The one, whose characteristic ought to be integrity, descends to chicanery; whilst another trifles with the health, of which it knows all the importance. The merchant likewise enters into speculations so closely bordering on fraudulency, that common straight forward minds can scarcely distinguish the devious art of selling any thing for a price far beyond that necessary to ensure a just profit, from sheer dishonesty, aggravated by hard-heartedness, when it is to take advantage of the necessities of the indigent.

The destructive influence of commerce, it is true, carried on by men who are eager by overgrown riches to partake of the respect paid to nobility, is felt in a variety of ways. The most pernicious, perhaps, is it's producing an aristocracy of wealth, which degrades mankind, by making them only exchange savageness for tame servil-ity, instead of acquiring the urbanity of improved reason. Com-merce also, overstocking a country with people, obliges the majority to become manufacturers rather than husbandmen; and then the division of labour, solely to enrich the proprietor, renders the mind entirely inactive. The time which, a celebrated writer says,* is saun-

tered away, in going from one part of an employment to another, is the very time that preserves the man from degenerating into a brute; for every one must have observed how much more intelligent are the blacksmiths, carpenters, and masons in the country, than the journeymen in great towns; and, respecting morals, there is no making a comparison. The very gait of the man, who is his own master, is so much more steady than the slouching step of the servant of a servant, that it is unnecessary to ask which proves by his actions he has the most independence of character.

The acquiring of a fortune is likewise the least arduous road to pre-eminence, and the most sure; thus are whole knots of men turned into machines, to enable a keen speculator to become wealthy; and every noble principle of nature is eradicated by making a man pass his life in stretching wire, pointing a pin, heading a nail, or spreading a sheet of paper on a plain surface. Besides, it is allowed, that all associations of men render them sensual, and consequently selfish; and whilst lazy friars are driven out of their cells as stagnate bodies that corrupt society, it may admit of a doubt whether large work-shops do not contain men equally tending to impede that gradual progress of improvement, which leads to the perfection of reason, and the establishment of rational equality.

The deprivation of natural, equal, civil and political rights, reduced the most cunning of the lower orders to practice fraud, and the rest to habits of stealing, audacious robberies, and murders. And why? because the rich and poor were separated into bands of tyrants and slaves, and the retaliation of slaves is always terrible. In short, every sacred feeling, moral and divine, has been obliterated, and the dignity of man sullied, by a system of policy and jurisprudence as repugnant to reason, as at variance with humanity.

The only excuse that can be made for the ferocity of the parisians is then simply to observe, that they had not any confidence in the laws, which they had always found to be merely cobwebs to catch small flies. Accustomed to be punished themselves for every trifle, and often for only being in the way of the rich, or their parasites; when, in fact, had the parisians seen the execution of a noble, or priest, though convicted of crimes beyond the daring of vulgar minds?—When justice, or the law, is so partial, the day of retribution will come with the red sky of vengeance, to confound the innocent with the guilty. The mob were barbarous beyond the

tiger's cruelty: for how could they trust a court that had so often deceived them, or expect to see it's agents punished, when the same measures were pursuing?

Let us cast our eyes over the history of man, and we shall scarcely find a page that is not tarnished by some foul deed, or bloody transaction. Let us examine the catalogue of the vices of men in a savage state, and contrast them with those of men civilized; we shall find, that a barbarian, considered as a moral being, is an angel, compared with the refined villain of artificial life. Let us investigate the causes which have produced this degeneracy, and we shall discover, that they are those unjust plans of government, which have been formed by peculiar circumstances in every part of the globe.— Then let us coolly and impartially contemplate the improvements, which are gaining ground in the formation of principles of policy; and I flatter myself it will be allowed by every humane and considerate being, that a political system more simple than has hitherto existed would effectually check those aspiring follies, which, by imitation, leading to vice, have banished from governments the very shadow of justice and magnanimity.

Thus had France grown up, and sickened on the corruption of a state diseased. But, as in medicine there is a species of complaint in the bowels which works it's own cure, and, leaving the body healthy, gives an invigorated tone to the system, so there is in politics: and whilst the agitation of it's regeneration continues, the excrementitious humours exuding from the contaminated body will excite a general dislike and contempt for the nation; and it is only the philosophical eye, which looks into the nature and weighs the consequences of human actions, that will be able to discern the cause, which has produced so many dreadful effects.

THE END

EXPLANATORY NOTES

3 *Reflections on the French Revolution*: Edmund Burke, *Reflections on the Revolution in France* (1790); eleven editions had appeared within a year.

Not having leisure: Burke's *Reflections* appeared on 1 November and Wollstonecraft's reply was published before the end of the month. William Godwin in *Memoirs of the Author of a Vindication of the Rights of Woman* (1798), ch. 6, recounts that the manuscript sheets were sent to the press as they were written.

5 *raised him to notice in the state*: Burke (1729–97) was not only an eminent orator and statesman but author of many pamphlets as well as more substantial works such as *The Vindication of Natural Society* (1756), *A Philosophical Inquiry into the Origin of our Ideas of the Sublime and the Beautiful* (1757), and *An Account of the European Settlement in America* (1757); he was the editor of and main contributor to the *Annual Register* (1758–91).

rights of men: see Burke, *Reflections*, 86–92.

his eloquence: once famed for his eloquence, Burke was becoming notorious for his long-winded speeches in the House of Commons.

7 *'horse-way and foot-path'*: *King Lear*, IV. i. 55.

sixty years: Burke's age in 1790.

Chinese erection: pagodas were very fashionable in England in the 1770s and 1780s.

that compact: cf. John Locke, *Two Treatises of Government* (1690), ii. 95, 97: 'The only way whereby any one devests himself of his Natural Liberty, and *puts on the bonds of Civil Society* is by agreeing with other men to joyn and unite into a community, for their comfortable, safe, and peaceable living one amongst another;' 'every Man, by consenting with others to make one Body Politick under one Government, puts himself under an obligation to every one of that Society, to submit to the determination of the *majority*, and to be concluded by it; or else this *original Compact*, whereby he with others incorporates into *one Society*, would signify nothing, and be no Compact.'

9 *a former grant*: Burke, *Reflections*, 45. Burke cites the famous jurists Sir Edward Coke and Sir William Blackstone in support of his theory of the connection of Magna Carta (1215) with the charter of Henry I (1100), and of both with the ancient laws of the kingdom. As opposed

372

to natural rights he suggests that the 'most sacred rights and franchises' are 'an *inheritance*' (emphasis original).

10 *certain or undisputed rights*: 'certain undisputed rights' in the original.

 'he was a prince . . . weakest of the whole': David Hume, *The History of England* (1778), I. xvi. 499–500.

11 *Wickliffe . . . Rome*: John Wyclif (1324?–84) launched his fullest attack on the Church in a series of lectures in Oxford (1379–80), and in *De Eucharistia* (1381).

12 *a pension*: Wollstonecraft's accusation was unfounded at the time. In 1794, when Burke was heavily in debt and Pitt granted him an annual pension of £2,500 p.a. for thirty years' service to the country, there was a predictably hostile reaction from his political enemies.

 Mr Burke's Bills: Burke's *Speech . . . to the House of Commons on the 11th of February 1780* (1780), introducing his plan of five economic reform bills, began and ended with an appeal for the virtue and independence required for reform.

13 *defend American independence*: Burke's *Speech on Conciliation with America* (22 Mar. 1775) considers the American Revolution as an assertion of traditional English liberties.

 pressing men for the sea service: the impressment of able-bodied but unwilling men into the Navy continued until the end of the Napoleonic wars in 1815.

14 *nervous*: Samuel Johnson, *Dictionary* (1755): 'well strung, strong, vigorous.'

 steals a few pounds: the theft of as little as five shillings could incur capital punishment until 1813.

 'The tears . . . possess': Rousseau, *A M. d'Alembert* (1758), 31–2; 'En donnant des pleurs à ces fictions, nous avons satisfait à tous les droits de l'humanité, sans avoir plus rien à mettre du notre.'

16 *game laws . . . press-warrants*: from 1389 to 1831 the game laws restricted the right to kill game to substantial landowners or long-lease holders; impress warrants were issued during war to compel able-bodied men into service.

 a decoy field: a field of unguarded crops designed to lure game.

 your attack on Dr Price: Burke in *Reflections* took issue with Richard Price, the distinguished Dissenting minister, who, in his *Discourse on the Love of our Country* (1789), celebrated the French Revolution's promise of civil and religious liberty.

 the pulpit is not the place for political discussions: Burke, *Reflections*, 14:

'politics and the pulpit are terms that have little agreement. No sound ought to be heard in the church but the healing voice of Christian charity.' Price's *Discourse* was delivered as a sermon to the Revolution Society on 4 November 1789, a society commemorating the Glorious Revolution of 1788. To the Dissenters, campaigning for the repeal of the Test and Corporation Acts which required office holders to sub-scribe to the established religion, the settlement of 1688 had signified a great advance towards freedom and equality. Full equality was not granted until 1871.

17 *moral excellence*: see note on Dr Price above and Introduction.

a great Lady's eyes: see Burke, *Reflections*, 111–13, for the praise of Marie Antoinette.

I now see . . . matured wisdom: when Wollstonecraft lived in Newington Green (1783–5) Price was the lecturer at the Presbyterian chapel which she occasionally attended; they became close friends.

18 *an apology*: Augustus Henry Fitzroy, Duke of Grafton's *Hints, etc. Submitted to the Serious Attention of the Clergy, Nobility and Gentry, Newly Associated, by a Layman* (1789) called for a revision of the liturgy.

establish one for themselves: Price, *Discourse*, 18: 'those who dislike that mode of worship which is prescribed by public authority, ought (if they can find no worship out of the church which they approve) to set up a separate worship for themselves.'

contradictions: Burke, *Reflections*: 'His zeal is of a curious character . . . It is not for the diffusion of truth, but for the spreading of contradiction.'

19 *great deference*: ibid. 45.

'The doctrine . . . the king': Blackstone, *Commentaries on the Laws of England* (1765), I. iii. 188 (emphasis original).

Aristotle: Burke, *Reflections*, 185–6, quotes Aristotle, *Politics*, IV. iv: 'that a democracy has many striking points of resemblance with a tyranny.'

OUR SOVEREIGN LORD THE KING: cf. Price, *Discourse*, 23–6: 'more properly the *servant* than the *sovereign* of your people', and Burke, *Reflections*, 40–2: 'The law, which knows neither to flatter nor to insult, calls this high magistrate, not our servant, as this humble Divine calls him, but "*Our sovereign Lord the King*".'

20 *the dregs of the people*: Burke, *Reflections*, 82, quotes Price, *Discourse*, 42, where political representation in England is described as 'chosen principally by the Treasury, and a few thousand dregs of the people, who are generally paid for their votes'.

electioneering interest: the security of balanced power was sought by 'influence'; accordingly the Crown held sway inparliament through its disposal of civil, military, and ecclesiastical office, and of pensions and honours raised by taxation, whilst the aristocracy cast similar influence over county and borough elections in order to protect the interests of the Lords in the House of Commons. Reform to curb the abuse of 'influence' began in 1762.

21 *a summer's fly*: Burke, *Reflections*, 141, argues that without constitutional continuity 'Men would become little better than the flies of a summer.'

legal prostitution: The phrase was used by Defoe in *Conjugal Lewdness; or, Matrimonial Whoredom* (1727).

violations of liberty: cf. Helen Maria Williams, *Letters Written in France in the Summer of 1790* (1790), chs. xvi–xxii, which tells the story of the du Fossés, who suffered this very violation. Until 1791 one French citizen could imprison another without trial by means of a *lettre de cachet* obtained from the monarch.

22 *Hymen*: in Greek mythology the god of fruitfulness and marriage.

contemplation: Plato, *Phaedrus*, 274: 'an immoderate desire to please . . . immerges . . . the soul in matter, till it becomes unable to mount on the wing of contemplation.'

23 *'grew . . . strength'*: Alexander Pope, *An Essay on Man* (1732–4), ii. 135–6: 'Grows with his growth, and strengthens with his strength.'

overpower talents and depress virtue: cf. Locke, *Two Treatises of Government*, ii. 25–51.

24 *'loses . . . grossness'*: Burke, *Reflections*: 'Never, never more, shall we behold that generous loyalty to rank and sex, that proud submission, that dignified obedience, that subordination of the heart, which kept alive, even in servitude itself, the spirit of an exalted freedom. . . . It is gone, that sensibility of principle, that chastity of honour, which felt a stain like a wound, which inspired courage whilst it mitigated ferocity, which ennobled whatever it touched, and under which vice itself lost half its evil, by losing all its grossness.'

is . . . romance: the emphasis is Wollstonecraft's in both quotations.

'Regicide . . . homicide': Burke, *Reflections*, 14–15; 'parricide' is also included in the original.

misrepresent Dr Price's meaning: see ibid. 96 ff., and Price, *Discourse*, 49–50; in the preface to the 4th edn. (1790) Price insisted upon what

Wollstonecraft here states, and the context of the sermon implies, that he was celebrating the events of July 1789 when the king voluntarily submitted to the will of his people, 'as the restorer of their liberty', and not to the violent abduction of the royal family from Versailles on 6 October 1789.

25 *King of the British*: Burke, *Speech . . . to the House of Commons on the 9th of February 1789* (1789); the original uses the phrase 'King of the Britons!'

a mote . . . the beam: Matt. 7: 3: 'Why beholdest thou the mote that is in thy brother's eye, but considerest not the beam that is in thine own eye?'

a late melancholy occasion: Burke, *Speech . . . to the House of Commons on the 6th of February 1789* (1789), opposed the granting of an allowance to Queen Charlotte, following her husband's insanity, on the grounds that it would 'create a fund for bribing members of parliament'.

you personally aggravated: Burke, *Reflections*, 105 ff. When George III was declared insane in November 1788, the Prince of Wales attempted to become king, winning Burke's support with the offer of the post of Paymaster-General. The Prime Minister, Pitt, introduced a Regency Bill to limit the Prince's powers. Burke hurriedly collected statistics from mental institutions on the unlikelihood of the King's recovery at the advanced age of 55. This undignified display of self-interest made him a figure of ridicule in the press, and nearly ruined his career when, despite statistics, the King recovered before the bill was completed, not to suffer another attack until 1801.

26 *Marius . . . Carthage*: Gaius Marius (155–86 BC) was a Roman general who was defeated by Sulla in 88 BC. Marius fled to Carthage, but was refused entry by the governor Sextilius. Marius put his case by sitting as a fugitive among the ruins of Carthage to demonstrate his subjection to changes of fortune.

strip him of all his hereditary honours: Burke, *Speech . . . on the 9th of February 1789*.

hurled him from his throne: ibid.: 'did they recollect that they were talking of a sick king, of a monarch smitten by the hand of Omnipotence, and that the Almighty had hurled him from his throne, and plunged him into a condition which drew upon him the pity of the meanest peasant in his kingdom. Ought they to make a mockery of him, to put a crown of thorns on his head, a reed in his hand, and dressing him in a raiment of purple, to cry, "Hail, king of the Britons!".'

27 *not exact*: Burke, *Reflections*, 11–12: 'Everything seems out of nature in this strange chaos of levity and ferocity, and of all sorts of crimes jumbled together with all sorts of follies. In viewing this monstrous tragi-comic scene, the most opposite passions necessarily succeed, and sometimes mix with each other in the mind; alternate contempt and indignation; alternate laughter and tears; alternate scorn and horror.'

28 *wit and madness*: John Dryden, *Absalom and Achitophel* (1681), i. 164: 'Great wits are sure to madness near allied.'

 'fine phrensy': *A Midsummer Night's Dream*, v. i. 12: 'The poet's eye, in a fine phrenzy rolling.'

 rodomontade: Samuel Johnson, *Dictionary*: 'an empty noisy bluster or boast; a rant'; after Rodomonte, the warrior in the poems of Ariosto.

29 *a ruling passion*: the psychological concept of the ruling passion originated in the theories of Bacon and Montaigne, who understood it as the source of self-control at the centre of the human personality; Pope, who most fully propounded the concept, treated it as the force that provides the individual with direction, stability, protection from chaos, which can be channelled towards either good or evil. In the scheme of providence its function is to differentiate the objectives of individuals so that the world's work can be accomplished. See Alexander Pope, *An Essay on Man* (1733–4), ii. ll. 123–44; *On the Use of Riches, An Epistle to . . . Lord Bathurst* (1732), l. 154; *An Epistle to . . . Lord Visct. Cobham* (1733), ll. 174 ff.

30 *eternal fitness of things*: Henry Fielding, *Tome Jones* (1749), II. iv. 4, p. 20.

 'who . . . rights of men': Burke, *Reflections*, 120: 'Poets, who have to deal with an audience not yet graduated in the school of the rights of men, and who must apply themselves to the moral constitution of the heart would not dare to produce such a triumph [the French Revolution] as a matter of exultation.'

 'in . . . glance': ibid. 121.

 ignorant, consequently innocent: cf. Rousseau, *Émile; ou, De l'éducation* (1762), i. 112: 'La raison seule nous apprend à connôitre le bien et le mal. La conscience qui nous fait aimer l'un et haïr l'autre, quoiqu'indépendante de la raison, ne peut donc se développer sans elle. Avant l'âge de raison nous faisons le bien et le mal sans le connôitre; et il n'y a point de moralité dans nos actions.' (*Translation*: Reason alone teaches us to know good and evil. Conscience therefore, which makes us love the one and hate the other, although independ-

ent of reason, cannot develop without it. Before reaching the age of reason, we do good and evil without knowing it; and there is absolutely no morality in our actions.), and Locke, *Some Thoughts Concerning Education* (1693), 1–2: 'I think I may say, that of all the Men we meet with, Nine Parts of Ten are what they are, Good or Evil, useful or not, by their Education. . . . I imagine the Minds of Children as easily turned this or that way, as Water it self.'

32 *'because they were prejudices'*: Burke, *Reflections*: 'instead of casting away all our old prejudices, we cherish them to a very considerable degree, and, to take more shame to ourselves, we cherish them because they are prejudices.'

 phlogiston: a hypothetical substance regarded as the principle of fire, which separated from matter in the process of burning; Samuel Johnson, *Dictionary*: 'the inflammable part of any body.'

33 *untaught feelings*: Burke, *Reflections*, 128–9.

 'We fear God . . . nobility': Burke, *Reflections*; the emphasis is Wollstonecraft's.

34 *'under the auspices . . . piety'*: Burke, *Reflections*, 133, says of the English constitution 'The whole has been done under the auspices, and is confirmed by the sanctions of religion and piety.'

 'emanating . . . understanding': ibid. 133–4: 'The whole has emanated from the simplicity of our national character, and from a sort of native plainness and directness of understanding, which for a long time characterized those men who have successfully obtained authority amongst us.'

 we make a clergyman of him: Wollstonecraft here contradicts Burke, *Reflections*, 135: 'We are protestants, not from indifference but from zeal.' Her emphasis on 'we' implies the common scorn of Burke's claim to represent English Protestants; he was an Irishman born of a Roman Catholic mother, though he was educated as a Protestant and lived in England from the age of 20.

 'the paltry pelf of the moment': ibid.: 'Such sublime principles ought to be infused into persons of exalted situations;' 'they should not look to the paltry pelf of the moment.'

 'very high . . . destination': ibid. 136–7: 'all who administer in the government of men, in which they stand in the person of God himself, should have high and worthy notions of their function and destination'.

35 *electioneering frolic*: see second note to p. 20 above; in 1762 fines were introduced to curb election bribery, but investigations of 1771, 1775,

and 1782 revealed that corruption was increasing.

36 *'habitually . . . good'*: Burke, *Reflections*, 140–1: 'When they are habitually convinced that no evil can be acceptable, either in the act or the permission, to him whose essence is good, they will be better able to extirpate out of the minds of all magistrates, civil, ecclesiastical, or military, anything that bears the least resemblance to a proud and lawless domination.'

fee-simple: fee-simple was originally a feudal term for an estate of inheritance held in return for service to a superior lord.

Art thou there, True-penny: *Hamlet*, I. v. 159.

the property of the church: Wollstonecraft is referring to Burke's support of American independence. The protection of church property is a major concern of his *Reflections*, see e.g. p. 80.

37 *Lord George Gordon*: Gordon (1751–93) led the anti-Catholic Gordon riots which caused much disruption in 1780. In 1787 he was imprisoned for the rest of his life in Newgate for the libel of criticizing the severity of British justice and accusing Marie Antoinette of persecuting the innocent Cagliostro, who had fled to England after being implicated in the Diamond Necklace Affair.

38 *It has been observed*: e.g. by Rousseau, in *Émile* (1762), where the passions are seen as the greatest threat to individual liberty and morality; I. iv. 248, the pupil implores his tutor: 'rendez-moi libre en me protégeant contre mes passions qui me font violence; empêchez moi d'être leur esclave, et forcez-moi d'être mon propre maître en n'obéissant point à mes sens mais à ma raison'. (*Translation*: set me free by protecting me from my passions which assail me; prevent me from being their slave and force me to be my own master, showing obedience not to my senses but to my reason.)

40 *censure . . . of the National Assembly*: see Burke, *Reflections*, 58 ff.

43 *senatorial virtues*: ibid. 287–8.

eloquence . . . judgment: John Locke, *An Essay on Human Understanding* (1690), III. x. 34; cf. Burke, *Reflections*, 245: 'eloquence may exist without a proportionable degree of wisdom.'

44 *Cicero*: the Roman politician Marcus Tullius Cicero (106–43 BC) was famed for his great oratory.

Richard is himself again: *Richard III*, ed. Colley Cibber (1700), V. iii: 'Richard's himself again.'

church establishments: Burke, *Reflections*, 136–57.

public will: the emphasis is Wollstonecraft's.

44 *live in obscurity*: Wollstonecraft is referring to Rousseau's posthumously published autobiography *Les Confessions* (1782).

45 *such bitter sarcasms*: in fact Burke's attack on Price never stoops to the kind of personal abuse that Wollstonecraft levels at Burke.

Enquiry . . . Beautiful: *A Philosophical Enquiry into the Origin of our Ideas of the Sublime and Beautiful* (1757), III. ix; and III. xvi.

'learn . . . creatures': *Hamlet*, III. i. 146–8: 'You jig and amble, and you lisp, you nickname God's creatures and make your wantonness your ignorance.' Cf. Burke, *Sublime and Beautiful*, III. ix: 'they learn to lisp, to totter in their walk, to counterfeit weakness and even sickness.'

46 *the mussulman's creed*: the very low status of women in Muslim countries gave rise to the widespread Christian misconception that Islam denied that women had souls.

Plato and Milton: Plato, *Symposium*, 178–85; *Paradise Lost*, viii. 589–92: 'love refines | The thoughts, and heart enlarges, hath his seat | In reason, and is judicious, is the scale | By which to heavenly love thou may'st ascend.'

Spartan regulations: the Spartan State held an absolute claim to the services of its citizens, whose obedience it sought to establish by rigorous training from childhood.

47 *your own definition of virtue*: Burke, *Reflections*, 118: 'Already there appears a poverty of conception, a coarseness and vulgarity in all the proceedings of the Assembly'; M. de Menonville, a conservative member of the National Assembly, complained of Burke's denigration, and received an apology: *Letter to a Member of the National Assembly* (1791). In *A Vindication of Natural Society* (1765) Burke aligns virtue with naturalness.

a dozen people of quality: Burke, *Reflections*, 76–7: 'A government of five hundred country attornies and obscure curates is not good for twenty-four millions of men, though it were chosen by eight and forty millions; nor is it the better for being guided by a dozen of persons of quality, who have betrayed their trust in order to obtain that power.'

48 *'deceitfulness of riches'*: Matt. 13: 22.

some honourable exceptions: for example: Louis-Marie, vicomte de Noailles, proposed the abolition of feudal dues and interests; he was seconded by Armand-Desire Vignoret du Plessis Richelieu, duc d'Aiguillon.

daring sacrilege: see Burke, *Reflections*, 72.

51 *your bitterest animadversions*: ibid. 206–27.

Page 210: 'The archbishop of Paris, whose function was known to his
people only by his prayers and benedictions, and his wealth only by
his alms, is forced to abandon his house, and to fly from his flock (as
from ravenous wolves) because, truly, in the sixteenth century, the
cardinal of Lorraine was a rebel and a murderer.'

all their ideas, and all their habits to it: the emphasis is Woll-
stonecraft's.

55 *Some celebrated writers*: see notes to p. 56.

56 *Sterne*: the publication of the extremely popular *The Beauties of
Sterne: Including All his Pathetic Tales, and most Distinguished Observa-
tions on Life Selected for the Heart of Sensibility* (1782) confirmed
Laurence Sterne's name as almost synonymous with sensibility.

Judgment is sublime, wit beautiful: see Immanuel Kant, *Critik der
Urteilskraft* (1790), I. ii.

according to your own theory: Burke, *A Philosophical Enquiry into the
Origin of our Ideas of the Sublime and Beautiful* (2nd edn. 1759),
'Introduction on Taste', 18: 'a perfect union of wit and judgement is
one of the rarest things in the world.' Having assigned wit to the
power of the imagination (p. 16), he declares (p. 35): 'the judgement
is for the greater part employed in throwing stumbling-blocks in the
way of the imagination, in dissipating the scenes of its enchantment,
and in tying us down to the disagreeable yoke of our reason.'

57 *They . . . justice*: the emphasis is Wollstonecraft's.

ah! there's the rub: *Hamlet*, III. i. 65.

Arcadia: the Peloponnesian region of idyllic rustic contentment
according to classical mythology.

58 *a despotic country*: Portugal, which Wollstonecraft visited during
1785–6, before and after the death of Fanny Blood.

enclosed: in 1700 half the land in England was common land culti-
vated by the open-field system; by 1830 the development of farming
methods which made large farms more feasible had led to the enclo-
sure of almost all agricultural land.

59 *lay up a treasure in heaven*: Matt. 6: 20: 'But lay up for yourselves
treasures in heaven, where neither moth nor rust doth corrupt, and
where thieves do not break through nor steal.'

60 *a hell beyond the grave*: see Burke, *Reflections*, 114–15; 117; 170;
202–27.

61 *blame . . . insult them*: ibid. 254 ff.

In theory it appears more promising: the vote was given to 'active' male

citizens, i.e. those who paid taxes equivalent to at least three days' labour. There were two levels of representation; to be eligible as an elector in the first a candidate had to pay taxes of at least 10 livres p.a.; a national deputy had to pay more substantial taxes, and to own land. This fell short of the universal male suffrage envisaged in *La Déclaration des droits de l'homme et du citoyen* (1789).

62 *as Shakespeare makes a frantic wretch exclaim*: *King Lear*, IV. i. 36–7: 'As flies to wanton boys, are we to the gods; | They kill us for their sport.'

the sincerity of many modern philosophers: see *Reflections*, 93–5; Burke accuses Republican thinkers of hypocrisy.

65 *M. Talleyrand-Périgord*: Charles Maurice de Talleyrand-Périgord, prince de Benevento (1754–1838), was Bishop of Autun from 1788 to 1791, when he resigned to concentrate on political activity and was excommunicated three months later for ordaining new bishops after his resignation. He served in the Estates-General, the Constituent Assembly, and the National Assembly, advocating the confiscation of church property to meet government expenses. After 1792 he was involved in French foreign affairs as both envoy and minister. Wollstonecraft met Talleyrand in London between the two editions of *The Rights of Woman*.

a pamphlet: *Rapport sur l'instruction publique, fait au nom du Comité de constitution* (1791) called for free intellectual, physical, and moral education for both sexes at all ages. It falls short of Wollstonecraft's ideal in its concurrence with Rousseau's *Émile; ou, De l'éducation* (1762) that the education of women should be directed towards a subservient role.

I dedicate . . . humanity: the first edition reads: 'On National Education, I dedicate this volume to you, the first dedication that I have ever written, to induce you to read it with attention; and, because I think you will understand me, which I do not suppose many pert witlings will, who may ridicule the arguments they are unable to answer. But, Sir, I carry my respect for your understanding still farther; so far, that I am confident that you will not throw my work aside, and hastily conclude that I am in the wrong, because you did not view the subject in the same light yourself.—And, pardon my frankness, but I must observe, that you treated it in too cursory a manner, contented to consider it as it had been considered formerly, when the rights of man, not to advert to woman, were trampled on as chimerical—I call upon you, therefore, now to weigh what I have advanced respecting the rights of woman, and national education—and I call with the firm tone of humanity. For . . .'

your admirable constitution: the French constitution of 1791 excluded women from all areas of political life, conferring citizenship only on men over 25. (Olympe de Gouges, *Les Droits de la femme* (1791), which Wollstonecraft apparently did not know, made the same demand for political rights for women for the sake of the moral improvement of humanity. Women got the vote in France in 1944.)

66 *'that to see ... impossible to explain'*: cf. *Rapport sur l'instruction publique*, 116: 'Une moitié du genre humain exclue par l'autre de toute participation au gouvernement ... ce sont là des phénomènes politiques, qu'en principe abstrait, il paroit impossible d'expliquer.' But he continues: 'Si l'exclusion des emplois publics prononcée contre les femmes est pour les deux sexes un moyen d'augmenter la somme de leur bonheur mutuel, c'est dès-lors une loi que toutes les Sociétiés ont du reconnoître et consacrer.' (*Translation*: 'One half of the human race excluded by the other half from any participation in government ... these are political phenomena which, according to abstract principles, it would seem impossible to explain.' 'If the debarring of women from public positions is a means for the two sexes of increasing their mutual well-being, it follows that it is a law which all societies should recognize and sanction.')

67 *NEW CONSTITUTION*: the first edition adds the words 'the first constitution founded on reason'.

68 *'wise in their generation'*: Luke 16: 8: 'the children of this world are in their generation wiser than the children of light.'

69 *a second volume*: only one volume was published.

71 *Mahometanism*: a reference to the widespread Christian misconception that Islam denied that women had souls.

 subordinate beings: the first edition reads 'only considered as females'.

72 *A degree of physical superiority*: the first edition emphasized male superiority more emphatically; the passage 'in point of strength ... therefore' reads: 'in general, is inferior to the male. The male pursues, the female yields—this is the law of nature; and it does not appear to be suspended or abrogated in favour of woman. This physical superiority cannot ...'

 Sandford and Merton: Thomas Day, *The History of Sandford and Merton* (1783–9); didactic children's book, influenced by Rousseau's *Émile*, which contrasted the wealthy, spoilt Merton with the poor, honest Sandford.

74 *These pretty superlatives*: the first edition reads 'nothings—these caricatures of the real beauty of sensibility'.

74 *a seraglio*: a harem.

75 *Let men . . . understandings*: the first edition replaces this sentence
 with 'Do not foster these prejudices, and they will naturally fall into
 their subordinate, yet respectable station in life.'

77 *'must hide its diminished head'*: *Paradise Lost*, iv. 34–5: 'all the stars |
 Hide their diminished heads'.

 the triple crown: the papal crown.

78 *Pandora's pent up mischiefs*: as a punishment for Prometheus' theft of
 fire from heaven, Zeus sent into the world Pandora, the first woman,
 with a jar from which all evils flew out; hope alone remained within it.

 Rousseau became enamoured of solitude: Jean-Jacques Rousseau (1712–
 78), *Discours sur l'origine et les fondemens de l'inégalité parmi les hommes*
 (1755); the author asserts the solitary nature of humankind; in *Les
 Confessions* (1782), ix, he describes his own love of solitude.

 God . . . creature: Rousseau, *Emilius and Sophia; or, A New System of
 Education* (1762, 1763) trans. William Kenrick; I. i. 1: 'All things are
 good as their Creator made them, but everything degenerates in the
 hands of man.' Wollstonecraft seems to be quoting from the English
 edition.

79 *Rousseau . . . disputes*: ibid. I. ii. 286; II. iv. 133–64.

 Fabricius . . . the brutal Spartans: Rousseau in *Discours qui a remporté
 le prix à l'Académie de Dijon en l'année 1750. Sur cette question . . . Si le
 rétablissement des sciences et des arts a contribué à épurer les mœurs* (1750)
 invokes Gaius Luscinus Fabricius (d. after 275 BC), the Roman gen-
 eral, who urged his fellow citizens to devote themselves to conquering
 the world; the author praises the Spartan regime for banishing the
 arts, and criticizes Athens for nurturing them. Thucydides, *The His-
 tory of the Peloponnesian War*, 4. 80. 3–4, tells how the Spartans tested
 the loyalty of helots, who were attached to one of the forces fighting
 against Athens, by declaring that those who claimed to have fought
 most bravely would be made free men; they then proceeded to mas-
 sacre the 2,000 men who made the claim, because these would be the
 most likely to lead a rebellion.

 citizen of Geneva: Rousseau was born in Geneva but spent little time
 there after the age of 16; none the less he liked to use the epithet
 citoyen de Genève.

80 *the detestable Dubois*: *a lit de justice* was a session held by monarch and
 parliament in which all authority rested with the Crown; during the
 infancy of Louis XV crown authority was in the hands of Cardinal
 Guillaume Dubois (1656–1723), the tutor and chief advisor of

Philippe, duc d'Orléans, who governed France as regent 1715–23.

figs from thistles: Matt. 7: 16: 'Ye shall know them by their fruits. Do men gather grapes of thorns, or figs of thistles?'; also Luke 6: 44.

81 *Dr Price*: Richard Price (1723–91), friend of Wollstonecraft and the famous Nonconformist minister of Newington Green where she lived in 1784. His speech *A Discourse on the Love of our Country* (1789) was criticized for its celebration of the French Revolution by Burke in *Reflections on the Revolution in France* (1790), to which Wollstonecraft replied in *A Vindication of the Rights of Men* (1790).

83 *had Rousseau mounted one step higher*: see especially Rousseau, *Discours sur l'origine et les fondemens de l'inégalité parmi les hommes*.

84 *the true Mahometan strain*: see note to p. 71 above.

contemplation: *Paradise Lost*, iv. 297–8: 'For contemplation he and valour formed | For softness she and sweet attractive grace' is quoted in James Fordyce, *Sermons to Young Women* (3rd corrected edn. 1766), xiii. 221.

85 *'Certainly . . . creature'*: Francis Bacon, *Essays* (1625), xiv 'Of Atheism', 89.

'To whom . . . praise': *Paradise Lost*, iv. 634–8; the emphasis is Wollstonecraft's.

86 *'Hast thou . . . delight'*: ibid. viii. 381–92; the emphasis is Wollstonecraft's.

87 *Rousseau's opinion*: see *Emilius*, I. i. 76: 'Reason only teaches us good from evil'; see also the confession of faith of the Savoyard curate, III. iv. 16–154.

from Rousseau to Dr Gregory: ibid. v; John Gregory (1724–73), a Scottish professor of medicine, wrote *A Father's Legacy to his Daughters* (1774), which Wollstonecraft quoted extensively in *The Female Reader*.

to reason on Rousseau's ground: *Emilius*, IV. v. 74–5, which Wollstonecraft quotes, pp. 106–7 above.

89 *a passion for a scarlet coat*: see Swift, *Works*, 'The Furniture of a Woman's Mind', l. 2.

90 *Sophia*: see *Emilius*, v; Sophia is the 'idealized' submissive heroine.

91 *Milton's pleasing picture*: see *Paradise Lost*, iv.

He carries the arguments . . . still further: see *Emilius*, IV. v. 31–3.

92 *sober*: the first edition has 'subordinate'.

Moses's poetical story: Gen. 2: 18–22; Genesis is traditionally ascribed to Moses.

92 *the whole creation . . . pleasure*: the first edition reads 'she, as well as the brute creation, was created to do his pleasure'.

 Yet ne'er . . . hate: Alexander Pope, *Of the Characters of Women: An Epistle to a Lady* (1735), ll. 51–2.

93 *to out Quixote Cervantes*: Miguel de Cervantes Saavedra, *El ingenioso hidalgo Don Quixote de la Mancha* (1605), a popular work in the eighteenth century, especially among those who mocked romantic novels.

 to render them pleasing: *Emilius*, IV. v. 19–20.

94 *The worthy Dr Gregory*: Gregory, *Legacy*.

 Dr Gregory goes much further: ibid. 57–8.

 Out of the abundance . . . speaketh: Matt. 12: 34.

 a wiser than Solomon hath said: Luke 11: 31–41.

95 *he advises . . . affection*: Gregory, *Legacy*, 87–8.

96 *the philosopher's stone*: a hypothetical substance, sought by alchemists, which could transform base metals into gold and produce an elixir to prolong life.

 'that . . . rarer': La Rochefoucauld, *Réflexions; ou, Sentences et maximes morales* (1664), no. 473: 'Quelque rare que soit que la véritable amour, il l'est encore moins que la véritable amitié.'

98 *Rousseau . . . St Preux*: Rousseau, *Lettres de deux amants . . . Julie; ou, La Nouvelle Héloïse* (1761); on her death-bed Julie, who has been a faithful wife to Wolmar, declares that her real and lasting passion has been for her former lover St Preux.

 Dr Gregory's advice respecting delicacy of sentiment: Gregory, *Legacy*, 119.

100 *Rousseau, and Swedenborg*: see *Emilius*, IV. v. 48, which Wollstonecraft quotes, pp. 160–1. For Emanuel Swedenborg (1688–1772), the Swedish scientist and mystic, the full development of human potential required the marriage of woman's innate capacity for love and man's natural wisdom; see especially *Delitiae sapientiae de amore coniugali* (1768).

 'submissive charms': *Paradise Lost*, iv. 497–9: 'he in delight | Both of her beauty and submissive charms | Smiled with superior love.'

 neither marrying nor giving in marriage: see Matt. 22: 30: 'For in the resurrection, they neither marry, nor are given in marriage, but are as the angels in heaven.' Also Mark 12: 25; Luke 20: 35. See the end of *Mary: A Fiction*.

fair defects, amiable weaknesses: cf. *Paradise Lost*, x. 891–2: 'this fair defect | Of nature'; and Wollstonecraft's misquotation of Pope, *Of the Characters of Women*, l. 44, on p. 132.

Mahomet's coffin: according to legend Muhammad's coffin was magically suspended in the centre of his tomb.

101 *conjecture respecting Newton*: Sir Isaac Newton (1642–1727); this is possibly a reference to James Thomson, *A Poem, Sacred to the Memory of Sir Isaac Newton* (1727), ll. 161–5: 'can a soul | Of such extensive, deep, tremendous powers, | Enlarging still, be but a finer breath | Of spirits dancing thro' their tubes awhile, | And then for ever lost in vacant air?'

102 *'If weak women . . . they'*: Matthew Prior, 'Hans Carvell'.

104 *China . . . God*: Chinese emperors were considered to be divine; cf. Gottfried Leibniz, *Novissima Sinica historiam nostri temporis illustratura* (n.p., 1697), preface: 'Quis vero non miretur Monarcham tanti Imperii, que pene humanum fastigium magnitudine excessit, et mortalis quidam Deus habetur.' (*Translation:* Who indeed would not be amazed at the monarch of such an empire, who almost exceeds human condition in grandeur, and a mortal is considered to be a god.)

105 *almost proverbial*: cf. Rousseau, *Les Confessions*, II. v. 86: 'L'épée use le fourreau, dit-on quelquefois.' (*Translation:* The sword wears out the scabbard, as it is sometimes said.)

Dr Priestley has remarked: Joseph Priestley (1733–1804), *A Description of a Chart of Biography* (1765), 25–6.

the baseless fabric of a vision: cf. *The Tempest*, IV. i. 151.

106 *Shakspeare . . . hand*: see *Macbeth*, II. i. 33–49.

Milton . . . prison: *Paradise Lost*, ii.

'in a fine phrenzy': *A Midsummer Night's Dream*, V. i. 12: 'The poet's eye, in a fine phrenzy rolling.'

107 *bashaws*: or pashas: high-ranking Turkish officers, proverbial for their imperiousness.

Rousseau's Emilius: IV. v. 74–5.

108 *Sandford and Merton*: Day, *The History of Sandford and Merton* (6th, corrected, edn. 1791), iii. 207–9.

109 *Chinese bands*: the feet of Chinese female infants were bound to keep them dainty.

Rousseau's remarks: *Emilius*, IV. v. 21; 25; 45.

109 *a favourite paradox*: ibid. IV. v. 21.

110 *a man . . . the soul*: ibid. III. iv. 16–98: 'The profession of faith of a
Savoyard curate.'

 the learned pig: the learned pig was a performing animal displayed
around England in the early 1780s; see Sarah Trimmer, *Fabulous
Histories* (1786), ch. IX; and James Boswell, *The Life of Dr Johnson*
(1791), ii. 552.

 Rousseau's Emilius: IV. v. 29.

111 *the Sybarites*: the inhabitants of the sixth-century Greek colony of
Sybaris in Italy were proverbial for their luxurious life-style.

 that destructive blast: refers both to the 'simoom', a fierce sand wind
which sweeps across the African and Asiatic deserts during spring and
summer, and to the notorious despotism of the Ottoman Empire
which continued until 1908.

112 *seeking whom he should devour*: 1 Pet. 5: 8: 'Be sober, be vigilant;
because your adversary the devil, as a roaring lion, walketh about,
seeking whom he may devour.'

113 *justify the ways of Providence*: i. 25–6: 'I may assert Eternal Provi-
dence, | And justify the ways of God to men.'

114 *a matter of sentiment or taste*: Gregory, *Legacy*, 13: 'Religion is rather
a matter of sentiment than reasoning.'

115 *'be pure as your heavenly Father in pure'*: 1 John 3: 3: 'And every man
that hath this hope in him purifieth himself, even as he is pure.'

 thus far . . . be stayed: Job 38: 11: 'Hitherto shalt thou come, but no
further: and here shall thy proud waves be stayed.'

116 *Rousseau's Emilius*: IV. v. 3–4.

117 *The serpent's tooth*: cf. *King Lear*, I. iv. 297–8: 'How sharper than a
serpent's tooth it is | To have a thankless child!'

 mint and cummin: cf. Matt. 23: 23: 'Woe unto you, scribes and Phari-
sees, hypocrites! for ye pay tithe of mint and anise and cummin, and
have omitted the weightier matters of the law, judgement, mercy and
faith.'

118 *not as other women are*: cf. Luke 18: 11: 'The Pharisee stood and
prayed thus with himself, God, I thank thee, that I am not as other
men are.'

 Rousseau's Emilius: IV. v. 128.

119 *talents*: for the parable of the talents see Matt. 25: 14–30.

121 *yet . . . tomorrow we die*: cf. Ps. 72: 9: 'His enemies shall lick the dust.'

Heb. 12: 16: 'Esau who for one morsel of meat sold his birthright.'
1 Cor. 15: 32: 'Let us eat and drink for tomorrow we die.'

'absolute in loveliness': cf. *Paradise Lost*, viii. 546–8: 'when I approach | Her loveliness, so absolute she seems | And in herself complete'.

122 *'The brutes . . . upon them'*: James Burnett, Lord Monboddo, *Of the Origin and Progress of Language* (Edinburgh, 1774), I. x. 137; the emphasis is Wollstonecraft's.

Milton: *Paradise Lost*, viii. 57–8: 'O when meet now | Such pairs, in love and mutual honour joined?'

'Pleasure's . . . design'd': Anna Laetitia Aikin, later Barbauld, *Poems* (1773), 47, 'To Mrs. P——, with some drawings of birds and insects'; the emphasis is Wollstonecraft's. Barbauld is referring to birds as 'th' inferior kind' and using 'man' in the generic sense.

123 *'To a Lady . . . PLEASE'*: Aikin, *Poems*, 95; the emphasis is Wollstonecraft's.

generalizing ideas: see John Locke, *An Essay on Human Understanding* (1689), II. xi. 9 and 10: 'the having of general *Ideas*, is that which puts a perfect distinction betwixt Man and Brutes.'

125 *Saturnalia*: the ancient Greek feast of Saturn, god of agriculture, which lasted seven days over the winter solstice, during which all distinctions of rank were suspended.

'But what . . . sovereigns': David Hume, *Essays and Treatises on Several Subjects* (1777), ii, 'A Dialogue', 386.

'in the noon of beauty's power': cf. *Analytical Review*, 1 (June, 1788), art. xxxvi, where Wollstonecraft uses the same phrase in her review of Adam Beuvius, *Henrietta of Gerstenfeld* (1787, 1788), apparently paraphrasing ii. 27: 'the beauty of Henrietta obscures that of her mother as much as the meridian splendours of the sun outshine the light of the moon.'

neither toil nor spin: cf. Matt. 6: 28: 'And why take you thought for raiment? Consider the lilies of the field, how they grow; they toil not neither do they spin', and Luke 12: 23 and 27.

'In beauty's empire . . . ador'd': Aikin, *Poems*, 70, song v, ll. 16–18.

126 *Lewis the XIVth*: Louis XIV (1638–1715).

'I have endeavoured . . . given a fig for': Philip Dormer Stanhope, Earl of Chesterfield, *Letters . . . to his Son* (1774), II. lxxii. 299: 'my vanity has very often made me take great pains to make many a woman in love with me, if I could, for whose person I would not have given a pinch of snuff.'

127 *'To be observed . . . advantages which they seek'*: Adam Smith, *The Theory of Moral Sentiments* (6th corrected edn. 1790), I. i. III. 2. 122; Smith's sentence ends: 'are all the advantages which we can propose to derive from it.'

129 *'he surpassed . . . superiority'*: Voltaire, *Siècle de Louis XIV* (Berlin, 1751), ii. 24, pp. 22–3; the translation is Adam Smith's.

　　'Do the great . . . before them': Adam Smith, *The Theory of Moral Sentiments*, II. i. III. 2, pp. 130–3; Wollstonecraft abridges slightly.

　　'in herself complete': *Paradise Lost*, viii. 546–8.

　　'That what she wills . . . wait': ibid. viii. 549–54; the emphasis is Wollstonecraft's.

130 *legally prostituted*: the phrase 'legal prostitution' was used by Defoe, *Conjugal Lewdness; or, Matrimonial Whoredom* (1727). See also p. 21.

132 *'Fine by defect, and amiably weak'*: Pope, *Of the Characters of Women*, l. 44: 'Fine by defect, and delicately weak.'

133 *'Educate women . . . over us'*: *Emilius*, IV. v. 17: 'Educate them, if you think proper, like the men; we shall readily consent to it. The more they resemble our sex, the less power will they have over us; and when they once become like ourselves, we shall then be truly their masters.'

　　Dr Johnson: Johnson, *Dictionary*: 'Quickness of sensation. Quickness of perception.'

　　seventy times seven: Matt. 18: 21–2.

134 *'He that hath . . . childless man'*: Francis Bacon, *The Essays* (1625), v, 'Of Marriage and single life'.

135 *'The power . . . sensibility'*: cf. the discussion of blushing in Gregory, *Legacy*, 27: 'That extreme sensibility which it indicates, may be a weakness and incumbrance in our sex . . . but in yours it is peculiarly engaging . . . Nature has made you to blush when you are guilty of no fault, and has forced us to love you because you do so.—'

140 *Cowley, Milton, and Pope*: Abraham Cowley (1618–67) produced his first collection of poems, *Poetical Blossoms*, in 1633, claiming to have written one of the pieces at the age of 10. John Milton (1608–74) wrote verse in both Latin and English in his youth, of which the most famous is 'On the Morning of Christ's Nativity', written in 1629, first published in *Poems* (1645). At the age of 14 Alexander Pope (1688–1744) wrote an epic poem, 'Alexander', which he later destroyed; and recalls in *An Epistle from Mr. Pope to Dr. Arbuthnot* (1734–5), ll. 127–8: 'As yet a child, nor yet a fool to fame, | I lisp'd in numbers, for the numbers came.'

twenty: e.g. Georges Buffon, *Natural History*, trans. William Smellie (1780), ii. 436: 'A woman at twenty years is as perfectly formed as a man at thirty.'

142 *If this be applied . . . females*: John Reinhold Forster, *Observations Made during a Voyage Round the World* (1778), 425–6, but the following paragraph is not his.

143 *Asylums and Magdalens*: these were homes for reforming prostitutes.

shunned the light of day: Edward Young, *Busiris, King of Egypt* (1719), I. i: 'So black a story well might shun the day.'

Clarissa . . . honour: Samuel Richardson, *Clarissa* (1747–8), v. 250.

'Errors . . . errors': Gottfried Wilhelm von Leibnitz, *Essais de Théodicée* (1710), preface: *'les erreurs mêmes ont leur utilité quelque fois: mais c'est ordinairement pour remédier à d'autres erreurs.'*

144 *pleasure or sway*: Alexander Pope, *Of the Characters of Women*, ll. 207–10: 'In Men, we various Ruling Passions find, | In Women, two almost divide the kind; | Those, only fix'd, they first or last obey, | The Love of Pleasure, and the Love of Sway.'

145 *some eloquent writers*: *Emilius*, III. iv. 89–90.

146 *'scale to heavenly'*: *Paradise Lost*, viii. 589–92: 'Love refines | The thoughts, and heart enlarges, hath his seat | In Reason, and is judicious, is the scale | By which to heav'nly Love thou maist ascend.'

thy paradise: paradise not of the individual soul but of the united man and woman which Rousseau considered a higher moral unit.

147 *lappets*: the parts of a head-dress that hang loose.

148 *Ranger*: Benjamin Hoadly, *The Suspicious Husband* (1747) I. i: Ranger, a rake, reads from William Congreve, 'Poems upon Several Occasions', *Works* (1710), iii. 193, 'Song': 'You think she's false, I'm sure she's kind, | I take her body, you her mind; | Which has the better bargain?'

Knox's Essays: Vicesimus Knox, *Essays, Moral and Literary* (1782), I. 5, p. 21.

149 *Sappho . . . Madame d'Eon*: Sappho (seventh–sixth centuries BC), the Greek poet, headed a great school of poetry on the island of Lesbos. Héloïse (*c*.1101–64), a Frenchwoman of noble birth, was the secret wife of the more lowly scholar Peter Abelard, whom her guardian uncle castrated when he discovered the liaison. Her correspondence to Abelard reveals great strength of character and selfless devotion. Their story inspired Pope, 'Eloisa to Abelard', *Works* (1717). Catherine Macaulay (1731–91), liberal historian and controversialist.

Catherine the Great (1729–96) deposed her husband in 1762 to become Empress of Russia. Charles de Beaumont, Chevalier d'Éon (1728–1810), was a French secret agent who disguised himself as a woman. His true sex only became known at his death.

150 *Sophia . . . sex*: *Emilius*, IV. v. 2.

151 *'Hence we deduce . . . expedient'*: ibid. IV. v. 7–8; the emphasis is Wollstonecraft's.

 the fall of man: Gen. 3.

153 *'It being once demonstrated . . . decorate themselves'*: *Emilius*, IV. v. 15; 18–22; 25–7.

154 *the first years . . . to form the body*: more precisely, Rousseau wants Émile's early years to be devoted to the education of the senses (ibid. I. ii. 234); the child should be encouraged to draw, to sing, and to articulate. Specifically intellectual abilities will have been absorbed (I. ii. 197): 'I am almost certain that Emilius will know perfectly well how to read and write before he is ten years old, because I give myself very little trouble whether he learn it or not before he is fifteen.'

155 *'Girls . . . hath caused us'*: ibid. IV. v. 30.

 'The common attachment . . . obedience': ibid. IV. v. 31.

 'These dogs . . . beauty': Buffon, *The Natural History of the Dog* (1762), ch. IV, associates the droopy ears of a certain kind of dog with the 'gentleness, docility, and even . . . timidity . . . he has acquired by the long and careful education bestowed on him by man'.

 'For the same reason . . . boys': *Emilius*, IV. v. 31.

156 *'There results . . . superiority'*: ibid. IV. v. 32–3.

157 *'Each sex . . . triumph over him'*: ibid. IV. v. 33.

158 *'Daughters . . . abuse'*: ibid.

 'Whatever is, is right': ibid. IV. v. 35; in his translation Kenrick follows the expression of Pope, *Essay on Man* (1733–4), i. 294: 'One truth is clear, "Whatever IS, is right".' Rousseau's original sentence, *Émile*, IV. v. 55, was: 'Ce qui est, est bien.'

 'The superiority . . . cultivate both': *Emilius*, IV. v. 35–6.

159 *'Beauty . . . Eastern bashaw'*: ibid. IV. v. 42; 46. The people of Circassia, NW Caucasus, were notorious for selling their young daughters to the harems of the Turkish nobility.

 'The tongues of women . . . untruth': ibid. IV. v. 45–6.

 how few speak: cf. Matt. 12: 34: 'out of the abundance of the heart the mouth speaketh.'

161 *'It is easy . . . infidelity'*: *Emilius*, IV. v. 48–50; the emphasis is Wollstonecraft's.

'*Her dress . . . imagination*': ibid. IV. v. 91.

'*that with her . . . neatly*': ibid. IV. v. 94; the emphasis is Wollstonecraft's.

'*Your husband will instruct you in good time*': ibid. IV. v. 97; the emphasis is Wollstonecraft's.

162 *Tully's offices*: Marcus Tullius Cicero (106–43 BC) examined virtue in *De officiis*.

'*Besides . . . amiable*': *Emilius*, IV. v. 124–5.

163 '*Sensual pleasures . . . ideal*': ibid. IV. v. 214.

'*Emilius . . . reason*': ibid. IV. v. 288–9.

Rousseau's Emilius: ibid. IV. v. 289–90.

164 '*The charm of life . . . our own breast*': Smith, *The Theory of Moral Sentiments*, I. i. I. 2, p. 15: 'But whatever may be the cause of sympathy, or however it may be excited, nothing pleases us more than to observe in other men a fellow-feeling with all the emotions of our own breast.'

165 *the shade . . . contemplation*: according to tradition Newton first considered gravity in 1665 sitting in the shade of an apple tree.

Dryden: John Dryden, *The State of Innocence: and Fall of Man* (1677), V. i: 'Curs'd vassallage of all my future kind: | First idolis'd, till loves hot fire be o'er, | Then slaves to those who courted us before.'

166 *Telemachus*: François de Salignac de La Mothe Fénelon, *Les Aventures de Télémaque fils d'Ulysse* (1699). Sophia, the heroine of *Emilius*, reads this work as part of her educational programme, falling madly in love with its hero.

Dr Fordyce's sermons: James Fordyce, *Sermons to Young Women* (1765).

168 '*Behold . . . vengeance*': Fordyce, *Sermons* (3rd corrected edn. 1766), I. iii. 99–100.

Hervey's Meditations: James Hervey, *Meditations and Contemplations* (1745–7) was in its 26th edition by 1792; the most popular of its pieces was the morbid 'Meditations among the Tombs.'

leading-strings: straps to prevent children from falling who are learning to walk.

dress and needle-work . . . the fair: see Fordyce, *Sermons*, I. ii. 69 ff. (on dress) and I. vi. 149–53 (on needlework). Like Rousseau, Fordyce advocates modesty in dress; he repeatedly addresses the reader as 'the Fair.'

169 '*Never . . . kindred angels*': ibid. II. ix. 163.

'*As a small degree . . . beauty*': ibid. II. xiii. 248.

170 '*Let it be observed . . . gentle*': ibid. II. xiii. 224–5.

'*I am astonished . . . domestic bliss*': ibid. II. xiv. 264–5; the emphasis is Wollstonecraft's.

171 '*that they will hear . . . deceiving them*': Gregory, *Legacy*, 6: 'You will hear, at least for once in your lives, the genuine sentiments of a man who has no interest in flattering or deceiving you.'

172 *the lady . . . blood*: cf. Arthur William Costigan, *Sketches of Society and Manners in Portugal* (1787), i. 400–3; which tells of two cousins, rivals in love. One of them, a widower, has the other, an officer, horsewhipped. The officer later kills the widower, who is travelling with his sister, 'this being done, he asked a thousand pardons of the lady, for having so incommoded her, and begged to know whither she wished to be conducted'. Wollstonecraft reviewed Costigan's book in the *Analytical Review*, 1 (Aug. 1788), 451–7.

'*Be even cautious . . . understanding*': Gregory, *Legacy*, 31–2.

173 *under a bushel*: see Matt. 5: 15: 'Neither do men light a candle, and put it under a bushel, but on a candlestick.' Also Mark 4: 21, Luke 11: 13, and Matt. 25: 25: 'And I was afraid, and went and hid thy talent in the earth.'

Hamlet: *Hamlet*, I. ii. 76 and 85: 'Seems, madam? Nay, it is. I know not "seems"'; 'But I have that within which passes show.'

174 '*The men . . . not aware of*': Gregory, *Legacy*, 36–7.

'*The sentiment . . . your sex*': ibid. 43–4.

'*The power . . . conceives*': ibid. 42.

delicacy of constitution: ibid. 50–1: 'We so naturally associate the idea of female softness and delicacy with a corresponding delicacy of constitution, that when a woman speaks of her great strength, her extraordinary appetite, her ability to bear excessive fatigue, we recoil at the description in a way she is little aware of.'

175 *How long . . . men*: Prov. 1: 22: 'How long, ye simple ones, will ye love simplicity? and the scorners delight in their scorning, and fools hate knowledge?'

on an elephant . . . earth: according to ancient belief the world was a disc, surrounded by water, supported by a huge creature, either a tortoise or a mammoth; in Greek mythology Atlas supported the world on his shoulders.

176 *Cowper*: William Cowper, *The Task* (1785), v. 733; the emphasis is Wollstonecraft's.

peace 'which passeth understanding': Phil. 4: 7: 'the peace of God, which passeth all understanding.'

Mrs. Piozzi: Hester Lynch Thrale Piozzi (1741–1821), the writer and friend of Samuel Johnson, whose most famous work was *Anecdotes of the Late Samuel Johnson* (1786).

177 '*Seek not . . . husband*': Piozzi, *Letters to and from the Late Samuel Johnson* (1788), letter lxxii, pp. 98–100.

Medicean: a reference to the Venus de' Medici, a standard of female beauty in the eighteenth century.

The Baroness de Staël: Germaine, la baronne de Staël-Holstein (1766–1817), author of *Lettres sur les écrits et le caractère de J.-J. Rousseau* (1788).

178 '*Though Rousseau . . . adoration*': de Staël, *Letters on the Works and Characters of J.-J. Rousseau*, trans. (1789), 15–16.

'*he admits the passion of love*': ibid. 16.

'*What signifies if . . . theirs*': ibid.

179 *Madame Genlis*: Stéphanie-Félicité Brulart de Genlis, marchioness de Sillery (1747–1830); *Adelaide and Theodore* (1782; London, 1783).

She tells a story: Genlis, *Tales of the Castle*, trans. Thomas Holcroft (1785), ch. III, 'Theophilus and Olympia'.

an accomplished young woman: see Genlis, *Adelaide and Theodore* (1783), iii. 237–8.

180 *Mrs Chapone's Letters*: Hestor Chapone, *Letters on the Improvement of the Mind* (1773).

without sufficient respect being paid to her memory: Catherine Macaulay, the historian and polemical writer, was generally derided after her marriage at the age of 47 to the 21-year-old William Graham.

181 *the worm in the bud*: cf. *Twelfth Night*, II. iv. 111–13: 'She never told her love | But let concealment, like a worm i' the bud | Feed on her damask cheek.'

For every thing . . . there is a season: Eccles. 3: 1: 'To every thing there is a season.'

I have already observed: p. 88 above.

183 *He who loves . . . men*: 1 John 4: 20: 'he that loveth not his brother whom he hath seen, how can he love God whom he hath not seen?'

183　*all that is done under the sun is vanity*: Eccles. 1: 14: 'I have seen all the works that are done under the sun; and, behold, all is vanity and vexation of spirit.'

185　*Inkle*: Richard Steele, *Spectator*, 11 (13 Mar. 1711), tells of Thomas Inkle who sails to the West Indies to make his fortune; his ship is attacked by Indians, on the American mainland, but Inkle is saved by an Indian woman, Yarico, who hides him in a cave until she is able to communicate with a passing ship bound for Barbados. They travel there together, but on arrival Inkle sells her as a slave, only raising her price when she pleads that she is pregnant. Wollstonecraft includes the story in *The Female Reader*, i. 29–31. Steele gives his source as *A True and Exact History of the Island of Barbados (by Richard Ligon)* (1657).

　　Sidney: Sir Philip Sidney, *The Countess of Pembroke's Arcadia* (1590), i. 18: 'I find indeed that all is but lip-wisdom, which wants experience.'

186　*'pursuing the bubble fame in the cannon's mouth'*: *As You Like It*, ɪɪ. vii. 152–3: 'Seeking the bubble reputation | Even in the cannon's mouth.'

　　Pantaloon's tricks: Pantaloon, stock character of sixteenth-century Italian *commedia dell'arte* and of the harlequinade in eighteenth-century London, was a devious and rapacious Venetian merchant who was constantly fooled.

187　*Dean Swift's . . . Houyhnhnm*: Jonathan Swift, *Travels into Several Remote Nations of the World, by Lemuel Gulliver* (1726), pt. ɪᴠ.

189　*Burke*: Burke, *Reflections on the Revolution in France* (1790), 129–30: 'Prejudice renders a man's virtue his habit,' and 'is of ready application in the emergency'; Burke argues that there is more 'latent wisdom' in a long-standing prejudice than in the individual's reason.

　　'Convince . . . still': Samuel Butler, *Hudibras: The Third and Last Part* (1678), canto ɪɪɪ, p. 226: 'He that complies against his Will, | Is of his own opinion still.'

190　*cannot serve God and mammon*: Matt. 6: 24: 'Ye cannot serve God and mammon'; also Luke 16: 13.

　　Miscellaneous Pieces in Prose: J. and A. L. Aikin, *Miscellaneous Pieces, in Prose* (1773), 59, 'Against Inconsistency in Our Expectations'.

191　*materialists*: the work of René Descartes (1596–1650), Pierre Gassendi (1592–1655), and Thomas Hobbes (1588–1679) led to the establishment of the classical theory that physical reality is entirely composed of particles of matter in motion; in the eighteenth century the theory was developed by Julien Offroy de la Mettrie (1709–51), Paul, baron d'Holbach (1723–89), and David Hartley (1705–57).

192 *grows 'with our growth'*: Pope, *Essay on Man* (1733–4), ii. 136: 'Grows with his growth, and strengthens with his strength.'

193 *Egyptian bondage*: probably reference to the Muslim bondage of women; but Egypt was also under the bondage of Turkish rule from the sixteenth until the nineteenth century.

 'a set of phrases learnt by rote': Jonathan Swift, *Works* (1735), ii, 'The Furniture of a Woman's Mind', l. 1.

 'highest praise is to obey, unargued': in *Paradise Lost*, iv. 635–8, Eve addresses Adam: 'My Author and Disposer, what thou bidst | Unargu'd I obey; so God ordains, | God is thy Law, thou mine: to know no more | Is Woman's happiest knowledge and her praise.'

 'a passion for a scarlet coat': Swift, *Works*, 'The Furniture of a Woman's Mind', l. 2.

 'that every woman is at heart a rake': Pope, *Of the Characters of Woman*, l. 216: 'But every woman is at heart a rake.'

195 *'Where love ... pride'*: John Dryden, *Fables Ancient and Modern; Translated into Verse* (1700), 'Palamon and Arcite', iii. 231–2.

196 *Lovelace*: the rake who rapes the virtuous heroine in Samuel Richardson's *Clarissa* (1747, 1748).

197 *a universal blank*: see *Paradise Lost*, iii. 48.

 'Whose service is perfect freedom': *The Book of Common Prayer* (1549), Morning Prayer, Second Collect, for Peace; original refers to God, not reason.

198 *Modesty! ... sleep life away*: cf. *Paradise Lost*, iii. 1–55.

 a prophecy: Milton implies his future fame in 'Ad Patrem' (?1632), *Poems of Mr. John Milton: Both Latin and English* (1645).

 General Washington ... forces: George Washington (1732–99) was made commander-in-chief of the armed forces of the United Colonies, to fight the British, on 15 June 1775.

199 *Gay*: John Gay, *Fables* (1727), no. xiii, 'The Tame Stag'.

200 *'The lady ... cannot'*: John Berkenhout, *A Volume of Letters to his Son at the University* (1790), no. xxxii, p. 307.

202 *'Can any thing ... temptation'*: Knox, *Essays (Moral and Literary)* (expanded edn. 1782), i. 34. p. 154.

203 *Heloisa*: see note to p. 149 above.

205 *Essenes*: Jewish order practising elaborate ritual bathing.

208 *the Temple of the living God*: 2 Cor. 6: 16: 'for ye are the temple of the living God.'

210 *the chameleon's food*: the chameleon was popularly thought to live on air.

lull their Argus to sleep: according to Greek mythology, when Zeus, the king of the gods, fell in love with Io, a priestess of Hera his wife, he transformed her into a heifer to protect her from Hera's wrath. Hera set the many-eyed Argus to guard Io, and prevent her retransformation, but Zeus sent Hermes to lull Argus to sleep by playing the flute and then to cut off his head, and release Io.

212 *'that reputation . . . chastity'*: cf. Rousseau, *Emilius*, IV. v. 19: 'their glory lies not only in their conduct, but in their reputation; and it is impossible for any, who consents to be accounted infamous, to be ever virtuous.'

'A man . . . women': ibid. IV. v. 19.

213 *'That . . . presumptions'*: Smith, *Moral Sentiments*, I. iii. 5, pp. 416–17.

the Pharisees . . . seen of men: Matt. 6: 5: 'And when thou prayest, thou shalt not be as the hypocrites are: for they love to pray standing in the synagogues and in the corners of the streets, that they may be seen of men.'

214 *Lucretia*: a Roman lady (d. 510 BC) who was raped by Sextus Tarquinius, the son of the king; before stabbing herself to death she exacted an oath of vengeance from her husband and her father.

Smith: Smith, *Moral Sentiments*, I. iii. 2, p. 285.

215 *Java tree*: *Eugenia jambolana*, the java plum tree, was incorrectly believed to be poisonous in the eighteenth century.

serpent's egg: cf. *Julius Caesar*, II. i. 32.

216 *'there is . . . impunity'*: Catherine Macaulay, *Letters on Education* (1790), 210; 'let her only take care that she is not caught in a love intrigue, and she may lie, she may deceive, she may defame, she may ruin her family with gaming, and the peace of twenty others with her coquettry, and yet preserve both her reputation and her peace.'

'This has . . . their own sex': ibid. 212.

218 *levees of equivocal beings*: according to Ned Ward, *A Compleat and Humourous Account of All the Remarkable Clubs and Societies in the Cities of London and Westminster* (1749), homosexual levées occurred in London as well.

223 *wealth leads women to spurn*: in England the practice of wet-nursing continued to be common throughout the eighteenth century.

224 *As soldiers . . . incline the beam*: a reference to the war of intervention against revolutionary France which was to last for twenty years (in 1792 the northern European countries and Russia were not yet involved).

 Fabricius . . . Washington: Fabricius died in quiet poverty. George Washington was brought up on a farm, Mount Vernon, to which he returned after his military success in 1755, and at the end of his public life in 1796.

 Faro Bank: a complicated card game, played for money, which was very fashionable at the court of Louis XIV.

 bowels: compassion.

225 *bubble*: to cheat.

 the milk of human kindness: *Macbeth*, I. v. 17.

 Cerberus: in Greek mythology the three-headed dog guarding the entrance to hell.

 the abominable traffick: the slave trade.

226 *The laws . . . cypher*: see William Blackstone, *Commentaries on the Laws of England* (1765), I. xv. 430: 'By marriage, the husband and wife are one person in law: that is, the very being or legal existence of the woman is suspended during the marriage, or at least is incorporated and consolidated into that of the husband: under whose wing, protection and *cover*, she performs everything.'

 leave the nursery for the camp: Rousseau, *Emilius*, IV. v. 13: 'Can a woman be one day a nurse, and the next a soldier?'

229 *suckle fools and chronicle small beer*: *Othello*, II. i. 160; Iago's description of the activity of a praiseworthy woman.

 accoucheur: male midwife.

 'that shape hath none': *Paradise Lost*, ii. 667: 'If shape it might be called that shape had none.'

 mantua-makers: dressmakers.

230 *'the lily broken down by a plow-share'*: Fénelon, *The Adventures of Telemachus*, trans. Isaac Littlebury (1699), i. 152: 'As a beautiful Lilly in the midst of the Field, cut up from the Root by the Plowshare, lies down and languishes on the Ground.'

232 *baseless fabric*: see *The Tempest*, IV. i. 151.

232 *'assurance doubly sure'*: *Macbeth*, IV. i. 83: 'But yet I'll make assurance double sure.'

232 *L'amour propre, L'amour de soi-même*: see J.-J. Rousseau, *Discours sur
 l'inégalité*, I, n. 12. pp. 252–3: 'Il ne faut pas confondre l'Amour
 propre et l'Amour de soi-même; deux passions très différentes par
 leur nature et par leurs effets. L'Amour de soi-même est un sentiment
 naturel qui porte tout animal à veiller à sa propre conservation et qui,
 dirigé dans l'homme par la raison et modifié par la pitié, produit
 l'humanité et la vertu. L'Amour propre n'est qu'un sentiment relatif,
 factice, et né dans la société, qui porte chaque individu à faire plus de
 cas de soi que de tout autre, qui inspire aux hommes tous les maux
 qu'ils se font mutuellement, et qui est la véritable source de
 l'honneur.' (*Translation*: One must not confuse self-love and self-
 esteem; two passions which are very different both in their nature and
 in their effects. Self-love is a natural emotion which leads all animals
 to strive for self-preservation and which in man, directed by reason
 and modified by pity, produces humanity and virtue. Self-esteem is
 no more than a subordinate emotion, an artificial product of society,
 which leads each individual to pay more attention to himself than to
 anyone else, which alone drives men to harm each other and which is
 the true source of honour.)

233 *Rebekah's*: Rebekah, mother of Esau and Jacob, through her love of
 Jacob, tricked her eldest son Esau out of his rightful blessing from his
 dying father, Isaac.

234 *when I treat of private education*: see Ch. XII.

235 *the same observation*: Samuel Johnson, *The Rambler* (17 Aug. 1751),
 no. 148: 'tenderness once excited will be hourly encreased by the
 natural contagion of felicity, by the repercussion of communicated
 pleasure.'

237 *'if the mind . . . industry'*: John Locke, *Some Thoughts Concerning Edu-
 cation* (1693), 45, p. 2.

243 *usher*: under-teacher.

244 *wise in their generation*: cf. Luke 16: 8.

249 *vices . . . delicacy of mind*: masturbation was regarded as physically
 and morally harmful; see, for example, the widely read *Onania; or,
 The Heinous Sin of Self Pollution, and All its Frightful Consequences in
 Both Sexes Considered with Spiritual and Physical Advice to those who
 have Already Injured themselves by this Abominable Practise* (1710).

252 *men . . . ministers*: probably refers to Diane de Poitiers (1499–1566),
 who held great influence over her lover Henry II throughout his reign
 (1547–59); Catherine de' Medici (1519–89), the wife of Henry II,
 who effectively ruled France during the reigns of her sons Francis II

(1559–60), Charles IX (1560–74), and Henry III (1574–89); and
Marie de' Medici (1573–1642), the wife of Henry IV, who became
regent during the minority of her son Louis XIII (1610–17) against
the express wishes in her husband's will.

255 *market penny*: *OED*: 'a perquisite made by one who buys for another.'

Juno's angry brow: Juno, the wife of Jupiter, was traditionally por-
trayed as a nagging wife.

the love of pleasure and the love of sway: Pope, *Of the Characters of
Women*, l. 210.

260 *Rousseau*: probably refers to Julie, in *La Nouvelle Héloïse*.

Theresa: Marie Thérèse Le Vasseur (1721–1801), French seamstress
and Rousseau's lifelong companion.

261 *celestial innocent*: see *Les Confessions*, pt. II (Neuchâtel, 1790), IV. viii.
190: 'Le cœur de ma Thérèse était celui d'un ange.' Thérèse was
widely rumoured to be both simple and an alcoholic.

Nay . . . affection for him: see ibid. pt. II, VI. xii. 123: Rousseau's guilt
about placing his children in a foundling hospital, his fear of the
financial necessity of doing the same with any further children, and
his illness owing to a congenital defect of the urinary tract led him to
decide to abstain from sexual intercourse in 1762: 'c'était aussi depuis
cette époque, que j'avois remarqué du refroidissement dans Thérèse:
elle avait pour moi le même attachement par devoir, mais elle n'en
avait plus par amour.' (*Translation*: it was from this period that I
noticed a coldness in Thérèse; she had the same attachment to me out
of duty but not out of love.)

263 *treating their infants*: a reference to women who suckled their chil-
dren; among the eighteenth-century medical advocates of the practice
was Ben Lara, *An Essay on the Injurious Customs of Mothers not Suck-
ling their own Children* (1791), which Wollstonecraft reviewed in the
Analytical Review, 10 (July, 1791), 275–6; see *Works of Wollstonecraft*,
vii. 385–6.

moloch: a Canaanite idol to whom children were sacrificed.

suffer for the sins of its fathers: see Exod. 20: 5: 'I the Lord thy God am
a jealous God, visiting the iniquity of the fathers upon the children
unto the third and fourth generation of them that hate me;' see also
Exod. 34: 7; Num. 14: 18; Deut. 5: 9.

264 *bills of mortality*: records of deaths kept in London from 1592
onwards.

266 *nativities*: horoscopes.

268 *magnetisers*: healing and performing magnetizers became popular in the late eighteenth century; an influential practitioner was Friedrich Mesmer (1733–1815), who believed that diseased bodies could be cured by magnets and who later advocated hypnotism.

269 *Jesus*: John 5: 14: 'Behold, thou art made whole: sin no more, lest a worse thing come unto thee.'

271 *particles of fire*: phlogiston, the hypothetical inflammable element of matter, was named at the start of the eighteenth century and, though discredited as a theory by Lavoisier by 1790, was firmly believed in by Joseph Priestley.

275 *how naturally . . . ruffles*: Jonathan Swift, *Miscellanies in Verse and Prose* (1727), ii. 330, 'A Letter to a Young Lady on Her Marriage': 'And when you are among yourselves, how naturally, after the first Complements, do you apply your hands to each others Lappets and Ruffles and Mantra's, as if the whole business of your Lives, and the publick concern of the World, depended upon the Cut or Colour of your Dresses.'

276 *pleasure . . . sway*: see Pope, *Of the Characters of Women*, l. 210.

 'Matter . . . fair': ibid., ll. 3–4.

277 *'that women . . . men'*: Smith, *Moral Sentiments*, I. iv. 2, p. 428: 'Humanity is the virtue of a woman, generosity of a man. The fair-sex, who have commonly much more tenderness than ours, have seldom so much generosity.'

 Cato's . . . Carthage: Marcus Porcius Cato (234–149 BC), Roman statesman, was sent to Carthage in 157 BC to arbitrate between the Carthaginians and the Numidians; he became convinced that Roman supremacy required the annihilation of Carthage. See Smith, *The Theory of Moral Sentiments*, II. vi. 2, pp. 97–8: 'The sentence with which the elder Cato is said to have concluded every speech which he made in the senate, whatever might be the subject, "*it is my opinion likewise that Carthage ought to be destroyed*", was the natural patriotism of a strong but coarse mind.'

280 *figs from thistles*: see Matt. 7: 16; Luke 6: 44.

282 *Butler's caricature of a dissenter*: a reference either to the pompous Puritan knight who is the eponymous protagonist of Samuel Butler's *Hudibras* (1662–3), or to the 'Hypocritical Nonconformist', *The Genuine Remains in Verse and Prose* (1759), ii. 35.

283 *trade with Russia for whips*: Russians were notorious for wife-beating and for the flogging of peasants and convicts.

 last volume: there were no further volumes published.

288 *Locke . . . civil liberty*: John Locke (1632–1704) wrote *An Essay Concerning Toleration* (1667), four letters *Concerning Toleration* (1689, 1690, 1692, 1714), and an essay *On the Reasonableness of Christianity* (1695); his *Two Treatises of Government* (1690) opposed the divine right of kings.

The Declaration of the Rights of Man: *La Déclaration des droits de l'homme et du citoyen* (1789) was announced by the French National Assembly on 26 Aug. 1789.

impress-warrant: the British wartime practice of 'impressing' able-bodied men into the army and navy against their will was long established. Poor men were always most vulnerable.

290 *Voltaire leading the way*: Voltaire (François-Marie Arouet, 1694–1778) repeatedly criticized the superstitious nature of conventional religion. See e.g. *Lettres anglaises ou philosophiques* (1734); *La Pucelle d'Orléans* (1755); *L'Essai sur l'histoire générale et sur les mœurs et l'esprit des nations depuis Charlemagne jusqu'à nos jours* (1756); *Dictionnaire philosophique* (1764); *Le Sermon des cinquante* (1749 [1762?]); *Droits des hommes et les usurpations des papes* (1768); *Le Cri des nations* (1769).

Rousseau . . . inequality: Jean-Jacques Rousseau (1712–78) makes these attacks most explicitly in *Du contrat social* (1762), and in *Discours sur l'origine et les fondemens de l'inégalité parmi les hommes* (1755).

291 *Quesnai . . . economists*: François Quesnai (1694–1774) established the physiocratic theory of economics through his contributions to the *Encyclopédie ou dictionnaire universel des arts et des sciences* (1751–65), and his books such as *Physiocratie* (1768). Considered the first scientific school of economists, the physiocrats advocated reform of a taxation system which weighed most heavily on the poor.

Turgot: Anne-Robert-Jacques Turgot, baron de l'Aulne (1727–81), the controller-general of finance (1774–6), was also a physiocrat. His attempts to establish a rigid economy and to reform feudal privileges alienated members of the court, who contrived his downfall.

293 *'do unto others . . . do unto them'*: Matt. 7: 12: 'Therefore all things whatsoever ye would that men should do to you, do ye even so to them: for this is the law and the prophets.'

296 *raree-shows*: Samuel Johnson, *A Dictionary of the English Language* (1755): 'A show carried in a box.'

Francis the first: Francis I (1494–1547) ruled France 1515–47; in foreign policy he abandoned the traditional Christian crusades against the Turks.

the Guises: a powerful ducal family of Lorraine, traditionally in enmity with the French Crown.

296 *Henry the fourth*: the first Bourbon king of France (1553–1610).

297 *Richelieu*: Armand Jean du Plessis, duc de Richelieu (1585–1642), governed France as the chief minister of Louis XIII (1624–43).

 Mazarin: the Italian-born Giulio Mazzarini [Mazarin] (1602–61) succeeded Richelieu as chief minister in 1642, and was retained by the Queen Regent Anne of Austria after the death of Louis XIII in 1643 until his own death.

 Louis 14th: Louis XIV 1638–1715.

 Molière's: Jean-Baptiste Poquelin (1662–73), French dramatist.

 Corneille: Pierre Corneille (1606–84), French tragic dramatist.

 Dryden: John Dryden (1631–1700), English poet and dramatist.

298 *Racine*: Jean Racine (1639–99), French dramatist. He was an accomplished courtier and as royal historiographer he produced several highly flattering plans of histories of Louis XIV (reigned 1643–1715).

 madame de Maintenon . . . king: Françoise d'Aubigne, marquise de Maintenon (1635–1719), married Louis XIV privately in 1685. Racine's letter is collected in *Recueil des lettres de Jean Racine* (1750?), 317.

299 *Louis*: Louis XIV.

 Fénélon . . . Burgundy: François de Salignac de La Mothe Fénelon (1651–1715) was employed in 1689 as tutor to Louis, duc de Bourgogne (1682–1712), the grandson of Louis XIV and father of Louis XV. *Les Aventures de Télémaque fils d'Ulysse* (1699) was a fictional work in which national difficulties are solved by the exile of a king from his people.

 states-general: 'Les États Généraux' constituted a national assembly first convened in 1302. It was composed of three orders: the nobility, the clergy, and the commons, who were summoned to grant subsidies or to advise the Crown. As absolute monarchy was established during the seventeenth century the practice of convoking the assembly was abandoned. It last met before the Revolution in 1614.

 publication . . . convoked: Louis François Armand du Plessis, duc de Richelieu (1696–1788), describes this incident in his *Mémoires du Maréchal de Richelieu* (1790–3), i. 81–8.

 a reply written: Richelieu refers to several 'mémoires clandestins' written anonymously.

300 *empty promises*: as a result of the disturbances following the death of Henry IV, Louis XIII convoked the Estates-General between Octo-

ber 1614 and March 1615. The king undertook to abolish the purchase and sale of offices, to reduce the number of state pensions, and to bring recent state financiers to trial. Only the first of these promises was carried out, and that only briefly.

regency: during the minority of Louis XV, Philippe, duc d'Orléans, acted as regent (1715–23).

the prior de Vendôme: Philippe de Vendôme (1655–1727) was Grand Prior of France, and a notorious rake. He visited England in the spring of 1683 and wooed Louise de Keroualle (1652–1725), the French mistress of Charles II. Vendôme refused to leave when asked, and Louis XIV intervened to preserve good relations between the two countries.

Dubois . . . memorial: Guillaume Dubois (1656–1723) was the tutor of Philippe, duc d'Orléans, becoming his private secretary in 1715 when the duke became regent. He acted as virtual ruler of the country until his death, being appointed chief minister in 1722. Wollstonecraft is referring here to his *Mémoire du Cardinal au Régent sur les États Généraux que ce prince avoit envie de convoquer* (1789).

301 *dauphine*: born Maria Antonia Josefa Johanne, Marie Antoinette (1753–93) was the daughter of Empress Maria Theresa of Austria; she married the future Louis XVI in 1770, and became queen of France in 1774.

Madame du Barry: Marie Jeanne Bécu, comtesse Du Barry (1743/46?–93), became the mistress of Louis XV in 1768 and influenced the court until his death in 1774.

302 *Louis*: Louis XVI.

Joseph: Emperor Joseph II of Austria (1741–90), who became king of Germany in 1764 and Holy Roman Emperor in 1765.

necklace . . . Trianon: in 1785 Boehmer, the court jeweller, offered Marie Antoinette a diamond necklace for 56,000 livres which she declined because of the vast expense. However, the comtesse de la Motte forged the queen's signature, obtained the necklace, and absconded with it. She was caught, tried, and sentenced in 1786, but escaped to London. At the time the French public suspected the queen of involvement in the fraud. Valeria Messalina (*c.* AD 22–48), the third wife of Emperor Claudius, was notorious for her licentiousness. Louis XIV built two pleasure palaces at Trianon, 'le grand Trianon' and 'le petit Trianon'; Louis XVI gave the latter to Marie Antoinette.

302 *Necker . . . Comte-rendu*: Jacques Necker (1732–1804) was controller-

general of finance after Turgot (1776–81). Wollstonecraft is referring to his *Compte rendu au Roi par M. Necker . . . au mois de janvier 1781* (1781), which publicly presented the details of state finances for the first time.

303 *Calonne*: Charles Alexandre de Calonne (1734–1802) was controller-general of finance (1783–7), succeeding Jean François Joly de Fleury (1718–1802) and Henri-François de Paule Le Fevre d'Ormesson (1751–1807), who both held the post briefly.

assembly of notables: the 'assemblée de notables' was an assembly of notables, bishops, knights, and lawyers, equivalent to the aristocratic sections of the orders of the Estates-General. Calonne summoned it for three months in February 1787 to tackle the state finances, and again in November 1788.

305 *'that he had acted . . . king'*: cf. J. P. Rabaut Saint-Étienne, *Précis historique de la Révolution Française* (1792), i. 41.

accusation . . . La Fayette: Marie Joseph Paul Yves Roch Gilbert du Motier, marquis de Lafayette (1757–1834), made this accusation at the assembly of notables on 15 April 1787; see the *New Annual Register* (1789), 4–5.

count d'Artois: Charles Philippe, comte d'Artois (1757–1836), was Louis XVI's younger brother and, with Marie Antoinette, leader of the reactionary party at the French court. During the Revolution he toured the European courts soliciting support for the royalist cause.

306 *M. de Breteuil*: Louis Auguste le Tounelier, baron de Breteuil (1730–1807), was a politician and diplomat and a supporter of the autocracy of monarchy. His return to office on 12 July 1789 was an immediate cause of the Bastille riots.

fled . . . out of the kingdom: Calonne lived in exile in England (1787–9); he was forbidden to return to France during the Revolution and joined the comte d'Artois in leading *émigré* opposition.

308 *M. de Brienne*: Étienne Charles Lomenie de Brienne (1727–94) succeeded Calonne as controller-general of finance in 1787, to be forced out of office by public opposition in Aug. 1788.

dissolved: 25 May 1787.

309 *deuxieme vingtieme*: the 'vingtieme', a 5 per cent income tax paid mainly by peasants, had been doubled in 1756.

séance royale: a royal session of the Estates-General.

keeper of the seals: François de Lamoignon (1735–89) was keeper of the seals 1787–8.

310 *duke of Orleans*: Louis Philippe Joseph, duc d'Orléans (1747–93), was

nicknamed 'Philippe Égalité' because of his revolutionary sympathies, which Wollstonecraft believes to have stemmed mainly from his antipathy to the royal family. He was elected deputy for Paris to the convention in 1792, but was guillotined in 1793.

bed of justice: a 'lit de justice' was a plenary session of the Paris parlement presided over by the monarch, whose presence automatically secured the registration of any edicts he wanted.

cour plénière: this was another aristocratic assembly designed to bypass the obstructive Paris parlement in order to register taxes. It was summoned by Brienne and Lampignon on 8 May 1788 but suspended on 8 August.

in favour of the protestants: this edict was proposed by Louis Alexandre, duc de la Roche-Guyon et de la Rochefoucault d'Enville (1743–92). From the revocation of the Edict of Nantes (1685) until 1788 those who refused the Catholic sacraments had no legal rights, including no right of inheritance.

311 *L'Hôpital*: Michel de L'Hôpital (1507–73) was chancellor of France 1560–8.

312 *the two members dragged to prison*: Duval d'Epremesnil and Goislart de Montasbert were arrested at 5.00 a.m., 6 May 1788.

313 *recalling Necker*: 25 August 1788.

 a great author: Necker was a prolific writer. Concerned mainly with finance, his *Œuvres complètes* (1820–2) ran to 20 vols.

314 *Importance of religious opinions*: Jacques Necker, *De l'importance des opinions religieuses* (1788), was translated into English by Wollstonecraft in the same year.

315 *Sangrado*: in Alain René Le Sage, *Histoire de Gil Blas de Santillane* (1715–35), Dr Sangrado (Sp. 'sangrar', to bleed) believes bleeding to be the best cure for all ills; although scores of his patients die, he refuses to change his method.

 1614: the decree was passed on 25 September 1788 that the three orders be represented in equal numbers (though the numbers which they represented were by no means equal), and that they deliberate separately, as they had at the last meeting of the Estates-General in 1614.

 convened a second time the notables: 6 November 1788.

316 *tiers-etat*: the commons, or third order, in the Estates-General.

 monsieur: the king's younger brother Louis Stanislas Xavier, comte de Provence (1755–1824).

316 *Dauphine*: a province in SE France.

317 *the abbé Sieyes*: Emmanuel-Joseph, comte de Sieyès (1748–1836), was author of *Qu'est-ce que le Tiers-État* (1789), which called for the doubling of the number of representatives of the commons; he was a member of the National Assembly in 1789.

 the marquis de Condorcet: Marie-Jean-Antoine-Nicholas de Caritat, marquis de Condorcet (1743–94), like Sieyès, produced many pamphlets; Wollstonecraft is probably referring to *Lettres d'un gentilhomme à messieurs du Tiers-État* (1789).

 Mirabeau: Honoré Gabriel Victor Riqueti, comte de Mirabeau (1749–91), was a great orator who led the moderate phase of the Revolution, until his death. Wollstonecraft makes extensive use of his accounts of the proceedings of the National Assembly.

320 *'that he remained . . . concord'*: cf. Thomas Christie, *Letters*, 80: 'The king, according to his own declaration, remained *alone* in the midst of the nation, occupied in the re-establishment of concord.'

321 *the 27th*: June 1789.

323 *a corrupt, supple abbé*: abbé Matthieu Jacques de Vermond (b. 1735) was recommended by the Bourbons to teach French to Marie Antoinette in preparation for her marriage.

 circean . . . Julias and Messalinas: in Greek legend Circe was the sorceress who surrounded her palace with human beings whom she turned into beasts by means of drugs and incantations. Wollstonecraft is probably referring to Julia (d. AD 28), wife of Lucius Aemilius Paulus, who was banished for an alleged affair with the poet Ovid in AD 9. Her mother Julia (39 BC–AD 14), daughter of Augustus Caesar and Scribonia, was also banished by the emperor for profligacy. Valeria Messalina (see third note to p. 302), third wife of the Roman emperor Claudius, was notorious for her profligacy and ambition; she was executed at the age of 26.

324 *death of the queen*: she was guillotined on 16 October 1793, nine months after Louis.

326 *the son of a nobleman . . . intruders*: Helen Maria Williams's *Letters Written in France in the Summer of 1790* (1790), letters XVI–XXII, describes exactly this situation in the story of the du Fossés.

327 *How silent is now Versailles*: Versailles had remained empty since 6 Oct. 1789, when the mob had forced the royal family to return to Paris.

 the posterity of the Banquoes: see *Macbeth*, III. iv.

331 *Themistocles . . . Caesar*: Themistocles (*c.*527–460 BC) was an Athenian statesman and general; Marcus Tullius Cicero (106–43 BC) was a Roman statesman and orator; Marcus Junius Brutus (85–42 BC) was the Roman politician who instigated Julius Caesar's assassination in 44 BC.

Wedderburne: Alexander Wedderburne, first Baron of Loughborough and first Earl of Rosslyn (1733–1805), was Solicitor-General under Lord North in 1771.

Franklin: Benjamin Franklin (1706–90) was the American diplomat and statesman who was the principal negotiator of American independence both before and after the war.

if the supercilious . . . independence: in 1774 Franklin exposed an anti-American correspondence between two governors of the Massachusetts Assembly and the British government; defending the two, Wedderburne launched an attack on Franklin who subsequently lost his post as Deputy Postmaster-General for North America.

in prison: following an amatory scandal, Mirabeau was imprisoned for six months in 1767 on the authority of a *lettre de cachet* obtained by his father.

332 *Aristides*: Aristides 'the Just' (d. 468 BC) was an Athenian statesman committed to conservative, moderate policies in opposition to Themistocles.

336 *magna charta . . . habeas corpus act*: the Magna Carta was sealed in 1215; the Habeas Corpus Act was passed in 1679.

Venice and Genoa: in the second half of the eighteenth century these cities were booming as pleasure resorts.

a mercenary aristocracy: the rise of the privileged and closed class of the burghers was a central feature of Swiss politics in the seventeenth and eighteenth centuries.

covetous Hollanders: the Dutch, 'covetous' of colonial possessions, fought Britain for naval supremacy (1781–3).

an association of the nobles: after the humiliating Stockholm Treaty of 1719 a new political party of nobles sought to restore the primacy of Sweden under a strengthened monarchy.

the ambition of her neighbours: between 1568 and 1768 Corsica was under the increasingly strict control of Genoa; a series of revolts throughout the eighteenth century and periodic French intervention culminated in the sale of the island to the French.

a contemptible bigotry: Roman Catholic inquisitorial measures continued in these countries until the end of the eighteenth century.

336 *military phalanx*: under the autocratic rule of Maria Theresa (1740–80) and her son Joseph II (1780–90) Austria was at war with her neighbours throughout the eighteenth century.

337 *tzarina . . . Peter the great*: as empress of Russia (1762–96), Catherine II (1729–96) followed the expansionist example of Peter I (1672–1725), who reigned 1689–1725.

 formed by nature . . . most important: cf. Locke, *Two Treatises of Government*, ii. 95: 'The only way whereby any one devests himself of his Natural Liberty, and *puts on the bonds of Civil Society* is by agreeing with other men to joyn and unite into a community, for their comfortable, safe, and peaceable living one amongst another;' *An Essay Concerning Toleration*; the letters *On Toleration*; and Rousseau's *Du contrat social*.

338 *republics of Italy*: the five republics of Italy were constituted in the mid-fifteenth century.

 apostles of Machiavel: the political theories of Niccolò Machiavelli (1469–1527), author of *Il principe* (1513), were also perpetuated by Trajano Boccalini (1556–1613), Giovanni Botero (1540–1617), Filippo Paruta (1540–98), and Scipione Ammirato (1531–1601).

 Medicis: the ruling family of Florence from 1434 until 1737. Among the most famous of its patrons of the arts were Lorenzo the Magnificent (1449–92) and Cosimo I (1519–74).

 Descartes . . . Newton: in *Principia philosophiae* (1644) René Descartes (1596–1650) established a theory of vortices to explain motion, replacing the Aristotelian explanation. This was supplanted by the theory of gravity which Sir Isaac Newton (1642–1727) presented in *Principia mathematica* (1687).

 their courts: in the seventeenth century the courts of Brunswick, Kassel, Dresden, Heidelberg, Munich, Stuttgart, and Vienna were all renowned as literary centres. The eighteenth century saw the rise of an intellectual bourgeoisie through which the ideas of German classicism and liberalism could spread.

339 *Frederic the IId of Prussia*: Frederick II of Prussia (1712–86) reigned 1740–86 and was the author of the critical *Examen du Prince de Machiavel* (1740).

 Hertzberg: Count Ewald Friedrich von Hertzberg (1725–95) rose to prominence during the Seven Years War of 1756–63; he lectured on administration and politics, but was mainly involved in the formation of foreign policy according to his vision of Prussia as the arbiter of Europe.

literary pursuits . . . Petersbourg: Catherine II (1729–96) wrote plays and pamphlets and corresponded with Voltaire and Diderot.

the supercilious Joseph: Joseph II of Austria (1765–90) was notorious for his confidence in his own reasoning, in the power of the State when directed by reason, and in his right to speak for the State, uncontrolled by laws.

Mansfield: Sir James Mansfield (1733–1821) was Solicitor-General 1780–2.

340 *ignominious servitude*: cf. Richard Price, *A Discourse on the Love of our Country* (1789), 49–51.

the first of October: 1789.

excluding the dragoons: the dragoons gained the approval of the constitutionalists and survived the Revolution.

341 *'O Richard . . . t'abandonne'*: Michel-Jean Sedaine, Richard, *Cœur-de-Lion*, trans. (1786), I. iii. 'Ariette', ll. 1–2; cf. Rabaut, *Précis historique*, iv. 145, and Le Courrier, 50: 5.

'The national cockade . . . faction': cf. *Le Courrier*, 50: 5.

342 *chevaliers of St Louis*: knights of an honorary military order created by Louis XIV in 1693 which served until 1830.

canaille: literally 'a pack of dogs,' *canaille* had been used since the 17th century to refer to the populace, the mob.

'The nation . . . thursday': cf. Rabaut, *Précis historique*, iv. 146.

345 *bailliages*: districts run by bailiffs.

347 *'Accordingly . . . basis'*: cf. *Journal des débats et des décrets*, 55: 2; and *Le Courrier*, 50: 8.

'pitiful respect for false honour': cf. *Lettres à M. le comte de B**** (1789), ii. 145–7.

One of the members remarked: cf. *Le Courrier*, 50: 9; and *Journal des débats et des décrets*, 55: 3, which report the speech of M. Muguet de Mantoue.

Another asserted: ibid., 50: 10; and *Journal des débats et des décrets*, 55: 4, which quote M. Duport.

348 *'that his majesty . . . the people'*: ibid., 50: 15.

Robespierre . . . the people: ibid., 50: 10.

'by a pious fiction . . . ministers': cf. *Le Moniteur*, no. 68.

350 *count d'Estaing*: Jean-Baptiste Charles Henri Hector, comte d'Estaing (1729–94), was a French naval commander who became Admiral of France in 1792.

350 *Metz*: a town in Lorraine.

351 *eleven o'clock*: 11 p.m., 5 Oct.

 the commune of Paris: in 1789 the revolutionary committee which
 replaced the city council took the name 'commune of Paris', with
 Petrion as Mayor; it fell with Robespierre on 17 July 1794.

359 *introducing the sale of honours*: in the 1640s.

 the gallant Henry: Henry IV of France.

360 *the Encyclopedia*: see note to p. 291 above.

 Scylla or Charybdis: in the *Odyssey* Scylla and Charybdis were mon-
 sters inhabiting a reef and a whirlpool, between which travellers could
 only pass with the greatest difficulty.

 The economists: Quesnai and Turgot were the leading economists of
 the *Encyclopédie*. See note to p. 291 above.

362 *original compositions*: e.g. Immanuel Kant (1724–1804), *Kritik der
 reinen Vernunft* (1781); Johann Wolfgang von Goethe (1749–1832),
 Die Leiden des jungen Werthers (1774); Johann Christoph Friederich
 Schiller (1759–1805), *Die Räuber* (1781).

 ingenious, if not profound writers: after the deaths of the great
 'philosophes', Voltaire in 1778, Condillac in 1780, Diderot in 1784, a
 breed of young writers arose who survived by the patronage of the
 wealthy bourgeoisie. These imitative writers included the poet Jean-
 François Marmontel (1723–99); the poet and historian Claude
 Carloman Rulhière (1735–91); and the critic Jean-François La Harpe
 (1739–1803).

365 *egotism . . . signification*: Johnson, *Dictionary*: 'The fault committed
 in writing by the frequent repetition of the word *ego* or *I*; too frequent
 mention of a man's self, in writing or conversation.' Wollstonecraft is
 confused; 'egotism' was an English word used in French according to
 its English signification; the French word 'egoism' meant excessive
 self-love.

366 *'every man . . . all'*: first recorded in J. Heywood, *A Dialogue Contain-
 ing the Number in Effect of All the Proverbs in the English Tongue* (1546).

 comfort: the French word *confort* meant assistance until the modern
 English meaning was adopted at the beginning of the nineteenth
 century.

369 *a celebrated writer says*: Adam Smith, *An Inquiry into the Nature and
 Causes of the Wealth of Nations* (1776), I. i: 'The habit of sauntering
 and of indolent careless application, which is naturally, or rather

necessarily, acquired by every country workman who is obliged to change his work and his tools every half hour, and to apply his hand in twenty different ways almost every day of his life; renders him almost always slothful and lazy and incapable of any vigorous application even on the most pressing occasions.' Smith is arguing for the division of labour, and goes on in I. ii to argue that the ability to co-operate in divided labour distinguishes humans from brutes.

	Women's Writing 1778–1838
WILLIAM BECKFORD	Vathek
JAMES BOSWELL	Life of Johnson
FRANCES BURNEY	Camilla
	Cecilia
	Evelina
	The Wanderer
LORD CHESTERFIELD	Lord Chesterfield's Letters
JOHN CLELAND	Memoirs of a Woman of Pleasure
DANIEL DEFOE	A Journal of the Plague Year
	Moll Flanders
	Robinson Crusoe
	Roxana
HENRY FIELDING	Joseph Andrews and Shamela
	A Journey from This World to the Next and
	The Journal of a Voyage to Lisbon
	Tom Jones
WILLIAM GODWIN	Caleb Williams
OLIVER GOLDSMITH	The Vicar of Wakefield
MARY HAYS	Memoirs of Emma Courtney
ELIZABETH HAYWOOD	The History of Miss Betsy Thoughtless
ELIZABETH INCHBALD	A Simple Story
SAMUEL JOHNSON	The History of Rasselas
	The Major Works
CHARLOTTE LENNOX	The Female Quixote
MATTHEW LEWIS	Journal of a West India Proprietor
	The Monk
HENRY MACKENZIE	The Man of Feeling
ALEXANDER POPE	Selected Poetry

The Oxford World's Classics Website

www.worldsclassics.co.uk

- Information about new titles
- Explore the full range of Oxford World's Classics
- Links to other literary sites and the main OUP webpage
- Imaginative competitions, with bookish prizes
- Peruse the Oxford World's Classics Magazine
- Articles by editors
- Extracts from Introductions
- A forum for discussion and feedback on the series
- Special information for teachers and lecturers

www.worldsclassics.co.uk

American Literature

British and Irish Literature

Children's Literature

Classics and Ancient Literature

Colonial Literature

Eastern Literature

European Literature

History

Medieval Literature

Oxford English Drama

Poetry

Philosophy

Politics

Religion

The Oxford Shakespeare

A complete list of Oxford Paperbacks, including Oxford World's Classics, Oxford Shakespeare, Oxford Drama, and Oxford Paperback Reference, is available in the UK from the Academic Division Publicity Department, Oxford University Press, Great Clarendon Street, Oxford OX2 6DP.

In the USA, complete lists are available from the Paperbacks Marketing Manager, Oxford University Press, 198 Madison Avenue, New York, NY 10016.

Oxford Paperbacks are available from all good bookshops. In case of difficulty, customers in the UK can order direct from Oxford University Press Bookshop, Freepost, 116 High Street, Oxford OX1 4BR, enclosing full payment. Please add 10 per cent of published price for postage and packing.